AI WEIWEI

HUMAN FLOW

STORIES FROM THE GLOBAL REFUGEE CRISIS

Editors
Boris Cheshirkov
Ryan Heath
Chin-chin Yap

Princeton University Press
Princeton and Oxford

Published by Princeton University Press, 41 William Street,
Princeton, New Jersey 08540
In the United Kingdom: Princeton University Press,
6 Oxford Street, Woodstock, Oxfordshire OX20 1TR
press.princeton.edu
Library of Congress Cataloging-in-Publication Data
Names: Ai, Weiwei, interviewer. | Cheshirkov, Boris, editor. | Heath, Ryan, 1980- editor. |
Yap, Chin-chin, editor.
Title: Human flow : stories from the global refugee crisis / Ai Weiwei ;
editors, Boris Cheshirkov, Ryan Heath, Chin-chin Yap.
Description: Princeton : Princeton University Press, [2020] | Includes index.
Identifiers: LCCN 2020011535 (print) | LCCN 2020011536 (ebook) |
ISBN 9780691207049 (paperback) | ISBN 9780691208060 (ebook)
Subjects: LCSH: Refugees—Interviews. | Refugees—Biography.
Classification: LCC HV640 .A2226 2020 (print) | LCC HV640 (ebook) |
DDC 362.87092/2—dc23
LC record available at https://lccn.loc.gov/2020011535
LC ebook record available at https://lccn.loc.gov/2020011536
British Library Cataloging-in-Publication Data is available
Design: hesign, Berlin
Assistant Editor: Hanno Hauenstein
This book has been composed in IBM Plex Serif / Akzidenz Grotesk BQ / Couteau
Printed on acid-free paper. ∞
Printed in the Czech Republic
10 9 8 7 6 5 4 3 2 1

Contents

Editors' Note

Interviews may have been edited and condensed for clarity. Some interviews have been translated from Arabic, Farsi, French, Greek, Kurdish, Malaysian, Rohingya, Spanish, and Turkish into English.

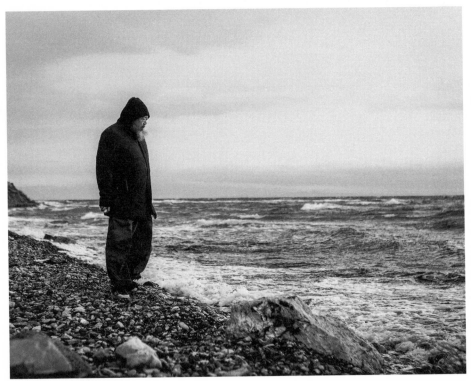

Ai Weiwei, Lesvos, Greece, 2016

Introduction

The interviews in *Human Flow: Stories from the Global Refugee Crisis* were conducted as part of the making of *Human Flow* (2017), my feature documentary on the global refugee crisis.

Human Flow documents the lives of refugees in twenty-three countries: Afghanistan, Bangladesh, France, Germany, Greece, Hungary, Iraq, Israel, Italy, Jordan, Kenya, Lebanon, Macedonia, Malaysia, Mexico, Pakistan, Palestine, Serbia, Sweden, Switzerland, Thailand, Turkey, and the United States. My aim was to portray the history and scale of the refugee crisis around the world. For this project my team interviewed more than 600 refugees, aid workers, doctors, historians, politicians, and local authorities.

Most of the people we approached were receptive to sharing their stories and opinions. A number of politicians declined, and some refugees were afraid of reprisal or endangering their loved ones back home. This selection is the result of our sincere and dedicated effort to provide a portrait of our time.

As an artist, I believe that any individual effort can make a change, which also comes with responsibility. We are grateful that these one hundred voices can be heard, and we hope they will offer insight into the greatest humanitarian crisis of our times.

Ai Weiwei
Berlin, September 2019

Human Flow
Stories from the Global Refugee Crisis

001

Pascal Thirion, *Tempelhof Management*
Tempelhof Refugee Camp, Berlin, Germany, 2015-12-16 and 2016-02-09

AW What's the history of this building?

PT It has a difficult history, but it's a very special place for me and for many people.
We're in the main hall of the former Tempelhof airport, an incredible old struc-
ture that ceased functioning as an airport in 2008—not a long time ago—but,
since then, many things have happened.

The building was constructed in 1938, during Hitler's time. We're in a space full
of history, good and bad. When the airport stopped being an airport, nobody
really knew what function it would assume. The first thing that happened was
that we started hosting events here. We had a big fashion show and some smaller
events, which was a good way to open up these spaces to the public, otherwise
the building would've been closed. You could feel that something special was
happening here.

Not being German, I always felt Berlin was very different from other German
cities. I came here because I knew this place from about thirty years ago. At that
time Berlin was still occupied by American, French, and British military forces,
and the wall was still there. This airport was run mainly by the US Air Force, so in
one half of the building, it was like being in the US and the other half of the
building was a normal public airport. My parents were working for the military,
so I was able to walk in all these spaces. Of course, if you come to Berlin as a
foreigner, you want to know a lot about the city.

You probably know how and why the airport was built, what happened with it
when the war was over, and how it was used for people coming from East Germany
or East Berlin. At that time, the wall wasn't built yet. It was the only way to get to
West Germany, an orderly way to get out of the city.

I came here because I knew that Berlin was becoming more of a truly international
city. I was privileged to work in many huge cities all over the world before coming
to Berlin: in South America, the US, the Middle East. There's still a gap when
you compare Berlin to other big cities outside of Europe. When talking about a
city in Asia, you're talking about millions of people, but if you talk about a big city
in Germany, it's still small compared to the megacities in the world.

What I saw in all these cities—Shanghai, Bangkok, Singapore, Hong Kong, or even
Rio de Janeiro, Mumbai, and Moscow—was the challenge of accommodating all
these people in adequate spaces. This was the specific reason why I thought
Tempelhof could become a special place for Berlin and for Germany. When you
have a large, open space like this, you have the possibility of creating new things
because you don't have to work within a framework. People can come here and
decide what they want to do. They can create the space they want to have. Inside
these larger spaces, things can happen that could probably never happen
somewhere else.

AW What's the current condition of the camp?

PT When I came here the objective was just to rent out spaces that could be used to earn a bit of money to contribute to its huge maintenance cost. We started by sponsoring commercial events. We had about eighty commercial events every year. The number and size increased exponentially. We had huge events that had never before happened in Germany. In the past five to ten years, we've seen more of a mix between commercial and cultural events. We have huge halls here— seven hangars where aircraft were maintained in the past.

Last year more refugees were coming to Germany. Last summer, people were already looking to Tempelhof: if we couldn't open spaces for refugees to live in, at least they could have a place to sleep. But you can't take refugees and put them in a hangar, because it's cold and windy; it's very nice for art shows or parties, but it isn't really a living space. We said, "Please, even if you can imagine living here in the summer, what's going to happen when it starts getting colder?" The hangars don't have heating or sanitary systems.

Normally there are twenty-five to fifty people working at Tempelhof, but now there are about 500 to 600 people living there. It wasn't easy to imagine how that transformation would unfold. Every night 500, 600, 700, even 800 people came to Berlin; every single night the city needed at least 700 new beds. It was only a matter of time before we had to open the hangars for refugees.

To be honest, in spite of having a few people who were specialists in organizing events, hosting refugees is a totally different situation than hosting a party where everything is ready at a certain time and then it's over and you tear everything down. The hangar has everything in place to host people at events—sanitary installations, lights, sound, a heating system, and so on—but holding temporary events is a completely different project than providing accommodation for refugees. Nobody knew exactly what was going to happen: Would people be there for a week, a month, a year? There simply wasn't enough time to prepare for this large influx of people.

Another issue we ran into is that there were many other organizations involved in this process. Could we work with them? Could they work with us? In the beginning everybody was full of energy. They came to Tempelhof and were fascinated with this space. Everybody thought, *Wow, look at this . . . this will become the best shelter ever.* You could feel the energy and history; you knew something very special was going to happen. But again, running a shelter or working with this very complicated issue of refugees is totally different. You know that every day you have to do so much more to offer better and more comfortable spaces, and at the end of the day, it's not happening at the speed that everybody wants it to happen. Every day it's like you're opening a new book. You're still in the same story but you don't really know what's going to happen, because you're a part of something that's happening worldwide.

Tempelhof is unique because of its enormous size. If you go to Jordan or Turkey, there are shelters for more than 100,000 people, but those in modern Western cities can't imagine 20,000 people in terms of size, smell, noise, and needs living

together in a small space. Berlin had to create space for 70,000 people last year. They all came, more or less, at the same time. Of course, nobody can be prepared to offer that many people housing, but you have to take care of their needs, including social work and health care. The other difficulty is that everyone came from regions where they don't really like one another for religious or political reasons. Now they're all put together into one small space. How do we deal with the fallout of this?

When the company Tamaja opened the first hangar, there were about 500 people living there. We had to put them in tents because it wasn't possible to set up other rooms for them. So we opened one hangar, then another, and now there are four open hangars with about 2,000 refugees living in them. The hangars could probably fit many more, but that's not working at this time. It's a huge logistics operation. At the end of the day, you need the infrastructure of three skyscrapers for each hangar. In the beginning we thought that people would come in for a week or so and then, after registering, go to other places where they could stay in much better conditions. Unfortunately, this isn't the way it works. People come here and stay for one to three months, and to be honest, nobody really knows how much longer they'll be here.

I still think it's absolutely necessary that we help these people, even though we now have to deal with problems we'd never anticipated before. How do you deal with men beating women? I'm not used to that. How do you deal with young people who have their whole lives ahead of them, who come into a rich society with cars and shops but who aren't able to be a part of it? Of course they're frustrated. I deeply believe that our society isn't ready to integrate people. It's a process that has to work both ways. Nobody really knows what's going to happen.

The most important thing is that we use the space, that refugees and other people have the possibility to meet, talk, and discuss what's happening in their lives. It's not only an issue for the refugees but also for the local people. I believe that the best way to integrate people is by using cultural events, because they are nonpolitical. People can simply meet as people. I would like to work very hard on this in the coming months to make these events possible. I know that there are a lot of people thinking similarly; they approach us and want to talk about their ideas. I hope that we can start very soon and make all these things happen. It's an ongoing part of the history of this fantastic building.

AW Yes, it's tremendous, there's architectural and also planning work. I once brought 1,000 Chinese people to Kassel, so I know how it works. Every day you need a truckload of food and another truck to carry away the garbage. And these people are from different locations; they don't know one another.

PT They come from Syria, Iraq, Pakistan, Afghanistan, and African countries.

AW How many different countries do they come from?

PT's colleague Eight to nine. They're mostly from Syria, Afghanistan, Pakistan, and Iran. A few are from the Balkan areas of the former Yugoslavia. There are only a few people from Africa.

AW Do they have conflicts?

PT's colleague Yes, indeed. The main conflict is between the Afghans and Syrians. Apparently, during their escape from their respective countries, their tracks crossed in Turkey and Greece, and Syrians were treated differently from Afghans. Afghans were stopped at many borders. Maybe it's jealousy, but there is no exact reason. It could be vengeance from a thousand years ago.

AW You must have a lot of volunteers or translators.

PT's colleague Yes.

AW Otherwise nobody knows what they're thinking.

PT Taking care of families is different than taking care of younger people between eighteen and thirty. People are full of energy. The funny thing is, they're all connected to their friends around the world because of Facebook. One of the biggest challenges is maintaining control and gathering information. I don't mean this in a bad way, but everything happening here immediately has an impact on other shelters, on people on the road, and so on. We're not prepared for it.

AW It's a very sensitive situation.

PT Yes.

PT's colleague Three months ago we opened another, smaller venue. Some refugees entered but many didn't. We asked, "Where are you going?" and everybody answered, "To Sweden." We asked, "Why Sweden?" No matter where they came from, the answer was always "Sweden." For some reason, initially people in these networks were saying that it was best to say you were going to Sweden. Four to six weeks later this changed, so it was interesting to see how they communicated. When there was a rumor that Hungary was closing its border—when, in fact, it wasn't closing the border but creating channels to control refugees—for the refugees it was very clear that it didn't make sense to enter Hungary through the fence, so they kept waiting until the way was clear again. Social media is something very special for refugees.

AW They create their language and their own code.

PT's colleague Probably.

AW How many languages do you have here now?

PT's colleague Six to eight.

AW How many people are there now?

PT's colleague Nearly 2,200.

AW And how many do you expect to come here in the future?

PT About 4,500 in the first phase. The city is still planning to set up tents, so this place should be able to handle up to 7,000. It doesn't necessarily mean that 7,000 are coming, but you have to see the bigger picture. So many people are coming to Germany, and specifically to Berlin. To control the situation, you need big places to sort everything out, to set up a clear structure to help the refugees.

AW It's a perfect location for them.

PT Don't tell me.

PT's colleague It depends on the point of view.

AW I mean, where can you find such a desirable place?

PT Yeah, for sure, and in the middle of the city. You also need to recognize that Berlin doesn't have a hinterland. In Munich they always say, "We have everything under control." They can say that because they send everybody out of the city and into the hinterland, out of sight. But cities like Hamburg, Berlin, and Bremen have to do everything, because they're responsible for the whole city. I think there are now 79,000 refugees in Berlin alone, which is double the number in all of Austria. It's incredible how the refugees disappear in the city. Everybody knows that they're there, and it's a lot of hard work to take care of them. Many schools offer their gyms for refugees to stay overnight.

This situation is also disturbing our plans to some extent because we've been dreaming about museums and all sorts of things at Tempelhof. But on the other hand, it's a positive challenge because we're helping people.

AW I think it's a heroic situation.

PT Let's go outside.

During the Second World War there were aircraft departing from these hangars for the West every ninety seconds and bringing back everything needed to keep the city alive: food, energy, everything, because there was no connection between West Berlin and the rest of the Western world.

AW So Germany was also used to this kind of humanitarian aid.

PT Exactly.

AW It's not new for them.

PT No, it isn't. At the end of the day they know that a huge world war started from German territory. I think what they're doing now is an incredible symbol of humanity, simply saying that you can't stop refugees from coming to this place, to Germany. My friends in France, Belgium, and Holland say, "Oh God, how can Germany do such a thing? What are they going to do with all these people?"

I always tell them, "Listen, at the end of the day Germany can be proud that all these people are coming to Germany." The question should be, why don't they want to go to France, Belgium, or Holland?

Money isn't the only reason. I think it's because this place has one of the most stable democracies in the world, and I think individuals are still extremely respected here. It's a free country. It's not corrupted. You can live your life here and make a living, especially young people. They come from all around the world because they simply want to start living here and do what they can't do in their countries because the older generations are still preventing younger people from taking care of the country. I think it's an incredible space where these things can happen. But it's also a challenge. I think it will work; I think that in about five years, other countries will say, "Why didn't we have similar ways of accepting people?"

AW This is a beautiful airport.

PT The whole airport stays like this as a monument. You can do everything in this airport as long as you leave it the way it was afterward.

AW It's so open, so liberal here. They do everything from high fashion and art to refugees.

PT Exactly. But at the moment there are no fashion shows, only refugees. In the original architectural plans there wasn't a restaurant but a glass wall. So you'd come into the airport and look upon the airfield. It's a beautiful piece of architecture.

AW It will be remembered; you made a new history.

PT Exactly; it's now part of the history of this building. When the wall was built, a lot of people from East Berlin wanted to leave. They came to this airport and flew out to West Germany. That was also an important part of history.

002

Amama, Refugee
Tempelhof Refugee Camp, Berlin, Germany, 2015-12-18 and 2016-02-10

A I'm from Syria and my name is Amama. I came here with my mother, three sisters, and stepfather, because we can't live anywhere else.

AW Which level are you in at school?

A I was in third grade. My school was a very beautiful place.

AW I'm sure you're a very good student. Would you like to tell your story about your journey and why you wanted to come here?

A We left because my father died. In the beginning we went to Lebanon and then to Turkey. There we got the news that my father had died. I asked my mother to leave Turkey because she couldn't afford the cost of living there. So I said, "Let's go to Germany."

AW Can you tell me how your father died?

A He died on the beach. He was going to work in the morning, carrying a large iron bar with him. He was stopped at the checkpoint because the security guards thought he had a weapon. My father didn't have any weapons, but they took him to prison.

After a month or two the authorities told us, "Your father is dead." We didn't believe the news at first. They said it was 100 percent sure, and still we didn't believe them. My uncle took us to Lebanon and we stayed there for a year. We gave our uncle a real hard time, so he threw us out onto the street. We left him and ran away, back to Syria.

We stayed in Syria for ten days and then we left for Turkey. We stayed there for two years. We were watching the news on TV one night and they were showing people who had been imprisoned in Syria. My father's face was among them; you could tell he'd been badly beaten up.

We worked in İzmir and my uncle also helped us. He saved up some money and sent us to the Greek islands. From there he took us to Athens. My uncle is the one who provided for us. I see him as my father because he helped us in everything. He gave us money and everything else, and he treated us like his own children. This is my little brother. He didn't know our father at all. He was six months old when my father was arrested. He looks to my uncle and calls him father.

AW You're from Syria; I assume you'd never seen the ocean before. What do you remember from this long journey? Were you scared?

A The first time I saw the sea I felt strange and a little scared. We got into a boat and the smugglers had to change the boats three times because they all had holes in

them. The third time, the boat had a big hole and some people tried to fill it with air along the way. We finally got midway across the water. We were very close to the beach. It would've only taken half an hour to reach Greece, but the engine stopped and the boat started swerving left and right. The men jumped into the water to push the boat. We didn't know if we would live or die. All the people lost hope. We thought we'd arrived at our last moment before death.

Then suddenly a plane appeared and we started waving at it. Someone in the plane took photos and then left, but the plane came back with a coast guard boat to rescue us. They helped the women and girls get onto the boat, but they kept the men in the other boat, flooded the engine, and taunted them.

We sailed for a long time. It took us two hours to get to the coast. Once we were there, we got our papers to cross, and then we headed to Athens on a ferry.

From there we traveled in buses, trains, and so on. We reached Serbia, where we stayed for two hours. Many of the people there had been beaten by the authorities. There were a lot of journalists there, so we stayed near them in order not to be beaten as well. We asked them to stay with us. We had to demonstrate to push the authorities to bring buses to take us away.

Many of us rode buses to Austria, and from Austria we took a train to Germany, where we arrived in Munich. From Munich we went to Bonn. From Greece to Germany, our trip was easy, but the other trips were difficult. When we took a boat in Turkey, there was a woman holding a small baby that was one month old. She wanted to put her baby in the boat, so she gave it to a man in front of her. But the child flew out of his hands and was crushed on the rocks. The baby was broken into pieces.

AW Thank you for this clear description of your journey. After so many things happened—traveling, the ocean, your difficulties, no money, your father passing away—how do you look at the world?

A Everyone hates their life in such dirty conditions. Do you know why we don't have money with us, even here in Germany? Because when we buy food to eat, they throw it in the trash in front of our eyes. We wait in front of the social services center from morning till late in the evening to buy food. But they take it and throw it in the trash in front of us. This is our life in Germany. In the camp, everything is forbidden. If you want to get out of here, you must go with your parents.

The most exhausting period in my life has been here in this camp. I'm so bored with my life and everything, and so is everyone who lives here—my mother, my sisters, and all the people here. Everyone here suffers from boredom. Do you know what I think about when I go to sleep? I think about whether this iron ceiling will fall on my head and if I'll die the next day.

AW I think you're a very brave and talented young lady. If there was one thing you could tell the world, what would it be?

A Do you know why I stay awake at night? Because I need to take care of my sisters. The door to our room is a piece of cloth, and every ten minutes someone comes and opens it. Once when I was in the room and my mother had gone to the doctor, I saw the bed moving. Sometimes things happen at night that make me afraid. Even the guards are afraid of the sounds here. Being on watch makes my eyes hurt.

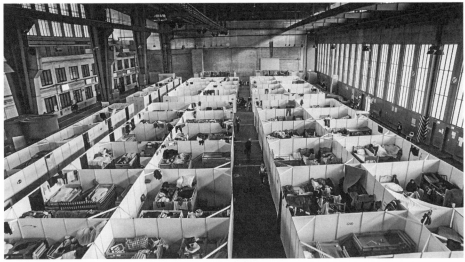

Tempelhof Airport Camp, Berlin, Germany, 2016

003

Atiq Atiqullah, Refugee
Moria Camp, Greece, 2015-12-26

AA My name is Atiq Atiqullah. I'm from Afghanistan and I'm twenty-two.

I arrived here yesterday. This has been the worst part of my life. I left Afghanistan because there were many problems for my family and me. We went to Iran and then to Turkey. It took more than a month to get to Turkey. Yesterday, or the day before yesterday, we took two boats from the Turkish beach to Greece. There were about a hundred of us Afghans. More than fifty were children, women, and old men. There were forty-five people in one small boat and fifty-five in the other.

We had been in the water for about an hour when a Turkish patrol ship came and harassed us. I can still remember even now how it made me feel. If they were human and regarded us as humans, they should've shouted to us, "We will help you." But they were like robbers and killers; they were worse than the Taliban and ISIS. All the children were screaming and crying. We shouted to those on the patrol ship, "What are you doing? If you're going to help us, please give us a hand or push us back to Turkey. But you're going to kill us. We're in the water. We can't do anything." They had big sticks and they were abusing us; they wanted to beat us with these sticks.

The waves were rising two meters high and our boat was nearly capsizing. We tried many times to restart the ship engine and finally got about 200 meters away from them. They were also harassing the people in the other boat. We escaped in the other direction. When we went the other way, the sea was violent and the small children were crying. It was a very bad situation, the worst I've experienced. When we got to Europe the boat was broken and filling with water. The engine stopped working. I took my mobile phone, which was in a plastic cover, and I called the Greek police to help us. I said, "We're in a very bad state, and if you don't come in ten minutes we will die."

The Greek police came quickly and saved us. We were in the water and everybody was screaming. It was a bad day.

It's a shame. I'm a refugee, and in my life I've never seen such a situation. I thought, *How could they do this to us? Why were they trying to kill us? Is this humanity? You are in a Muslim country and we are Muslims, so help us.* Instead, they were abusing us. They told us, "You will not live here."

AW What kind of boat did you take?

AA Two kinds of boats. Small, cheap rubber boats almost eight meters long with small engines. There were forty-five people in one and fifty-five in the other.

AW How many children?

AA More than fifty children—twenty-five in one boat, twenty-five in the other.

AW How long did you prepare before the trip?

AA We didn't know it would be like this. When we planned to go to Greece, they told us there would be a big ship.

AW But were you prepared to take this trip?

AA Yes, we were prepared for this.

AW It could be very dangerous.

AA We knew that.

AW Do you know how to swim?

AA I can swim, but the children can't.

AW So it's really risky.

AA Yes, it's full of risk. We were forced to leave. I love my country. Nobody in the world wants to leave his country. But there's no way for people to live in that place. All the world knows: Taliban, ISIS, al-Qaeda, fighting, killing, explosions, suicide bombers every day, every night. We got many threats from them. We finally decided that with all that killing in Afghanistan, we would die if we didn't leave. So this was the one and only way to safety and a better life in the future: to go to other countries, especially to Europe.

AW You're so lucky you arrived here.

AA Yeah.

AW Is there something wrong with your eye? Do you need treatment?

AA My head was injured during the clash with the Turkish police ships. I got a shock.

AW Are you okay?

AA Now I'm okay. I'm very happy in Greece and with the UNHCR [United Nations High Commissioner for Refugees] office and the people working and helping the refugees here. When I arrived on this beach, I didn't think that I was in another country. I thought they were all my family members. Everyone was helping us. They replaced our clothes and shoes, gave us bread and tea. Everything was ready for us. People from all over the world, especially from UNHCR, and volunteers from other countries came to help refugees at this border. We are thankful.

AW Thank you for speaking out. People have to speak out loud. We're all human; we're the same.

AA I hope one day I can sit in a UN conference and speak about this so that all the world knows what's going on. We were in Turkey, which wants money from the

European Union. You see us as humans, but they see us as animals. I'm worried for the future of those people and families on their way. Will they arrive alive or dead? Will they be killed, kidnapped, robbed? Syrian, Pakistani, Iranian, Afghan—all people are human. They're coming here because their countries are in bad conditions.

AW You're probably a good spokesperson for the refugees. The refugee situation examines humanity and civil rights worldwide. This isn't just a local problem, this is a human problem. We have to make people understand that all humans share this problem.

AA Thank you very much.

AW Do you have children?

AA No, I'm single.

AW What's your profession?

AA I'm a construction engineer. I graduated from the engineering faculty of the university in Afghanistan. I worked in my country for two years, serving my people as a road engineer and construction engineer. I had many hopes. Unfortunately, the terrorists and other people didn't let us work safely. I got many threats from terrorists. I have the letters. I complained to the Afghan police. My life is in danger in Afghanistan.

I contacted the UNHCR office from Kabul: "Hello, I'm in a very bad situation. I got threats from the Taliban. They will kill me. Can you help me?" UNHCR replied, "No, unfortunately we don't have any UNHCR officer in Kabul to help you. You can contact any foreign embassies in Kabul." I contacted the German and Turkish embassies. The Turkish embassy didn't answer me. The German embassy said, "Stay one or two months, then we'll contact you." I also contacted the International Organization for Migration and said, "My life is in danger here. What should I do?" They said, "Thank you for emailing us and telling us about your problem." And then they said that they couldn't do anything. "Go to the foreign embassies in Afghanistan, in Kabul." When I emailed the foreign embassies, they didn't answer me.

After that I was forced to go by foot. There were many problems on the way. Every day, everywhere, every hour that I was on my way, I thought that if I could arrive in Europe, this would be my place. Otherwise I would die in Afghanistan. Many Afghan families who had previously gone to Europe talked about the same routes, problems, and stories on their way.

AW Do you have good communication with your family?

AA Yes.

AW Are they in Afghanistan?

AA Yes.

AW Are they happy because you're safe here?

AA For three or four days I didn't have contact with them and they were very unhappy. They messaged me a lot, asking if I was alive. When I arrived here, I found Internet access and emailed and called them, letting them know that I'm safe. They're very happy.

AW Will you bring them here one day?

AA I hope to arrive in a country that accepts my case. After that, I'll call my family to join me, and we'll have a good life.

AW I'm sure you're a hardworking and very smart person. Which nation will you choose? What is your destination?

AA Now, I want to go to Germany. But I haven't decided 100 percent because I studied the countries of the European Union, their culture, their economies, and their policies with refugees, especially those like me. I have my bachelor's degree and would like to go to a country where I can pursue my master's or PhD. I want to work, too. I'll decide if Germany is good for me, and if not I'll go to another country to have a bit of life.

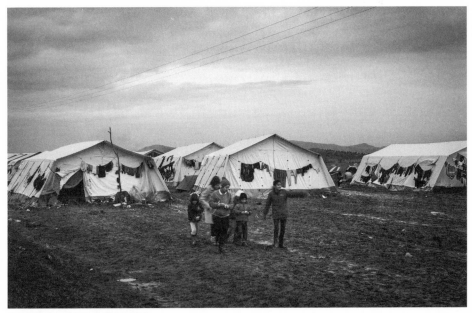

Makeshift Camp, Idomeni, Greece, 2016

004

Boris Cheshirkov, UNHCR
Lesvos, Greece, 2016-01-01 and 2016-02-19

BC In order for us to understand what has been happening, particularly in this last year in Europe, we need to go back to who is a refugee and why people are on the move. A refugee is a person who has experienced terrible conflicts: country torn apart by war, home bombed, loved ones and relatives lost. A refugee is someone who is forced to move, to flee their home and country, and who leaves behind family members, relatives, friends, and a way of life.

Never in recorded history have so many millions been forcibly displaced from their homes because of war, human rights abuses, and persecution. At this very moment there are more than sixty million people around the world that have had to flee. This is extraordinary. The reason for this level of unprecedented displacement is the wars around the world. In just the past five years or so, we've seen more than fifteen conflicts around the world, many of which are taking place in Africa or in the Middle East. We've even seen some at the European Union's doorstep in Ukraine.

Right now we're on Lesvos island, the point where half a million people, most of them refugees, set foot and entered Europe in 2015. In the last year alone, more than one million have come to Europe through the Mediterranean Sea. These are movements we haven't seen in decades, in fact, not since the Second World War. But it's still something that we need to consider in the global context with so many millions displaced.

We've observed something quite extraordinary in the last year: boat after boat, usually rubber dinghies carrying about fifty people, coming through this very narrow stretch of water between Turkey and Greece to find safety and a dignified life in Europe. They fled the Syrian war, which has claimed so many lives and pushed out millions of people. Initially, they went to Lebanon, Jordan, or Turkey. Turkey is now the single largest refugee host in the world with more than 2.5 million registered Syrian refugees. However, people aren't getting the humanitarian assistance they need in those countries of first asylum.

In fact, what we've observed in Lebanon and Jordan is that nine out of ten refugees are living below the national poverty line, which means that they can't make ends meet; they don't necessarily have a way to access labor opportunities in these countries. Their children aren't in school. We're seeing more people begging on the street to survive; many are now resorting to survival sex work just to be able to put food on the table. Children, instead of being in school and having a normal, decent childhood, are working at a very young age to help sustain their families. At the same time we've seen these momentous arrivals in Europe. Many of them come because their family members are already here, while others are in search of a dignified way of life and self-sufficiency.

Last year the situation intensified with the unscrupulous smuggling and trafficking networks that have complete disregard for human life. In many ways they're

complicit in murder, because they've sent people into terrible conditions, and many have lost their lives. Last year, more than 3,700 people drowned or went missing in the Mediterranean. In 2016 we've already seen more than 400 people dying in shipwrecks off the coasts of Lesvos and other islands, as well as off the Turkish coast. This extraordinary desperation is completely unique in our lifetime.

I remember January 20 this year very vividly. We had a day of very poor weather conditions—severely inclement, ice-cold, gale-force winds and subfreezing temperatures. It was snowing that day. The sea, unlike today, was extremely turbulent, and yet one boat after another, full of people, came through. We had more than forty boats arriving, mostly on the southern shore of Lesvos, and all the people that were on board were families from Syria or Iraq, some of them Yazidi families, families that had been on the water for three to five hours. We had children frozen stiff; they couldn't move. Everyone was in complete distress and shock. It was an unbelievably dramatic situation, but we had to compose ourselves because the people needed support.

AW So, as a UN official, you don't actually have that much information to cope with the situation.

BC We're a humanitarian agency, not a political entity. Obviously we work in very politicized environments. Sometimes it's extremely complicated for us to do our work because of the political dynamics, but at the end of the day we're here to provide humanitarian assistance. We came to Greece, and specifically to Lesvos, at the invitation of the government and the European Union. We've come to help them improve their reception capacity and their coordination between the volunteer networks and the national and international organizations, but we're also responding to a humanitarian emergency. We're on the shoreline with the volunteers, helping people disembark from the arriving boats. On any given boat there is an elderly woman or an unaccompanied child or a pregnant woman or a family with a baby just a few weeks old.

We really need to celebrate the way that the people of Lesvos have been respond-ing. They've been so generous, going out to the shoreline and helping refugees, regardless of the fact that hundreds of thousands have come through this small island. Greece is just one country, and it can't be expected to do everything on its own. It needs resources and support from the European Union and other European countries.

AW What is the general policy toward refugees?

BC For us at the UN Refugee Agency, everyone is equal, everyone gets a blanket, everyone has access to shelter, everyone can be registered, and everyone can seek asylum, because it's a universal human right. There should not be any difference between nationalities. We recognize that there may be procedures in place because of the governments' and the EU's rules.

AW What are the EU's rules?

BC There are many rules, directives, and regulations involved in the Common European Asylum System. Greece, as a European Union member state, needs to adhere to these. As long as the international standards given in the 1951 Refugee Convention are met, the system is credible and functioning, but many improvements are needed. Certainly, the level of support is much more meaningful at the end of 2015 than it was at the beginning of 2015. It has been an extraordinary year. One million people have come across the seas of Europe, and 80 percent of those people have come to Greece—half of them to Lesvos.

AW Where are those one million people now?

BC It's very difficult to say where they are. Many of them have moved to western and northern Europe in this great movement to Germany or to Sweden.

AW What is the officially accepted number?

BC We're still waiting to see the final numbers for 2015, but obviously Germany has received the most refugees this year.

AW How many?

BC I can't say for sure. Some say that one million people have come to Germany. We won't know this statistic until later in the year, but what we know for sure is that many have gone to Germany. In relation to population size, most have gone to Sweden. Others have gone to the UK, France, and Norway.

AW How many went to the UK?

BC Very few.

AW It's shameful.

BC We're not here to point the finger at countries, but we recognize that much more can be done by all the EU countries.

AW Why are they not acting?

BC There are probably many reasons why countries aren't receiving as many refugees as they could. We really need to see every country make a commitment, a pledge, and help refugees by taking in meaningful numbers under legal channels, including family reunifications. I met a family just a couple of weeks ago. A twenty-five-year-old man in a wheelchair from Aleppo in Syria, permanently disabled, came across the sea with his wife and his elderly mother. He has a brother in the UK. He applied for family reunification in Turkey but said he was rejected. Sadly, he was forced to use his life savings to come across the sea in a rubber boat full of people instead of legally reuniting with his brother on humanitarian grounds.

Greece is dealing with extraordinary circumstances. It's under a lot of pressure. It needs help from the EU and the international community.

AW What's your evaluation of the situation in Greece at the moment?

BC We have very good cooperation with Greek authorities, especially on Lesvos. We have the full support of the mayor, Spyros Galinos. He has shown, on behalf of the people of Lesvos, that they'll continue to be generous and continue to receive and help refugees, which is inspiring on its own.

AW How much support does Greece actually get?

BC The improvements are tangible. Frontex, which is the EU external borders agency, has come to help the Greek coast guard. Now, most of the boats are picked up on the sea and taken safely to the port. We're seeing more resources allocated to registering the arrivals. These are important elements, but we need full participation and solidarity from every country in the European Union and beyond, because this situation isn't specific to Greece. It isn't even specific to Europe. It's a global phenomenon.

We've entered a desperate era, an extremely dangerous era, in which war is governing this huge displacement. We need political solutions to stop these horrible wars, and we need governments to support the smaller countries that are hosting large numbers of refugees. We need the full engagement of the international community so that women, men, children, and families have a chance to regain control of their lives and their dignity. And we need to celebrate the bravery of the refugees to move through so many countries, experience the horrors of war and conflict, be subject to humiliation and human rights abuses, and endure the loss and grief that they must be experiencing. Their loved ones have been slaughtered and murdered. To still smile and be happy to continue with your life in that situation—that's an incredible achievement, and it should be celebrated. I think that refugees are some of the bravest people on this planet.

AW Thank you. I share the same feeling. I feel for those women and old men who are around eighty, ninety years old—they've lost everything but they bring their babies out. That's all they want to do. Do you think Europe and the world understand this?

BC We have to be frank. The situation has really challenged Europe as a union in many ways. It has shown that the asylum and protection systems are uncoordinated and dysfunctional. Countries are taking unilateral action. We're seeing more restrictive policies. Xenophobia is becoming rampant, intolerance more frequent and mainstream. We're seeing countries that are pivotal to our civilization now having restrictive asylum policies, putting caps on asylum applications, limiting the numbers of refugees that can enter their countries. We're seeing borders close, governments introducing legislation to limit family reunification, or even confiscating property and valuables so that the asylum procedure can be paid for. This is a very troubling time, and these developments are challenging the European Union and Europe's founding principles of solidarity, human rights, tolerance, and diversity. The big question now is whether we can pull ourselves together as a global community and uphold the principle of asylum, give protection to those who are fleeing war, and stop the wars to end this suffering on a global scale.

AW After you've seen so much, do you think the world is going to pull together to stop wars?

BC There's no other chance. If we don't come together and end this madness, refugees will continue to be collateral damage. It's a race to the bottom. Countries are now making themselves unattractive to refugees and trying to push what they perceive as a problem to the next country. This isn't benefiting anyone. In fact, it's escalating a volatile situation into something even more sinister. Governments are trying to move this issue from one border to another, and if this doesn't change, we'll be making parallels with different eras in our history, some of the darkest times that we've experienced as a global community. We need to go back to the principles that unite us: fundamental human rights, upholding an individual's right to be alive, to have dignity, to have support, and to have what all refugees want—a chance to be themselves and to have a life for themselves and their family.

That's all that is necessary: a helping hand to pull people out. Refugees aren't looking for handouts or looking to leech social benefits from local economies. They want to go home, back to their environment, their country, their city, their house, their families. But there is no going back until wars end. Refugees want to be part of society; they want to work, study, build their lives, be self-sufficient, give back. Refugees are some of the most productive members of society: they pay their taxes, respect the laws. The more that we give to refugees so they can stand on their own two feet, the more they'll contribute to societies in the long term. And yes, some of the wars will end. But it will take time, and then refugees will go back and help rebuild their own countries and communities. Some will stay, others will go back, but for the time being they need to be received and hosted.

Look at the weather right now. It looks sunny and calm, but it's actually quite cold. Winter has come to Lesvos. But when the weather improves, when spring comes, we'll see the numbers pick up again. We should be prepared for a year quite similar to 2015.

AW One thing I don't understand is why many of the European nations show a totally unsympathetic attitude toward refugees and act against very fundamental beliefs of civilized society.

BC In many ways this has been a turbulent time for Europe. After the global financial downturn, several countries, Greece being one, suffered and tried to rebuild their economies. We've also seen a completely different security environment since the September 11 attacks on the World Trade Center. For many, refugees and migrants have become synonymous with threats. At the same time, there was a chaotic and very poorly managed response, especially in the early stages of the European emergency, as country after country was struggling to manage and to respond to what was happening. This created another level of public confusion and misunderstanding. It's important that we look at countries like Lebanon. It's a small country with a population of 4.5 million, but now it's hosting more than one million Syrian refugees. A quarter of the population in Lebanon are Syrian refugees. Despite the overwhelming burden this has placed on Lebanon,

the country is still managing. It's very difficult, but it's trying to provide whatever assistance it can.

The European Union is the richest union on the planet with 508 million people. There's the capacity to manage the situation if the European Union works together as a whole, if responsibility is shared among all the contributing and participating member states. Germany can't take in all the asylum seekers coming to Europe and neither can Sweden. Europe needs to respond collectively, urgently. The longer the situation is left unmanaged or poorly managed, the more problems it will create and the more countries that will take unilateral action. Every country has a sovereign right to protect its borders, to provide security to its population. But this shouldn't undermine the seeking of asylum and international and European laws.

AW What exactly does the UNHCR do?

BC The UN Refugee Agency has a global mandate to help refugees around the world. We work in the most difficult situations, usually in conflict zones or in the countries that are first countries of asylum.

Along this southern shore of Lesvos, where boats are arriving, our teams help to welcome the people off the boats. We assess the most vulnerable, put the arrivals on buses, and transport them to the Moria reception center for registration. That is the humanitarian aspect. We're also here to help the government create more reception places. Right now Moria and Kara Tepe, the two centers that are temporary accommodation facilities, can only house about 1,500 people at any given time. In October 2015 there were days when there were 20,000 people on the island. At the peak, there were 10,000 people arriving each day.

We're here to help the government with our expertise, acquired in more than six decades of work with refugees, to strengthen the asylum system so that those who arrive don't have to move. They can stay and trust the asylum system, which, very quickly and rigorously, identifies those who have a refugee history and allows them to stay, work, and study, to have a new life away from home.

It's actually very important how we brand this emergency, because migrants, well, migrate, whereas refugees flee. That's a very significant difference. Here in Greece, 91 percent of arrivals are from the top ten refugee-producing countries: Syria, Afghanistan, Iraq, and others. We're also here to identify those who have the most pressing needs, to help the government prioritize the elderly, pregnant women, women who are heading their families on their own with small children, disabled people, and people with other specific needs.

We're here to promote the need for a strong European asylum system, which reminds European citizens and governments of the EU's values. Saving lives should be of paramount importance. We also promote tolerance. Refugees shouldn't be scapegoated or marginalized. If someone could avoid being on the sea, knowing that they could die or that their children could drown, they would not get on that boat. They're getting on that boat because of the lack of alternatives, because the level of desperation is so high.

AW What kind of resources do you have? Do you receive money from the EU or can you also get money from other governments?

BC We have appeals, such as our Winter Appeal and the European Emergency Appeal. We're trying to raise funds to cover those needs in Europe. We have moved 600 staff members into the European emergency group. These are strong, dedicated professionals who could be somewhere where the needs are far greater, but who had to come in from other areas of service because of the magnitude of this humanitarian emergency. Europe has the resources to manage this emergency, but it can only manage if the European institutions are strong.

AW Do you work with the Syrian government as well?

BC We'll work with any government if it helps refugees, but we're not affiliated with any government. We're a nonpolitical organization.

AW You mentioned that this was the first time UNHCR has worked in Europe.

BC We didn't expect to be back working operationally in Europe. UNHCR operates in very volatile conflict zones in countries that are impacted by war or in the surrounding neighboring countries. We work in Africa, the Middle East, Asia, and Colombia, where there is a very large internal displacement. We didn't think that we would be back in Europe, and for a long while we had internal discussions about this. Should we be engaging? We're underfunded everywhere we're operating, so we can't keep up with the pace of the humanitarian needs every-where, whether it's because of the Syrian crisis, South Sudan, Burundi, the Central African Republic, or elsewhere. We don't have the resources to manage the daily workload that we already have. Although we're receiving a record number of contributions, it's still not enough, regardless of how we optimize our resources.

We came to Lesvos at the invitation of the Greek authorities and the European Union. We now have a wide program across the European Union and the Balkan Route, supporting governments or coordinating those on the ground working with volunteer groups. We work with organizations, helping to build up reception capacity and to improve reception conditions and helping governments with registration procedures and promoting the relocation program. This is the first stepping-stone toward a consolidated European response.

AW I see your service and I think it's extraordinary. The system of help and support for the refugees here is very effective, thanks to the Internet and all the volun-teers who've started to get involved. I'm very impressed with both the difficulty and the effectiveness of your work. Can you give some insight into the role of the Internet and the volunteers?

BC Lesvos has been really unique. Many of the volunteers came after seeing the photo of Aylan Kurdi, the three-year-old boy who washed ashore in Turkey. I know that you're well aware of the photo, which really galvanized support and changed the course of the discussion on the refugee situation. From that moment on, hun-dreds of volunteers came. They went out on the shoreline—lifeguards from Spain,

medics from the Netherlands and elsewhere from the Nordics, volunteers from Asia and Latin America—arriving with one specific goal: to help refugees.

Initially this was loosely arranged and chaotic, especially at a time when the government was struggling to come to grips with the extent of this massive movement. Since then, things have changed. We've delegated responsibilities; we know which teams are stabilizing the boats and helping people if they fall in the water. We know which teams are dedicated to search and rescue with the coast guard and Frontex, which of the volunteer groups has a medic, and whether a doctor, nurse, or paramedic is present on a specific shore. We know how we're going to hand out the blankets, who's going to organize the clothes, and where the people are going to change. We know that the UNHCR will be there to provide transportation from the shoreline to the port and then to the registration points. We know who's working in the sites where people are accommodated, and we're constantly working together to improve situations. The end goal for all of us is to be very effective at simultaneously helping refugees and supporting the government.

Our use of technology in this crisis has been extraordinary. We're using WhatsApp to communicate with one another, drop pins on an incoming boat so that different teams can move there and be organized, and to know who will be doing what. We also use it to communicate with our staff in Moria, the designated hotspot where people are taken for shelter and registration. All of this is coordinated with modern technology, and it has contributed a lot to our work here with volunteers, organizations, and the government.

AW Thank you. Do you have anything on your mind that you'd like to say?

BC This is a historic moment and a dangerous time. We need to reflect on where we've come from and how far we've come. Many of us are descendants of refugees; many of us have people in our own families who've gone from one country to another. At the end of the day, we need to ask ourselves whether we stand for tolerance or xenophobia, or whether we're upholding our values and making a change in someone's life. We need to be there for refugees.

005

Fareshta Ahmadi, Refugee
Tempelhof Refugee Camp, Berlin, Germany, 2016-02-09

FA My name is Fareshta Ahmadi. This is my husband, Mohammad Qayoum Azimi. I have three children: Morteza Azimi, sixteen years old; Yegane Azimi, twelve years old; and Mehdi Azimi, eight years old.

AW Where did you come from and why did you come to Germany?

FA We came from Afghanistan in the middle of the war, fleeing from insecurity. Our kids were in a bad situation there. During the war, my husband was badly beaten. We had enemies who cut his tongue with a knife and broke his teeth. They beat him so hard that he had a seizure. Now he needs medical treatment.

AW How did you come here?

FA We went from Afghanistan to Iran. It took us ten days. From Iran we traveled to Turkey, where we stayed for a couple of days, and then we continued on our way. It has been six months since we left. My youngest child, Mehdi Azimi, got so sick on the way that he was hospitalized for twenty days. I was also hospitalized for ten days. We've been in this camp for four months. We were in Hamburg for twenty days and in Austria for ten.

AW What are your problems in the camp? How many of you share a room? Are they taking care of your needs?

FA Twelve of us live in a small room. We still don't know what we should do, even six months after our arrival. We want them to take care of us, to help us solve our problems, because we had to come here.

AW Do you wish to return to Afghanistan if it becomes peaceful there?

FA & MQA Yes, we want our country to be safe again. We wish that there was no war and no enemies, so we could take care of our kids and send them to school. If we have peace in our country, we'll return. Would you like to see our case documents?

AW Is this yours?

FA Yes, yes. These are our case papers that show how long we've been here. I'll show you another document too.

AW What are these pages?

FA I wrote about our lives and my husband's illness. He's epileptic, and I have a heart condition. My youngest son has lung and ear problems; he uses hearing aids in both ears. I took him to the doctor but he said that we have to wait until we have full-coverage insurance before he can have surgery.

006

Peter Albers and Andreas Lindner, Tempelhof Medical Centre
Berlin, Germany, 2016-02-10

AW Can you please introduce yourself?

AL My name is Andreas. I'm a medical doctor. I specialize in infectious diseases and tropical medicine, and I work here for the vaccination campaign.

PA My name is Peter Albers. I'm head of this medical center, which is run for the refugees by the Vivantes Hospital and the St. Joseph Hospital in Tempelhof. I'm trained as an orthopedic surgeon and an emergency medic.

AW How did you get involved with this situation?

PA After a large amount of people came to Berlin, and the former Tempelhof airport became a reception center, basic medical supplies were needed for these people. Since the Vivantes Group stocks the majority of municipal hospitals, it was put in charge of this task. As head of civil protection, from the beginning I was entrusted to work at this medical center along with other medical staff and volunteers.

AW As a doctor, you have many patients from different locations and different cultural backgrounds. Can you tell me what the general practice here is? What kind of patients are you treating?

AL We do consultations in general medicine, pediatrics, and gynecology. We see patients who've been on the run for a long time and suffer from health problems as a result. We also have patients with chronic and acute diseases.

AW How is their mental condition?

AL Mental problems are a big issue. Sometimes it's difficult to understand the patients' actual problems because we depend on translators. For example, I remember one case of a sixty-year-old patient from Iraq who wanted to get his hypertension pills, but then he started crying. At the end of his appointment, he told us that his four daughters had been abducted in Iraq. Sometimes it's hard to discern what the main health issue is, and how best to help the patients with their problems.

AW What's their condition after they've come so far?

AL They aren't different from us, but their stories, background, and experience are totally different. They lived with bad conditions in their home countries, suffered during their long trips to Germany, and then were challenged by the housing conditions here. Just imagine a tent like this; sometimes people have to stay here for weeks. Living together in such tight quarters makes their situation special and sometimes difficult.

AW The situation is ongoing, and it doesn't seem that a real solution can be found. What developments would you like to see in the future?

PA People will continue to come to Germany searching for help. They'll also bring their problems, which are grave. We're prepared to work for a long period of time and to keep improving. I think what we do here is good, but we've not finished yet. Every day we learn new things.

The fates we encounter here also have an emotional effect on us. One can't avoid that. We have to treat many things in a different manner than how we did in the beginning, and it's clear that this won't end soon.

AL We learn every day anew and try our best to deliver the best medical support. For example, we recently started a mass vaccination campaign and we've already vaccinated more than 1,300 people in two weeks, the majority of them children. Prevention of disease is a big issue for us, as is giving the best individual support, as difficult as it sometimes seems, for mental problems, chronic diseases, and acute diseases.

AW Who supports your work?

PA At the moment everything we do here, or the money we spend, is paid by the public purse. The city of Berlin pays. This is difficult sometimes because the numbers are very high. We had to prefinance campaigns, such as our vaccination campaign—a fast procedure with high numbers—which was very urgent and quite a big success. Otherwise, the whole system would've broken down. Our company prefinanced the project, but the state will reimburse us.

AW How many people in Germany are involved in this process?

PA I can't say clearly because it changes. We work a lot with volunteers. We have to provide for about 80,000 people in total here in Berlin. In Tempelhof, it's between 2,500 and 3,500 people, and that number will still increase. The whole center was planned for accommodating 5,000 people. We're trying to work with a special accounting system in order to mobilize enough doctors and nurses for the whole task. But special campaigns, like the recent vaccination campaign we did, are only possible because we convinced volunteer doctors and nurses who aren't Vivantes employees to work here. This has worked out very well up to now.

AW How do you get those doctors? Are they from hospitals or from organizations? How do you select them?

PA The municipal hospital group is in charge of the main organization, Vivantes. We're looking for doctors within our hospitals who have relevant experience in providing medicine for a large number of people and, of course, in the fields of infectious diseases and tropical medicine. This also applies to nurses and the administrative staff. We get them from our own division. Additionally, we hire manpower and pay them. We look for volunteers for special campaigns and thank God we find them.

We'll need a lot of support, because we'll have to run the center for a long period of time, most likely for years. But I also think we have the strength to meet the challenge. The most important thing is that all politicians who are responsible for public money should understand that they must not talk around the subject but say clearly: "We have this problem; we're a rich country. We're going to solve the problem, but everybody has to take part in it, even if sometimes it won't be very comfortable." We're obliged to do that.

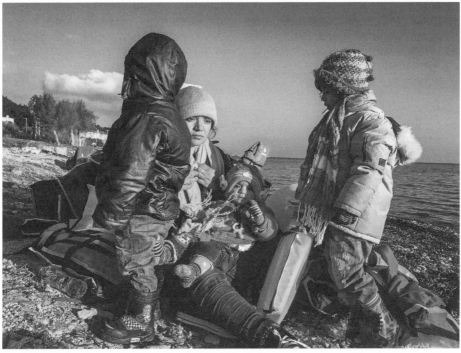

Lesvos, Greece, 2016

007

Ioannis Mouzalas, Former Greek Minister for Migration Policy
Lesvos, Greece, 2016-02-13

AW You're deeply involved in the various conflicts with the refugee crisis from every perspective: Greek, as well as European. Every day you're in meetings, you give a lot of talks, and you're also on the Internet. Can you give us a brief interpretation of what has happened in this refugee situation?

IM We're now experiencing the greatest refugee flow in Europe since the end of the Second World War. This coincided with the deepest financial crisis our country has faced since the end of the Second World War. The combination of these two events has been very difficult.

For many, Greece has been the first step on the pathway toward safety in Europe. While ensuring security for those entering the country was a concern, the other issue—no less serious and important—was securing human rights for both the refugees and the local population, which was suddenly experiencing an enormous influx: 850,000 people crossed into Greece in 2015; 500,000 of them arrived in the last four months from the small island of Lesvos.

I think we've done well in meeting these challenges, though this doesn't mean that we're pleased. We still have too many shortages and weaknesses to work out. However, I think we maintained our morality. Despite the difficulties, we cared for refugees' and illegal immigrants' health and safety and didn't use violence against them. We didn't act like before with the "pushback practices" [the unlawful, forced return of refugees at a border] returning incoming boats, which had caused deaths; rather, we contributed to saving lives—128,000 souls at sea. We saved young children, including those who were unaccompanied or who had lost their parents during the journey, and protected them in institutions. While people aren't living in luxury, at the very least we've provided them with food, clean clothes, a shelter over their heads, and security.

AW Last January, the crisis happened in Lesvos, and gradually it became a focus of the world community. Through this whole crisis Greece showed great courage and integrity despite pressures from other nations. Tell us what happened and how Greece can sustain giving humanitarian aid to the refugees.

IM A few reasons help explain the way the Greek people and our government reacted. One is the history of our people. One hundred years ago in Greece, we had many refugees from Asia Minor and from the Turkish coast. The parents or grandparents of many of the islanders welcoming the refugees today had themselves been refugees arriving on the same shores and on similar boats. This shared history created a bond with the refugees. Second, until the 1960s, poverty forced many Greeks to emigrate—some legally and others illegally—to Germany, America, and Australia. Here, in Mytilene [Lesvos's main port town, seventy kilometers south of Molyvos], many people had been immigrants in Germany and Australia.

We've experienced immigration ourselves, so the policies implemented by our

government have been sensitive to refugees' needs. Instead of refusing them, we assist them. Our people accepted this. We give what little we can. I also think that the way these people arrived played a part in this attitude. It's one thing to welcome a flow of people on land at the borders, but it's quite a different thing to see up to a hundred people packed into a rubber boat arrive—tired, hungry, frozen, and soaked. A sense of humanity compels you to help and not to repel.

AW You once mentioned that Europe just wants to push refugees away. What were your most difficult moments?

IM The most difficult moments are when I hear discussions in Europe by panicked officials who want to send both an army and a navy because they claim that Greece can't defend its sea borders. Greece has maintained an army for the last 3,000 years. We've had a navy for the last 300 years. Who is the enemy? Refugees aren't the enemy. Our only action at sea—according to the Law of the Sea, the Geneva Convention, European law, and the Greek legal system—is to rescue those arriving by boat. Many in Europe want us to push them back, to send them to Turkey by force, but that would mean drowning them in the sea. By saving these people, Greece is guarding the European borders. More importantly, Greece is guarding the Europe of the Enlightenment against the Europe of the Middle Ages.

AW Greece has a great history in art, literature, poetry, and humanity. When you look at what's happening in the world today, what's your position about the future and what do you want to tell people?

IM In ancient Greek mythology, literature, and drama, "Xenos" means "foreigner." The foreigner is a supplicant—one who pleads and petitions for help—and is considered a holy person. This ancient Greek tradition is connected to Orthodox Christianity, the second major cultural wave in Greece. In the Orthodox world, the foreigner has a holy significance, and the ancient meaning of supplicant remains: the foreigner enters the temple and is a subject of protection. The Orthodox Christ says that the foreigner is himself—is Christ—and we ought to respect him. These two historical influences have shaped Greek perception on the meaning of the foreigner.

AW During this crisis, we see that European nations have very different opinions and policies. Some are very protective or even selfish, limiting or even forbidding refugees. Those states never act together; they never try to find solutions to protect essential values. What happened?

IM Currently, Europe is deeply traumatized. It has developed a xenophobic move-ment that is expressed not only on a social level but also at the state and institu-tional level. Entire countries ask us to drown the refugees. Government members ask us to push back the refugees. Politicians suggest we take valuables and money from the refugees. This isn't the Europe we've dreamed of. There's a struggle, and we don't know who's going to win. But if a humane Europe doesn't win, what will remain is a weak Europe, a selfish and introverted Europe that is broken into little pieces and unable to play the role it has dreamed for itself.

I've dealt with this issue for the last twenty-seven years. Every time we're obligated to cope with a tragedy, we often forget the essence of that tragedy, which is always the same: war and poverty. Therefore, while managing these crises, we must remember that the real enemy is war and poverty. Humanity's response should be peace and a just distribution of wealth.

Europe will have to live with the refugee issue in the following years. There may be a decrease of refugees from Syria because there is a possibility that the war there will end. But the UN and everyone involved in this issue (including myself) predict that a new flow is coming: climate migrants from Africa and refugees of great and intolerable poverty. Therefore, Europe, America, Canada, and the rich Asian states must prepare for this and not be caught by surprise. These countries must include, within their financial and social plans, the fact that such flows will come and should be dealt with on friendly and humane terms.

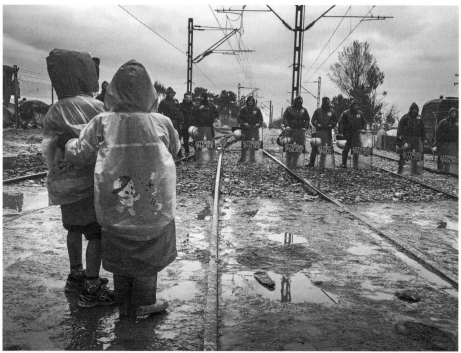

Makeshift Camp, Idomeni, Greece, 2016

008

Mustafa Dawa, *Funeral Director*
Lesvos, Greece, 2016-02-14

MD My name is Mustafa Dawa, and I'm from Egypt. I came to Greece in 2007 to study. I'm at university, in the Department of Greek Language and Literature. I came to Mytilene a year ago to work with an organization as an interpreter. I worked with them until December 2015. Later, I became involved with the cemetery and the Muslim burials on this island.

AW When did you start working as a cleric and why did you begin this work?

MD I've been conducting funerals since August [2015]. I did it because as a Muslim, I'm obliged to prepare the funerals of other Muslims when there is no other Muslim cleric to do it. Also, the ones who had previously prepared the bodies for burial before me didn't do everything according to Islamic law, meaning they didn't wash the dead or wrap them. This is what compelled me to take over the duties and conduct the burials myself—to wash them, wrap them, say the prayer, and do what's required.

AW This graveyard was once the land of the local farmers. When did you start burying the bodies here?

MD We had previously buried the bodies at the old cemetery, Saint Panteleimonas, a Christian cemetery, but soon there was no more space. Seventy bodies had piled up at the morgue. I had gathered them and they waited about thirty days in the freezer. Someone tried to persuade the mayor to give us a field to use as a grave-yard, but we waited thirty days and nothing was given to us. One day, I made a decision. I gathered the relatives who were on the island waiting to bury their family members, and some others, and we went to the city hall. I remember that it was on a Friday, November 13, and we looked for the deputy mayor, George Katzanos, to ask for the graveyard. The mayor himself wasn't there, but we found the other deputy mayor, Mr. Karatsapas. We talked with him and the authorities gave us this field here. By Saturday, November 14, I had already buried six people in this cemetery.

AW How many graveyards do we have in Lesvos and how many people in total have been buried here?

MD There are no other cemeteries like this in Lesvos. It's the first one for Muslim refugees and immigrants. There are fifty to sixty people buried in the other Christian graveyard. I've buried seventy people in this one.

AW They're from many nations. Some have identities, while others don't. What can you tell us about them?

MD Here we have seventy people—seventy dead bodies and seventy graves. Forty-five of them are unidentified and twenty-five have identities. We have a whole family of the dead who've been identified, and we have dead families who are all

unidentified. The unidentified ones are always the majority. Those buried here are mostly Afghans, Iraqis, and Syrians.

AW From where do you receive the bodies and how do you move them here? What kind of procedure is involved? Do you have some training in Muslim tradition?

MD When a body is found, the port authority collects it and takes it to the morgue. Then the coroner conducts an autopsy and calls me. I go to the hospital with a car owned by the funeral office, collect the body, and bring it to the cemetery. Here, I wash it and wrap it with cloth in a special way, then I say a prayer and place the body into the grave in a specific direction. Then I conduct the funeral ceremony by myself. I studied the Qur'an for sixteen years, during primary school, junior high school, high school, and university.

AW Some of the dead must have relatives. Do they get notified? Do they know their relatives are going to be buried here? Or do the bodies just have to be buried?

MD If they are identified, yes, their relatives know that we bury them. Sometimes I ask them to come with me to help with the washing and the rest of the burial process. If they agree, they come and help. Other times, they refuse.

AW Are the men, women, and children all treated the same? Can they be buried together?

MD No, the procedure is different. If it's a woman's body, another woman washes and wraps it. If it's a man's body, I do it. For children, there's no difference. But there's no difference in the grave. We put them in the grave the same way, facing the same direction—"sleeping" on the right side and "looking" toward Mecca. There's no difference other than the gender of the person who conducts the ritual.

AW Is there a religious ceremony or some kind of action beforehand? Do you have to choose a location or date?

MD No, there's no specific date for the funeral. According to Islamic law, when someone dies, they must be buried immediately if there's no reason otherwise. When the coroner gives me the green light that the autopsy is complete and the body is ready, I collect it immediately, regardless of the day or the time, and I come here to bury it. It doesn't matter if it's day or night. I've buried some bodies at night, others during the day, in the morning or the afternoon. Once, I was here at 1:00 a.m. to bury the dead.

AW All this must have a very strong impact on you. Why are you doing this? You don't know these refugees who lost their lives at sea.

MD Of course, it's very hard. It was really difficult for me, but what gave me the power to do it was one day when I went into a freezer with a relative of a dead woman, so that he could identify his sister. I was with him to support him. What frightened me was that I saw forty-five bodies—women, children, and men—each stacked on top of the others, and the sheets had fallen off. The women and men were naked. That's when I realized how hard this was, and this is why I made the decision to

conduct the ceremonies and bury the dead. I knew it would be very difficult, and I knew it would affect me psychologically. It already has, but God will help me get through this.

AW After you've seen so many deaths, is there something you want to say to the world?

MD After a year of being on the island and seeing all these things, I really want to say to all the people responsible for the situation in the Middle East that they should be ashamed of themselves. There's a tragedy occurring here and people are dying unnecessarily. They came here to find freedom, not to find a good and easy life, as many may think. That is the reason why they made this dangerous journey, and they know that many of them will die at sea. But still, they make the journey. The people responsible should be ashamed of putting them in this situation.

A few days ago, I buried a twelve-year-old girl whose one leg and pelvis were the only parts of the recovered body. Nothing else was found. Not even the head, the back, the stomach, the other leg, or the arms—nothing; only a leg and the pelvis. What fault did the child commit to deserve this? There was also a three-month-old baby found decapitated and in a state of advanced decay. The baby's parents must have drowned. It's a real shame. These people aren't to blame for anything. Why do you torture them? Why do you kill them this way? Why is there so much injustice? I say this to the people who are to blame and to those who have the power to stop this situation and don't do it: shame on all of you!

AW In the refugees' efforts to find a peaceful or safe place, more than 4,000 have lost their lives, and there are more to come.

MD Yes, but there are not only the 4,000 who've drowned. There are also millions more who die in their own countries. Those 4,000 refugees who drowned came here after losing their families; these people don't emigrate on a whim. They only do it after losing their father or mother, or the rest of their family. They come here to protect those remaining family members, such as the children. Usually those who arrive here have come to save their little ones, not themselves. A father comes to save his child; a mother comes to save her children when her husband is already lost at war.

All the politicians, governments, and people should be ashamed that they don't help put a stop to this situation. Whoever is afraid of Allah should know that they'll have to answer to him, and whoever isn't afraid will pay the price on their last day on Earth.

AW After you wash, wrap, and bury the body, is there a personal moment or a story you want to share?

MD At the time of washing and wrapping, I try to think of something else so that I can endure it. If I think of the body at that moment or if I stare right at it, I won't be able to complete the ritual.

I told you the story of the twelve-year-old girl and what was left of her; her body was shattered. I couldn't wash her body parts, and I couldn't touch them by hand

because the skin would fall off, so I just wrapped them. If I stared at the parts while I was wrapping them, it would've been really hard for me. My last funeral was a thirty-year-old man who had spent about three months at sea. The coroner had his brain in a bag because the man's head was smashed and it couldn't remain inside the skull during the autopsy. These situations are really hard.

When I was in Egypt I'd never seen a dead person at a funeral. When I saw one later, I had nightmares for days. But here, I just suck it up and pray that God helps me. Honestly, I don't know how I make it through all these tough scenes. Another day, a three-year-old girl was found decapitated. When I put her body in the grave, the smell was terrible. I knelt and placed her body in the grave with my own hands, but then I couldn't bring myself to get up. For about two minutes I couldn't stand, even though I should've run from there because of the great stench. It's really hard.

I wonder how politicians sleep at night. Don't they hear about things like this? There's a family resting here. It was a family of six—a mother, a father, and four children. The mother, the father, and two children are dead. Two other children were left behind. That family had a good life. They had jobs and didn't want to leave, but they lived in the United Arab Emirates and didn't have the right papers to continue their business. They wanted to go to Europe to get the necessary papers, but there was a shipwreck and they drowned. One dead child was two and the other was seven.

AW During the whole refugee situation, most of the world, including Europeans, expressed a lot of distrust toward the refugees and not much understanding about humanity. Do you want to say anything about that?

MD First and foremost, I believe the politicians are responsible for this. Those who call themselves humanitarian organizations share a part of the blame as well, because most of them only care about making money and filling out the required reports according to the law or the politicians. They don't report facts or say who's to blame. Most organizations, in my opinion, just take advantage of the people.

009

Spyros Galinos, Lesvos Mayor
Lesvos, Greece, 2016-02-14

AW The people of Greece have made a big effort to warmly receive refugees into this city with open arms. I'd like you to tell us about the beginning of the refugee inflow and your reflections on how this situation has evolved.

SG The refugee inflow started at the beginning of February and March 2015, and then it increased gradually—a hundred refugees arrived per day. In a short period of time, we succeeded in managing groups of 6,000 or more daily. In the summer, the arrivals went from 6,000 up to 10,000 daily.

We weren't taken by surprise, we stayed calm, and we welcomed the refugees the best we could with the resources we had. In the meantime, we tried to find solutions and to propose policies that would aid the refugees. The greatest problem was—and still is—the failure of European politics to understand that the key factor of the refugee crisis lies within the refugees' countries of origin. Many of the people have left their homes because of wars and exploitation.

Refugees aren't the problem. The main problems are the bombs falling in their countries and the conspirators who exploit them physically, economically, and mentally, and the smugglers who make these poor people cross the Aegean Sea in dangerous, rotting boats. Many of the people drown during this effort.

AW You've received half a million refugees since January 2015. How did you help rescue them? How do you manage the crisis and the local people on this island? How has the crisis impacted both Lesvos and you?

SG This past year 550,000 refugees arrived, and most of them came within a period of five months. This put an enormous financial and physical burden on the island and its people, but I stubbornly refuse to put human lives on the same level as economic interests. I encouraged the Lesvos citizens to remember that human lives matter most, and we really must try to warmly welcome these people who are the victims of illogical politics, wars, and smugglers.

My fellow citizens rose to the occasion. Together, we managed to define Lesvos as the capital of solidarity throughout the world. Our response to the crisis was to pass on the right message to those who have a tendency to create racist and fascist groups that reject the refugees arriving in their countries.

We wanted to show the people who came to our land that this small island represents true European culture, a culture that includes solidarity, sensitivity, humanity, and the ability to manage a humanitarian crisis. Our message to other countries who reject the refugees is that they need to stop the abuse and the crimes that continue to cost people their lives. Hundreds have died during the illogical and dangerous journey from the Turkish coast to this island.

AW You've made two proposals to the European Parliament and the UN concerning

the management of the crisis in order to convince the Turkish side to provide safe passage and to help protect refugees' lives.

SG Everybody knows that it's not just a pan-European problem but a universal one. We know we can't carry this entire burden on our shoulders. We have to deal with this problem by confronting its core—the countries that the refugees are fleeing from to save their lives. Another key to the problem lies in Turkey. I proposed that registrations should be made in Turkey. I'm well aware of the fact that Turkey isn't a member of the EU and that registration of refugees can't be made solely by Turkey. But there's a way it could be done with EU supervision, so that these people wouldn't be forced to use a smuggler in order to travel. We could save their lives and prevent the abuse many of them suffer. Moreover, we could successfully employ an organized transport of the masses. Controls could be made in a more efficient way, and this would result in European societies that were better protected. I believe that if there was an organized inflow, there wouldn't be as many problems.

But even if Europe agreed to this proposal, they'd never put it to use, because they negotiate with the Turkish government without using the proper arguments. Knowing this, I decided to make a new proposal, because the most important goal is to save the people. If Turkey doesn't agree, or if registration can't be made in Turkey based on the treaties, then I'm willing to take more responsibility, as long as we can save lives. I suggested that ships could travel to the Turkish coasts, collect the people, and then bring them safely to the island and register them here. My effort is to give the right message to the European communities. This island, which carries the weight of 65 percent of all those people who pass through to Europe, is willing to permanently shelter a few thousand refugees, knowing that this means we must create job opportunities so that these people can make a decent living and be integrated into our local society.

AW You've made two proposals to the EU that you explained to us before. What was the EU's reaction? How do you evaluate the European response or the world's response?

SG I'll tell you what surprises and depresses me. Everyone accepts my proposals as the right ones, that these are the proper principles and the reason that the EU was created in the first place. Nevertheless, these policies aren't put to use. Of course, I know that there's a great deal of bureaucracy in Europe and that decisions are made and applied slowly. But there's far too much delay.

I believe that at some point Europe will realize that this is the only way to confront the humanitarian crisis. Even though we've made proposals that they've accepted, I was informed that they assigned NATO to greet people. I don't understand this. I can't comprehend the fact that they sent a national alliance to confront a humanitarian issue for which the necessary institutions already exist. It should be dealt with in a different way so that there wouldn't be all this skepticism concerning Europe's latest decision, such as: "Is NATO really here for this specific purpose, or is there some other plan that they want to implement under the false pretense of the refugee problem?"

This crime has to end. In order to stop it, you shouldn't debate it with the other countries. Crime stops through commitment toward law, but also toward a moral obligation. It might sound a bit harsh, but I believe that when you see a crime and don't intervene, you become an accomplice. All humans are accomplices for every life that gets lost in the Aegean. Greece has a very different attitude toward the refugees, while other European nations want to stop them, or think that this is Greece's problem. Today you see many nations within the European community that don't accept any refugees.

AW We've even seen nations that think this is Greece's problem and that we should sink refugee boats to prevent them from coming.

SG Those who claim that it only concerns Greece are obviously lying. They know that this is a universal problem. They just don't want to confront it. I haven't heard words as shameless as those who have told us to stop refugees by projecting our cannons at them and throwing them back into sea to die there. But that's what some countries actually believe. I find this most disturbing. It's inconceivable for Greeks to turn a cannon against people who come here to be saved.

There are some countries who accept a small number of refugees. I think they do it to have an alibi, to show that they've taken action. There are some extreme opinions in many countries, and also in mine. Those people are trying to deceive us into reacting in a racist manner, but we isolated and rid ourselves of those opinions at the very beginning.

AW Why do you think that Greece, and especially this place, showed such hospitality toward the refugees? Do you believe it's the culture or something else?

SG You said it just right. The Greek culture is one of humanity, sensibility, and even realism. Greece has applied a good strategy from the beginning. It's based on the capability of being able to pull through in difficult situations, but also according to our culture and the difficulties and experiences that we ourselves have borne: all those experiences from the past, when our own people lived through persecution and were forced to leave their homes and countries behind, just like those who left Asia Minor to come to this island.

AW A last question: In this past year, many aid workers from all over the world came here, and the people gave them a very warm welcome. Those aid workers play a big role in this crisis. How do you evaluate their effort? I've also heard that aid workers are now restricted and some of them were dragged to court. Is there any way you can help in this situation?

SG I'm grateful for the volunteers on this island. Many people came who were miles ahead of their governments' response to the crisis. Citizens volunteered, but no governments were in sight. While we don't aim for strict supervision of the volunteers, their tasks revolve around the types of skills they have to offer, so the right services are given to the people who come to the island. We accomplish this with accurate coordination. Every organization and citizen offer help in their respective fields.

Of course, there were some negative incidents involving people who tried to take advantage of the situation. There were also some unfortunate cases brought about by the Greek government, meaning that some people were not treated appropriately. I really want to apologize for such cases, as we stand by the volunteers and want them here. We don't want the volunteers to be compromised.

AW Almost no refugee boat has arrived this past week. We all realize that there's a new agreement and new controls for boats and people. Can you give us some information on what's going on and how you view the future with this policy to close the border?

SG Obviously there have been some agreements made. As far as I know, there was a meeting with Chancellor Merkel, the Turkish consul, and the Turkish president to discuss NATO's involvement. I don't know what they agreed on. It's a fact that the last week has been slow with refugee boats, but we can't forget that in January 2015, there was a great increase compared to a year ago. Last year we had about 745 arrivals in January; this year, we had more than 30,000. We have to prepare for the future, because the problem isn't behind us but also ahead. The main issue is for the right policies to be applied and for us to save lives and not create more problems. I'm afraid that we might drive ourselves into some difficult situations, because there is already a lot of turbulence on the island. But so far we're still here. We're determined to rise to the occasion and give the right message.

AW As a mayor in this crisis, you've taken in a refugee population more than six times the local population. What kind of pressure are you under, and how do you look at the future of this refugee situation produced by war? What do you want to tell the governments that provoked this crisis?

SG I've already mentioned that there's a general turbulence in the area. I don't know all the parameters of this turbulence, but what I must do is stick by the values that I serve and that my fellow citizens believe in. First and foremost, we'll remain humane. We'll stay put in order to offer help to people who've been chased out of other countries, to those who come to this island in order to save them-selves. We know that this is our duty.

On the other side, we don't know what all these governments will do. As I said before, citizens are often quicker to respond than governments, and they have great power in their hands. As long as we can all unite and send the right message, it will force the governments to follow our example.

AW I've seen the strength and courage and integrity of Greece. Greece responded with dynamism and great compassion to this crisis, while, at the same time, the UN hasn't offered any assistance. What's really happening in today's world?

SG The reality is that Greece, being a small country, a country afflicted by the financial crisis, showed such character; it stands on its own two feet and helps people in need. It's a small, poor country that has taken a beating from the crisis and is bound by the memoranda that forces the application of strict austerity policies. Nevertheless, it has succeeded in taking on the burden of a pan-European

problem. The big and rich countries of Europe should realize that if Greece and this small island can make it happen, then all the European countries can do it better and easier. That's what I want us to achieve. All of Europe should try to solve this humanitarian problem. It's quite easy to solve if we follow the right policies.

AW What would you like to tell Europe and the people watching you about the crisis and its future?

SG People can deliver the right messages to their governments. They've shown compassion. People from all over Europe have come here to help. Others who couldn't make it here ask us if they can send help. We've already shown that people want to deal with this problem in the right way. What remains is for them to pass the right message on to their governments so that they, too, can apply the proper policies.

I'd like to thank you personally. I believe that art sends its own message, and you came here to help us as a volunteer and through your art, in order to give the right message about this place, even through objects that we collect, such as boats and life preservers. I believe that the power of art surpasses our own powers. Thank you again for that.

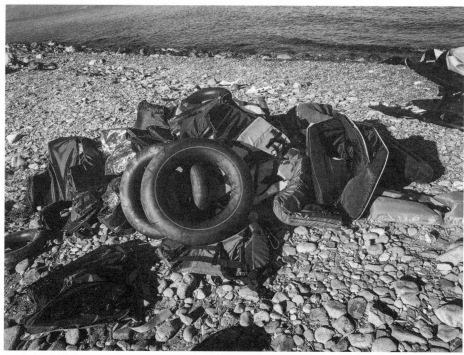

Lesvos, Greece, 2015

010

Salam Aldeen, Team Humanity
Lesvos, Greece, 2016-02-14 and 2016-02-17

SA My name is Salam Aldeen. I started with Team Humanity on September 5. I came to Lesvos on my birthday and have been here ever since.

AW Where are you from?

SA I'm from Denmark. My mother is originally from Moldova and my father from Iraq. I've been living in Denmark for twenty-five years.

AW Where were you five years ago?

SA Five years ago, I was having fun in Denmark—traveling, partying, and working. That was my life.

AW When you came here, did you notice the refugee situation or did you come here for vacation—or your birthday?

SA I came here for one week just to see what was happening. While watching TV, I saw a little child [Aylan Kurdi] dead on the beach on the Turkish side, so I thought, *Let me see what's happening, what's wrong with this world.* I came here and that week changed my life. I think I only slept for about six to seven hours that week. At that time, there weren't many people or organizations. I often took the boats onto the beach alone, though sometimes there were one or two other people. I pulled the boats in and gave the people water and food. Then we squeezed about twenty-five people—women, children, and men—into a car, like a Volkswagen Transporter, and drove them to the camps and helped them with their needs.

People were walking all the way from Molyvos to Mytilene. You could see old people, children, and small babies sleeping on the road at night. You can't just pass by them and go back to sleep. It was difficult to see all that. I was passing by the water all the time. I'd have a carful of people and still people were jumping and screaming, "Please help us, please help us!," and you just couldn't help them all. There was only one day, when I was going back home at five o'clock in the morning, that suddenly the road was free of people. The whole night I was working and taking people from the road. So, I was really surprised not to see any.

I slept for about two and a half hours and then we'd start again. That was my first week. I saw so many people sleeping on the roads, and if you drove at night and didn't know that there were people on the road, you'd hit their feet, because they were sleeping right there. I've seen 500 people sleep like this. It was a crazy time. That was in September.

AW Can you tell me who they were and where they were from?

SA I've been helping many people from the sea and the coast. I've seen all

nationalities—Syrian, Iraqi, and others. I saw a couple from Thailand, people from Nepal, Pakistan, India, Iran, Libya, Morocco, Tunisia, Algeria, and Burma. I always asked them, "How did you sit in the boat and come here? Weren't you afraid of the big waves?"

They said, "Listen, either we die there or we die on the way. It's better to die on the way. That way we have a chance, even if it's just 1 percent." I've seen small children and little babies who were just twenty-five days old. That's crazy.

One day a boat stopped, because the Turkish or Greek coast guard passed them with full power and the water got into the boat's engine. I panicked. I could see people jumping in the water. I took the refugee boat that had just arrived and went into the sea and tried to help them. At that time I didn't know what to do. I didn't know that we were supposed to call the coast guard. It was on Greek territory, 500 meters away. Rather than swimming, we took the boat. When I came up to the boat, I saw a woman in the water with a child, seven or eight years old. She was holding him and he was holding the rope. I saw another woman at the back and another woman on the left, and a man. Nobody had taken them from the water. Nobody came to help these people, so I took them on my boat and headed back. That was really crazy.

AW You've seen so much. Are you surprised? Why didn't anybody come? This is Europe.

SA I asked the people, "Where is the Red Cross?" We didn't see the Red Cross for the first three and a half or four months. Then we saw them driving up with the flag and one of the guys who was with the Red Cross didn't want to be with them anymore. I asked, "What do you do?" He said, "I was working with the Red Cross and I don't want to work with them anymore." I said, "What happened?" He told me that one person from the Red Cross came to them and said, "Listen, if I give you money, a car, a flag, and clothes, can you just drive to the sea and try to show that we're here?" The funniest thing is, I actually saw them and I believed his story, because these people from the Red Cross didn't know what to do. They asked me what to do. When there were people from the boat that needed help, I'd tell them, "These people need help; take them to the hospital, because you have a van." They said, "No, no, we aren't allowed to drive people to the hospital." I answered, "But you're the Red Cross." And they said, "Yes, but we aren't allowed to do that." So that was that. They came there to flash [the Red Cross], not to go into the water; not to actually help but only to stay and give emergency blankets and take pictures.

AW So you formed your team, and what do you actually do? You go into the ocean and you find boats. What's it like in the dark?

SA After I got back to Denmark, in four days I came back here with twenty-five friends and four cars. We drove all the way here with supplies and everything, and then we began to help people. Before I transported people with one van; now we had four. We could take people from Molyvos and drive them to Mytilene and help provide them with food, water, blankets, and tents.

At that time, they needed translators at the camps. I had to translate so many times to keep people calm because they didn't understand anything. They were screaming. If you have 5,000 people waiting to register, believe me, they don't want to wait ten or twelve hours. I was actually sitting at a table writing, "Where are you from? Syria? Okay, I'll write Syria."

During this time, we volunteers were by ourselves in tents and the refugees were alone in tents. When the media began showing up, taking pictures and videos, things changed and more people came. So many volunteers and good people came here to really help people from the heart. But some of them came here to exploit the situation and to get rich. I'd see people come for one week, take one or two pictures, then go back to try to get funds—and you'd never see them again. Many people make me very angry and sad.

AW Tell me about the rescues you've done with your boat in the ocean.

SA There was one especially crazy day. It was October 28: more than a hundred people died that day. I was at the sea and saw everything. I saw people in the water. With binoculars you could see their vests maybe three and a half kilometers away. I ran to a boat that had just come in, a big boat with Afghans. That day there were huge waves, so I was jumping into their boat, pulling everyone out and telling them, "Don't break the boat; it's very important." I took the boat and started to sail. I saw that the coast guard was on the way, but there were so many people they simply couldn't do it alone. I was sailing toward the coast guard, but about a hundred meters from the shore, the engine stopped. I couldn't start it and the waves took us back. If that boat had been working, I would've been able to save lots of people. The coast guard boats were large military boats; in fact, they were so large that they couldn't help people get out of the water, because the dinghies are very small. That day I saw so many people die.

Two days later, something happened in the sea that I'll never forget. We were looking at a refugee boat and two Spanish lifeguards on Jet Skis. We didn't see anyone helping the refugees, which surprised me. I was looking through my binoculars and I saw the Jet Skis coming back to the people waiting there. They were passing two small children. I think one of them was three or four years old and the other one was maybe eight. They were brothers. We asked, "Hey, what's happening?," but nobody told us anything. They just dropped off these children and were going back.

I decided to go with them. I found a boat and an engine. I had some gasoline, so if anyone arrived during the night, we could make a fire and warm them up. I managed to put everything in place in ten minutes, then I was on my way to the sea. I remember the waves were very big that day. The only time I had seen waves that big was on the Discovery Channel, so I was actually smiling. I was with Waleed from my crew, one local guy who helped us to push the boat into the water, and one volunteer. I didn't know the volunteer, and when he saw the waves, he jumped from the boat and said, "I can't do this. It's too dangerous." The local guy said, "Please, can't you help us? We need one more." And then the volunteer jumped back into the boat and said, "Okay, I'll go with you."

We were in the middle of the sea when we saw the coast guard coming. I told them, "Just go, just go," because we'd heard two days before that the coast guard didn't help the people in the water because of the waves. Twenty meters away from the boat, the Spanish lifeguards on the Jet Skis drove over to us. I asked them if they needed help and they said, "No, everything is okay." I told my friend, "Let's go see what's going on. Something is wrong. Why is this boat in the water?"

With about a hundred meters left, I saw the coast guard yelling to me, "Please help!," so we went over there. I'd never seen such a sight before. There was a boat with people sitting on the pontoons and on the back of the engine. The engine had fallen away and the plate in the back was falling off. The boat collapsed suddenly, so there was no bottom. Imagine experiencing this in the middle of the sea where the biggest waves were. I was actually looking up at the waves, and I remember there were like ten to twelve people in the water holding on to a rope. I saw all the people sitting on the pontoons, and when I got to them, I told them, "I'm going to take you all, but slowly, so don't panic. I'll take you one by one." I put eighteen or nineteen people in my boat.

They were so tired and had no energy. I was pushing them up, and I remember the coast guard was hitting them because they didn't have patience. Everybody wants to jump up first, so I said, "Listen, one by one, please, one by one." I was taking them up—imagine the waves slamming into us while we were doing this in the middle of the sea. I'd never tried that kind of rescue before.

We took all the people except for one guy. It took me ten minutes to get this guy into my boat. He took the rope and wrapped it all the way around his body and then put the rope in his teeth because he didn't have any energy left to hang on. The boat was close to actually sinking, and he was going down. I took the rope away from him and told him to hold my hand, but he couldn't grasp my hand, so I was holding him, and I told the guys to hold my feet, because I was about to go down with him. My friend and some other people were holding my feet, and I said to the guy I was holding, "Please, do whatever you can. I need you to come up." He tried really hard, but he didn't have any strength. I don't know how, but we finally managed to get him up and into the boat.

The coast guard was yelling at us, telling us to come back to them, but I told them that it was impossible. I wouldn't risk the people's lives and my own because the coast guard wanted us to take them to the shore to show the world that they were doing something. I said, "No, we're going to go together to the port authority. I can't risk their lives."

We were going back and I remember I was in the front of the boat and everyone was looking at me and at all the refugees. I told everybody to hold on to each other because it was so cold. As I looked at the waves, I was thinking, *Now it's dangerous.* My friend actually told me that he saw death in my eyes. We were getting hit by the big waves, and every time the refugees looked back at the waves, I told them, "Relax . . . Everything is okay."

I remember our boat was suddenly full of water, but we managed to get to the

shore. The coast guard told everybody that if we hadn't come that day, those forty-two people would've died.

Look at what they wrote me on WhatsApp: "Be ready, it will begin again."

AW Be ready for what?

SA Many boats came in October and November. It's starting again now. Many people want to come and many are waiting. They don't have food, water, anything. They use the only money they have to make this trip. It's sad.

You see what the smugglers are doing to these people. They let them go in the night because they're less likely to get caught. They'll say, "Today the sea is very calm, but tomorrow it may be bigger." Then the smugglers push them into the water. The refugees paid the money, so the smugglers say, "Okay, you're going in two or three days." Even if the weather is bad, they say, "You have to go, and we aren't giving your money back." And the people say, "Okay, this is our last chance; we don't have any more money. If we stay here, we're finished. If we go, that's it." That's why they come, even when the weather is bad. The coast guard should send boats to help people during the night and not during the day, because it's more dangerous at night. Many people are dying at night.

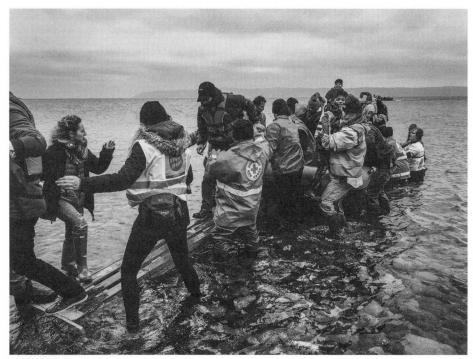

Lesvos, Greece, 2016

011

Sadia Moshid, *Médecins Sans Frontières*
Lesvos, Greece, 2016-02-15

AW Tell me who you are and what kind of work you're doing here.

SM I'm Sadia Moshid. I'm a French citizen from Paris, and I'm a clinical psychologist working with Médecins Sans Frontières [MSF]. I work here as a mental health supervisor for migrants arriving in Lesvos.

AW Psychology is a very special job, dealing with people's understanding of themselves and their perception of the world. After you see many people going through this crisis, the dangers of the road, and bad treatment by others, what's their condition?

SM My patients have multiple issues from their countries of origin, and during their journey they also face issues related to violence, robbery, and so on. Also, we know that it's not going to be easy for them later on. All of this has an impact on their well-being and on their psychological and physical condition. We see that they're suffering, and emotionally they're either overwhelmed or unable to interact with other people. They have psychological trauma from their experiences. This is a very serious condition that can lead to serious consequences.

AW I see many women and children. How do you deal with them?

SM We assume that the patient has issues related to loss—of relatives, property, and so on. In a certain way, it's grief, but sometimes it's a bit more complicated. The idea is not to treat it right now and say, "Okay, let's do something about it," but to make them aware of their diagnosis, and that it's much more complicated than just a natural reaction of grief. Once they're out of survival mode, we're able to give them emotional support for the mental health issues that may surface later on.

AW How do you help somebody who tells you that they just lost their baby?

SM We deal a lot with people who've lost family in a shipwreck, where sometimes the body hasn't been found. It's very complicated, because it raises ethical dilemmas not just about providing emotional support but about how to deal with the fact that we don't yet know [the specifics of] what's going on. In a shipwreck, chances are high that the baby or children have died. But what do we do with this knowledge when we don't yet have clear information? The question is if people can continue their journey. It's very complicated.

There's a zone that remains a little bit obscure, where our work goes beyond the traditional ways of support. Our concern isn't to pathologize or scare them too much, but at the same time we don't want to normalize the situation either. That's one of my main challenges: to find a good balance between normalization and pathologization. Of course, losing a child is an extremely complicated thing to deal with. Some people take a lot more time to go through this type of loss, and we never actually go through it completely. We need to help these people see that

we're trying to arrive at a certain understanding so we can help them, and that our answers aren't just ready-made for them. What I'm learning here is to try to be very cautious and to take this work case by case.

AW They come to a land where nobody understands them, where they're cut off from their parents or relatives. They don't speak the language or share their religion.

SM No, but we have to provide this support. We have control-mediators here who not only translate but mediate culturally, because distress, mental health, and physical health are always expressed according to certain norms. MSF is very careful to provide not only doctors and mental health professionals but also people who can build a kind of bridge.

AW Do people cut off their own memories?

SM Sometimes this is necessary because initially they're in survival mode. The problem evolves later on when things are more settled. The trauma will often return to a degree beyond what's expected. Sometimes, to forget and to cut off the memory of a traumatic event is a way to keep functioning. But one of our biggest issues is that we don't know the extent to which the trauma will come back. For some it will be okay, but for others we already know that it's not.

AW The damage leads to loss of trust in humanity.

SM I had cases that had totally lost hope and they were in a very, very serious condition. One part of my work is to provide a minimum level of hope for people, because otherwise it's just over.

AW What is the minimum hope you can offer?

SM The minimum hope is really to restore a sense of dignity. It might seem like common sense to say that, but people really lose complete trust in humanity when they've gone through torture, self-harm, and the kinds of experiences that make a person feel there's no point in continuing to exist afterward. When I was dealing with suicidal children in the past, I had a mentor who taught me that if I can't bring a minimum of hope, there's really no point in working with traumatized people. So it's not about saying to them, "It's going to be okay," because it isn't okay. It's really about helping them feel alive and grounded again, to show them, through positive human interaction, that there is goodness in humanity.

AW Humanity is about understanding, communication, and basic trust—very essential values. You can't build a building without many bricks.

SM But you still have to work on that, because people need to keep on living. We have to find a way for them to be connected with something that attaches them to life, because otherwise their life will be hell. So it's important to work on the minimum level of hope that makes sense for each individual. For some, just being acknowledged and having an interaction with another human being builds that hope. The idea isn't to lie to people by telling them that it's going to be fine quickly. That's not right, and it's also not fair or acceptable.

AW I think it's a challenge because they need a community, someone they can talk to.

SM Yes.

AW Do you think Europe provides them with good possibilities for their mental health?

SM I think that there's always room for improvement in mental health. We all know that more mental health treatment is needed for everybody, especially for those who suffer the most. There's a need for more specialists, and also a need to improve access and reduce waiting times.

AW So your impression is that they come here not just for better lives but to escape the tragedies at home?

SM For some of them it's clear that it's related to war and the consequences of survival: simply not to be killed in their country. Others are fleeing psychological warfare. Even if they come from places where there is no active war, their stories are always related to childhood trauma, exposure to violence, human trafficking, and other destructive experiences. A lot of parents see their children suffering from these consequences. I have cases where the child has simply stopped developing. They don't walk anymore or they have this kind of psychological death for a month. Then suddenly, slowly, they start to live again.

AW After you give them this treatment, and you know what their future is going to look like, do you still worry about long-term effects?

SM I think we always want to see more people to make sure that we've provided enough support. But at the same time, I'm not naive. The path is very long, but one day they'll reach somewhere. They deserve to live, work, learn, and have loving relationships. They deserve to have a better life.

012

Melinda McRostie, Starfish Foundation
Molyvos, Lesvos, Greece, 2016-02-15

MM My name is Melinda McRostie. I'm originally Australian, but my mother married a Greek fisherman, so I was brought up in Greece. I went to school in Greece and opened a restaurant called the Captain's Table.

Last November in 2014, even though we'd already been helping refugees for many years and they'd sort of petered off, boats suddenly arrived and the port police called me. They said, "Could you please come and help? We've got this group of very wet refugees." I live in the harbor and do a lot of charity work, so they knew that I had dry clothes for them. I went and helped the people change out of their wet clothes and gave them some hot tea from the restaurant. A week later I got another phone call. Another boat had arrived. We started getting a boat a week, and the port police kept calling me so I could come and help. Soon it became two or three boats a week and then it went up to fifty boats.

The boats that were arriving at that time were the black plastic tube boats that were meant for ten people, and inside each boat were fifty to sixty people, which is very dangerous, because the water actually starts coming through with the people standing in the boat. If they have a problem, the boat can actually fill up very fast, and unfortunately if they panic, that's when the younger people can actually drown inside the boat itself.

We were just a group of people trying to help them by giving them a sandwich and some hot tea. As time progressed tourists were leaving money for us at the supermarkets because we'd run out of money. Then the supermarkets contributed food. We'd phone them and ask, "Could you send us some cheese, bread, and tea?" Lots of locals were also giving us clothes, because we were running out of clothes with the quantity of people who needed them. Then we got to a stage where we couldn't cope without getting outside support. So we became a foundation so that we could legally help people in a better way. We named it Starfish.

AW Can you tell us more about what it was like in the beginning?

MM We started this foundation in the north of the island. Initially, we started a Facebook page for helping the refugees of Molyvos, but within a couple of days we realized that we didn't want to help just the refugees of this village but others as well. We wanted to change the Facebook posting, but because we had so many "likes" within a matter of days, we weren't allowed to change the name, though they did let us add the Starfish Foundation name afterward.

The Facebook page went viral. Sometimes we received more than 200 messages a day from people asking to come and help us. We've had hundreds of volunteers over this period of time. They're from everywhere and from all age-groups. They've just joined us, rolled up their sleeves, gotten down, did the hard work, didn't mind doing the hours, didn't mind doing the work, and it's just been an incredible movement. We're still shocked that there are so many lovely people

out there who want to come and help even after so many months. They pay their own way just to be here.

AW Who are they and where do they come from?

MM There have been some lovely stories with all these volunteers. At the moment, we've got an eighty-five-year-old volunteering with us. We've even had people who were as young as twelve. If they're underage, they must work alongside their parents, because we can't take responsibility for them. The main age-group of the people who come is probably twenty-five to thirty-five. They're from all over the world and every single one of them leaves here with a different feeling. It changes their lives. We've had so many volunteers that have come back to us and said, "I can't adjust to going back home. It's changed my life; it's made me stronger, a better person." So helping the refugees has also benefited the volunteers.

AW How many refugees have you helped?

MM Well, it's kind of mind-boggling. We live on this little Greek island and we're in the north in this small village of Molyvos. In the village we have about 1,500 to 2,000 inhabitants. So we've surpassed 200,000 refugees coming through Molyvos, counting from January 1 of last year. That's not the whole island; in the whole island, there have been almost 600,000 refugees. But in this little village, 200,000 people have passed through our hands. Because of the amount of people that were passing through, we opened up a camp area called Oxy, just a little outside the village, so that we could put people there instead of in the middle of the road. We had more than 130,000 people pass through that camp in some months.

AW I know this island has seen a huge flood of refugees even before the volunteers came. What was it like in the early days?

MM Before the volunteers came, we did have quite a few locals coming and giving us clothes. There were little ladies, the fishermen who've been pulling people out of the water, and many people that have been helping a bit here, a bit there—whatever they could do. Don't forget, early on this was a situation where people didn't understand what was happening—suddenly their little village was bombarded with all these different people from all over the world. There wasn't any information, so they didn't really know how to help, but they all did help in their own little way, maybe just by passing out bottles of water.

AW What was the early refugee struggle like? Now, they obviously receive help from volunteers or NGOs, but in the early days, did they just jump in the water and try to climb over the mountain?

MM There were some other people along the beach to help them out. Most people arrived with the coast guard and were brought into the harbor.

AW And before that?

MM Ah, before that, long before that—at the very beginning. Well, I don't know when the beginning was. When I was involved, they'd just arrive by themselves. We

tried to put up signs to explain where they had to go. We tried to have flasks full of tea for them, and then they were taken to an area in Mytilene where we also tried to help look after them. We kept children that were separated from their parents and young people in a more protected area that was tended by a lot of locals. Generally, there's been a lot of generosity from the locals.

AW Since when have people worked here in your organization? Do they just come and go?

MM Originally, when it was just me, it was easier, because I knew what I was doing. When the volunteers came, a volunteer had to help us arrange the volunteers. And as we've evolved and become a foundation, we've actually had to get a main core team in to make a schedule, look after the volunteers, answer their emails and queries, and look after them if they need any help, because some people come here for a couple of months and they also need some help adjusting and looking after themselves. Some like to work themselves to the bone, and some don't look after themselves. It's still a little bit difficult, and it's a full-time job for about three people, but we manage.

AW Can you tell us a little story about the work here that has touched you?

MM A volunteer came here and he was on drugs. We immediately saw that, and we felt that this guy shouldn't stay with us, so we spoke to him. He decided that he'd stop taking drugs, because he wanted to stay. We watched him very, very carefully. He completely stopped taking drugs and drinking, and he turned into a different person. He left here thanking us because it helped him become a better person.

AW And helping other people.

MM Lots of people.

AW What are the words you want to tell the world?

MM I know people are scared that criminals will also come in with the amount of people coming through. But the people that I've seen—the lovely women and children— are the type of people who are here to help these poor people. A little Syrian woman and her husband that left her three children behind said to me, "I knew if I stayed home, I would die. By traveling, at least I have a chance of surviving. What would you do, Melinda, if you were in that place and you knew that if you stayed home you would die?" I would definitely try to save my children and leave.

The other very important thing that I would love to tell the whole world is that Greece has gone through so much, and now our tourism has been shut down due to the refugees coming through. We're suffering now because we aren't getting any tourists on this island. You can still come to Greece and enjoy the village. If Greece loses all our tourism, we're really finished. We've opened our hearts and helped everybody else, so now please help us by coming and visiting us, because we need tourists to survive. The poor fishermen have not been able to put down their nets, and if we don't have tourists to feed in our restaurants, we can't buy their fish. Thank you.

013

Krzysztot Burowski, Frontex
Lesvos, Greece, 2016-02-16

KB My name is Krzysztot Burowski. I'm a PR officer for Frontex, the EU Border Management Agency.

AW Can you please explain what Frontex is?

KB Frontex is an agency that supports EU member states to manage their borders. Here in Greece we have, at the moment, around 770 officers who are helping to register incoming migrants. We also have several crews and boats that patrol the waters here and help with search and rescue operations.

AW Would you explain how the operation has changed from your perspective?

KB I was here in August when things were kind of picking up pace, and since then, obviously, numbers have skyrocketed. About 800,000 people have come across from Turkey to Greece, and although in recent days we've seen the numbers fall, the migrants continue coming. That's why we have so many officers here. The Greek coast guard patrols these waters and we support them with our boats. We also have officers who work with Greek officers who are receiving the migrants and trying to work out what country they're coming from. We help fingerprint and register them here on the island before they move on.

We have several ongoing operations in Europe, but the main spots where we have the biggest presence are here in Greece and in Italy, where we assist in handling the migrants coming from Libya. What happens, basically, is that the country requests support from Frontex and then we send our officers to help them in various ways, either patrolling the waters or registering migrants on land borders. We're also present at checkpoints and at some airports. So Frontex has officers all around Europe. It's important to point out that these officers are coming from various member states, but they aren't employed by Frontex. They are sent here to take part in Frontex operations.

AW Could you tell us why Frontex is important?

KB Frontex is important because in an area with open borders—such as the Schengen area—you have to support countries that have external borders and face challenges they might not be able to handle themselves. Frontex is an agency that supports those countries in managing the EU's external borders.

AW I imagine it as a reinforcement unit.

KB That's exactly right. It's a reinforcement force. Obviously, every country has its own border force, and so what we do is to come in when we're asked and support those countries that are having a difficult time. Obviously, when you have hundreds of thousands of migrants coming in, for example, to the Greek islands, there's a need for assistance from outside of Greece.

AW This unforeseen refugee flow to Europe is probably posing new challenges for Frontex.

KB As you can imagine, this is certainly an unprecedented moment for all of Europe. This is the largest migration flow since the Second World War. Now, no country can handle this by itself, and it's certainly a challenge for Frontex. We ask member states to provide us with 700 additional officers to assist, especially in Greece, and we basically receive half of them. This shows the challenges, for Frontex and all member states, of securing the manpower and equipment to support countries at the external borders.

AW How did your personal outlook change in the last two or three years?

KB I joined Frontex about a year ago and I had no idea that Europe would face such an incredible, unprecedented challenge of people coming in. Being out here, I see various people coming across the water, and it certainly is a moving experience for me.

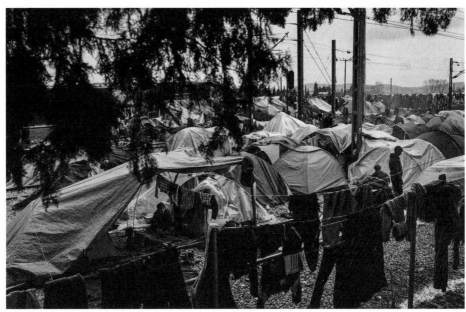

Makeshift Camp, Idomeni, Greece, 2016

014

Giorgia Linardi, Sea-Watch
Lesvos, Greece, 2016-02-17

AW How many boats do you have contact with?

GL Today we had a very long operation that lasted for three hours. We followed the movement of seven boats, along with the other rescue teams, and assisted them; the authorities also intervened to assist some.

AW When we filmed from the lighthouse, some boats transferred people from one boat and then one of the other boats got towed away toward the beach, toward the lighthouse.

GL Yes, that wasn't us. Usually that's the operational policy of the coast guard, of Frontex. They usually take the people on board and ask the rescue teams to tow the empty boat. The NGO rescue teams take people on board only when the rubber boat is losing air or taking in water, and because we can't take all the passengers on board at once.

AW How's the cooperation between your NGO and the other rescue teams, the coast guard, and Frontex?

GL This is a very complex question. Sea-Watch has established a very good collaboration with the other NGOs. We have what we refer to as a "common land-spotting system," so we don't have to patrol that much. We have a pretty good collaboration with Frontex. With the coast guard, it's more difficult at times, because they tend to see us as trying to avoid the authorities and their rules, which is really not our point. It's just that we have different ways of operating sometimes. They receive pretty strict orders from above that don't always comply with the necessities and the realities on the ground. I don't blame the coast guard for being strict with us, even if we have some operational problems at times. They're in a very difficult position. Overall it's okay but not always easy. It's a little bit like the cat and mouse game. But as long as we all manage to take people out of the water, the NGOs are okay with working under the orders of the coast guard. Also, we're working in their territorial waters, which legally is the same as on land.

AW And how does it work in very practical terms? For example, how do you know about the boat and what happens next?

GL The NGOs developed a pretty good system based on spotters who are located along the north coast. They all defer information to a main spotting reference that used to be a radio station called Romeo that worked 24/7 but has since been shut down by the police. Right now we have a system that works only during the day because we don't have a station anymore, and it's called Juliet. That's the way we're alerted about boat positions.

We only operate in Greek territorial waters. We don't cross the border unless we have a clear distress case, and the moment we cross the border, we would, of

course, inform the authorities. We just go and check the condition of the spotted boats. If everything is fine, we give them a direction toward a safe place for landing and organize land assistance upon arrival. Very often the engine stops during the trip. That's why we tend to stay quite close and try not to lose sight of the boat, so that we can intervene if anything happens. Sometimes it's just a matter of instructing them on how to restart the engine, but sometimes the engine really breaks, and then you need to transfer people or tow them. In that case, we inform the coast guard, but we're normally able to tow the boat ourselves or disembark people onto our boats. Lately, it's mainly the coast guard and Frontex that disembark people, unless there's a serious distress case like a boat sinking or taking in water, or a rubber boat that's seriously deflating. In that case, the RIB [rigid inflatable boat] rescue teams are the most suitable for providing immediate assistance, because you can guarantee immediate boarding. We all operate together, so we're quite quick and manage to evacuate people pretty efficiently.

AW Can you remember the people that you saw on the boat? What kind of people did you meet?

GL I especially remember one old man in a wheelchair that was carried in and out of our boat. He was very friendly and had a long white mustache. He looked very funny with a red and white keffiyeh wrapped around his head. He promptly fixed it as soon as he got onto land. He was grateful and funny, and he'd talk to me in his language expecting that I'd understand. But I really enjoyed that because somehow, we were able to communicate without understanding each other. I also remember this eighteen-year-old guy from Iraq who told me, "I would like to go to Germany because it's a safe place and it's peaceful. I'm escaping war, and I know that that is the safest and most peaceful place I want to be." It was kind of difficult for me to listen to this, and I had to tell him, "Okay, but just be aware that it's not that easy," and he replied, "Yeah, I know." But he obviously didn't know, and at the same time I couldn't tell him how hard it is. This reminds me of how difficult it is for us to say "Welcome to Europe" to people every day, when it's actually "Welcome to Nowhere." But still, it's a moment of humanity when you talk to these people. It's really interesting every time to see that they're people like us, just coming from a worse situation.

When you're helping, somehow, you always feel that the helpers and the people who are helped are on a different level. That bothers me a bit. I feel kind of guilty because we put them in that position of being wet and miserable. And we always meet these people in a moment of desperation. From what I've witnessed so far, I always say, "Wow"; after each mission I always tell myself how brave and dignified these people are. It's pretty impressive to me every time.

AW How long have you been working in sea rescue?

GL Since July 2015, so around eight months so far. And theoretically, I had exclusive, detailed knowledge of the rescue, because I specialized from a legal perspective in interception and the rescue of migrants at sea in the Mediterranean. But over the summer I just found myself on a boat, actually taking people out of the water and learning how to speak on the radio, which is a completely different thing. That's something that you basically learn by doing.

AW And what do you think? How many people did you actually rescue during this time, in the eight months you've been here?

GL Personally, I really have no idea. More than 1,000 for sure. Also, I'm not involved all the time in rescue operations, because I do a lot of coordination from land with all our different volunteer crews. So it's not just me on the boat all the time. But altogether, for sure, more than 7,000 people.

AW Maybe it's a hard question to ask, but do you think people would've died without you being there?

GL Not all; it's not always the case, you know. That's why I don't like to say how many people we've saved. You know, sometimes that's too extreme. I always like to use the word "assist" because sometimes it's not about saving lives; they'd make it themselves, though maybe in a harsher way. But a few hundred people probably would've died without our intervention. Especially if you consider that in the central Mediterranean, you have boats that never carry less than a hundred people, and you just find them drifting in the middle of nowhere. If you don't spot them, they die at sea. We managed to spot 500 people just with our binoculars in the middle of the Mediterranean Sea.

Here in Lesvos, it's a very different way of operating. We have the spotting system, but we've had cases where we were there and could immediately intervene and take people on board from a sinking boat. In situations where we were literally taking people out of the water in a panic situation—people who couldn't swim, babies—I think we were quite helpful there.

AW I think that this is an extraordinary experience for most people. Since you've been with this crew a long time, how do you think this experience changes people?

GL It's very interesting, because I've been on seventeen crews, and each time you have to deal with different people, different personalities, different reactions, a difference in stability toward the issue, toward people, refugees, migrants—call them as you wish; I like to call them people. But it's very difficult to acknowledge these reactions when the people are operating on the island. Usually you realize things when you're back to your normal life. That's difficult for me because then I'm not with the crews anymore, and I tend to avoid maintaining too much contact, because you have to remain sane when staying here for a long time. You have to deal with your own reactions, take care of the crews, and go on. It becomes a very big burden if you absorb everybody's frustration. It might sound sad, but you have to build a little bit of a thick skin. But surely everybody goes back more aware, especially of how reality is different from the information and images we see back home. It's very different and complex and peculiar. People become much more aware and probably also more critical and sensitive.

AW Do the people want to come back after they've been on a rescue boat?

GL Yes, they do. Most of the time, people enjoy the experience and want to come back. It also becomes a little bit addictive, because there are certain moments that are so real. There's a lot of humanity and a lot of adrenaline; it's a very unique

situation in the middle of the sea. It's very peculiar and it's quite new because it's not been that long that NGOs and the Sea-Watch society have engaged in these kinds of activities. Even for the authorities, this kind of mass rescue is something that just came up in the last few years and then increased massively recently. So yes, people get addicted to this, which is a bit perverse. It's definitely a moving experience, but it can also be very traumatizing.

AW How has it been for you, your relationships, and your other life? Do you still connect with your previous life or how do you feel about it?

GL It's difficult to maintain relationships with family and friends. I'm not talking about love relationships. It's not easy, because you tend to detach a lot. It's hard for me to talk about this with the people that love me the most and that I love the most, because it's too complex, it's too much. I don't know how to frame it. I've probably given a hundred interviews on this, but it's still difficult for me to really talk about it with the people close to me. I don't know how to do it, and unfortunately people can't understand. They're not to blame; it's just a matter of fact. People don't understand, so you tend to create a barrier. If you open up, you scare people. They're confused, and they don't understand what you're talking about or why you talk about certain things in a certain way.

You can't work on the boat forever. It kills you psychologically and physically. For the moment, I'm interested in remaining in the field of sea rescue. Even if I'm not going to be involved forever in the actual rescues, for me the knowledge I gathered at sea is important. I think it's very unique because it's quite new. So I'd like to continue working here and also for other organizations, people, or entities that might need that kind of knowledge to do this kind of work. At the same time, this situation needs to stop. If I remain involved in sea rescue for years, it means that something went wrong.

015

Aris Messinis, Photographer
Athens, Greece, 2016-02-18

AW You're from Greece and you have three daughters. You told me you know every piece of rock on this island. Your photos are the most striking images I've ever seen. What has happened in the past months? What have you seen? You can start from the very beginning.

AM Thousands of thousands of people. Some of them made it; many didn't. We're talking about almost 4,000 people who died. Many are missing. I've seen death outside the war zone. I've seen death in a peaceful place. People suffering, fear, the struggle for survival, lots of feelings—bad feelings.

AW As a professional photographer, how do you cope with the situation? You want to capture the image, but at the same time, you must be struggling, morally speaking.

AM It's hard to shoot human pain, but you have to do it. You have to show it. Life isn't only sunrise and sunset, it's also pain and death. Unfair death. You have to be strong to capture this and show it to people. It doesn't matter if it affects you in a bad way because someone must do it. By luck, it's you. That's it.

AW What have you learned after going through so much?

AM I've covered migration for at least a decade, from the land, the sea, everywhere. After all these years in this profession—I've seen war, human anger, hate—my thoughts about humans are that they're the most evil creatures on this planet. We've become so wicked. I'm not as much in love with our humanity as I once was. We're very dark souls. Not all of us, obviously. If we see outside the everyday frame and look into the future, humans are probably the most evil creatures on this planet, the only species that kills for fun.

AW You're dealing with all the news. What do you think about the role of the international press? Was there not enough attention on the topic, or was the reporting misleading?

AM There are many ways that the general media can cover the struggle of these people. You can choose to see it in a good way or in a bad way. I've been there, and I know what they're facing every day on their way to a better life. To survive, they need to leave. Through my work I only try to show what's going on, but personally, I'm with them.

AW Can you tell me about the people you're filming?

AM They're just humans, like me, you, everybody. They don't have any special signs that set them apart from the rest of humanity. It's me, my daughters, my mother, my father. We don't have to divide people into nations or cultures or whatever. They're just people that are suffering from war, from all this madness that

humanity is creating for its own benefit. I could be in that boat also. So let people live, eh?

AW Do you think Europe should provide safe passage?

AM A few hundred kilometers to the north [at Greece's land border with Turkey at the Evros River], there's a much safer passage that was used for many years. But smugglers and those connected to the black market receive less money for safe passage.

AW So is migration a natural act for you, like flamingos that fly here for the season?

AM If we think that, for example, flamingos travel for their survival, for the weather and the food, yes, it's something like that. But nature determines their flight. These people didn't choose to leave their countries; somebody else forced them into it. They lost their homes and their families because of someone else's decision, for political or economic games, religious games, or whatever.

AW I saw your photo of a dead baby. I think it's a very striking image. Your photos are so powerful. Can you talk about those incidents and how you encountered them?

AM I've seen many, many babies and children—from just months old up to fifteen years old—dead, washed up on the shore. It's very hard to look at it. After all these months, I have many contacts here with fishermen, locals, everybody. So every time somebody saw something happening, they called me and I went to take photos.

One time, a baby washed up on shore after a storm in a rocky area. I had to climb down the cliffs for about an hour to get there. To be honest, I picked that baby up and a colleague of mine and I put it in a bag and brought it back to the authorities. Otherwise, it would probably have been eaten by the birds. These are very hard images, things that I don't like to remember. But every time I see these pictures, I relive the same scenes. Many people died in front of us while the coast guard was trying to rescue them after an accident. The coast guard was trying to revive them, but the people couldn't make it.

We need a safer passage, otherwise we'll see worse things. And there are many people who died that we never saw. If you're brave enough to dive to the bottom of the sea, you'll see many more people than what we saw. Two weeks ago, a young child without a head washed up on the shore weeks after an accident.

AW After so many deaths, when 500,000 or 1,000,000 people are fleeing, another 90,000,000 are stuck. They're poor and can never make the trip, and the whole world pretends they don't know about it. Where is the humanity in the twenty-first century?

AM It's the whole system of the world. You know, politics, or whatever you want to call it. People don't know or don't want to know the truth. All these people are suffering because the other part of the world is getting richer from all this pain.

There's enough space and food for everybody. But it's a war between the two parts of the world. People in Africa are suffering because people in what we call the West want to become richer; people in the Middle East are suffering because of energy sources. Some must suffer in order for others to become richer.

AW Thank you for sharing with us. Is there anything else you'd like to say?

AM Right now I'm not in a good mood to talk. When you have three daughters and you see children dying in front of you, it's not easy. But no one cares, eh? Even people who see the news images, films, or documentaries say, "Oh, so sad," and then just change the channel or keep surfing the Internet. That's their phrase: "Oh, so sad. Oh, I'm sorry," and that's it. The child I saw, the one we were talking about earlier, was the same age as my young daughter. Yesterday I went to the cemetery and saw its grave—the grave of a child nine months old.

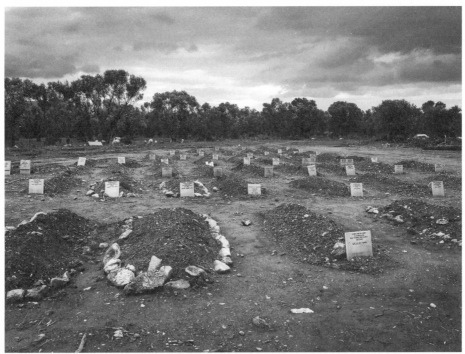

Kato Tritos Cemetery, Lesvos, Greece, 2016

016

Nikos Golias, *Hellenic Coast Guard*
Lesvos, Greece, 2016-02-19

NG I've been the captain here in Lesvos for fifteen years. Our job is to patrol the Greek boundaries and our maritime borders. Our first concern is to help people in danger in the sea. We were able to achieve this so far with the few means we have. As Greeks, and as people of the sea, our history shows that we've always helped people who are in danger. It's an honor for us. I believe that few people who work in the coast guard of any country have faced migration flows such as that in Lesvos in 2015, which numbered as many as half a million people. We had almost no loss of life. For this reason, I'm so proud of my job. It gives me strength to continue.

AW The refugee crisis happened in the past year. More than 500,000 refugees have crossed the border from Turkey to Lesvos. As a captain and someone who controls the border, what's your position? What are the difficulties you face and how do you cope with them?

NG The hardest part for all these people who work on the sea is when the "shipload" is human beings, and when these humans are in a state of panic and danger. You need to be assertive, make them feel secure, and regardless of the weather conditions, you need to be able to rescue these people, take them on your vessel, and transfer them safely to land. As you mentioned, we had more than half a million people who crossed the maritime borders of Lesvos in 2015 alone. Regardless of the hours at sea, we've always been there for people in danger. Unfortunately, most of the time they're in danger not due to weather conditions but due to other mistakes, such as a lack of training concerning the sea. Difficult situations are mostly caused by human errors.

AW The situation has become so dramatic. It has never happened like this for any nation in human history. Lesvos is a small island. As a captain here, can you describe what happened?

NG The hardest thing for us was when we had more than one or two boats that were in danger simultaneously due to weather conditions or human error. The boats that the migrants use have a fuel tank where you put the petrol. This tank has a safety valve that needs to be opened so water flows through the engine. They often forgot to open it and press this button, which resulted in mechanical failure. Then we'd have forty to fifty lives stranded on a boat in the middle of the sea. Also, we had a few cases where some of the migrants attempted to cross in dilapidated wooden boats, and it was doubtful if they could make the journey. My crew and I were most vigilant in these cases, when we encountered wooden boats or boats that we knew were taking in water.

AW Greece had a clear policy not to reject this sudden flood of refugees but to accept them and act in a humanitarian way. What's your procedure when you see a refugee boat? How do you know if they're refugees?

NG During the summer months when we had the biggest inflows, when a boat crossed our maritime borders, we would always stay close to it, regardless of whether it was in danger or not, to make sure these people reached land safely. Just the fact that there are fifty to sixty people on a boat that normally carries ten to fifteen means danger. When there are people in danger on the sea, we don't take into account where they're from, who they are, or why they've come. As the coast guard, our main concern is the safety of the people.

AW At the peak of the refugee crisis, sometimes you would see a few thousand people coming in, sometimes eighty to a hundred boats a day. How did you cope with this situation?

NG Usually, an average of 3,000 people came in one day. This means about sixty boats with fifty people on each of them. This was happening round the clock, twenty-four hours a day. The coast guard vessels, alongside the Frontex vessels, were in a constant state of surveillance and standby. If I remember correctly, at that time we had eleven vessels available on Lesvos, and we shared the work, depending on the capabilities of each vessel.

AW As a person who protects the Greek border, and who has seen many refugees and probably rescued many of them, what's your opinion about the refugee situation?

NG My personal opinion is that it's clearly a political matter. We're trying to keep balance and safety in our maritime borders and the Aegean Sea. But on Chios island, they say there's no such thing as a "good captain" or a "good crew" but only a "lucky captain." I believe, after 500,000 people crossing the borders, that we also had luck on our side. The conditions could've been much worse; we could've faced even harder situations and had more deaths to mourn. That's why it must be handled by the politicians of the countries affected by the crisis. A solution must be found, because there may be days and harder times ahead when we won't be able to simultaneously handle the rescue of so many people in danger.

AW More than 4,000 people have died on this ocean. Why do you think Europe seems unwilling to provide a safe passage for refugees? For instance, the Lesvos mayor suggested a better way for refugees to reach Europe.

NG It's much harder to control the maritime borders than land borders. I'm from Lesvos, and personally I believe that one of the reasons our island had to carry this great burden is because it's a big island with a population of almost 100,000. The people of the island, our grandfathers and grandmothers, were themselves refugees in 1922, so we know what it means to be a refugee. We feel their pain, and we feel empathy for these people who are now refugees. All these factors, and the fact that the local community showed compassion and offered great help, is something that the smugglers took advantage of. They increased the influx of people to our island.

AW What's the most difficult task you faced during this whole situation?

NG The most difficult task in our job is when boats sink and because of the conditions

we must choose which people we have sufficient time to save. Hypothermia, and the fact that older people or very young people can't withstand difficult weather conditions, forces us to make some very hard choices.

AW How do you predict the situation will develop in the coming months?

NG The most important thing that the local community and the European leaders know, and that anyone who has visited the island of Lesvos knows, is that they need to be organized. There must be cooperation among all the organizations that work on land or at sea, because while luck helps, prevention should be the main priority for the local communities and the organizations who provide for the refugees' welfare and health.

Our part is to bring people safely to the port, but there are many more things to take care of when they arrive, like their registration, health, food, and shelter. The coast guard isn't involved in these areas, but the local community and Europe must find solutions.

AW When you're on duty and you go out and see a boat with, say, fifty, sixty, or even eighty people, what kind of decisions do you have to make to know if they're refugees or not?

NG With experience you can immediately tell if a boat is carrying migrants or it's a different kind of vessel. You can also examine a boat with a thermal camera to see what type of boat it is and whether it's carrying refugees or if it's a yacht. The thermal camera shows if there are many people on board.

AW Is there something you want to tell us?

NG My crew began patrolling up to sixteen hours a day. The salaries became less and less. All the guys have second and third jobs, but they still have the courage to help and save people. That's the most important thing. We feel very proud and very lucky that we have our government's trust. I was ready to retire, since after fifteen to twenty years in the system you're usually sent to an office. However, we were given the honor of operating this boat, and we're still on the front line.

AW You have a state-of-the-art boat here. It's very impressive. That also means you really have more to do.

NG This patrol boat is designed for this job. We have a heated, enclosed space for all the migrants, so the babies and the elderly can be inside. This is important because the problem is that three incidents may occur simultaneously, but we can't be in the harbor and out at sea at the same time. We need space to secure the people, prevent hypothermia, and to continue saving others.

AW What was the most extreme day in your memory? Can you describe what you remember most strongly?

NG There was an incident where a boat was in trouble, but nobody had notified us, so the boat sank. We found some people who could swim and still had their senses,

and at some point my crew found a girl, about ten or twelve years old, who had drowned just minutes before. I gave my crew false hope, so they offered first aid to the child. There were spasms, which was a sign that she might still be alive. I didn't want my crew to lose their nerve, and I also wanted to see how they responded, knowing we might have many cases similar to this in the future. I knew that the girl wouldn't survive, but I still had to encourage my crew to offer her first aid, to overcome any emotions and sensitivities and be able to function properly. It was a tough moment. But there are also pleasant moments. Two days after this incident, a yacht—Russian, I think—approached us. They had rescued two women who had been in the water for forty-eight hours. You never know who will make it in the sea and who will not. That's why you must always try.

AW It's such a beautiful ocean here. It seems very peaceful, but sometimes it can be very rough at sea, especially for the migrants who travel in those very unsafe rubber boats with so many people aboard.

NG What has been remarkable to me personally is that in previous years, migrants didn't cross with boats in the southerly, strong winds with generally bad weather conditions. When the influx started, people were coming regardless of the weather conditions. This made our job even harder, and what we couldn't understand was how the people responsible for the transfer—the smugglers who earn millions by doing this—let so many humans cross the sea in such awful conditions. This is something we haven't been able to explain. These people should be judged for war crimes; they're criminals.

AW What you and your team have done will be remembered and recorded in human history. What would you like the world to remember?

NG The most important thing is that although life originated in the water, people must be above the water, breathing, not drowning.

017

Ibrahim Abujanad, Refugee
Eleonas Refugee Camp, Athens, Greece, 2016-02-21

[Singing]

How beautiful, oh, letters of home like a necklace on a chest!
How beautiful it is
How beautiful it is
The "P," the beloved Palestine, how precious is the Motherland, oh Arabs
How precious it is
And the "L," the "L," the "L"
And the "L," when they have united, how strong was the stone!
And the "S" is the question of the detained: "When will I meet relief?"
And the "T" is the rise of a full moon on the martyr where his soul rests
And the "I" Oh people of manhood, how beautiful is the reunion
And the "N" is the light of the Prophet! And our Quds is his path
My homeland, my homeland
The beauty . . .
Dearly I yearn for my mother's bread
And my mother's coffee,
Mother's brushing touch.
Dearly I yearn for my mother's bread,
And my mother's coffee.

I'm Ibrahim from Palestine, a refugee who arrived here in Greece. My story is long. I don't know where to start and where to finish. I was born in Libya in 1984. My grandfather was exiled to Jordan. My father studied in Lebanon, in Beirut. He got a job in Libya and I was born there. We lived in misery for fourteen years in Libya. After the Oslo Agreement, the Palestinians were expelled from Libya, so we moved to Gaza. I studied and grew up in the elementary school of al-Karzabih in Libya till the sixth grade. After that, I finished my secondary and high school studies in Abu Tammam boys' school. Then I moved to university. I worked as a taxi driver and I was a part-time barber from the age of ten.

I finished my university studies in 2006 with a bachelor's in accounting and searched for a job in Gaza. Unfortunately, it was too difficult to find a job in Gaza even with an excellent academic degree. My father was and still is the main provider for the family and now he's going to retire. I have one brother and five sisters. Two of my sisters are married and three are still studying, because my father's condition for marriage was that my sisters must first finish their studies or have a bachelor's degree or a diploma in a lesser degree. He said, "I won't let my daughters get married unless they are educated."

I found a job for about one year. After that, the events in Gaza worsened in 2007 and 2008, and things became more difficult for me, so with my father's help I decided to complete my master's degree in accounting at the Islamic University in Gaza. I got married right before I defended my master's thesis. Now I have my own children. My eldest son Hussein is four years old and my daughter Leen is

nineteen months old. Once I finished my master's studies, I searched for a job. I found one at al-Quds Open University based on an hourly wage, but the salary is less than average.

I decided to try to leave Gaza because of the situation there and for the sake of finding a better life that included doctorate studies, taking my family with me, and improving my living situation. I wanted to be able to educate my kids in the future, help them get married, and have my own house. The border crossings in Gaza aren't open for patients, students, or any other humanitarian situation. The economic situation is bad and unemployment is prevalent. Students can't find work after graduation. Electricity is only available for eight hours a day. This doesn't help a human being lead even a basic life.

Unfortunately, no one understands death unless he's living under it. We've suffered from a bad economic situation and repeated wars in Gaza. A war in 2008, a war in 2012, and a war in 2014. Since 1948 and 1967, all are wars. So I hope to reach Europe, continue my studies, arrange my affairs, and bring my family with me.

[Singing]

I walk with my back held straight,
I walk with my head held high
I hold an olive branch in my heart,
And on my shoulders I carry my coffin
As I walk, as I walk, as I walk, as I—as I—as I walk
My heart is a green cage, my heart is a garden
It is filled with boxthorn, it is filled with basil
My lips are raining fire!
A fire, when it rains sometimes!
My lips are raining fire!
A fire, when it rains sometimes!
It is not like this!
It is not getting right!
With me
Come on, with me!
I walk with my back held straight,
I walk with my head held high
I walk with my back held straight,
I walk with my head held high
I hold an olive branch in my heart,
And on my shoulders, I carry my coffin
As I walk, as I walk, as I walk, as I—as I—as I walk
My heart is a green cage, my heart is a garden
It is filled with boxthorn, it is filled with basil
My lips are like a stormy sky
Raining fire one moment and love the other
My lips are like a stormy sky
Raining fire one moment and love the other
I hold an olive branch in my heart,

And on my shoulders, I carry my coffin
As I walk, as I walk, as I walk, as I—as I—as I walk
I walk with my back held straight,
I walk with my head held high
I hold an olive branch in my palm,
And on my shoulders, I carry my coffin
As I walk, as I walk, as I walk, as I—as I—as I walk
I walk with my back held straight,
I walk with my head held high
I walk with my back held straight,
I walk with my head held high
I hold an olive branch in my heart,
And on my shoulders, I carry my coffin
As I walk, as I walk, as I walk, as I—as I—as I walk
Repeating first verse
My heart is a green cage, my heart is a garden
It is filled with boxthorn, it is filled with basil
My lips are raining fire!
Raining once one moment and many times the other!
I hold an olive branch in my heart,
And on my shoulders, I carry my coffin
As I walk, as I walk, as I walk, as I—as I—as I walk

018

Rozhan Hossin, Refugee
Idomeni, Greece, 2016-03-04 and 2016-03-05

My name is Rozhan and I'm Kurdish. I thank God that we left Iran safely. I had no life in Iran. There were political problems with the Iranian government. They were arresting us.

When we heard that the Iranian police had occupied our house, we immediately escaped to Maku with all our savings. Maku is a city located on the border of Iran with Turkey. As we made our way, it was icy cold and the mountains were covered with snow. We were trying to keep warm with the clothes we had.

From Maku the smugglers brought us to the foot of the mountains. Turkey was on the other side. I was there with my brother, my husband, and my child, with about 700 or 800 Afghans who were totally exhausted and hungry. We walked up the mountains in deep snow.

They told us that if they lifted the barbed wire we should begin to run until we had crossed the border into Turkey. When the time came, they cried with a loud voice, "Run! Run! Go to the barbed wire!" We all ran. When they held the wires up high, we ran underneath. Suddenly we heard shots in the air. It was the Turkish police. With huge spotlights they searched from the air and fired shots. We were afraid for our lives and just ran. Unfortunately, fifty or sixty Afghans had to stay back.

We walked about one kilometer. There was ice and snow on the mountains, and we slipped and fell many times. My husband broke his toes. Finally, we arrived at the second smuggler's place. He told us that we should go down the hill until we arrived at a cowshed. We followed the path for two or three hours until we reached the cowshed. When we arrived at the cowshed, only one light was on, and there were many dogs or wolves roaming around it—I couldn't tell which; I only heard those terrible howls. They sounded so fierce in the mountains. We were so thirsty that we ate snow.

My child traveled with great difficulty. He couldn't walk anymore, so we took him in our arms and dropped our bags. We were afraid the smugglers would steal our money, so we all walked close together to prevent this.

When we arrived at the cowshed, they put us in a shared taxi without windows in the back. There was only one door that could be opened. They took us to a village that was called Doğubayazıt. When we arrived there we saw 300 or 400 people— Afghans, Pakistanis, Kurds, Iraqi Kurds, Syrians—all of them were in this village in a compound. They were hiding from the Turkish police.

They allowed us to spend the night there. The next morning we walked one kilometer to reach a place where there were buses, but it wasn't a terminal. These buses were only for people who were on the run, to bring them to Istanbul.

We were treated inhumanely. They shouted profanities and degrading things while pushing us onto the bus. I ridiculed the smuggler and asked him why he was shouting like that. He came toward me, called me out, and threatened to beat me. He shouted at me, "Why do you laugh?" and said that I should shut my mouth. Immediately I kept my mouth shut and clammed up.

The trip wasn't easy. The bus was full of people. There were even women and children in the aisle. I sat in the front with my husband, and my child sat on my lap. My brother was sitting behind me. A lot of people couldn't get seats and had to sit in the aisle.

From there, our situation worsened dramatically. The smugglers gave us papers to show the police if we were stopped, which we repeatedly were. It was snowing and raining heavily. They took us off the bus and went through our backpacks on the snow, while our bodies were shaking, then they pushed us back into the bus and shouted, "Next." We were stopped by the Turkish police up to four times on the way to Istanbul. They were so merciless.

When we arrived in Istanbul I got a call from the smuggler from Doğubayazıt, who we already knew. He said we should wait in the terminal at Istanbul, where he would pick us up. Within ten minutes, a young Afghan came in our direction and asked us who we were. He said that Mehran the smuggler had sent him. I just said, "Okay." He took us to Aksaray Street.

From there we went through many small streets until we reached a house. It was like a ruin. We went up three floors along a narrow and dark stairway. They put us in a room; six young Afghans were in the room next to us. My child, my husband, and my brother and I were in one room. I asked the smuggler when we would move on and what we should do there. He replied that the sea was very rough and there were police everywhere at the borders. That was why we had to wait a few days, and then they would bring us to the boat. They told us that they would take us to the city of Didim, which lies on the border, and from there they could easily bring us to Greece with the boat.

We spent the night there. The next day, there was a smell at six or seven o'clock in the morning, and I couldn't sleep because the stench was horrible. My husband told me to be quiet. The people next door were consuming intoxicants. We were afraid that they would come in and beat us or steal our money. Fearful, we sat close together and didn't say anything. Suddenly someone knocked at our door at 6:30 a.m. and yelled that we would drive to Didim.

They brought us back to the terminal. There was a bus that brought all refugees to Didim. At first I was afraid because I thought that we were the only ones. But when we arrived at the bus, I saw endless refugees. When I went to board, one of the smugglers, Ismail, gave me a bag and said that when I arrived in Didim, I should give the pants to Aziz. I was afraid and didn't want to anger him, so I said okay. I didn't ask anything. We got on the bus and drove toward İzmir. In İzmir there was another bus that drove us to Didim. On the bus I noticed that the pants were heavy. I looked in the pockets but there was nothing there. I thought that the pants were just like that. Suddenly, my husband asked why the trouser waistband

was so fat. I checked and discovered that the waistband was full of drugs! I was to carry these drugs because I was a woman and had a child. I was heart-stricken because I realized they were playing with my life. What would happen if a Turkish policeman had examined me and found pants full of drugs?

When the bus stopped for the first time so that we could drink water and use the toilet, I took the pants and threw them in the trash. I was relieved that I had discarded the pants, but I knew that I would have to account for my actions.

We reached the İzmir terminal where we had to change buses. Then they took us to Didim. When we arrived in Didim, the smugglers were waiting for us in the terminal. Each family, each group, had its own smuggler. Each smuggler sought his group and went off with them. They all brought us to a hotel. I say hotel, but it was a ruin. We went to the hotel and they told us that night we would go farther. We were so happy. We thought we would be saved, that it would soon be over. Each of us had given them 800 euros and now everyone had to give them another 1,000 euros.

They had an available rubber boat. I told the smuggler, Aziz, that I had no more money. I asked him to allow us to travel in the rubber boat, which would be safer, and I promised that I would get him the money when I arrived on the other side. He asked for the trousers that I had been given. I acted dumb and said, "Oh my God, where are the pants? Oh no, I left the pants in the bus." He asked why I had left it there. I said I had forgotten them. "It's just a pair of pants. Here, you can have my husband's." He said these pants were very important to him. He was very angry with me and left. I never saw Aziz again. He was the chief and had his own bodyguard and drove expensive cars. He thought himself very important.

For three days we had to stay at this hotel without food and water. Nobody took care of us, just because I hadn't brought those pants. After three days someone called Fezoilar came to chase us out. The police were there and the sea was restless, so we had to drive to Çeşme. In Çeşme they took us to another hotel. Each room had about six or seven people in it.

I grew to like the Afghans very much. They are very good people. They were treated so unfairly. Six or seven people had to stay together in one room, and these poor people didn't make a sound. In Çeşme the smugglers came to us every night and said we should get ready to travel. The first night it didn't work out, nor the second or third night. On the fourth night we were supposed to be picked up at midnight. At 4:00 a.m., the smuggler Ghalandar came to us and said that the police had found the boat and torn it apart. We lost our hope.

Every day seemed endless. The next night smugglers came back at 8:00 p.m. and informed us that we had to move on foot. We would have to walk a long distance until we reached a point from which we would be brought to Greece. About sixty or seventy of us walked from 8:00 p.m. in the cold, passing two cities, mountains, and forests, until we reached the departure point at 2:00 a.m. I was glad that we would go on a boat, but on the other hand, I was afraid that it would be the last time that we saw each other.

When we arrived, we hid behind some boxes. When I crouched down I saw all the mud under my feet. We were so exhausted from going on foot that we fell asleep in the mud while they were inflating the boats. When I awoke after two hours, at 4:00 a.m., I asked my brother why we hadn't moved yet. He replied that a boat had already set off. We would depart when it returned. Nothing happened. Not at four o'clock, not five or six o'clock. We cried until our bodies shook.

In the morning Ghalandar came and said that there was no other boat. The police had confiscated it and we would have to return on foot to the hotel. I cried so much. I asked Ghalandar if he had no heart, and why he was so inhumane. Why had they brought us there? He said he could do nothing. He was anxious and angry. We went back to the hotel and slept. At 1:00 p.m. there was a heavy knock on the door and a smuggler shouted that we had to go.

We arrived at the shore at seven or eight o'clock and again we had to hide behind the boxes until midnight. Suddenly we were 200 meters away from the water. There were so many people around me. Everyone was ready to go. They were going to prepare two boats. At midnight a boy carrying a pistol around his waist shouted, "Go. Go down!" When he counted to three, we were to put on our life jackets.

We started running. It was hilly; we ran and ran. When we reached the sea, the water was up to my knees. We ran on. The water rose higher and higher, up to my throat. My whole body was shaking. I was crying and screaming, "My baby, my baby!" The smuggler yelled at me and told me to keep my mouth shut and get into the boat. I was running with my husband, so I didn't know that my child and my brother were already on the boat. The smuggler on the boat took my arm and dragged me into the boat. My bag fell into the water and I cried, "My bag, my bag." But he ignored my cry and pushed me aside.

My husband, brother, and child sat on the edge of the boat. All the men were sitting outside on the edge of the boat with the women and children in the middle. I had given them 800 euros and they promised me that they would only put thirty people in a nine-meter boat. But they packed people together so tightly that a total of eighty people were on a boat, including women and children. The boat careened and threatened to capsize. I was sure that my last breath was coming, that I was going to die. I looked at the sky and prayed to God. The moon was reflected in the water, and around the moon was a circle. I thought God had sent it to take care of us.

I kept looking at my child because I was afraid it would be the last time I'd see him. I wanted to kiss him, but there wasn't even room to breathe. It wasn't the people's fault but the smugglers who had filled the boats. They forced people at gunpoint to get in. If anyone refused, he would've been shot. A human life means nothing to them.

They had told us that the sea passage would take thirty minutes. After sixty minutes we could no longer feel our legs. Our feet were asleep. I cried and my husband said that he couldn't continue anymore. He called my name. My child could hardly breathe.

When we reached the Greek sea it was windy and stormy. The waves first shook the men and then the women. I was soaking wet and shivering. A young man sitting next to me said I should not cry because we had arrived. I couldn't raise my head to see Greece. I asked again and again if we had arrived. He said, "Over there is a light. These are the lights of Greece. Do not be worried, do not cry."

On the island people warmly welcomed us and gave us hot tea. They immediately replaced our clothes and gave us new ones. Then we rode the bus into the camp. In the first camp they gave us different colored stickers (red, green, and blue) around the wrist that were signs of exile, of homelessness. We were in the red group. They drove us to another camp where they asked us where we were from, why we were there, where we wanted to go, what our names were, and so on.

A young Kurd named Youssef bought us our tickets for the ferry when he learned that the smugglers had taken our money. Finally, we had our papers and boarded the ferry for Athens. Once there, we managed to buy tickets to go to the Macedonian border. It was such a cold night. We were exhausted and shivering when we arrived.

The young man who accompanied us didn't leave us on our own but brought us to a place where he had booked a room, and we stayed there until the next day. In the morning we went with him in a bus toward the Macedonian border. We had forgotten about the stress and strains of our escape. We thanked God that we would arrive soon. It didn't matter that we had suffered, because we would soon be happy and the suffering would end. We believed that the sea would be the most difficult part of our escape. But then we realized that we didn't even have money for food. We had nothing. Even the money for the bus came from someone else. My son cried again and again. He said, "Mum, I'm so hungry." I cried too and was ashamed that I couldn't give him food. I wanted to die. Then a man sitting next to us said, "I don't have a mobile phone. If you have one, sell it to me and I'll give you money so you can buy something to eat." He was an Afghan. My husband deleted his data from the phone and sold it to the man for 200 euros.

We went to a restaurant where I bought my son a delicious meal; I watched him the entire time he ate. We spent the night on the bus and woke up at about 6:00 a.m. We saw that we had stopped somewhere. For four hours we were surrounded by police cars. I was so afraid. I was wondering what they wanted and why they had surrounded us. We couldn't understand the Greek bus driver. Then they took us off the bus and we realized that the Greek police didn't allow Afghans to go to the border. We are Kurds; I speak Farsi. Our papers say we are Iraqi Kurds and we can continue together with the Syrian people, so they allowed us to go farther. But not a single Afghan could be seen on the street. We cried and said goodbye to our Afghan friends. They were returned to Athens.

We stayed there on the streets without shelter, shivering until morning, because the driver had locked the doors to the bus. That night was extremely hard. I had a violent fever, and my whole body was shaking. In the morning they let us board the bus and brought us to a camp twenty kilometers away from the border with Macedonia. When we arrived at the camp they said, "Kurds on this side, Iraqis on

the other side, and the Syrians there." They separated us and asked for our identity cards.

There was an Arabic interpreter I'll never forget because of his extreme harass-ment. The authorities had passed a bill that only people who could prove their identities were allowed to travel onward. We couldn't move on because we didn't have Iraqi identity cards. I fell on my hands and knees in front of him, crying, imploring him to let me pass. I didn't want to stay there. He shoved me, pushed my brother back, and said, "Return to Athens." He wanted me to speak Arabic to him. I told him, "No Arabic. I can't speak Arabic." He was very drunk. He had a bottle of alcohol in his hand and he drank and drank, just like that, amid all the people. He was an interpreter for the Greek police. He ran through the crowd, abused my child and me, and knocked others aside. He was so disrespectful. They wouldn't allow my child, my brother, my husband, or me onto the bus with those who had identity cards. We were all crying.

We were desperate. It was the end for us. Suddenly a young Syrian asked us why we were crying. We told him our dilemma. He said that he, too, had no documents and he was going to walk to the Macedonian border. If we wanted, we could go with him. We asked him how it would work. He said that we would walk seven hours along the railroad tracks until we reached the border of Macedonia. We were hopeful. We didn't know what to expect at the border. We set out along the railway tracks, walking for hours without water or food. It was cold and rain was pouring down on us. Then we reached the Macedonian border.

When we got there, we saw an incredibly large crowd. No one was allowed to cross the border, and I saw so many people crying. They ordered us to stay in line. My brother took a number: we had the number 133. Everyone was question-ing one another about the numbers. We found out that the number 65s were all gone. That meant group 65. I didn't know how many groups there were.

On the first day, we waited at the border, but nothing happened. No one moved on. Our health worsened dramatically. My child and husband got sick. For three days we slept in the open on the ground. The Idomeni camps were overcrowded. It was raining heavily. We were soaked. Finally, my brother spotted a man who sold tents. I begged him to go to him. He said there wasn't enough money left. If he bought a tent with the money, nothing would be left for food and other things. I asked him to purchase a tent anyway. So my brother bought a tent and we set it up and crept inside, out of the rain.

All the people were going to buy tents. It wasn't that the organizers had done nothing. They had gone to a lot of trouble for all of us. But the Greek organizations were unable to feed 8,000 people even for a single day, much less give them tents, clothes, and blankets. I was thirsty, and my husband stood in the queue for three hours to get water. When it was his turn, they said nothing was left and he should leave. We couldn't even get water.

Each day began and ended in tears. The borders were still blocked. We were glad to be able to sleep in a tent, but in the morning we were soaking wet when we woke up. There were terrible storms. We were in the tent night and day, freezing,

without clothes, without water, without food. Finally, the young Syrians began to demonstrate. "We have already been here five days. Why is no one answering our questions? Why are the borders still closed? We ask you, border guards, how can you hold these people, women and children, at the border with such heavy rain?" The young people demonstrated. And suddenly my husband said that I should get up. The people moved on. I hurried and fetched my child and we went to the train tracks. Chaos broke out. The border police used tear gas against the people. They were beating the young people, and the women and children crouched on the ground. You couldn't see anything. Everyone was crying.

A Greek policeman was standing there watching. He just stood there and looked at the crowd. I watched him. I was overcome with tears. I thought how relentless they were. Were we not humans to them? We hadn't gone there to start a war. We were there to be rescued. We hadn't gone there so that they could use tear gas against young people. But the policeman just looked arrogantly at me. I cried and cried.

In the evening I decided that I would wait for another night. I'm really not a weak or easily frightened woman, but when life comes to an end, I say you have to end life. In the night when everyone was asleep and the cold came, I thought that I would kill myself in the morning before anyone woke up. I would wait for the train that traveled through here and throw myself in front of it with my child so that I might set an example, not only there, but in Austria, Croatia, and Germany. Life had become unbearable. As I was thinking these thoughts, I looked at my phone and saw that I had received a text message in a foreign language. It was someone from the television station.

This message came at the same moment that I had decided to end my life. I asked these people for help. I told them that we'd been there for days without water, food, and clothing. They were so friendly, warmhearted, and caring. They brought me medicine and clothes. We were finally able to take a shower after not washing for days. They gave us something to eat. I hadn't eaten for quite some time. Every day there were women and children crying over the filth because there were no toilets and no washing facilities. It all makes me tremble.

Every day I had to watch how these innocent children were exposed to the rain and how those innocent women were covered with mud. The men could do nothing; their dignity was taken away. Everyone there had become so sick. There wasn't a single healthy person among us.

This morning I'm with my dear friends. They helped me a lot. After such a long time I was able to wash myself and my child. I'm so grateful to them, but when this interview is complete, I'll have to return to this tent and this nightmare. Only God knows when the borders will be opened and if they'll grant us admission, because we don't have our Iraqi identity cards. I hope the day will come when at last I arrive somewhere in the world.

019

Peter Bouckaert, Human Rights Watch
Idomeni, Greece, 2016-03-09

PB I'm Peter Bouckaert. I'm the emergencies director for Human Rights Watch. The situation in the Idomeni camp is getting very bad because the borders are all closed now. The Macedonian border was closed first and then the Slovenian, Croatian, and Serbian borders were closed. There's no way for these people to advance toward Germany. They're trapped here now.

There are about 13,000 people in this camp and most are from Syria, Iraq, and Afghanistan. They're fleeing from war. I talked to people who just fled from the bombs a few weeks ago; they're trapped, and it's been raining since Monday. Everybody is completely wet. They have no way to dry their clothes; it sometimes takes two hours just to get a little bit of food, one cup of soup. It really is a desperate situation, and this is happening in Europe. I mean, this is Greece, not some third-world country. And this is a policy crisis, it's not a naturally made crisis. It exists because of the policies of the European Union.

AW Now they're making this agreement between Turkey and Greece. What kind of tensions will this create? Do you think the border will be completely closed? Do you think that is a violation of human rights?

PB This border, the Balkan Route, is now closed to refugees. It's not possible for them to continue, but they don't want to go back to Turkey because they want their children to have an education. Turkey is also not a safe country for them because it has actually pushed Syrian refugees back into Syria. They just closed the main opposition newspaper a few days ago. Why does Europe want people to go back to a country where their children can't go to school and where they face the prospect of being returned to Syria? There's a lot of desperation here.

AW Is there any hope? What will the solution be?

PB These people are fleeing from the most brutal wars in the world, the conflicts in Syria, Iraq, and Afghanistan. We have to take a collective responsibility toward them. We can't just insist that Greece take all the refugees.

Europe is a very wealthy region, and even if these people continue to come at the same rate that they're coming now, only one out of 250 people in Europe would be a refugee, compared to Lebanon, where one out of four people, 25 percent of the population, are refugees. Europe talks about a refugee crisis in Europe, but the real crisis in Europe is a lack of empathy toward these people. The real refugee crisis is in Lebanon, Jordan, and Turkey, where there are more than four million people living under much more difficult conditions.

020

Thomas Conin, Filmmaker
Calais, France, 2016-03-09

TC My name is Thomas. I'm with a collective of French filmmakers that has been working in the Jungle for a couple of months now. We've tried to maintain media pressure on this subject. The last two weeks have been pretty ambiguous. As you can see around us, they've been having a ball taking the whole thing down. It's quite a weird feeling.

AW How many people are going to England?

TC Well, if they succeed in getting to England, I don't see them anymore. But in the time I've been here, I've known some who got there. Sometimes when you eat in a restaurant, somebody gets a phone call from somebody who got across and there's a big explosion of joy in the whole restaurant. Those scenes stick with you. I can really only imagine what it must be like for somebody to arrive in England after so much time. I imagine a morning in a parking lot somewhere where a man exits a container and has finally reached his goal. It's imaginary for me, but I like that idea. Most of them have spent between four and nine months here, so getting there must be very exciting.

AW What will happen to the people who won't be able to stay in France? Do you think they're going to go back?

TC What's happening here is the same thing that has been happening with previous "jungles." Obviously, this is one of the biggest camps in Europe so far. But the same thing will happen as in all the previous times, which is that they'll move elsewhere. The smaller "jungles" around Calais and the northern part are already filling up, because a viable alternative hasn't been provided. We knew there wouldn't be, so the problem will just shift elsewhere, as it has before.

AW Do you have a word or an idea or a symbol to describe this place?

TC It's weird because a symbol is hard to find. Perhaps you could imagine, on the street where you were born, that there was a bar you didn't really like. You never went there, and one day it burned down. That's how I feel about this now. So you might know some people who liked that bar or maybe loved spending time there. You saw it many times, even if you didn't like it. It's a far-fetched comparison, but even if the conditions here are inhuman, it's still better than nothing, and it still represents a transit city for exiles.

AW Is there some example of migration in your own family? Why are you touched by this subject?

TC I live that question every day. I still don't know. I knew about the project, and I obviously supported it, but there hasn't been a day where I haven't wondered why I'm here. Obviously, I'm doing a job here; I'm not here because of 100 percent goodness toward humanity. I've tried to have relationships with the people here as I would anywhere else. That was my best solution.

AW Do you often dream about the Jungle?

TC Yes. I've had many dreams about this place. When you first arrive, you spend every day here, and you start dreaming about it. The last dream I remember is that I was teaching cosmology in the school here. I've never taught lessons here, but I was teaching, because it was right after gravitational waves had been discovered, and I was explaining this to an entire class of Sudanese people. I don't know if they understood. I don't think so. It was a nice dream though. I went to the school the day after to try and relive it, and it was a nice feeling.

AW Do you think this human flow coming in can be seen as a kind of wave of gravitational pull?

TC It sort of is, yeah. Geographically, it could obviously be a kind of bottleneck to England, so maybe you could see that it all crumbles down and amasses here. There are geological reasons why this camp is here and not elsewhere. You can compare it to gravitation, sure. And migration is often referred to as waves. I can relate to that. England has taken on mythical proportions in the minds of many people here. It's sensitive when you try to ask about this, because obviously it isn't paradise. And the longer they get stuck here and the more fences that are built around them only seem to confirm this myth of England, which you can actually see from here on a nice day.

I don't know if it's useful to try and put this dream in a more realistic perspective. It depends. I always try to bring in a bit of nuance where I can. Nobody's waiting with open arms over there. I've heard people say that the hardest part of their journey was arriving in England. I guess when you have a dream that you build up for months, and you've been traveling so far, when you finally get there, it doesn't seem easy at all. Reaching a dream or the dream itself is perhaps the hardest part. On the other hand, these people have been disillusioned before. Maybe they can handle it better than I.

AW I have a last question. Thomas, you've been working here for a while now, and I wanted to ask if you now have another definition for a border.

TC Obviously there are natural borders. There's a particular group of militants who are very active here called "No Borders." I've had many philosophical discussions about this subject. Personally, I think it's a total utopia to try and get rid of them. I don't think it's the borders themselves that hurt people; rather, it's the systems behind, within, or around them. Those systems are a lot more real than any border. I like the idea that a map of a country can sometimes be more real than the land itself. What I strongly disagree with is the idea that we should get rid of governments and borders. It's like saying that money is basically not real. Obviously it's not, but its consequences are. So I think you have no choice but to play ball with borders and governments. I don't see the point in anarchy or utopia in that sense. I'm Belgian; I'm always looking for compromise.

AW Thank you very much.

TC This was a bit like a therapy session.

021

Christian Salomé, L'Auberge des Migrants
Calais, France, 2016-03-10

cs I'm Christian Salomé. I'm retired and seventy-seven years old. That's about it for the interesting part. L'Auberge des Migrants has been functioning for eight years now. For seven years the association had around a hundred people with about thirty to fifty volunteers who were mostly distributing food to migrants, collecting clothes, and helping them to obtain their papers and stay in France. But the most important aspect was humanity. Last September, British associations called us after the death of the small boy in Turkey, Aylan Kurdi. At that time only four of us knew enough English to answer the phone.

Today our association welcomes 200 to 300 people every day in the warehouse from almost all the countries in the world. This is really great. We give out approximately 5,000 meals every day and collect and give out clothes for 5,000 people as well. Since last year, about 12,000 volunteers have worked in this warehouse.

aw Can you tell us more about the dismantling of the Jungle?

cs What you need to understand is that the dismantling is linked to the upcoming elections. Its main aim is to not take in the refugees. That being said, among the 10,000 people in the camp, about half of them accept or can be convinced to stay in France and seek asylum. For these 5,000 people, offering them to stay in France is a good thing. The remaining 4,000 to 5,000 people face another problem. They have valid reasons to go to the UK. Of course, they are fleeing war, but they also have a spouse, children, or a brother or sister in the UK who already lives there and is telling them, "I'm waiting for you"; "I have room for you, I'll help you integrate"; "You'll get your diplomas again here and have a normal life in the UK." These people don't want to stay in France. These shelters are dreadful since it's a shanty town. But nothing else is being offered once the shelters are broken. And that's a problem. We've heard that the government has created CAOs.

aw Do you know how these will be organized?

cs CAOs are holiday centers that are closed in autumn that the state has rented until December 21. They often open for the Christmas and New Year period. An association is in charge of providing meals and some supervision for each center, and as compensation these associations receive twenty-five euros per person per day, so they should recover their costs. It's not enough to make a profit, and it's not quite enough for hiring experienced people who are skilled in receiving foreigners, especially war refugees, who are often traumatized upon arrival. The type of help they need can only be supplied by external voluntary associations.

All of these details have to be organized. There isn't a list of the centers yet, but there should be soon. When people arrive, a diagnosis is made in order to detect sick people, fragile people, old people, unaccompanied minors, families, and

other people who need important psychological support. All of this should be planned soon.

Although everything is being kept secret for the moment, the current plan is that during the next five days, 2,000 people will be transferred by bus each day to the different reception centers in France. They would like us to believe that every person will be interviewed before departure to discuss their situation, where they want to go, and whether the reception center is the most appropriate solution. Minors, especially unaccompanied ones, should be taken in. Families should be placed together in centers adapted to families. They want us to believe that they'll sort out 2,000 people per day before sending them to the reception centers. It might be achieved.

We offered the help of volunteers in this matter. I have a list of a hundred volunteers ready to help. I sent this list to the prefecture and I'm waiting for the answer. Now, how it's really going to happen, unfortunately, might consist of gathering 2,000 people on the side, taking bunches of fifty and putting them in forty buses, and that's it: "Our work is done. Two thousand people have been placed. We'll sort them out and redirect them if they're at the wrong place." Well, it could be the best-case scenario, but it could be the worst. For the first time we're witnessing the dismantling of a town that has 10,000 inhabitants. They're going to be evacuated in five days and spread throughout France. This has never happened before. We don't have the experience to predict what's really going to happen.

AW In your personal opinion, do you think another Jungle will appear? Do you think people will really leave?

CS I think at least half of the people will accept transfer to the centers. They'll make the effort to integrate, learn French, find jobs, and so on. I think it'll put an end to half of the exodus. As far as the other people are concerned, some will leave the night before, hide somewhere until the situation gets calmer, and come back one or two weeks later. And you'll probably find these people in public parks, under bridges, and along the highway. We've already prepared 500 to 1,000 tents, sleeping bags, and covers for those who'll come back, when there won't be any official reception left. Unfortunately, at that point, instead of reception there will be some kind of manhunt. It's going to be quite difficult for these people.

AW You're talking about the migrants who want to go to the UK, right?

CS Yes. Some people have very valid reasons to go to the UK, for example, people who have relatives who already live there. The day before yesterday I talked with a woman who's here with her two children who are three and six. Her husband is imprisoned in Libya, and her only family is a sister in the UK. She really wants to join her sister, so it's no use transferring her to a reception center somewhere else in France; she'll come back here and continue to try to go to the UK. But instead of having a bed to sleep in and a warm place for the night, she'll have to stay in a tent.

AW We heard there was an accident near the Jungle yesterday. Could you tell us about it and whether accidents are common?

CS In fact, fourteen people have died since the beginning of the year. Yesterday a couple was crossing the highway and they weren't used to highways. They believed they were visible to oncoming traffic, but they weren't, and they were struck. In these cases, the driver isn't to blame—it's impossible to see people on the highway. The man died this morning at 10:00 at the hospital. This happens quite often. Fourteen people within nine months have died this way. Most of the time it's people trying to hide in the trucks along the highway. When you can't pay the smugglers, it's the best way to pass through for free, but this kind of crossing is very dangerous. At night, someone driving at 100 or 130 km/hour doesn't have the time to stop if they see someone in front of them.

AW Do you know about people entering the tunnel?

CS There are very few people who enter the tunnel. If a person is detected inside the tunnel or near the railways, Eurotunnel stops all the train traffic. Like the SNCF [Société nationale des chemins de fer français, France's state-owned railway company], the rules are very strict. If there's a risk of an accident, they stop the trains. These are international railway rules that Eurotunnel follows, just like everyone else. Also, the tunnel is thirty-five kilometers long. It's not that easy to walk through a tunnel. Trains travel at 160 km/hour, meaning that between the train and the wall, the wind blows at 200 km/hour. There's nothing in the tunnel to cling to. There's almost no chance of making it alive to the other end. As far as I know, only one man succeeded in crossing since the tunnel opened twenty years ago.

AW Could you tell us about the wall that is being built?

CS For two years now Britain has been paying for barbed wire fences with presence sensors to prevent refugees from entering the Eurotunnel site. They've done the same thing around the harbor; it's very difficult to get in. Refugees created traffic jams or accidents on the bypass leading to the harbor when they tried to hide in the trucks stuck in traffic. To prevent that, the authorities started putting in double, four-meter-tall fences topped with barbed wire. And, because you can overcome a fence with a wire cutter, the current idea is to build a four-meter-high concrete wall topped with two rows of barbed wire and razor blades on both sides of the bypass for one kilometer. They're not building the wall in a strategic place since it's surrounded by fields. It will only push the attempts a kilometer away, which will make things more problematic, because it's surrounded by residential and industrial areas, and then it drives people to do the same thing on the highway.

The state has started installing lighting again in the western part of Calais. Right now, refugees block the roads on the eastern side of Calais. But it takes eighteen months to start the lighting again. The situation is going to get worse, and maybe very soon there will be an accident in which a European, not a refugee, will die. When it's a refugee, we write five lines on a newspaper's tenth page and no one talks about it, but the day it's a truck driver or a European who dies, it will become a national or international tragedy. And now, due to the blocking of less dangerous spots, we're actually making the process more dangerous.

We've heard that the state and the mayor of Calais disagree about the wall. First, the mayor of Calais wanted this wall. Now she thinks it's useless, given the fact that it's going to ruin the landscape. She's absolutely right about that. On the other hand, the state is well aware that even if it destroys the shanty town and transfers the Calais refugees throughout France, many refugees will come back within a few days or weeks. So the state continues to light highways and to implement this wall. It will probably also build other walls along the highways and find other means to try to prevent accidents.

AW Are you from Calais yourself?

CS No, I live twenty kilometers away from Calais, which is important on a psychological level. When I leave Calais, I leave the problems behind.

AW What do the local inhabitants think of this situation?

CS There are several aspects. The first aspect is that, like many cities with homeless people, 98 or 99 percent of people don't show interest anymore because they got used to it. Refugees have been in Calais for more than twenty years. One percent of the people want to help them, but the remaining percentage of people have real problems with them, such as those who have car accidents. Some locals say, "Tourists don't come anymore because of refugees," which isn't that obvious at all. Some blame their personal problems on the refugees. If you sum up all those opinions, there's mostly indifference.

This is an unusual time. We're about to have presidential elections in nine months. The candidates can't promise the end of unemployment or a raise in salaries. Since they don't know what to say, they say, "I'll reject all war refugees because they cost money." This breaks my heart. We used to be a welcoming country until a few decades ago. Now we're in a time of elections that are based on the rejection of others. It's appalling. But it's political.

AW How many refugees are in the camp?

CS According to the last census about a month ago, there are more than 10,000 people. One-third of the refugees come from Afghanistan, one-third from Sudan, and the rest of the people are from Pakistan, Eritrea, Ethiopia, Iraq, and Syria. Ninety-seven percent of them come from a country at war. So basically, we can consider them all as war refugees, although they'll technically only be refugees once they obtain refugee status.

AW What is the legal status of people in the camp?

CS That's complicated. We don't have any precise census of their administrative situations. Some of them have Italian papers but can't work in Italy and are hoping to find work in the UK. Some of them are currently applying for asylum. Some have asked to go back to their own country and are waiting for the procedures to start. Some would like to request asylum, but the next appointments are in December. There's no precise information on that subject. It's too complicated, and it's always changing.

AW Why do the refugees come to Calais?

CS People come directly to Calais because geographically it's a door to the UK. Those people are fleeing war. Often their houses were bombed and they left with only the clothes they were wearing. They follow the group that speaks their language. If one person in that group has family in the UK, that person draws the whole group with him. And if the others like that person, they want to go to the UK as well. So there's a domino effect . . . and why not? We follow the group; that's the way it is.

Also, there's the fact that English is the international language. Many people have a very high educational level. They are doctors, engineers, and such. They'll have to obtain their diplomas again in the receiving country, which would be easier to do in English than in French. That's a big reason why people come to Calais. Then there's another phenomenon: in order to decrease the number of people in the shanty town, the state offered those willing to stay in France conditions that are a little better. About 2,000 to 3,000 people come to Calais with the aim of requesting asylum, not of going to the UK.

What about the minors? At the last census, there were more than 1,000 people under eighteen on the site. Among these 1,000, about 200 were with their parent or with one of two parents, and 800 were what we call unaccompanied minors, meaning nobody from their family is with them. Last week we learned that the youngest unaccompanied minor was only eight years old. Often these young people were sent by their families. When the country is at war and they have the means to save one person, they save a child. That's why we find many unaccompanied children here. Sometimes children travel with an accompanying adult that they refer to as "my uncle." If they get arrested along the road, the police keep the adult and let the minor go, otherwise the minor would have to be entrusted to child welfare. Most children will leave because they want to go to the UK and join their family. We can assume there are 200 to 300 minors who have family members in the UK with whom they share a viable genetic connection.

Family reunification is possible for them. And we hope that in the framework of this dismantling, the UK will accept at least those minors. Yet it causes many problems. A fifteen- or sixteen-year-old teenager who's traveled thousands of kilometers to get here isn't a child anymore. So placing him in a specialized institution as requested by the law is a good thing, but is it really appropriate? They should be in structures of reintegration, to try to remove the suffering of their departure and the trip. These children have been disturbed by the wars.

AW Could you tell us about the containers?

CS The state bought the containers through a call for bids. I think they cost twenty-two million euros. The association La Vie Active won the bid and implemented that plan. It was a lot of work, especially cleaning the site, because it was a swamp. The containers were bought in China, fitted out in Rennes, brought here, and opened less than a year ago. They are dormitory containers. Each container has twelve beds and twelve small cupboards. It meets the needs of an asylum seeker quite well. He's alone, he's got a backpack, he can put his stuff in the

cupboard, and he stays here a few days or weeks while he's applying for asylum. Then he'll leave for Paris or elsewhere. So it absolutely meets these temporary needs. It's not adapted to families because there's no privacy. It's quite complicated for families. For protection purposes, women and children are separated from men. It's also not adapted to couples. But still, it's progress.

AW You've been here for six years. How did the Jungle evolve throughout the years?

CS The number of refugees in Calais depends directly on wars in the world. Whenever there is a big conflict—I'm thinking in particular of the wars in the Balkans, Bosnia, Iraq, Afghanistan, or now in Syria and Sudan—the number of refugees in Calais starts to increase again. Then, as the wars are winding down, the number of refugees decreases—before increasing again. Until very recently there was absolutely nothing set up to receive refugees in Calais. People were sleeping in tents provided by associations in sand dunes, industrial areas, and disused factories. Eighteen months ago the Calais municipality offered an empty lot that was developed by the state afterward. A shanty town has emerged here. Although it's awful and totally unacceptable, it's still better than before. And the destruction of this shanty town might bring us back to a situation where people sometimes only get a sleeping bag and a canvas sheet to sleep in the fields and the parks. That's our fear.

Makeshift Camp, Idomeni, Greece, 2016

022

Gilles de Boves, Unité SGP Police
Calais, France, 2016-03-10

GB My name is Gilles de Boves. I'm the union representative for the Unité SGP Police. I'm in charge of the French coastline from Berck to Dunkirk.

AW What's the legal role of the riot police?

GB The CRS [Compagnies Républicaines de Sécurité] has various roles: securing, policing, guarding, and fighting illegal immigration. It has the same role as public security. CRS's mission here is securing the camp dismantling and policing if necessary, for example, if people start throwing rocks or invading the ring road. Those are our missions for the time being.

AW Do your missions also include protecting the people?

GB There's an example that you might have witnessed recently. You can see behind me that there was a fire in a tent. A gas cylinder exploded nearby or inside the tent. The CRS's mission is to secure the perimeter and to discourage migrants from coming too close to the tents.

Calais is quite a unique situation in France. There are eleven CRS squads here and seven squads of gendarmes in Calais. This mission is almost considered a punishment because it's very difficult and has a special schedule. Policemen are present twenty-four hours a day, divided into three shifts of eight hours. They have little sleep. When they wake up, they don't know the time of day because they just sleep whenever they can. Their hotel is more than an hour away because there isn't an available one closer. The conditions are difficult.

All policemen know their job has consequences on their social life. Recently there were terrorist attacks. Not even a policeman is prepared to find multiple dead bodies in a restaurant or on the street. The issue with such a place is that it creates legal and security problems.

AW But it's also a question of human rights.

GB I totally agree. My answer is simple. During the day you're securing the area by patrolling the Jungle, and then in the evening you have rocks thrown at you. The CRS had more than 150 wounded. They agree with the humanitarian aspect, but in the context of this mission, they also want to protect themselves, even if they realize the situation is difficult for migrants. The policemen who were wounded felt like they'd been sucker-punched.

There's no anger among my colleagues who work in the Jungle. It becomes difficult when there's an assault or an arrest. I was there during the first days of the dismantling, and I can assure you that it went very slowly. Then, one tent was set ablaze. The pressure rose and then rocks were thrown—before tear gas was used. In the context of their mission, the CRS have to ignore their feelings. They know that anything can happen at any time, so they're very careful.

AW Can you tell us about the relationship between France and England? It seems that no one wants to take responsibility for this situation.

GB The UK has a share in this. The Touquet Agreement [of 2003 between France and the UK on frontier controls at seaports on the Channel and North Sea] shielded England. There's an important financial aspect as the UK financed scanners in the port. They also financed fences and walls to prevent migrants from crossing. On the legal side, they passed laws, setting a fine of 2,000 euros per migrant found in a truck. For us, it's totally hypocritical. Here's a simple example: When a migrant manages to cross controls and arrives on British territory, the truck driver that transported him is fined 2,000 euros. But the migrant who is on British soil, even though the border is in France, can't seek asylum in the UK and is brought back to France. It's the same for illegal work. The migrants here know very well that if they go to the UK, they can get documents and find a job. But even if they don't get documents, illegal work is a part of the British economy. Despite what the British government says, they can't stop it, because it's a part of their economy. Illegal work represents a large financial influx. This shows the hypocrisy and the ambiguity.

AW Do you think this place is a bit like a jammed funnel? How would you define this place?

GB For me, this place is a dead end where policemen are supposed to fulfill expectations from the French government, but also from the British, which is to make the border impassable and forbid migrants to cross. Most in the CRS perform it as best as they can, but they need to be given the means to perform it. We had twenty policemen as reinforcement in Calais. We're requesting fifty border policemen. In 2010, there were 800 migrants here and 427 policemen. In 2015, we had 6,000 migrants and 431 policemen—four more policemen for several times the number of migrants. That's why the unions are giving out a warning here, because there is no real support, and police forces are stretched thin.

AW When you hear Macron saying that they'll open the door if the UK leaves Europe and the UK answers with promises to invest twenty million more in security, what do you think?

GB In our humble opinion, we have the feeling that the British are buying their own security. But I can't comment on the minister's declaration because I'm not into politics. What I know is that migrants don't leave because they're waiting to see what will come out of Brexit. Will the border be pushed farther away? Will they be able to cross? Or will they stay where they are? These economic and financial considerations are prioritized way above the humanitarian issue.

AW When we talk with migrants, we have the feeling they're lost. They don't really know what they want because they're exhausted.

GB Smugglers are already in place in the migrants' countries. Their first goal is to push the people to leave, to bring them into Europe, and then tout the UK to them. They're marketing in human misery. Once they're here, they're only thirty kilometers from the UK, where they're given documents and allowed to work.

They already have family there. So they tell themselves that they just have to cross thirty kilometers. You can see the English coast. They've already gone thousands of kilometers, risking their lives. Some may feel lost because they tell themselves, "I arrived here, but it's a dead end. I wasn't told about that, but they took my money. Now I don't have any money, and I'm stuck here."

AW What's your definition of the border?

GB Which one?

AW The one between France and England.

GB It's an economic border.

AW The Schengen area still exists.

GB Yes, but you can witness its limitations. You also realize that "Europe" is just a name. Let me tell you a story: I spent a night with a camera team from the Netherlands. I was strolling around with a journalist when a migrant approached us to ask us about the story that was being filmed. The journalist told him he was working for Netherlands TV. The migrant asked him, "How is it in the Netherlands?" So, I tell this poor guy, "I'll answer you as a true European. The Netherlands is great." That's how it goes. Each European country passes the buck. Migrants pass through Italy. Even if they're brought back to Italy, according to the Dublin agreements, they come back by the coastline. It's the same in Greece. Europe is just a name. Each country has its own immigration policy.

AW Does it affect you personally?

GB This situation started in 2000. The immigration issue has existed here for sixteen or seventeen years. People are very hospitable here. The problem is that we let things happen and let too many people in. There was no control, no explanation. We just blocked and accumulated migrants in Calais. Personally, I'm tired of the situation we've been managing for two years. As a union representative, there's a lot of administrative work, a lot of support to give to the police personnel. I'm not in my colleagues' shoes. It's even harder for them. They live that situation every day.

CRS comes here for two weeks and then we leave and come back again two months later. But the personnel living here experience these issues every day. It's exhausting for them, even though they're told that they were given the resources. But that's the least you should expect. Every entrepreneur should give his employees the appropriate resources to fulfill their tasks. A lot of associations are campaigning here. They always try to put the CRS at odds, because they're the first visible representatives of the state. When someone wants to put pressure on the state, the police are the first target, which is sad, because they do their job very courageously.

AW It looks like a vicious circle. As representatives of the state, they're considered the bad guys.

GB Besides the problem of the Jungle, migrants aren't the only ones who give us difficulties. When there's a demonstration in support of migrants, we're fascists. When it's a far-right demonstration, we're collaborators. We're being used, and we're on the front line, but it's our job. We know that we're the scapegoats. During our first demonstration in October 2014, we blocked the roundabout to alert public opinion and make people understand one another's position in Calais. We made signs saying "Calaisian victim," "Worker victim," "Policeman victim," and "Migrant victim." Everyone was a victim of the European inertia that brought no solution and led us to the actual situation.

I'd like to tell migrants, "Think thoroughly about your future. Don't let yourselves be manipulated by activists or smugglers. Think on your own and think about what you want to do." But they can't think about that here in such conditions, when they're cold, hungry, and mired in the mud. It's just not possible. I try to slip into their shoes, and if I lived in a tent, under the rain, in the cold, always hungry, I wouldn't be in a good position to think about my future.

AW This phenomenon gets bigger and bigger, and we talked with volunteers who told us that it was like an experimental lab here, where you see what could become of Europe. Because there'll be more migrants coming from the Middle East. If by a miracle the actual crisis were solved, a much larger wave of climate migrants will follow.

GB If all migrants want to go to the UK, climate refugees would add an influx of many millions to the UK. That's not possible. Saying that this is a lab, what lab? We're not lab rats. I find the image shocking. Let me go back to the idea of prevention in the country of origin. Smugglers must be eradicated. If refugees have a real desire to reach Europe, okay, but they need to agree to be identified by giving their fingerprints and name. We have rules. You have an ID card. I do too. That's a part of personal integrity and the ability to think about one's future. For example, some migrants refuse to go to the reception center because they have to give fingerprints. But we need to identify these people. They can't come to France or elsewhere without being identified. That's important for them and for us. We need to get the message out to them that in France you need a passport; you have to go through all this to become a European citizen.

AW Are you optimistic about the future?

GB For Calais? Truthfully, I've been speaking with an open heart from the beginning. I think there are solutions for the human part. You have to eliminate the economic and financial part that defiles the humanitarian side, which is the most important. There are financial issues, and you have to be careful. Some countries need the workforce and need refugees. Others have high unemployment and want to give priority to their own citizens. You can't prevent people from moving. You can pour all the money you want into Turkey or elsewhere, but if people want to cross, they will.

023

Amina Khalil, *Refugee*
Idomeni, Greece, 2016-03-10

AK I'm Amina and I come from Syria. I'm a Kurdish girl and am twenty years old.

AW How long have you been here and what's your experience?

AK I've been here for twenty days. It's so bad; these are maybe the worst days of my life. It's such a difficult situation, and I hope it will pass.

AW What do you think of humanity here?

AK I actually, absolutely believe there is humanity, but I can't see it here at the moment. I can't see any humanity, but I have a big hope that I'll see it soon with these borders opening.

AW Borders opening?

AK Yes.

AW Do you know that they just closed the border?

AK I know, but I have hope that they'll open the borders after their next meeting.

AW If you had a chance to talk to the politicians, the ones who decide to close or open the borders, or talk to the world, what would you say?

AK I would say: Open the borders, because these lives are in your hands. Open them for the babies and the children and all the people who are here. It's a crime not to.

AW Thank you. I hope you have a good future. What do you want to do in your future?

AK Actually, I'm no different than other girls. I want to complete my studies and have a simple life, just like everyone.

AW Thank you so much.

AK You're welcome.

024

Emran Kohesta, Refugee
Idomeni, Greece, 2016-03-11

EK Hi, my name is Emran, and I come from Afghanistan. It's dangerous for me there because of the war.

AW Who are your friends?

EK My cousin's name is Emran too, and my other friend's name is Zabi, Zabiullah. I'm eleven years old.

AW Can you tell me about your life in Afghanistan? How was it and do you miss Afghanistan?

EK It's very dangerous. I can't study in Afghanistan because of the war. For forty years, there has been war in Afghanistan, but people say, "No, in Afghanistan, it's not war." But the war is real war. Why don't they open the borders?

AW How long have you been here?

EK We've been here for eighteen days and in all of Greece for one month.

AW Why do you still stay here?

EK I've asked everybody why we can't leave here, and they say, "I don't know, I don't know."

AW Nobody tells you?

EK No.

AW And do you know why they closed the border?

EK No, I don't know.

AW Do you want to ask? You can ask.

EK Why did they close the borders? Why can't we go from here?

AW Why can't you escape from the war? It's your right.

EK Yes, it's war in Afghanistan. I came here because of that. If there was no war, I wouldn't have come, ever.

AW What do you think of this camp and the situation here?

EK It's very bad and very cold for everybody. Everything is for Syrians, Iraqis. It's very bad for Afghanis, and for everybody.

AW So many children here can't go to school. They're suffering here. I see your cousin is coughing, and you know many people get sick.

EK Yes, everybody is sick here; it's very chilly. It's very dangerous for everybody; children are sick.

AW Where are your dad and mum?

EK My dad and mum are in Afghanistan. I'm with my aunt. They're in Afghanistan because they don't have money to come here. I tell them, "Come. Come with me," but they say, "We don't have the money."

AW Do you miss them?

EK I miss them.

AW You're such a small, smart boy. You must be a very good student in school.

EK Thank you. I'm at the top of my class.

AW How about the other students? Are they still living there?

EK Yeah, I think about 500 students are still in my school in Afghanistan.

AW And do you think about when you'll see your mum and dad again?

EK I don't know when I'll see them. I want to go to Germany and get a passport, and I want them to come with me.

AW Your parents must think about you all the time.

EK I speak with them, but they say, "No, we can't come." Every time I say, "Come, come from Afghanistan," but they say, "We can't, because we don't have money."

AW How much money is needed?

EK I don't know. I think $40 . . . $20 . . . $20,000 for them.

AW So expensive?

EK Yes, it's very expensive for them.

AW And to come here to this kind of condition.

EK I tell them, "If Afghanistan is good now, or if the future is good, I'll go back to Afghanistan," because I love it. I want to become an engineer in the future. I want to help my country.

AW You're a very good boy; thank you. Do you have something you want to tell the world?

EK Yes. Why are the borders closed? Why? One month ago, everybody could cross, but why not now? They want money, Macedonia wants money, yeah, I know, Macedonia or Syria or Turkey—every country wants money to open their borders.

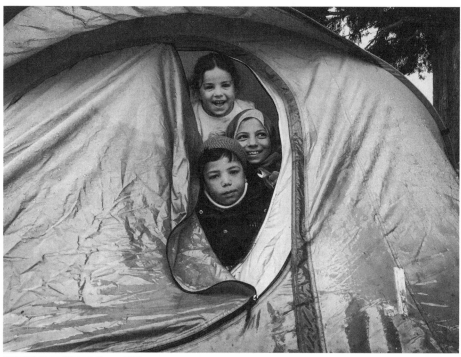

Makeshift Camp, Idomeni, Greece, 2016

025

Bahareh, *Refugee*
Gevgelija Camp, Macedonia, 2016-03-15

I'm Bahareh and I'm thirty-four years old. I left Iran in the year 1388 [by the Solar Hirji calendar, or 2009 by the Gregorian calendar]. I was a law student at university, in my fourth semester. In 1388, I participated in riots in Iran and the government was after me. They even put us in prison. It was difficult for my kid. I was dismissed from my job and expelled and banned from university. My life became so hard. I couldn't live in Iran any longer.

During those years after the events in Iran, I was under police surveillance. I couldn't go to a party or participate in events. I let some of the young people who were demonstrating with us inside my house. Because of this, my house was under surveillance. We rescued people at night and brought them into our house.

I decided to leave Iran. We got ourselves to Turkey with a lot of difficulty. From Turkey we came by boat (everyone knows about this system) and safely reached Greece. We did all of this with the help of smugglers. The smugglers received 4,000 euros from us and my cousin Ali for two cousins, my son, and myself. Ali was a journalist with political problems. His family was also persecuted by police because of his political activities and the news he wrote in the newspaper.

We've been in Greece for fifteen days now. They took us through forests four or five times, and each time it took sixteen to seventeen hours. We slept two to three days inside the forest so that we could pass the border and get to Macedonia. The police would take us and send us back to the Greek camp.

During the last night, we encountered a big problem. We were supposed to cross a big river through muddy lands because it had been raining for three nights and the weather was bad. The river was shallow, but because of that downpour, the water was high. There were about twenty-eight or thirty people, though I'm not quite sure. Six or seven of them were Afghans and twenty or twenty-three were Iranian.

When we were crossing the river, there was a pregnant woman with two kids. She fell down in the river in front of my eyes and the current took her. Then, while my son and I were crossing the river, the water was about to take him. Despite everything, I managed to throw him onto the riverbank, and some people took his hands and rescued him.

I was carried away for about 100 to 200 meters and didn't have any hope left to live. I saw death in front of my eyes. Above all of these things, my mum was stuck in the middle of the river, and I didn't know what to do. When I got out of the water, I saw my kid near the river. My family, my uncle, and his wife and two kids—everybody was there except my mother and my sister-in-law, who were stuck in the middle of the river. We took them out of the river with great difficulty and the help of others. Everybody was injured.

These injuries aren't important. The only thing that tortures me is seeing those people, the pregnant woman with two kids, dying in front of my eyes. It's always on my mind. I ask God, "Why didn't you give me the power to save them? I beg you to open the borders and give shelter to these helpless people." If it wasn't for their problems, they would've never left their countries.

In Iran, we were sentenced to death because my father changed his religion to Christianity. We're apostates. Please, help these refugees. I get panic attacks every time I see the death of those kids. I struggled for the life of my kid so he could stay alive. I'm so sad that God didn't give me the power to save the other three people, because they were in front of my eyes and I couldn't do anything for them.

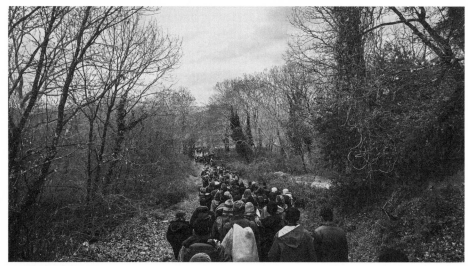

Near Idomeni, Greece, 2016

026

Vaise, Refugee
Idomeni, Greece, 2016-03-18

v We're refugees from Syria. We're here because the Syrian situation is so difficult
because of Russian air strikes and bombardments.

We fled from our country because we want peace and safety for our families and
our children. The situation there is very dangerous under the dictatorship. We're
from the liberated area in Syria under the control of the Free Syrian Army. But as
I said, we were in danger every day and lived underground.

There's no electricity in the liberated areas, no water, no telephone lines, no
heating, no petrol, and Russian aviation is targeting so many civilians. Because of
this we fled our country. We wish to go back to our country after the war stops.

Now we wait for the Europeans' decisions to reopen the border and hope that we
can pass Macedonia and Serbia and go to Germany, or other countries near
Germany: Holland, Belgium, or France.

AW Thank you. What's your name?

v Dr. Vaise.

AW Are you a doctor?

v Yes. I'm from Syria, but I graduated in Croatia. I lived in Zagreb about nine years,
from 1983 to 1992. When I finished my studies there, I went back to Syria and
had my own private clinic. Before the revolution, we were in a good situation, but
we always opposed dictatorship.

AW And this is your family?

v This is another of my daughters.

AW Such a lucky dad.

v Thank you very much. We want peace and safety for all.

AW What type of doctor are you?

v I'm a family doctor, a medical doctor.

AW How old are you?

v I'm fifty-one. We wish peace and safety to all the world. We don't want war, but we
look for freedom, free opinion, and political freedom. This is a very important
thing. We want dignity and prosperity for all.

AW How long have you stayed here?

v About twenty-six days waiting for the decisions. Until now, nothing is new.

AW Are you registered in Greece?

v Yes. I have regular documents.

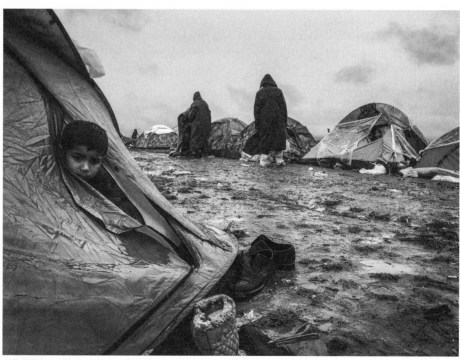

Makeshift Camp, Idomeni, Greece, 2016

027

The Abboud Family, *Refugees*
Idomeni, Greece, 2016-03-20 and 2016-04-01 / Sweden, 2016-05-22

Mother Esraa is so depressed because she didn't want to travel at all. She was forced.

Cousin None of us wanted to leave.

Mother Now if they tell me to go back to Syria, I'll go back for my son.

Cousin I know, I know.

Mother Do you think I can leave Damascus? I can't. I mean, you lived in it and you know. However, my son is more precious than the entire universe, and I lost one already, so I don't want to lose the other.

Cousin You don't have any news of him?

Mother Nothing at all. I feel guilty. I try not to speak of him or shed tears in front of Esraa. Her father agreed to travel for the sake of my son, but that isn't her fault. She was living a life—not the life of a king—but close to the life of a king.

Woman [in background] Where is Esraa?

Mother She and the foreigner are giving an English lesson in the black tent for the children.

Cousin What are you thinking of doing now?

Mother I don't know. Yesterday Esraa asked me the same question: "Mama, it's the fourth of this month and they didn't let us in; what do you want to do?" I told her I simply don't know. I told her that we're just like the others; whatever these people do, we'll do. The problem is that her father doesn't have a degree. He possesses nothing—no degree, no profession, nothing at all. And I'm the same. What can the baccalaureate mean right now? Here in the Western countries, it doesn't do a thing. Am I right?

Cousin Even if we went back to Athens.

Mother Exactly; this is what I'm saying.

Cousin If we stay in Greece, I'm assuming we won't find jobs here.

Mother What should we do? What's the solution? We don't know.

Cousin Don't feel sad or cry. Tomorrow it'll be easier, and life in the camp will be a memory.

Mother I'm not worried or concerned about myself. In a day or two, a year or two, I'll lay down my head. The future is for my daughter; what's she going to remember?

Cousin Don't cry, aunt. Our life is much better than yours. We still have our lives in front of us. Now we're going through a tough situation, but later it'll be better.

Mother I don't want her to experience tough times and harshness. Despite the war that you were born into, Esraa didn't experience it. I shielded her from it.

Cousin When there's a war in a country, everyone is harmed by it.

Mother Yes, but inside our house, there was no such thing; I didn't let her feel it.

Cousin But a day will come that she'll be harmed.

Mother I used to gather my relatives and their daughters together just to have parties for Esraa in the house, just to refresh her mood. Despite the fact that it was physically exhausting for me to prepare four parties instead of one, I was happy. Sometimes your uncle told me he couldn't sleep because we woke him up with our singing, but I told him to leave them alone. "Isn't my daughter happy now?" I asked him. "Then it's okay—leave them alone." Maybe I feel Esraa's heartbreak because I'm an only child and Esraa is an only child.

Cousin You're an only child?

Mother It's different when there's a sister.

Cousin It's different. She feels for her.

Mother Indeed.

Cousin We don't know what to do. My mother was crying all night because we want a solution, but even if you ask what the solution is, you won't find an answer.

Mother None.

Cousin And to live in a camp like the Zaatari camp . . .

Mother We can't, because of our nature. I'm not saying that I'm important. I don't even have a problem living here, but I want my daughter to be happy and comfortable, and I know that living in this camp will not comfort my daughter or make her happy. It's uncomfortable for both of us.

Man [in background] There's a Swiss guy inside who's taking the names of people in the tents.

Mother Why?

Man [in background] To make sure that we're not related to ISIS and are running away from the war to go to Switzerland.

Mother Switzerland?

Man [in background] Some people are registering for Switzerland.

Mother [to Esraa's cousin] Is Switzerland rich or poor or what?

Cousin Switzerland is good.

Mother It's far from my son. Even if there's a solution, it's not one that gives us any comfort.

Cousin If you go to Switzerland, you'll have a residency and a passport, which will enable you to travel to your son's place.

Mother My son was able to bring me to Lebanon. He made me apply for a tourist visa to go and see him for one week in Lebanon. But this isn't a solution; we're not like Europeans where the child goes off to live by himself once he is eighteen. My son is twenty years old, and to this day he says that he wants to hug me and sleep on my lap.

Cousin My mother says that even when our children are grown up, we see them like children.

Mother At least the European countries that supported the idea of coming here should help; they opened their doors and motivated us, so they should help the family members who left everything behind to come here. At least they should help reunite family members rather than sending each of us to different countries.

Cousin They won't leave anyone alone, such as those who have a husband, son, or father.

Mother But my son is twenty years old now, and he entered Sweden when he was seventeen years old.

Cousin You didn't see him for three years?

Mother I didn't see him for three and a half years, both him and his brother.

Cousin God will help you. Tomorrow we'll try to go to the hotel for a change, to refresh your mood. Will you go?

Mother If we get the chance, but it costs money. The price shouldn't be so high. I mean, we don't even know how long we'll stay. Frankly speaking, I don't want to be in need of anyone.

Cousin You're right.

Mother I can please my daughter at my expense but not at someone else's.

Cousin Even if one has a well of savings, when spring ends, you still don't know how long you'll be staying here.

Mother That's it, how long? For example, if you told me that we're going to be here for one month, then I'd live in luxury. I'd keep going out with my daughter and having fun. That wouldn't be a problem for me. I don't mind using my savings if I know that the time limit is one month. But we don't know.

Cousin That's what I was telling my mom yesterday, that if we knew that after two months we'd have an appointment, we could rent a house. We could even bear to live in the camp for two months, if we knew we had an appointment scheduled. At least we'd know that there's hope.

Mother Now we're living by the wind. Yesterday we were completely in the wind—a wind that takes us, and scatters us, and we're not even aware if we're standing or walking.

Cousin Our life is the same. Sometimes I ask myself why there are bad people who have an easy life when good people suffer.

Mother It's because God loves us. He always loves to hear our voice. We always say, "Oh Lord. Man was created very impatient." We want everything now and quickly. But nothing comes quickly. The Lord of mankind could've created the universe in one day, but he did it in seven days. And he's the Lord of mankind, who can create in one second by his will. I always say, "Oh Lord, who gave the palace of the Queen of Sheba to the prophet Solomon in a blink, may you soon ease the situation for us and send us relief." Nothing is far from his will.

Cousin We need patience. I sometimes say, is it possible that there's no good person among the people here, that God answers his prayers?

Mother I say, "Oh Lord, if we're undeserving of your care, please have mercy on our situation for the children's sake and for the sake of Tabboush, the cat that we carried with us, because it has no guilt. What's the fault of this animal sitting here? It just wants to play.

Cousin There's a story in the era of the prophet Muhammad that my brother always tells me. He was told that this nation is a bad nation, and that Muhammad could wipe it out in the blink of an eye. But Muhammad said, "No, maybe there is a good man among them," and then he said, "Maybe there is a good child among them."

Mother When he wanted to close the two mountains on the people of Yathrib, the prophet Muhammad refused that as well. Our situation will be relieved. God is generous. His name is "the Generous." Thank God. I told you, I'm annoyed because this isn't a condition or a life that we're used to. There are many people who are accustomed to this kind of life, living in a tent and starting fires with firewood, but not us.

Cousin We don't even know how to make a fire with wood.

Mother All of us are like that. There are people who know how to do these things, so they're adapting to life in the camp, but this isn't our way of life. Despite that, we thank God.

Cousin We were living a good life, and we were arrogant, taking our comfortable life for granted.

Mother You're so right.

Cousin [laughing] Maybe God is punishing us because of that.

Mother The food, the drinks, the outings, the picnics. Even during the crisis, Esraa and I used to go out. "Mom," she'd say, "Let's go to the market and buy some stuff." Every week or ten days, I swear to you, we used to go to the market and spend about 10,000 Syrian pounds, more or less.

Cousin I believe you.

Mother Most of the clothes that we left behind—sweaters, pants, shoes—were new. I told her that we should bring them with us because we might travel, and she said, "We've been saying that for a year, but what if we don't?" May God ease the situation for us. I'm thinking about how tough these days are. Esraa might not forgive me even if God eases the situation and our life changes. She might not forgive me because of the cruelty of these days.

Cousin Don't say that, aunt. She will forgive. It's not your fault that the days are cruel to us. I remember when Mom used to tell me how happy she was at our age. She said they cared about nothing and nothing used to bother them. We grew up with burdens and the war. These days of our life are supposed to be the most beautiful days, when we can hang out with our friends and wear fine clothes. We didn't see any of this coming. Esraa will forgive you, because it's not your fault. Where is she now in the lesson?

Mother Teaching the children has cheered her up a little bit.

Cousin How long does the lesson last?

Mother I don't know . . . yesterday it was one hour, but the day before that it was a half hour. It depends on how much the children can handle. [Laughing] Once you tell the children that the car distributing clothes has arrived, they'll leave everything and run to it.

Cousin The Palestinians don't have any interest in harming this region.

Mother The displaced people from Quneitra [in southwestern Syria] are the ones who attacked us at the beginning. They claimed that we took their land.

Cousin They just remembered that history?

Mother Now they remembered, when destruction has resurrected.

Cousin After sixty years.

Mother Yes, after the destruction. They say that this is their land, and now, after they've

been displaced, they should take it, not us. I say, "If you want it, let the state give you whatever you want. We didn't take it by force anyway. The state gave that land to us." That's what drove them crazy, that the first attack was by the displaced. Then others came.

AW Not the regime?

Mother No, no. The first attack was by the displaced, and then the regime entered to stop them. Later, the other fronts emerged, such as the Free Syrian Army (FSA) and al-Nusra. They were gathering in a mosque, and the regime came and bombed them. Once the jets started shelling, we moved far away from the mosque. Once the war plane had dropped shells, we said to ourselves that they would bomb the whole camp. We're the last people who stayed there. When most of the people were gone and no one was left in the district, the attack happened under our house, between the FSA and the regime. I was so afraid for Esraa because they used to kidnap girls and such things. Her aunt sent her son to take her, with Emad (Emad was still there as well). She told me, "I won't go out if you don't come with me." And I told her, "Go, both of you, and leave me here with your dad." She replied, "I won't go out unless you come with me." The next day, it wasn't possible to stay any longer. We took our clothes and left.

Cousin Tomorrow what happened to Quneitra will happen again. We'll return to see our homes made into monuments.

Mother We will return. It's okay as long as we smell Damascus. I swear by God, if they tell me, "Go back safely to Damascus," I swear I'd go back, although there's a war there. But the problem is that we came with smugglers, so there's no return for us. Otherwise, there's nothing like Damascus. There's no land that compares to Damascus.

[ten days later]

Ali Abboud
[Esraa's father] I'm Ali Abboud from Syria, and I'm originally Palestinian. I'm the only one in the world who has two homelands: my land Palestine and my motherland, Syria. I'm so proud of Syria and that I grew up in it. When I left Syria, I felt like I was leaving Palestine, but it was even harder than leaving Palestine, because I was raised in Syria, which was kind to us. Syria was kind to the whole world.

Syria welcomed the Palestinians, the Lebanese, the Kuwaitis, the Iraqis—Syria welcomed every nationality with a big heart. After we witnessed that and felt proud of Syria, we witnessed a crisis in Syria caused by the regime. The regime hasn't recognized the Syrian people at all. No one paid attention to Syria. I feel very sad that I had to leave Syria, but I had to because of my detained son Fahd; we haven't seen him for three years. My other son Emad is in Sweden, and his mother and sister have missed him. Between Emad and Fahd, they miss them so much.

My house was in the Yarmouk camp and the crisis was behind it. We had patience for many years, although 90 percent of the camp was destroyed. After the camp was destroyed, my wife got really tired and my daughter's spirit was exhausted, so we thought we would leave to meet Emad in Sweden.

Europe is kind to Arabs and toward every Muslim and every human who believes in God. That was clear to us during our stay in Greece. I'm proud of Greece and the Greek people. I appreciate and send my love to those who clean the bathrooms. Those people deserve special gratitude and thanks from us. Maybe there were doctors, engineers, or other professionals among them, and the value of cleaning the bathrooms is a really great one. We thank the Greek people for this special attitude toward us. And I deeply apologize on behalf of the Syrian and Iraqi people for any offenses we may have caused toward the Greek people or anyone else.

We came here with much hope in God. We like to be patient; we like law and order. I worked in Syria as a building contractor, and I had a good living, thanks to God; my life was entirely good. I didn't lack a thing. We came here and God willing, we hope for goodness. I thank the journalists because of their concern for the people here; I really thank them deeply. We have hope for the people fleeing and the Europeans, because the sky is one, the ground is one, and God is one. We must have compassion. Most of the people are heading toward Germany but now there's a crisis there. However, we have hope for them, since the land is vast and the sky is big there, that the Lord of mankind takes as much as is enough from these people.

Most Syrians are understanding, educated, and cultured people. They have professions that qualify them to be productive in Germany. With regard to the Syrian people, they're not coming to take a handout from the German government. Most of the youth I've met here, whether from Deir ez-Zor, Qamishli, or Iraq, have left to provide an education for their children and to build the prosperity of the Europeans.

As for my life, it's true that my son Fahd has been detained for three years, and my other son Emad has been in Sweden for about three and a half years. To comfort us, God sent Tabboush, this cat that he created, and I feel that he's even more precious than my children. Tabboush came to us when he was only one day old, and then he grew day after day after day until he became a grown-up cat.

When the mosque calls out, "God is Great" for Morning Prayer, Tabboush wakes my wife and me to pray. He's so tender toward us. He helps me have patience and comforts my heart and soul. We brought Tabboush with us as God facilitated the trips between Damascus and Homs, and the roads of Aleppo, Idlib, and Turkey. It was an exhausting hardship for us and we thank God we arrived here safely. For a believer, nothing comes after hardship but relief.

Islam teaches us patience, love, and loyalty, and how to live with our brothers—not only Muslims but also Christians and Jews. I lived in Lebanon for four to five years, and I respected all people. We had Jewish neighbors, and we respected them and carried no enmity toward them, and they did the same toward us. Those who are bombing our country aren't related to Islam or to any religion.

AW Tell me about your son who disappeared in Damascus.

AA My son Fahd was taken during Ramadan; he was staying with us in the al-Adawi

district with a guy called Noor Abdul Salam, who hosted us for three to four years in a very good house, perhaps better than a minister's house. During the last days of Ramadan, the second day of Eid, he asked his mother to let him go to the camp so he could see his grandma. I talked to him and told him to come back, and he said, "God willing, father, I'll be back tomorrow."

We waited for him to arrive the next morning, but he didn't show up. When we called him, there was no connection at all. We begged the Syrian intelligence authorities to help us find him. Sometimes they told us they had him and other times they said that they didn't have him, that only God knew who took him. But we think that the Syrian authorities took him. I'm sure that my son didn't do anything to warrant an arrest; he was only going for a day to visit his grandmother. I didn't leave any stone unturned in Syria looking for him. We hope that God protects him and all the detainees in the world when their situation gets difficult. If my son was released now, I have seven brothers who are ready to send him to me, whatever the cost.

AW How long have you been here?

AA Once I arrived, I expected that we'd rest for several hours or a day and then carry on, but we've been in Greece for more than a month. I was surprised by the circumstances here in Greece and in Macedonia. We didn't expect to stay this long.

AW How do you feel now that the borders are closed?

AA The borders are closed, but I feel secure that the situation will get better. I don't believe the Europeans will leave people in this living situation for too long. It's impossible that educated, understanding, and intellectual European nations would leave these women, children, and old people in such circumstances. God willing, relief is near. It's summer now, and the hot weather might cause many diseases.

AW How do you feel since Tabboush received an animal passport?

AA We've been really happy. As for Tabboush, the people care about animals and, of course, animals are created by God. They gave him a passport immediately. It's something that we're proud of. I thank everyone in Greece who contributed to securing Tabboush's passport, especially the veterinarian.

I'm going to talk to my son Emad in Sweden to see if I can send Tabboush to him for a time. Although it would break our hearts to send the cat away, we don't want him to suffer through the hot summer. Emad doesn't like cats that much but if he'll take him, I'll buy Tabboush a ticket and send him to Sweden from the Greek airport.

Maybe when Tabboush doesn't see us, he'll go on a hunger strike. If so, my son should inform the Swedish government that this cat isn't eating and see what its problem is. Perhaps a doctor there will find a solution for our problem, because Tabboush is a soul just like us. He eats with us, drinks with us, sleeps beside us,

and takes a shower with us. And if Tabboush goes and doesn't see us, maybe the Swedish government will be influenced regarding our situation. Everything is possible.

AW Do you miss Syria?

AA I miss the soil of Syria. I miss Syria's water. I miss Syria's sky. I miss Syria's mosques. I miss everything in Syria.

The war in Syria has affected all people. But even if there were no war in Syria, there are wars in Palestine, Gaza, Kuwait, and Iraq. People suffer from the effects of war no matter where they live. The Arab people are very warmhearted and kind people who believe in God. When bombing happens in Iraq, or in any place in Europe, it touches us emotionally. Even when a war occurs in Israel and with the Zionists, we feel sad for the children. We feel for the people and the children in their homes. We don't like bloodshed.

AW What comes to your mind when you're alone?

AA Everything comes to my mind, such as safety for all children and compassion toward mothers and the many things they're suffering from in the camp. What will happen to us after a while? I'm afraid my son Fahd will say, "Why did my family abandon me?" once he's out. This is the only thing that worried me during my departure from Syria: that my son would be set free and we wouldn't be there to greet him. However, God willing, my brothers would be there for him.

My son Emad sent a reunification invitation to us twice, once to Turkey and once to Lebanon, but I refused to leave. I wouldn't leave Fahd behind. Then, by God's will, I came here because of my wife's condition. I have deep sorrow knowing that my son might be released and I'll not be there to greet him.

Sometimes I start looking at the tents and I feel that I'm not hearing the sound of people but only seeing tents. Of course, living in the camp is a great hardship. Enter a tent and you'll either find a child, an old woman, or an old man and others. I was especially sad when I saw two people traveling in wheelchairs because their legs were gone; they went with us to Macedonia. If there was a European conscience, they would've let those two people enter. There should be a special jet that comes and takes disabled people for treatment. This is the only sight that made me really upset. I see those two every day, and I see the smiles on their faces. I noticed that probably one of them is married and has children. I sit and watch the old man from far away, and my heart cries from within for his situation. Where has humanity gone? We understand that there's a crisis, but they should find an immediate solution for these two in wheelchairs.

I don't know these two, and they don't know me. I don't know where they come from. However, we're Arabs and we feel for each other. The man queues for food in his wheelchair every day. Go now with your camera; you'll find him moving slowly in the queue trying to find someone who'll get him a box of food. Look at him and his face. We wish that the Greek government would provide artificial legs for him and the old woman. I'm prepared to visit every tent and collect money to

pay for artificial legs for them so they could stand and feel alive again. I mean, I thank the Greek government, but maybe they haven't seen them yet.

[Two months later]

AW So now you're in Sweden.

Esraa Abboud Yes. It was a really long trip.

AW How did this trip start?

EA The trip took around three and a half months. The first month was on the road and three months in Idomeni in the camp. We tried four or five times to escape from Idomeni to Macedonia on foot. They were all unsuccessful, and we always got chased by police and sent back to the same camp. When things got worse and we weren't able to live there anymore, we tried by air, and we succeeded on our first attempt.

AW You came alone and Tabboush will come after you.

EA It would've been too risky to show up together on the same flight, as we might have been recognized [as Tabboush was featured in the media]. That's why I went first.

AW How do you feel now that you're in Sweden?

EA Of course we feel more comfortable. Finally, we're rid of the nightmare. But I can't stop thinking about the people who are still there. I've become more concerned. When I was in Idomeni, I only thought about the border and when it would open, just as everyone else. But now that I'm relaxed, I know the rest are still suffering and living in tents.

AW Is Sweden as you imagined it would be?

EA It has a good landscape. We haven't seen people yet, but the space is huge for a small number of people. We're not used to it. We've never lived like this before, either in Syria or Greece. We were always surrounded by people. But we'll adapt. In terms of the environment and peoples' attitudes, it's been good. But who knows what will happen next?

I still can't believe that we made it. I feel that it's just a dream when I think about how we were living in the camp and then the trip. I was walking on the street and I remembered how we were walking in the mountains and in the forests. Until now, it hasn't felt real, but when I saw my brother, who I hadn't seen for three years, it was a great feeling. We finally met after all that suffering! So of course I was very happy that my dream finally came true.

I'll not stay idle in Sweden. I'll work. I just arrived three or four days ago and I'm already bored from doing nothing. I'll absolutely find a job soon and start working, even without a residence permit or a passport. I'll even work from home.

AW Is Syria very different from Sweden?

EA Yes. Syria is much better. You know, this isn't Syrian soil. It's true that there are people from Syria who live here, but it's still not home. But even though the people are different here, I'll be happy because I'm staying in a house and not in a tent. I'll never feel as comfortable as in Syria. I'll be happy with a simple house, Tabboush, and a dog (I have always dreamed of having a dog). I don't dream of having a villa or a huge house but rather the opposite—simplicity is more beautiful.

AW The home, as you said before, is a space, a house, a family, the country. What is home?

EA I was talking about a physical home, but the real home is, of course, Syria—my family, my friends, my district. It's very nice here, but my real home is, of course, Syria.

AW Now that you're here and reunited with your family in Sweden, you have your brother and Tabboush. What's missing?

EA It's true that we're here and that this is what we all wanted. But I still have my other brother Fahd in Syria. My dream is to go back there. I just want to see my brother and get a passport and return to Syria. That's it. Returning to Syria is my only dream. Nothing is over. On the contrary, we've just started. Now it becomes more serious. Just one more trip ahead: the return to Syria, the last trip of my journey. This is the future.

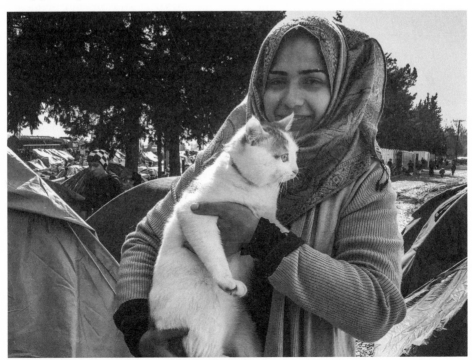

Esraa Abboud and Tabboush, Makeshift Camp, Idomeni, Greece, 2016

028

Muhammad Faris, Refugee
Amman, Jordan, 2016-03-20

MF Patience is the secret of life. The human being is exposed to many burdens, even disasters. When the human being loses his patience in disasters, he's not human anymore and he no longer exists. His existence breaks down. We have an Arabic proverb that says, "Patience is the key to relief."

AW You're one of few who went to space and saw Earth from a rare perspective. However, today you're a refugee. How do you reconcile these two events?

MF Home is very precious to the human being. Home means the air we breathe, the water we drink. It's our father and our mother. However, when the human being goes to space and looks at Earth, a small ball, he figures out that it's a small spaceship and all the people who live on it are astronauts. There's a futuristic plan that says we'll establish space-cities, and there's a possibility that human beings will be happy in them. Why? Because every human being in this space-city will fear destruction and harm for the city; something going wrong would mean danger for everyone.

I say, people on Earth! Earth spins in this dark and dim universe. It's for everyone. You should understand that this spaceship, Earth, is the most beautiful thing in existence. We should maintain and protect it. Then it'll be enough for all of us. It's beautiful and amazing, and has the capacity to host us. It feeds us, gives us water to drink, and complete nutrition and air. So why are we destroying it? Why are we killing its children? As an astronaut, I saw from space that each human being on Earth is a universe himself. I mean, humans are in a single state; they're brothers—the Syrian, the Indian, the Chinese, and the American—all of them are living on this amazing and beautiful Earth. All of them should share.

How do we protect Earth? It happens with solidarity, love, preventing monopoly, preventing injustice, not killing, preventing repression. Unfortunately, there are villains on Earth; we should send them into space. They should see Earth from space and realize how beautiful it is.

When I was in space, I used to dream of a plant in the desert—an amazing and beautiful, very, very wonderful plant. Imagine what we should do then, since human beings are the most beautiful plants in existence. God has created all of us. He created the Muslim, the Christian, the Buddhist; if he didn't love them, he wouldn't have created them. Therefore, our existence is based on love. Unfortunately, many people kill for money or for a government position, a temporal chair they call "president." Unfortunately, this temporal chair is killing millions of people so that a president can stay on this chair. But the chair will perish, and so will the one who is sitting in it. However, making an impact for good has staying power; it's what makes a real human being. The human who wants to take everything isn't a human being; the animal is better than him. The animal in the jungle kills to eat and then stops, but there are humans who can't get enough of killing. This is a great crime.

AW As a scientist, you were a dissident. However, you're still clinging to your country. What made you cling to your country, Syria?

MF I already said that the motherland is the mother and the father. The human being is the past; the future isn't my own, and this moment will immediately become the past. Therefore, all my memories are in my motherland in Syria.

I always remember the children of the neighborhood when we used to play together. I remember the walls of my old district where I used to live. I remember my father and my mother, and I remember their graves, may God bless their souls. Of course, all the world is amazing and beautiful, and all the people are brothers. However, the human being always clings to his memories. I went to space in order to create joy in my country. Therefore, my beautiful memories exist in my country.

AW Representing one's country in space is the pride of the nation. The former president has rewarded you and talked about your importance. However, today you became a strong voice for the opposition and took a brave step to leave the home that you love so. What compelled you to make this decision?

MF Unfortunately, we should speak the truth even if it's hard and bitter. Hafez al-Assad didn't honor me. There are many people who ask me, "Hafez al-Assad, the founder of Assad's family, has sent you to space, so why have you defected from his son?" I tell them, "The people are the ones who make leaders and heads of state; it's not the leaders and heads who make the people, or the scholars, engineers, geniuses, or great artists."

It's true that I went to space during Hafez al-Assad's era. However, unfortunately, Hafez al-Assad didn't accomplish a single thing with my scientific ambition. He didn't help me establish a scientific space base in Syria. On the contrary, when I went back to Syria, I was in my house for eight years without a job, and, I say it clearly and frankly, without any kind of work. The truth should be told. The dictator, in every state in this world, always fears science. The scientist, the intellectual, and the educated are lighthouses that light up the dictator's mistakes. They show his flaws. Therefore, this dictator tries to extinguish the scholar's candle.

Hafez al-Assad killed many human beings in Syria. He suppressed voices and liberties. Then his son came into power, and he was much worse on many levels about suppressing freedoms and blocking the voices of the scholars and the educated. In an interview I did, I said that in Syria there are schools, but no science classes. There are police stations but without security. There are courts but, unfortunately, without justice. There's an army, but this army defends the authorities rather than defending the country. This army has unfortunately killed and suppressed the Syrian people.

As a consequence, I left. I'm a son of the Syrian people. I'm a son of the neighborhood. I see with my own eyes how the warplanes are bombing children, how the thugs are killing people in the streets. The revolution used the finest slogans and words: "Freedom," "The Syrian people are one," "We want dignity," "We want

justice," "We want democracy." However, they were met with oppression, killing, terror, and intimidation.

I see every child in my home and in the whole world. I see the child in China, India, and America as the world. So why, oh Bashar al-Assad, are you killing the world a thousand times over every day? As I said before, the human is made up of memories, and your memories should be beautiful and amazing; they should be clean. Your memories should be with the sons of your country, with the child who's being killed, with the woman who's being raped. This is what I wanted to say: that I should raise my voice, because the voice is stronger than the bullets, tanks, missiles, and jets. This is me.

AW It's true that dictators fear the scholar, especially the scholar who went to space and saw states or the planet as such small things. Leaving Syria must've been a difficult decision. Do you see yourself ever returning?

MF We're ruled by hope. I'm always optimistic that we'll go back to Syria and rebuild it. You, being Chinese, say that China is a cultured, historical, and ancient country, and Syria has been a cultured country for 10,000 years. We've witnessed many invaders who destroyed Syria, yet despite that we have rebuilt it. If God wills it, the Syrian people will return, and we'll bring Syria back even more beautiful than it was before. It will be a country of freedom, a state of citizenship for all people, where they will love one another and help one another to build human civilization.

AW When you were in space and saw that Earth is this small, peaceful ball, could you imagine that today the world would be so full of hatred, grudges, and wars? What's your message to the world as a scientist?

MF Of course, when I was in space, I wished good for all humanity. However, I never imagined that hatred and criminality would reach this limit, by this regime, in my own country. I can't imagine that a pilot randomly throws a barrel bomb full of one ton or half a ton of explosive materials on the ground, resulting in the deaths of many children and women. What kind of a man is that who calls himself a fighter? The criminal comes face-to-face and kills with a knife or a rifle. I really don't have the words to describe such a man. A man launches a Scud missile from 300 kilometers' distance and destroys a district—an entire district destroyed by missiles! These missiles have been created to defend the motherland, not to kill the motherland's people. When one launches a missile from 300 kilometers on a city like Aleppo, it hits a district and devastates children, women, and homes . . . unfortunately, there are no words that can describe this criminality.

What's really important is that scientists are now discovering the secret of this great universe. Instead of making atomic bombs and missiles of destruction, they should be paid for science that explores human diseases and discovers the universe. We could go to Mars, Jupiter, and all these planets with this money that you're killing us with.

AW Human behavior is so hard to understand. Some people want to have more knowledge. Others always try to oppress people and keep knowledge from them.

MF And here's the secret of greatness of those who are seeking knowledge, despite the demons standing in their way. This is the secret of scientists' magnificence. We're trying. If we send the devils to space, they might become good, but for now we don't have the capability to send this many devils to space.

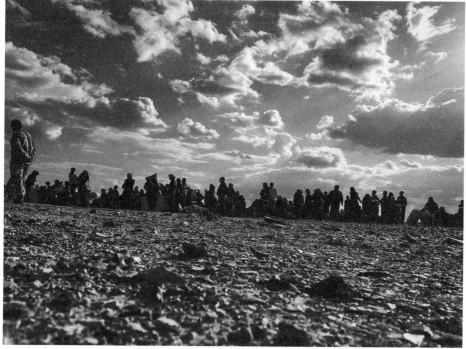

Hadalat Camp, Syrian-Jordanian Border, 2016

029

Cem Terzi, *Bridging Peoples Association*
İzmir, Turkey, 2016-03-22

CT Now we're on the way to Torbali, where the refugees live in very poor conditions. I'd like you to see the situation there.

AW How many refugees are there?

CT Last time we were there, two weeks ago, there were more than 2,000, mostly Arabs and 10 percent Kurds, all from Syria. There are lots of children and babies.

AW Can you generally describe how you started your work?

CT Our association is called Bridging Peoples Association, and we established it two years ago. We don't define ourselves as an NGO but as a solidarity group. The main aim of our association is to peacefully support people in Turkey and the Middle East. We started to work with refugees in the last two years, when İzmir became one of the centers for refugees who want to go to Europe. We realized there were 400,000 Syrian refugees in İzmir in very hopeless conditions.

In our association there are more than a hundred doctors and nurses. In the beginning we provided some health services, conducted medical examinations, treated some of the patients, and took them to hospitals. We tried to respond to all emergencies but then realized that sometimes other factors had to be considered, such as whether people had proper housing, food, and clothes. So in addition to providing health care, we also got involved in meeting basic needs. As you'll see, their living conditions are bad; they're in unheated tents with no electricity or proper food.

We think the government should be responsible for fulfilling basic needs for the people, so we write reports about what we've seen and done, and then we send them to government officials, asking them to fulfill their responsibilities. We also give information to the media so that ordinary Turkish people can understand the real situation. From the beginning the Turkish public was told that the refugees are guests who will stay just a couple of months and then go back to Syria, but it's not like that. We've been living with Syrian refugees for five years now, and survival is really difficult for them. So that's a very important aim of our association: to get the truth out to ordinary people.

AW What is the truth?

CT The truth is that there are three million refugees in Turkey who have no country to return to, as Syria is already gone. Even though there's a cease-fire agreement, they can't go back because their homes have been destroyed. This means that we have three million refugees to help, to give normal lives to, and to provide a means for social integration. The European Union and Turkey just made an agreement about the future of refugees, and if you talk to the refugees themselves, no one believes this agreement, as there's nothing in it in their favor. So I don't

think—and Syrian refugees don't think—that Europe will take some of them. Europe is always trying to limit migration by criminalizing refugees and adopting very unfortunate border policies. So three million people will likely stay in Turkey.

Refugees need standard legal rights, but Turkish law offers them only temporary protection, which means that they have no international rights here. If the government decides to send them back someday, it can legally do this, because they aren't defined as refugees but as "guests." Understandably, this situation makes refugees very nervous about their future in Turkey. We're asking the Turkish government to give refugee status to the Syrians—because they really are refugees—so they'll have some international rights.

We need to make a public plan that's transparent to everyone. Everyone needs to know the truth. They need a social integration program, job permits so they can work, and a standard income for food and rent. The children need to go to school—the majority of them haven't gone to school for even one day in the last five years. We're talking about a lost generation. What will happen to these children if they don't go to school? Now they're in the Turkish labor market, doing the worst jobs on the streets, and they're vulnerable to many dangers. If this situation continues, they won't have a future.

In the last five years, there were 200,000 Syrian babies born in Turkey. They aren't registered in Syria because they were born in Turkey, and they aren't registered in Turkey because Turkish law doesn't allow them Turkish citizenship. They're eligible for this only if they have a Turkish father or mother. We need to change the law for these babies—they need a future.

AW Who are these refugees in Turkey?

CT This is a human tragedy. But if you see them, talk to them, and touch them, you can really understand what's happening. They're just like us. Before the war, not long ago, they had a completely normal life. I remember a very young university student who tried eight times to go to a Greek island in a rubber boat and didn't succeed. He said, "I'll try again and again and again. Even if I die on the sea, I'll try. This is my only hope." He's just a normal young man, and this war interrupted his future, his possibility of attending university, everything. He was simply hoping to carry on with his education and to have a normal life.

We met another woman, Maha, in Basmane, who had arrived from Haleb. She had three children and had lost her husband just before coming to Turkey. She was hoping to find a smuggler in Basmane who would help her buy a normal ticket to go to Greece on a ship. We told her, "This is impossible. You can't find a smuggler to give you a ticket to go to Greece. It's completely illegal and very dangerous, especially with children." We convinced her to stay in Turkey. She had had a normal life and was hoping for a better life for her children. The only reason she was trying to go to Europe was to find schools.

These are normal people just like us. The European Union and the president of the US treat them like criminals. They're refugees from Syria, Iraq, Afghanistan,

and Somalia because they have no chance to live in their countries. There are wars and conflicts there, their lives are in danger, or maybe it's impossible to survive in these countries. That's the reason they're coming to Turkey and trying to go to Europe. They're going to Europe for hope.

AW For that hope they have to give up everything: their language, their country, their neighborhood, their property, everything. Now Europe is trying to find a way not to help them but to stop them at the border. Different nations set up all kinds of boundaries and excuses, trying to stop them from moving forward. This obviously violates our very basic understanding of human rights. Why do you think Europe has become so weak and scared today? Now Turkey is used as a sort of container to protect the European community. What will come from this?

CT I think European countries didn't consider this tragedy on the basis of human rights, because there are really deep political problems in Europe, and it didn't start with the refugee crisis. The right-wingers, the fascists, and xenophobia have a base in Europe. This isn't because of the refugee crises; they're politicizing the refugees for their arguments. So politics are really stuck in Europe. The European Union didn't behave like a union; every country reacted based on its own interests. On the other hand, the US and the United Nations are just watching. Who's bombing the Middle East? Whoever is militarily active in the Middle East is responsible for this refugee problem. Why is the US not doing anything or taking any refugees? It's impossible to understand.

If you look at the neighboring countries—Saudi Arabia, Qatar, United Arab Emirates—they're also militarily active in the field. Why aren't they taking responsibility for the refugees? It's really shameful. They say religion is so important. They're Muslims and they aren't taking any Muslim refugees into their countries. Only Turkey, Lebanon, Egypt, and Jordan take in the Syrian and Iraqi refugees, which isn't fair. It's impossible for Lebanon to socially integrate one million people. It's impossible for Turkey to socially integrate three million. Everybody knows what's going on, and everybody is ignoring the crisis and their responsibility in it.

When this influx started two years ago, the United Nations didn't give enough money to the camps in Lebanon and Egypt, so there was hunger in the refugee camps. Why did this happen? They said the budget wasn't enough. All the Western countries just watched these camps starve. So the Syrian refugees started to leave the camps in Lebanon and Egypt and either returned to Syria or went to Turkey. And then the neighboring countries closed their borders. There was only one open border left—in Turkey. So they came en masse to Turkey. Then Europe, the Balkan countries, Hungary, Bulgaria, and Greece closed their borders.

All of us pushed these people into the Aegean Sea to die. We're responsible for 5,000 deaths in the Mediterranean and Aegean Seas. We pushed them to the seas when we closed the borders, refused to give camps money for food, and failed to stop the war in Syria. Every country is responsible; everybody knows this. The United Nations, the US, France, Germany—anyone who is militarily active in the Middle East is responsible.

AW Thank you very much for your strong statement. Who's responsible for the political situation in Syria in historical terms?

CT Eighty years ago it was the Ottoman period, after which Syrian Arabs became an independent country with British help. In the beginning France was there. The Syrian state was established with French assistance. There were six different federations: one for Alawites, one for Druze, and so on. They got together and created an independent country called Syria. France had to leave Syria. Nothing was easy and there were some problems between Lebanon and Syria as well, because Lebanon was a part of Syria in the beginning.

The West took Lebanon away from Syria because of the Christian population in Lebanon. This is very complicated. The Ba'ath regime was a secular, socialist, nationalist regime, like Saddam in Iraq; the Assad family was like this in Syria. Even though Assad is Alawite, he made some agreements with the Sunnis and created a Ba'ath regime. But this had nothing to do with democracy. Twenty years ago, you needed a registration from the government to buy a typewriter. Can you imagine? They treated the act of typing like firing a gun.

If you look at the last uprising, in the beginning it was a public uprising against the Ba'ath regime for democracy, for rights. But immediately the Western countries and Russia got involved, and the Syrian people lost their real aim. It wasn't an uprising for Syrian democracy anymore but rather a war between Russia and America. It became a war between Saudi Arabia and Iran. Syrian people didn't lose this fight on the field in Syria; they lost it in Washington, Moscow, Paris, and Ankara. So, the right to fight for a better country was stolen from the Syrian people by these countries who are militarily active in Syria. I feel really sorry for them.

AW So it's not a civil war. It's between international players with very different interests.

CT Definitely. As you know, the US is gradually withdrawing its troops from the Middle East. In particular, Obama is taking troops from Iraq and also downsizing in Afghanistan. Everybody is thinking that if the US (the big boss) is leaving here, they—Russia, China, Western European countries, Germany, France—may be able to find an imperial role for themselves. It's all about this, unfortunately.

AW What about İzmir?

CT İzmir is a very, very old city; humans have been living here for 8,500 years. It was always the base for migrants. You can find traces of every civilization in İzmir. Migration happened here for the last hundred years. Many Europeans lived in İzmir. In the 1990s there was a huge migration from the Balkans and Bulgaria, so İzmir should be very friendly to others, to foreigners, because the history of İzmir is the history of migrations. This is one of the reasons I think Syrian refugees are coming to İzmir. There's also a chance for them to find jobs in İzmir because it's an agricultural center. They can work on farms.

The migration issue is also a matter of class. The middle- and upper-class Syrian people have already gone to Europe because they had money, resources, and

relatives there. The Syrians now living in Turkey are from the working and lower classes. They don't have any money or information. Some of them are just stuck here.

The latest EU-Turkey agreement is making Turkey an open-air prison for refugees. It means that Europe is actually renting an open-air prison in Turkey for Syrian refugees and the Turkish government is accepting this, which is really terrible. In this agreement there's nothing in favor of Syrian refugees, and they know very well what's going on. Greece will also start sending some refugees back to Turkey. These people endured a very dangerous trip and gave all their money to smugglers just to reach the Greek islands. Now the government will force them to go back to Turkey, but they'll never accept this; there will be lots of problems and fights between Greek police officers and refugees, and there will be a big human rights problem.

Europe must understand that this isn't a problem it can ignore or postpone for a couple of years. The war is going on in Syria, where there are six million more people who are candidates to be refugees, and there are two million Afghan people in Iran without any rights. All of them are waiting for a chance to come to Turkey and then to go to Europe. Now Europe is trying to stop them with NATO ships in the sea. This amount of military force against refugees is unprecedented. It affects the stability of all countries. Europe should calmly address the problem and find a rational and moral solution.

AW I'd like to talk about your practice. What kind of patients are you dealing with and what are most of the cases about? They're helpless, there are no facilities, and nobody really welcomes them here. I've been in the camps and have seen a lot of sickness, especially in children and women. Lots of the women become psychologically vulnerable, because they've lost their children. How have you been able to help them and how many doctors have been involved? Is there any help from the state?

CT They're suffering enormous psychological trauma. I'll never forget a mother I met. She lost her husband during a bombing and took her four tiny children to try to cross the border on foot. She told me she had to leave one child behind at some point. She continued walking with three children for a couple of kilometers. There was another group walking in the same direction, and they had the child she left behind and returned it to her. They were reunited again on the journey. But the other day she had to leave that child behind again. She told me she had to leave her child twice. And then she didn't hear anything about her child. She saved three children but had to leave one behind. When telling me that story, she couldn't even cry. That was one of the worst stories I've heard in my life from a mother, having to leave her child on the road twice.

The camps are full of these stories. It's really a big tragedy, and there's no organization in Turkey working with these people to help their psychological trauma. Lots of psychiatrists, psychologists, and other social workers should be working on this, but in the last five years, nothing has been done. A couple of international NGOs are working in that field but with very few staff; they weren't able to do a lot. And the government in particular did nothing, which is very unfortunate.

Many other health problems exist in the tents. Children haven't been vaccinated, and there are no systems of mobile health care facilities or health care groups. Nobody is going to refugee houses or tents to register them and provide primary health care. They're just sitting and waiting for the refugees to come to the hospital or to the health care service, which is impossible. The refugees don't know the language and don't have money to go to a hospital. On paper, health care is free for refugees, which is really important, but we need to do more than this. We need to go to the field with mobile equipment, and we need more health care workers to reach them. Language is also a problem; we need lots of translators.

AW Thank you. Where are we now?

CT We're in Torbali, which is one of ten settlements. Now you'll see hundreds of Syrian refugees and children working in the fields picking cabbage. There are many problems here. There's no electricity or clean water where they live.

AW Okay, let's go out.

CT Mehmed is a volunteer with our association. We met him one year ago in Torbali. He's a kind of local leader who addresses every problem. We work together to help the people. A couple of weeks ago he called me in the middle of the night. A pregnant woman had started to bleed. He took her to the private hospital, but it wouldn't accept her. He called me and I called the doctor in the private hospital. I told him, "You have to treat this patient under the law even if she isn't registered. This is an emergency case." The baby was delivered but unfortunately was stillborn, and the mother stayed two days in the hospital. Mehmed was the only one looking after the family. A pregnant woman bleeding and losing her baby with only one local person helping her is unacceptable.

This is the reason they try to go to Europe. They think they may have better living conditions there. We're talking about three million people, half of them women and children, because the men are already dead in Syria. There are many single mothers, elderly sick people, psychological trauma, chronic diseases, hypertension, and cardiac diseases. They don't have proper medication or follow-ups. You've seen the living and working conditions—anyone could get sick living like this.

I'd like to say something about our association. We don't accept money from the government or the EU or any other charity organizations. Our independence is important, and we don't want to be integrated with the government, other NGOs, or the EU. We need to tell the truth, and to tell the truth we need to be independent. Until now we've done everything with money from volunteer sources. That's really important to us.

Now we're at another tent settlement area. We need to walk a little bit because there's no proper path.

AW It's good. We have to walk.

CT There was a peace petition from Istanbul that started about a month ago. Some academics asked for support from other academics in Turkey, and I signed it as well. It called upon the government to return to the peace process for the Kurdish problem. As you might know, the government was talking to the Kurdistan Workers' Party (PKK) for two years, during which the gun battles stopped and nobody was killed. This was really important for both sides. Nobody wants to lose their children. During this time, many things happened. Legislation was prepared to change the constitution, to give more rights to Kurdish people, and to peacefully sort out this problem. Then suddenly the conflict started again and lots of people started dying. So this peace petition asks the government to return to the peace process and stop the military operations in eastern Turkey.

Now we're persecuted by police and at the university because we signed that petition. They think this statement is unlawful. I don't believe this. To declare your opinion as an academic is a responsibility to the public. If we don't talk, nobody can talk. That's our privilege in one way: to talk about something other people are afraid to talk about. To write, to criticize the government, is a crucial role of the university and academy. That's the only way we can protect the people, the public, and our future, to give strong ideas and alternative ways. That's our job. We work in public universities, yes. But we're the product of the public, so we have to serve the public and not the state.

Three young academics from Boğaziçi University were arrested. They're now in jail, in a very unfortunate position. In every city, there's persecution. We feel the pressure, but on the other hand, peace needs courage. If you don't show enough courage to ask everybody to do something, then peace can't come. It can't be spontaneous.

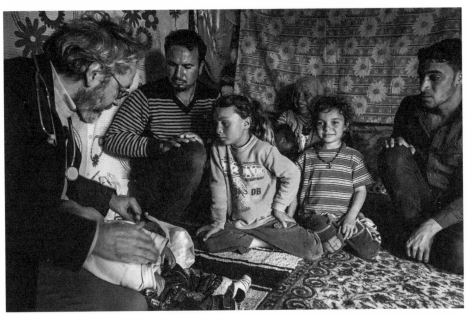

Cem Terzi, Makeshift Camp, Torbali, Izmir Province, Turkey, 2016

030

Chaled, Refugee
İzmir, Turkey, 2016-03-23

AW How should I address you?

C Call me Chaled.

AW Chaled?

C Yeah.

AW Chaled is a good name. Hi, Chaled.

C Hi, how are you?

AW I'm good. And how are you?

C Not bad. But it's a very bad situation.

AW What is the situation?

C You can see. I'm in Turkey. We're trying to go to Greece. I've tried to go to Greece eight times but didn't make it. The first time we tried to cross, the boat broke down suddenly while we were on the water. My family and I were almost killed. The second time we tried, the boat's motor dropped into the water. After trying eight times, I'm still in Çeşme. I can't go anywhere—back to Afghanistan or to Greece. I don't know what to do. We don't have a house. I spent a lot of money to get to Turkey. I lost it all. In Turkey, nobody takes care of us.

AW What happened in Afghanistan? Why did you make the decision to come so far?

C I was working with the US military in Afghanistan. Somebody attacked me and tried to kill me and my family. This happened three times. They shot at me. They called me and said, "You'll be killed because you worked with the American military. If you work with them, you're the same to us as American people. Don't do your job."

But I had to work. In Afghanistan, it's very hard to find a job. I fled to Iran with my family. I tried to stay there, but Iranian police sent us back to Afghanistan. I went to Iran again but couldn't find a job. I couldn't even walk on the roads between cities.

I went to the British embassy to ask for help, but there were Iranian police at the gate who asked me, "Where are you from?" When I told them I was from Afghanistan, they asked for my passport or ID card. When I said I didn't have one, they yelled at me.

I couldn't stay in Iran so I decided to go to Turkey and then try to get to Europe.

The Turkish police sent us back to Iran twice. We walked sixty hours between mountains. It was very bad at night. It snowed day and night. It was really dangerous for everyone, especially for women and children.

When we arrived in Turkey, I stayed in Istanbul and rented a house. I couldn't find a job because I don't understand the Turkish language. In a month and a half, I could only work two days. Everything is expensive here. My family can't live like this and wants to go to Europe. I paid someone to send us to Greece. We tried, but didn't make it.

I'm staying in this hotel without any money. I don't have a house. My children need food and clothing, but we don't have anything. I went to the United Nations for help, and they said, "We can't do anything for you. We can only give you papers. You're allowed to stay in Turkey and you can find a job and a house." But it's very hard for us. If I don't understand the language, how can I find a job?

AW Previously, they said the policy was to accept only refugees from Syria and Afghanistan. Now the border is closed. What's your plan?

C Right now, I don't have a plan. I still want to go to Greece. I can't stay in Turkey or go back to my country. I lost all of my money. I don't know what to do. Somebody must help us. They want to keep Syrians, but I heard from somebody that they want to send Afghans back to Turkey. It's not fair. Aren't Afghans human? In Afghanistan, there's war, just as in Syria. We have the Taliban and Daesh.

AW In Afghanistan, the current war is recognized by the world, but at the same time I don't think the European Union will decide to accept Afghans. If you go to Greece, they may deport you back to Turkey.

C I don't know. I really don't know what to do.

AW Do you have friends here from Afghanistan? How is their situation?

C I don't know anybody in Çeşme. I had some friends, but now they're in Greece.

AW Is it still possible to go to Greece?

C I'm trying to. I don't know if it's possible, but I can't return to Afghanistan because I've lost everything.

AW Do you remember which division you were working for? Do you have any photographs or any contacts in the US Army? What did you actually do for them and for how long?

C I worked with the American military for five years, but right now I don't have any contact numbers or photographs, just people I knew. I tried to find one of them to help me, but I wasn't successful.

AW What was the name of the American contractor you were working with?

c I worked with the military for one year and then worked four years with the Alliance Project Services, a company that works for the American military.

AW What are the smugglers saying right now about people who are in your situation? Are they telling you that there are boats going to Greece? What have they said you'll find on the other side?

c I don't know.

AW But you've gone with a smuggler eight times.

c Yeah.

AW And he said that he won't give you a refund on your money, but he'll take you across if you keep trying?

c Yes, he said, "If you want to go to Greece, I can send you, but I can't refund your money."

AW And people are still trying to take the boat?

c I think so, yes.

AW Do you think that you might try to take the boat?

c I don't know.

AW If you succeed in getting to Greece, do you think you can stay?

c I don't know. I heard from someone that they're checking people's cases; if their case is very important, they can stay. If their case isn't important, they'll send them back to Turkey. Still, I'm trying to go because my family and I were in danger in Afghanistan. It's a very bad situation and we can't return.

On one attempt, we were between the Greek and Turkish waters, close to Greece. We could see a city with people walking around and cars. The inflatable boat was very small and dangerous. They packed about sixty to seventy of us into it. The boat measured seven or eight meters. Children and women were tightly crammed in and were crying. Unfortunately, Turkish police caught us and brought us back to Çeşme.

I heard that Greece wants to send refugees back to Turkey. But I believe it's not the way to solve this problem. You can see this, I can see this. Many refugees in this hotel are still trying to cross the dangerous sea to get to Greece. It's not fair to return them to Turkey. I don't know everyone's situation, but I know that people sold their houses, furniture, everything, just to get there.

AW You have two children? How old are they?

c My daughter is five and my son is three.

AW It's so difficult for you to bring the family to this point.

C Yes.

AW Do they understand?

C My daughter understands, but my son doesn't.

AW What did your wife tell you the last time you wanted to take the boat?

C She said, "Don't try."

AW Can you tell us about that night, when the sea was rising and the waves were crashing and you went on the boat?

C When I got on the boat, my wife said to me, "Please, don't get on that boat. That boat is very dangerous." When we were in Iran, the guy who said he could get us to Greece told us, "We want to send you on a ship, not on a boat." He promised my wife and me. I told my wife, "We can go on a ship, not on a boat." But when we arrived in Çeşme, this city so close to Greece, everybody told me, "There are no ships, only inflatable boats." My wife was crying and was very scared the first time we tried to get on the boat.

AW What happened the last time you took the boat?

C The last time we were close to the sea, we were getting ready to board the boat and the sea conditions worsened. It was a stormy night—very stormy. We waited a few minutes until the sea was calmer, but then the police came and sent us back to Çeşme.

031

Piril Ercoban, *Association for Solidarity with Refugees*
İzmir, Turkey, 2016-03-23

PE We established the Association for Solidarity with Refugees in 2008 as a response to the increasing refugee and migrant population in İzmir and Turkey. Back then, İzmir was one of the hubs for irregular crossings from Turkey to Greece, so we established this organization in order to advocate for the rights of refugees and migrants in Turkey.

We didn't have any laws regarding refugees or asylum seekers in Turkey at that time. We advocated for a legal base for refugee rights, to advance the implementation of their rights in Turkey. We give counseling and referrals to people in need of legal assistance and give counseling to migrants, refugees, and asylum seekers about their rights. We do monitoring work, especially relating to the borders, the western borders of Turkey, and detention centers. We try to raise awareness and do advocacy and lobbying activities.

AW You cover every aspect of the refugee condition except for rescue.

PE Not rescue, no. We also don't provide humanitarian or financial assistance. We try to approach the issue from a rights-based perspective. Our aim is that the refugees, migrants, and asylum seekers in Turkey get easier and broader access to their rights and services.

AW Your work is centered on migrants' rights. Regarding the 1951 Convention, do you think its definitions and rights are still valid and working?

PE This is a very good question. First of all, let me say that the definition of the 1951 Convention for refugees and asylum seekers seeking international protection in Turkey is valid for a limited number of people. Turkey still maintains the geographical limitations of the 1951 Convention, which means that Turkey only recognizes the rights of refugees coming from European countries. So refugee status is only given to people from European Council countries in Turkey.

Although we claim to be the country that hosts the largest refugee population right now, actual refugee status is given to less than 200 people, which is ironic. From Turkey's point of view, we have a very limited number of refugees, whereas the reality is quite the contrary. We now have three million refugees. Unfortunately, in practice, I think the 1951 Convention isn't valid anymore. I'm really sorry to say that, but no state party really respects the 1951 Convention. In light of the recent developments between Turkey and the EU, or of the states' recent unwelcoming attitude to refugees from Syria, Afghanistan, Iraq, and other countries, it's hard to say that the definition of the 1951 Convention is still valid. We need to widen the definition. However, the trend in the states' policies and practices has been instead to further narrow it.

For example, in Europe countries recognize refugee status on the basis of nationality, whereas the 1951 Convention specifically and clearly states that

status must be given based on individual assessment. Now, individual assessments aren't made and the countries decide, "Okay, you came from a Balkan country, so you're not a refugee." At the beginning of summer last year, in 2015, they were defining people from Afghanistan, Iraq, and Syria as refugees. After some months, they narrowed it further, and now only the Syrians are refugees. They don't recognize Afghans or Iraqis as refugees; there's no assessment made of their protection claims under international law.

AW So the definition has already changed.

PE In practice.

AW Basically, the states change it according to their needs or policies. But if we talk about refugee rights, it's a human rights issue in extreme circumstances. Can you give a clear and simple definition of refugee rights?

PE First of all, as you clearly put it, seeking asylum is one of the basic rights underlined in the International Human Rights Convention. Article 14 clearly says that access to asylum is a basic right, just like the right to live, the right to freedom, and the right to belief and expression. All refugees have the right to seek asylum if their state or the state where they reside isn't giving them the necessary protection.

Once they're recognized as refugees based on the criteria of the 1951 Convention and the individual assessment, then they have a right to basic services in the country in which they seek asylum. This includes access to education, health care, and basic services. These rights apply to everybody regardless of their status. However, if they're recognized as refugees, they should also be given durable solutions, which means their status shouldn't be temporary. This process should give them access to citizenship and other rights that come with citizenship—not immediately after being recognized as a refugee, but after a while this path should be open. And, of course, they have the right to be protected from persecution.

AW We see that people have been risking their lives. They sacrificed everything to travel to Greece, which is part of the European Union, but now they're under this new treaty between Europe and Turkey, which is also a big violation.

PE Definitely.

AW Turkey has become like a container for refugees, and it takes so many of them. At the beginning, Turkey may have thought this was a temporary situation, but it still accepted them, which is amazing. I mean, three million people. But now it has become a kind of permanent condition that could last for decades. Does the EU use Turkey? How are you dealing with European nations?

PE Turkey is now hosting three million refugees. Under the circumstances, with what's happening in Syria, Iraq, and Afghanistan, it's to be expected. It's not a recent situation; for Syrian refugees, it's been going on for five years. For Iraqis and Afghans, the period was much longer. They've been displaced from

their homes for generations now. And neighboring states are always more affected.

In the past, for example, Pakistan and Iran were affected by the unrest in Afghanistan. They've been hosting millions of Afghan refugees in their countries. We didn't really recognize this fact for years. Now Turkey and the other states neighboring Syria are taking the major responsibility for displaced Syrians. Europe, and the rest of the world, only realized this fact in 2015, when people began to cross to Europe in large numbers.

We don't see the realities. We don't see the suffering of people until the fire reaches our house. And, unfortunately, Europe still doesn't want to see the fire next door. If every state says, "Sorry, no, I've had enough . . . I can't have anymore refugees in my territory," what will the solution be? It means that we'll tell people who are escaping from persecution, "Don't come. Die in your country. No, sorry, we can't accept you. You're destined to die in your own country or in the country where you're now living. Either you die from the bombs or you have to suffer under very difficult living conditions."

AW I see. What you're saying is very important.

PE We're very frustrated. We know that whatever we say, however we scream, it doesn't really help.

AW Today I saw in the local newspaper that the state has decided to stop giving refugees free medicine. Do you think the EU deal will help the situation?

PE We all call this deal a dirty deal because people's lives are on the table. It's not right for any state to negotiate with the lives and future of people who can't defend or speak out for themselves. But the deal also affected the neighboring states. Support can't be only in financial terms. Solidarity and support from other states should also be demonstrated through accepting more refugees in their countries, without any condition. People are persecuted and dying in these wars. There are very serious human rights violations. Under the circumstances, we can't just say, "Wait, sorry, I've got enough refugees. I can't take more in."

The states have to change how they perceive the situation. The response should be appropriate and meet the people's needs. It's necessary because the neighboring countries can't cope any longer with the strain. The infrastructure isn't enough.

Besides basics such as food and shelter, refugees need access to education. Today, in Turkey, 70 percent of Syrian children aren't in school, and there's a huge market for child labor in Turkey. Syrian and Afghan children have to work at a very early age to help with their family income. Sometimes they're the only source of family income.

Greater protection is needed for vulnerable cases. There's also a need for better access to health services, although Turkey has taken a big step in that respect. Now there's the problem of getting medication from the pharmacies. All these

needs require infrastructure, financial means, and human resources. For this, neighboring states have to be supported. You can't just say, "Here's some money, now deal with the rest." This is inhumane.

AW If people's refugee status can't be recognized, they become invisible. They become like ghosts, living in society but not having rights. They're there in big numbers, but they just become another class of people.

PE Absolutely. This is the situation. You know, until the Syrian people arrived in Turkey, refugees and asylum seekers were totally invisible in this society, not only in the eyes of the public but also in the eyes of state institutions. They weren't aware of the fact that there were refugees living in Turkey. Now they're aware, but the invisibility continues.

AW The war has created a huge global refugee population, and it's hard to recognize their rights. They're a new class of people with no basic rights, education, health care, or the responsibilities of a regular citizen. That will affect the global future and our political landscape. Why have so many politicians given up their basic responsibilities? Why do they deny what's going on?

PE I don't know. It's really hard to recognize the world today. It doesn't fit any idea we've developed up to now. We didn't expect much from the politicians, but we did expect the US, Europe, Russia, China, and the Arab countries to take more responsibility, whether they're directly culpable for the war or not. There's no question about that.

We see a deeper violation of human rights every day. People are apprehended, arrested, detained, and deported according to their arrival data and nationality, without any individual assessment of whether the respective person is in need of international protection. Europe doesn't care what happens after their deportation to Turkey. Turkey and the EU shook hands in order to deport these people to their countries of origin. What will happen there? Nobody cares. After readmission into Turkey, they'll be detained, and then they'll be deported. If they'd arrived a day earlier, they would've been refugees in Europe. But suddenly, the next day, they're not considered persons in need of international protection. That's why I'm saying the 1951 Convention is no longer valid.

AW States are just dealing with refugees as bargaining chips. The state acts exactly like traffickers. They're seeking their own interests, their own profit, but they fail to recognize these people's essential human rights.

PE Europe is concerned about its cultural and social fabric and its finances. However, the same concerns also exist for other states. In Lebanon, one out of every four individuals is a Syrian refugee. It's similar in Jordan. In Turkey, three million is a big population, but it's a small percentage of the country's entire population. We can't really meet these concerns through militarist approaches. We're talking about the biggest human movement since the Second World War. I think this is very important. Politicians and the media have a big responsibility to change this discourse and the attitude toward refugees.

AW You've been working in this field for so long and you have such broad knowledge and understanding. If you look at this crisis, this human flow, is there any positive side that may come out of this when we look back many years later at this time in history?

PE As long as the wars and human rights violations and persecutions continue, there won't be an end to this misery. Unless people are provided dignified and voluntary safe passage to their home countries, ending the war isn't enough. They have to establish stable and safe environments for the people to return to. However perfect conditions are in host or transit countries, their misery will continue, because there are bleeding wounds in their homelands.

Regarding your question about a positive side of this crisis, sometimes I consider this kind of altruism a trend in popular culture, but nonetheless, perhaps the sincere solidarity that some people—both individuals and groups—have demonstrated for refugees should give us hope. While as a whole, global response to the refugee crisis has been weak, I hope that even this weak solidarity and advocacy for refugees will gain greater ground and become permanent, spreading to wider populations—in Turkey, Europe, everywhere. I hope it'll not just be a fashionable trend. We have to accept that refugees are here to stay because, unfortunately, the prospect of the wars ending and people returning to a stable and peaceful environment in their home countries isn't around the corner.

AW What you say is very important because only with that kind of understanding can we really restructure our society and provide better conditions for refugees. It's about the human condition. It's not just that you have a guest, it's that they're also citizens who should have rights. Only when those rights are defined can society restructure itself, but that's never a fixed condition. Without that kind of understanding, the now fashionable trend will not last. How do we provide a constructive perspective to give energy and hope to rebuild the future?

PE We have to recognize that refugees need sustainable, long-term solutions. We can't make people depend on humanitarian assistance. We can't expect them to live dependent on hygiene kits or food carts. They have to be a part of society. They have to be offered dignified living conditions, access to the labor market, education, and recognition as a person with full rights. Otherwise, there will be huge divisions within our societies, and there will be very serious social unrest between the host and refugee communities. If we establish our principles without more delay, and implement them properly, there will be a future for all of us. If not, the future will be really dark.

032

Rami Jarrah, Activist News Association
Gaziantep, Turkey, 2016-03-24

RJ When we first founded Activist News Association (ANA), the idea was to support citizen journalists inside Syria who were reporting on the conflict, because any information they provided was considered unverified by the mainstream media. ANA's job was to create files of every citizen journalist and make that file available to mainstream media, such as CNN or BBC, so that they would be taken seriously as journalists on the ground, because there weren't many Western journalists reporting on the Syrian conflict.

At a later stage we realized that there was a problem: there wasn't much media coming out of Syria that provided context or that was aimed at a Syrian audience, so we began creating content ourselves and working with these citizen journalists. We decided to work on professionalizing their work and making sure that the content was worthy of being presented to a Western audience, a regional Arab audience, and a Syrian audience. ANA's goal is to provide context on what's currently happening in Syria, rather than reporting on ISIS or sensational stories that aren't really telling the truth about what's happening in the country.

AW What's the context that those Western news stories miss?

RJ Sometimes Western stories support narratives that aren't real narratives. For example, when CNN goes into Syria and chats live with a jihadist in 2012 and says that there are many jihadists in Syria, that's not the case. You'll have these people in the UK or France or Belgium who want to actually join groups like ISIS, who say, "You know what? There's room for me to become a jihadist," and then it becomes a reality.

AW How long is this war going to last, and what does it mean for the refugee crisis?

RJ At the moment there's a partial cease-fire. But if there's no serious approach that says the dictatorship will end in Syria, that there will be a new government that respects the rights of Syrian civilians, then I don't see an end to the conflict. I think this will be a very, very long conflict.

AW What is Assad's interest? Does this media narrative about migration as a major security threat to the West put pressure on policy makers?

RJ Many MPs and leaders of parties in the European Parliament are questioning the idea of working with Assad to eliminate terrorism. The problem in Syria is that Assad is the source of that terrorism and also an excuse for terrorism. You have a number of people protesting, saying that they want freedom, and then you have a government that's accusing them and saying, "No, you're terrorists." And then other groups come in and hijack this movement and say, "Yes, we want to fight the government, we're going to protect you." But those groups believe in an ideology that's very extreme and fundamentalist. This will continue to happen if there's no direct confrontation with the dictatorship in Syria.

I worry that the international community is going to take the easier option: let Assad do what he wants. That's just going to make the situation worse. I wish that the migration situation would pressure them to find an actual solution. But I don't see that happening. We're still working with people like Assad to stay in power, thinking that that will possibly eliminate terrorism, but that's not the case.

AW Tell me about your family background and why you got involved in the Syrian revolution.

RJ I grew up in London. I didn't know much about Syria before 2004, even though I'm a Syrian; my mom and dad are from Damascus. When I went to Syria in 2004, I'd studied journalism, but I wasn't able to practice it in Syria, because media wasn't free there. The government narratives controlled the media. I worked in import-export as a consultant for a distribution company in Damascus. In 2011, when the protest began, it was something I was waiting for. If that hadn't happened, I would've left the country.

My mother and father were antigovernment activists and hadn't been to Syria for thirty years. I spent 2004 to 2007 under a travel ban. I was interrogated on a daily basis by Syrian security forces and intelligence. In 2011, when the protests began, I was willing to live in Syria from then on, because I thought that we were soon going to see a democratic country, something that we saw happening in Egypt and Tunisia. The government was retaliating with a lot of oppression. They didn't accept any idea of change. Throughout the conflict I began working as a citizen journalist, and then we established ANA.

I was jailed on March 25, 2011, and was taken to a security branch in Damascus called the Amn al-Siyasi [Political Security Directorate; a Syrian intelligence service]. I was tortured for three days and forced to sign papers saying that I was a terrorist from abroad who had come to cause destruction in Syria. I think the only reason I stand out is that I'm able to communicate with a Western audience and explain what happened to me, but it's something that happened to millions of Syrians. Psychological and physical torture is a very common thing in Syria. After three days, when I was released, I had become more convinced that becoming a more serious and professional journalist would make me more capable of reaching a Western audience and explaining what's actually happening in Syria.

033

Ismetollah Sediqi, *Refugee*
İzmir, Turkey, 2016-03-24

AW Ismetollah, tell us how many were in your family? What happened to them?

IS [Showing family members' identity cards] They all died at sea. I have six kids. This is my brother, Sakhi Ahmad; he has gone completely mad. Sakhi has two kids and his wife is buried here. His son and daughter are buried here too. This is me, Ismetollah Sediqi. This is my wife, Muzghan Sediqi, and Ramin Sediqi, Rashid Sediqi, Sadaf Ramiz Sediqi, Sadaf Sediqi, Reshad Sediqi, and Sana Sediqi. There were seventeen of us with IDs. Now there are only twelve.

Five of us are under the dirt, two of us under the water. What is left for us? Our money and lives are gone. Everything we had is gone. I don't know what's going to happen to us tomorrow. We came for a peaceful life. We had enemies in Kabul. We encountered many problems there with the Taliban. We came here and God brought this upon us.

We went to İzmir, and from there to Ankara. In Istanbul, we slept in a mosque. I had six kids; they didn't give us a house. We had no other choice than to cross the Greek sea, either to die or reach Greece.

AW Why do you want to go abroad?

IS To settle my life. We had enemies in the war in Afghanistan, ISIS and the Taliban. There are thirty tribes. My wife was a women's rights activist. We couldn't live there. All of the world supports women's rights—Germany, Japan, and America. They kept saying, "Women's rights, women's rights!" Now, two of my brothers are the victims of women's rights in Afghanistan.

AW Now the borders are closed. You said you want to go to Greece. Why don't you live here?

IS Where? I have six children. Nobody lets us rent a house. Maybe they think Afghans might damage houses. We don't ruin their houses. I don't know what to do. My little babies are here under the dirt.

AW How did they drown in the sea?

IS On March 1, we came to the sea. The Turkish police captured us and imprisoned me. Five of us out of seventeen were imprisoned. Then we arrived at Didim. One of my brothers, with his wife and kids, set off in a ship, which sank in the Didim sea. None of them survived. On March 8, on Women's Rights Day, a woman took us from Didim. I went to a hotel that day. In the morning they told me about my brother. I buried the bodies on March 16. I waited until that day in case they found my nieces in the sea, but they didn't come back. I buried three of them here. Now, there are just twelve of us left.

I've got nothing left to say. All my money is gone and we've lost five people. Two people drowned at sea. They appear in my dreams at night.

AW Ismetollah, you've told me that you're the oldest brother, aren't you?

IS Yes.

AW And you've looked after this family since you were seventeen; you're their guardian?

IS Yes, yes.

AW And you promised them a better life.

IS Yes, I told each of them individually that I'm like a father to them, that I'll help them. We came illegally from Iran. We spent four months here and went back. Now we're miserable. Since the day we were born, we've had war; not one peaceful moment. From our childhood there was war in Afghanistan—it's been like this for forty to forty-five years. The powerful people create the war in which we burn, and then they close all our paths out.

I told my brothers I'd take them to another world. Maybe we could get peace there.

Lesvos, Greece, 2016

Murat Bay, Journalist
Nizip, Turkey, 2016-03-26 and 2016-04-21

MB My name is Murat, and I'm a student. I'd prefer to speak in my mother tongue, Kurdish, but we've been assimilated by the Turks, so I speak better in Turkish.

I've been working as a journalist for a long time. I'd intended to become a physicist, but when I was at university, the government put pressure on journalists, and I realized the necessity of turning to that field instead. At that time there were very intense protests. I began as a photographer and then as a journalist at the *Birgun* newspaper. After that I continued to work as a photojournalist. Later, when the Gezi Park protests began, I worked with a collective media network called Sendika.org. People in many Turkish cities began to protest against the government. After the Soma mine accident, there were conflicts in the streets every single day. It was hard for journalists to work.

The war in Kobane was an exceptional event in history. There were serious clashes between Kurdish forces and the Turkish government. Despite the so-called peace process in Turkey, it was really difficult to achieve balance among all the parties. Throughout this period I traveled to Kobane three times as a journalist. During the war, refugees regularly attempted to come to Turkey. About 200,000 refugees came from the Kobane region.

In September 2014, I arrived at the border of Kobane. Kobane was surrounded by ISIS, which had invaded all the 380 villages in an instant. People ran for their lives to Suruç, north of Kobane, in Turkey. People in Suruç opened their homes and workplaces for refugees, but there were so many that Suruç couldn't take them all in.

As a Kurdish person, I've lived in that region. That massacre and these attacks happened to my people, so being there was much more intense for me than for other journalists, because I empathized directly with what was happening. My relatives had to flee or be slaughtered. We share the same language and culture. There are only five kilometers between Suruç and Kobane, and many people have half their relatives living in Suruç and the other half living in Kobane, so the border between them is a meaningless, ideological divide. We don't accept those ideological borders, because they haven't been drawn with our will.

The conflicts at the border were very violent. We heard that Turkish soldiers didn't let some people from Kobane cross to Suruç. When we arrived at the border, families who attempted to cross to the Suruç side were prevented by the soldiers. Suddenly, more than 1,000 people rushed the border, pulled down its fence, and crossed from Kobane. It was one of the most important moments of my life. I saw how a border fence became meaningless and was crushed under thousands of feet. When I saw those people fleeing, I crossed into Kobane without hesitation.

The path we crossed ran through a mined terrain. People who hadn't yet left Kobane, who had escaped from surrounding villages and were sheltering there, welcomed us with open arms. It's impossible to explain how it felt to be welcomed as heroes when we weren't. We were in solidarity with the people, but we journalists couldn't save them. Surrounded by ISIS, they had only one contact point on the outside: Turkey. They gave us water because they didn't have anything else. A grocer offered us free goods. Everyone was trying to help us. Many shed tears, among them the elderly and a blind woman. Kurdish people, screaming in both victory and pain, shouted slogans like, "Long live the Kobane resistance!"

Those people were very happy, and it seemed terrible to leave them in the war zone. But we had to return to Turkey. Turkish soldiers wouldn't allow us to cross at the same point from which we had entered Kobane. When we persisted, they used pepper spray on us. We were stuck in that minefield being pepper sprayed. Luckily, none of us stepped on a mine as we crossed the field back into Kobane and traveled to the Mursidpinar border gate to cross into Turkey.

What we saw was unforgettable. Syria was like a desert. People were waiting in line near their cars or their animals, which they couldn't bring across the border. Not wanting to give up their goods, they waited until the last moment. When we walked amid a group of 2,000, a woman approached and asked where we were going. "Take us with you," she pled. I couldn't help because she didn't have a Turkish passport.

I'm a Kurd, but I have a Turkish passport so I'm able to cross borders. I took a picture of a family that included a girl with yellow-blue-green eyes. That photo haunted me for days because I had to leave them in that terrible war. When we arrived at the border gate, the soldiers wouldn't let us cross right away. They used pepper spray, fired guns into the air, and shot some animals. When they decided to let us cross into Turkey, they took our fingerprints, frontal headshots, everything. And we left behind all those civilians with their children and animals. I was so haunted by those images that I couldn't take it anymore, and I went to Istanbul.

I returned to Kobane months later, after the city war had started with ISIS. This war has historically been seen as a second Battle of Stalingrad, the one that happened between Nazi Germany and the Soviet Union. Likewise, the battle of Kobane was between the YPG [People's Protection Units] and YPJ [Women's Protection Units] and ISIS. Many young people came to the border to show solidarity during this hard war.

We'd heard that some people we were looking for had crossed to Kobane, to war. News of their funerals reached us. One day we'd been filming them, introducing ourselves to one another and spending time together. Then we were filming their funerals, because as journalists, we had to. We were burying our friends, but we had to do our job. It was hard.

In addition, the migration problem increased daily, and we struggled with diseases. It was interesting that even though the AFAD [Disaster and Emergency Management Presidency of Turkey] built a big camp, the people who came from

Kobane didn't want to stay. I don't know the specifics, but the camp was a big one, for about 60,000 to 70,000 people. However, only about 5,000 people—Arabs from Syria—stayed in the AFAD camp. Kurdish people stayed in the Kurdish municipality's camps, which were in bad condition.

About 70,000 to 80,000 people were placed in Suruç, a city in Urfa. In total, 200,000 people were placed in camps in Kurdish municipalities. It wasn't easy to meet the clothing, food, and health care needs of so many people, but they overcame that obstacle by organizing an international solidarity movement. People came here from all corners of the world to take part in this solidarity, to show their side in this war. We shot pictures and videos and wrote essays and articles. We also witnessed tragedy: every day there were fifteen to twenty funerals. It was really hard. Every day we buried people who were sixteen, seventeen, or eighteen years old. After a while it became normal, and actually, that's what hurt us the most.

The Kurdish camps were different because they hosted the refugees as guests, asking, "What can we do for you?" There was a collective life in the camps. People worked, cleaned, and cooked together. Teachers from Kobane taught the children. Those camps were like guesthouses rather than refugee camps. There was important solidarity between Kurdish people and people from Kobane. In most refugee camps there's a master-slave relationship between camp employees and refugees, but in the Kurdish camps, the employees were sleeping and eating among the refugees. Even though I was a journalist, sometimes I volunteered. I still have good friends from there and in Kobane.

AW The refugees came not only from the war in Syria but also from the war between Turkey and the Kurds.

MB The problem of refugees in Turkey is actually a general problem in Kurdistan. The world focused on Syrian refugees because the Western countries were intensely affected. But Kurds have lived as refugees in these lands for many years. In the 1980s and 1990s, when the struggle for freedom started between the PKK [Kurdistan Workers' Party] and the Turkish government, millions of people lost their homes. According to the Turkish government, 5,000 villages were burned. In the 1990s, 30,000 people were murdered, killed in acid wells. This isn't acceptable, even in war. Many of the victims were civilians or had supported the Kurdish grassroots movement. Warnings to "Leave in half an hour" to escape village burnings caused many Kurds to flee their homes.

People left with only their slippers. They immigrated to city centers like Diyarbakır and Batman. And when they couldn't earn a living there, they moved to big cities like Istanbul, Ankara, and İzmir. They arrived with only their clothes and lived in ghettos. They couldn't speak Turkish and were further disadvantaged by the 1990s state education policy against Kurdish people. All these factors made it hard to adapt to city life.

Thousands of people had to migrate in the 1990s. The people who left their villages and came to Sur, in Diyarbakır, had already adapted to city life. And when the war broke out in Sur, they had to migrate elsewhere in Diyarbakır. This cycle

continued for a long time. When the war spread farther, the people had to migrate for the third or fourth time, to big cities like Istanbul. This deep instability is painful and tragic for those experiencing it.

AW Turkey never officially recognized refugees but calls them "guests." What's your opinion on how Turkey is dealing with this refugee situation?

MB There's some data about those 2.5 million refugees who came to Turkey during the war in Syria. The demographic structure of Turkish cities on the Syrian border has been changed. Syrian people organized their own living spaces. There's no problem with that. But the main reason that Turkey accepts them as guests and not refugees is that it doesn't want to take formal responsibility. Of course, there's a definition of a refugee, and there's a responsibility that comes along with the classification. Turkey opened the gates and let the refugees step in but then left them to their fate.

AFAD has built some camps, but people can't live there for a long time. While we don't know the exact living conditions, we do know that the camps have problems. But, above all, refugees are low-cost labor in Turkey. Syrian people are working for 100, 200, or 300 lira in jobs where the actual salary should be 1,000 lira or more. This is a project [by the Turkish government] to change the demographic structure of the Kurdish region. There are some claims that Turkey implements those kinds of plans in an effort to place 2.5 million Syrian refugees in Kurdish regions to counterbalance the population.

I think the Turkish government defines refugees as guests in order to minimize its responsibility. But I also believe that Turkey opened its gates to so many refugees to use them as leverage with Europe. Turkey is demanding money or other gains from Europe by using refugees in power politics. It's ethically unacceptable and commodifies refugees for Turkey's benefit.

Actually, Europe is the critical factor. There are historical accounts of how Europe similarly uses refugees. Europe intends to send all refugees to Turkey. But those refugees don't want to live in Turkey, and they can't return to their own countries. It's already clear that the Great Powers of the world started a war in Syria for their own benefit. The result is ten million unprotected refugees.

035

Tibor Benkő, Hungarian Armed Forces
Hungarian Border, 2016-03-28

TB What time does your service end today?

Police It ends at six o'clock in the evening if I'm not mistaken.

TB When was the last time you were with your family?

Police Last week.

TB When are you going home?

Police Five days from now.

TB Five days from now. We wish you an incident-free service!

Police Thank you.

TB Thank you. How is your Easter going?

Police Quite nice; the boys have sprinkled me with water.

TB Do you like to be sprinkled?

Police At Easter.

TB I meant at Easter [laughs]. Many women refuse it. Is the teamwork good?

Police Yes.

TB You complement each other well.

Police Yes.

TB If you were alone, you'd be more scared than with these handsome soldiers, wouldn't you?

Police Yes.

TB We wish you an incident-free service!

Police Thank you.

[TB and police address the media]

Police Ladies and Gentlemen! I'd like to welcome you to this press conference today. Let me introduce you to the speakers, Major Colonel and Chief of Staff of the Hungar-

ian Armed Forces Dr. Tibor Benkő and Major General and National Deputy Chief of Police Dr. Zsolt Halmosi. First, I'd like to ask the major colonel to give his speech, and then he'll be followed by the deputy national police chief. After this we'll answer some questions.

TB Thank you. First of all, I welcome you and thank you for joining us on Easter Monday. Thank you for visiting the Hungarian soldiers and police officers who are completing their tasks together along the border. Assisting the police is the main task of the Hungarian Defense Forces. The protection of the border is a common task. The soldiers have been stationed along the border since last July. They started to build the temporary border barrier and have now been ensuring the stability of this fence system.

Why is this important? We've said earlier that border security constitutes a physical obstacle, but it's still unable to totally deter those who want to cross the border. Powerful, constant guarding and defense are needed on this side of the border. Our soldiers have already been deployed in the Great Plain region and also in Southern Transdanubia since the summer. I visited the Transdanubian region yesterday, and I can tell you from what I saw that they're well prepared to complete their tasks. They're motivated; many of them have just come back from a foreign mission, and they're continuing their service right here on the southern border. There are some soldiers in the Transdanubia region as well who are serving on the border now while simultaneously preparing for Kosovo and Iraq.

The question then arises: Why Iraq? First of all, because of what we're talking about, consolidating local peace so that people don't have to emigrate from their home country. Our cooperation with the police forces is very satisfying. We always receive information on where and in which form military backup is needed, and what kind of technical equipment and personnel recruitment are needed. We fulfill our border security tasks together, and if it's necessary, we're ready to strengthen the temporary border here on the Serbian border. If it comes down to it, we're able to build a temporary border barrier at the Hungarian-Romanian border.

036

Ahmet Osman, *Refugee*
Nizip, Turkey, 2016-03-29

AO There are now many opposition factions in Syria, including "rebel factions," factions that belong to Jabhat al-Nusra and other similar Islamist factions. These emerged at the beginning of the revolution and have been fighting on Syrian land. These are the main ones and haven't changed since the beginning of the revolution. They're fighting the regime, Daesh, and the PKK. We're currently in a war against ISIS on an almost daily basis in the northern rural areas, and thank God, we achieve victories almost every day.

AW Who do you hold responsible for the people's displacement?

AO The regime and Daesh, of course. From the beginning of the revolution, the regime started bombing cities with planes and also used tanks to expel those who rebelled against it. It expelled civilians under the excuse that they facilitated the revolution and thus terrorism. Later ISIS emerged and followed similar methods, in which it dislodged civilians from their homes and villages and took over their properties, exactly like the regime. We make no distinction between ISIS and the regime. Both have the same orientation and the same notion. Both destroyed houses over their owners' heads. Both have killed civilians and displaced them to every place in the world. There's no place in the world without Syrian refugees.

When Russia entered the war on the side of the Syrian regime, the destruction in cities and villages increased, as did the expulsion of civilians. Four months ago, in the northern rural areas, I saw thousands of people being displaced in one to two days. The Russian destruction was really enormous. The Syrian regime would sometimes bomb a town or village once or twice a day. However, the Russian bombardment was drastically violent and caused tremendous destruction. They used the most advanced Russian weapons. Russia came to the region to test its military system in Syria. They're establishing a semimilitary post here in Syria, and unfortunately it's being tested against Syrian civilians.

AW Who supports your brigade? Does Turkey support you as Turkmen?

AO Generally, anyone supporting the Syrian revolution is supporting us as Turkmen. For us, there's no distinction between us as Turkmen and other factions. Turkey hasn't given military support to the Turkmen. Turkey is a member state of NATO and has a specific strategy. Of course, when Turkey wants to provide weapons, they should get permission from all NATO member states. Turkey has supported us politically and morally, and on the humanitarian level. However, we get support from the friends of Syria, who stood by the Syrian people.

AW When do you see an end to the Syrian war? And when will the people return to their homes?

AO The equation is so simple. The end of this war will come with the fall of this regime. If the regime doesn't fall, the war will continue for many years. The regime

destroyed the Syrian people and their houses and displaced millions. The reason is obvious, so why don't we treat the matter from its roots? If we overthrew the regime, that would mean the end of war, the return of refugees, the lifting of the siege of the besieged areas, the entry of humanitarian aid, and the return of millions to their houses to live peacefully. The war's end isn't in our hands; it's in the hands of officials who don't want it to end.

AW If the regime of Bashar al-Assad left many factions that sometimes fight among each other, how will this be resolved?

AO That equation is also simple: If the regime and its dictator fall, we as armed factions will keep what's left from the regime, such as the military. The armed factions will then form a new structure to fight terrorism. When the regime falls, the terrorism that will remain is ISIS. Even the PKK has no role in toppling the regime, because the regime supports the PKK; all of us know that, and when the regime falls, the PKK activities will end. There will be one enemy left for us, which is Daesh. En masse we can easily fight Daesh and win. What delays us from fighting ISIS is the Syrian regime.

I want to send a message to the Great Powers. I believe that they can finish this war. The solution is in the regime's departure and the establishment of a Syrian state free of terrorism: a civil state with institutions, a state that establishes elections democratically, free of extremism and pressure from a dictatorship.

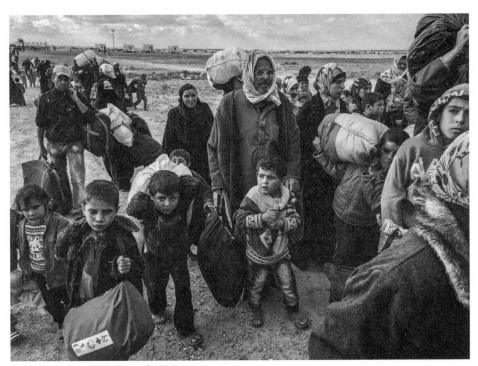

Hadalat Camp, Syrian-Jordanian Border, 2016

037

László Toroczkai, Mayor of Ásotthalom
Ásotthalom, Hungary, 2016-03-29

LT The township of Ásotthalom is located on the Hungarian-Serbian border. Its 4,000 inhabitants live on a huge territory of 122 square kilometers, and 50 to 60 percent of the inhabitants live on farms around the village. Because of this special settlement pattern, we have a common border with Serbia that is 20 kilometers long.

AW Could you please tell us a little more about what it was like in your village before the border fence?

LT We met the first group of illegal migrants from Africa in 2012. This invasion became unacceptable in September 2014. First, people from Kosovo came; then people from Bangladesh and North Africa replaced them in the spring of 2015. There were days in 2015 when thousands of people moved through the village, altogether more than 100,000 people in 2015. The townspeople were very welcoming to the migrants in the beginning. They assumed all were refugees, but later on it became clear that something was amiss. We noticed in 2015 that 83 percent of the people who were caught here in Ásotthalom were young men, and only 17 percent were families with wives and children. There was a new wave of migrants at the beginning of 2016, and many people came from safe countries like Morocco or Bangladesh.

AW What kind of atrocities took place?

LT Our main problem is that this was a very quiet village, and many people, including me, moved here from Szeged because we sought a farm community. Now, because of the immigrants, it's not quiet any longer.

The border behind me was completely porous. As you can see, this is an orchard, and the fields run into one another. Of course, we know our neighbors, so the border was only symbolic. Everybody respected the border before and knew it was illegal to cross it. These groups didn't accept the laws, not even private property. They occupied the farms; they stole bicycles, cars, and even a minivan at Mórahalom. We realized that they didn't respect the people living here, so consequently the harmony ended and our original feeling of safety was damaged by the uncontrolled invasion of thousands of people.

I've been telling this story for two to three years for international television networks, that there could be terrorists and criminals living among the immigrants. Now we know for sure that there were some terrorists in Belgium who were picked up at the Keleti railway station in Budapest, who moved to Western Europe from here.

AW I was informed that putting up the fence was your idea.

LT I asked for this fence at the beginning of 2014. I'm in contact with some representatives of the Hungarian government, and basically, I didn't get an answer. I'd

given up on the fence, but in the end, the Hungarian government decided to build one in the summer of 2015. It was personally a big surprise for me.

AW Your video caused a fuss in the media, but it's actually a little bit like "after meat, mustard." There's no more danger because the fence has been put up, but here comes a video that wants to horrify the refugees who still want to cross the border.

LT The illegal migration didn't end. In the last days, during Easter, hundreds of illegal invaders were apprehended here. The invaders are coming now as well. The difference with the previous situation is that, on the one hand, there are less of them, and on the other, everybody is intercepted. The fence itself isn't enough; there's a need for a strong, live defense behind it. Thank God, the Hungarian army and police are here in sufficient numbers. As you can see, we can walk free without meeting any migrants. It's not really guarded on the Serbian side even now. Previously, we rarely saw the Hungarian or Serbian police, but now some are guarding the border. The migrants still come and cut through the fence, but they're intercepted after a few hundred meters.

AW Did your video target the general public or the migrants? I don't know if the fence scared the migrants away or showed the voters how vigorously this area has been defended.

LT The timing of the video was perfect. We released it on September 15, the day that the legal rules [on intercepting illegal migrants] were launched in Hungary. Although the fence was built in the summer, the illegal migration ended after the legal rules came into effect, because it made it possible to intercept invaders and bring them to justice. It was a message to the migrants, but foremost I wanted to send a message to the smugglers.

There are two types of smugglers: the criminal networks and the politicians. Both groups engage in smuggling missions. The politicians hide behind the mask of humanity; in fact, their goal is political benefit, as they need cheap labor. I'm talking about Germany and Angela Merkel, in particular. I'm also referring to political forces who consider these migrants as future voters. These aren't the right parties, and they don't care about nation, homeland, and tradition. They're voters of the liberal left parties, and they help illegal migrants for political reasons and criminals for financial gain. My message goes out to both of these groups.

AW How do you think we can end this human catastrophe in Europe?

LT Basically, I think refugee camps with high-quality life standards should be established in the first safe countries. Hungary is a good example—it gave shelter to people who escaped the Yugoslavian war. The Transdanubian region took refugees who escaped the Croatian war. For example, if a mass of people came from Ukraine because of the war, we'd be one of the first countries who'd say that we should take them in as refugees. But this invasion, what happened here, isn't about that. These people pass through many safe countries, and they want to decide on their final destination in the hope of earning a lot of money. This is unacceptable and uncontrolled—and it's against the law.

We let in unknown people, including terrorists and criminals. We have no idea about who they are. Of course, there are some real refugees as well, but a real refugee could stop in the first safe country. So, there should be refugee camps that the European Union supports with money and humanitarian aid. The other important thing is that the European Union and the US should reconsider their foreign policy. They should reconsider where they support wars, and then this great migration could end.

AW One more question: In Hungary, is Ásotthalom still the most dangerous area?

LT The truth is that most of the people came to Ásotthalom at the beginning of 2015, and when the video became public in the second half of 2015, Röszke, next to Szeged, was most affected. I don't have statistics about the current situation, but I can assure you that there's order and safety at Ásotthalom, as you can see from our ten-kilometer trip from the office. If we'd come here a year earlier, it wouldn't be the same, because hundreds of illegal invaders would've marched in the middle of the street. Now it's quiet and there's peace.

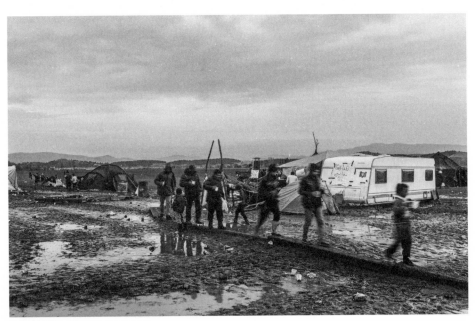

Makeshift Camp, Idomeni, Greece, 2016

038

Ahmad Touma, *Syrian Politician*
Nizip, Turkey, 2016-03-29

AW What will the latest peace talks in Syria lead to?

AT I believe we've reached the final turning point in the Syrian cause. It's the first time that the international community, whether led by the US or by Russia, is serious about finding a just political solution. The Russians have come to Syria, and that's changed the equation in the regime's favor. My guess is that the negotiations will bring about a solution for Syria that starts with a road map. This is what [UN envoy for Syria] Staffan de Mistura's team is seeking in the coming three months. Negotiations will happen based on this road map that De Mistura will establish according to the talks taking place in Geneva, which include inquiring about American intervention in the Syrian matter and the US's focus on fighting ISIS and not the regime.

AW What do you think about this?

AT I believe that the American position is essentially with the Syrian people, that America desires to see the Syrian people free from tyranny.

AW What is the Americans' priority?

AT Its recent priority has been facing Daesh and terrorism, and this has damaged us. We've told the Americans from the beginning of the revolution that if they interfered, they should resolve the problem and the misery in Syria [caused by the regime] before it gets worse. The Americans should've intervened and put pressure on Syria to find a just solution that favored the Syrian people before the situation worsened and ISIS arrived. Now, after the emergence of ISIS, the Americans think fighting ISIS is more important. I know that the American position isn't with the regime; they're against the regime and they want freedom for the Syrian people. However, their priorities decreased our support. Moreover, American nonintervention gave Russia an opportunity to intervene and rebalance the situation in the regime's favor.

AW Who do you blame for the huge number of displaced people? What's your responsibility as an interim government?

AT The direct responsibility for Syria lies with the regime. The regime fought people's demands for freedom and dignity and instead responded with killing and destruction. The secondary responsibility lies with the international community, which misinterpreted the Syrian tragedy as a civil war instead of seeing that the Syrian people were pursuing their freedom against a regime that enslaved the people.

With regard to our role dealing with the refugees outside of Syria, the Turkish government is responsible for most of the services for those refugees in Turkey. Our role is in coordinating with the Turkish government to provide education

through existing Syrian schools. We facilitate procedures for injured people and bring them to the hospitals through the Ministry of Health here in Turkey. We also coordinate with Turkish civil society organizations. Regarding refugees outside Turkey, we can't do more than communicate with countries like Germany, Austria, France, and other European states. Most of the refugees traveled to Germany, and we're communicating with the German government about their situation. I believe that the German and Turkish governments are making significant efforts to look after Syrian refugees.

AW What do you think about the EU-Turkey agreement for refugees? Is it in the interest of the EU or Turkey?

AT I want to look at the matter from another perspective. What we want is for the Syrian war to end, and for Syrians to return to Syria. Syrians themselves don't want to stay long in Turkey or permanently stay in Europe. The circumstances of war forced them to leave. At the same time, we understand the situation in these countries. Turkey hosts 2.5 million refugees, which is a huge number. Germany has also hosted one million refugees in one year who need much care. This requires a significant effort, and we really appreciate these efforts by the Turkish government and the European states, especially Germany.

However, we shouldn't overlook the main problem, which is this regime, which has committed crimes against its own people and intentionally expelled its citizens, emptying Syria of Syrians. With regard to the EU-Turkey deal, it has reduced the ability of Syrians to move and seek asylum. However, we can't reject this agreement and say that we don't want it, because we understand the situation of these countries. These countries aren't able to respond to Syrians' needs because the numbers are very high. What we want urgently from the international community, and especially from America, Russia, the European countries, and our friends among the Arab peoples, is to increase the pressure on the Syrian regime to end the war and start the return of Syrian refugees to safe areas in Syria. This is their land.

AW Do you think it's fair that all of Europe hosts one million Syrians, Turkey alone hosts three million, and then Europe stops hosting refugees?

AT If we talk about the matter in numbers, then the issue isn't fair. However, I'd like to return to the main idea. I want to make a plea to the whole world: We understand all these circumstances, and we don't look negatively at what these countries are doing. We understand that they are up to their capacity in terms of welcoming more refugees. We don't want all the people to migrate to Europe, but it isn't safe for Syrians to stay on Syrian lands. We want to find a solution in Syria where people can return to a safe environment in their own country.

039

Zaki and Manan, Refugees
Bicske, Hungary, 2016-03-30 / Hannover, Germany, 2016-04-12

z My name is Zaki and I'm from Iran. It's been two months since we started our trip from Iran.

m My name is Manan, and I'm Zaki's brother.

aw When did you arrive to Hotel Hara?

z About fifteen to twenty days ago. I don't remember exactly.

aw Can you tell us about your journey?

z We traveled from Turkey and came to a Greek island by boat. The police gave us a note to stay legally for thirty days. We arrived in Athens and found someone to take us to Germany or Austria for a fee. We stayed in Athens for ten days, and then he bought us train tickets and we came to Thessaloniki. I think it's the last border town of Greece.

Since the camp on the Greek and Macedonian border was full, the police didn't let us go to the Hara Hotel by taxi, because that's where everyone starts to try to cross the border. The police were in the middle of the road checking passengers. We had to get off and walk through the forest. We passed the police and then we got a taxi, which took us to the Hara Hotel. We stayed there for two nights. It was so busy that there was no room for us. We had to sleep outside in sleeping bags that we had bought before. It was so cold and it rained. We spent two days like this and then started our journey to pass the Macedonian border. We traveled together with some friends. There were eleven of us, all Iranians. We were with a group of fifty people of all nationalities, including Pakistanis and Afghans.

We set off to the border and walked about an hour and a half to two hours, then arrived at the fence. The Macedonian army was on the other side of the fence checking people. The guide held us for four to five hours in the mountains in cold weather and said we could continue after the police had gone. There were people who knew the road. I think they were Pakistanis. We slept for three to five hours and nothing happened. They sent us back the same way we had come, to the Hara Hotel. We spent the night and in the morning our Athens contact told us that he would send us another way. We started again and he told us he'd taken us as far as he could. I asked a person who knew the way how far we should walk, and he said twelve hours. It was a rainy day too. We thought that if we went, nothing good would happen to us, so we didn't go with him.

We stayed another night at the Hara Hotel, then the next day four of us—my brother, me, and two of our friends—decided to go back to Athens and return when the situation improved. But seven of our friends stayed; they set off at night, and thank God they passed, but barely. They spent ten to twelve hours crossing Macedonia until they reached Serbia. I think they were on the road for six to

seven days. They went the same way we did, and now they're in Austria. When we came back, we saw that our friends were gone. After two days we went through the same process in order not to encounter the police. Again, we came to Thessaloniki, then the Hara Hotel (the same night), and since then we haven't slept for two nights. Our contact made us leave.

M We were on foot all the way. We walked through the forest, villages, and farms. The night before it had rained so heavily that our feet were heavy with mud and we could hardly walk. We walked about twelve hours through the mountains. Then we passed the Macedonian border. We were told that there were police everywhere, so we had to wait until they were gone so our contact could bring a vehicle to pick us up. We waited until night and nothing happened. We were in the rain with no shelter. Our backpacks were so heavy, and it was impossible to walk. That night they handed us over to some Turks who were smugglers in Macedonia. They also made us walk for eight hours in the rain because there were police. This happened for three nights. We stayed in the rain for the whole seventy-two hours.

AW Where did you sleep?

M In the forest. We were all wet, as were our belongings. There was nothing left to eat. There were about twenty-five of us after three nights. A car with a capacity of four came and the smuggler crammed seven people into the back and two people into the trunk. He drove us to a point and said he would come back and bring more people, about nine to ten, to this point. He did this three or four times. Then they made us walk again, about one kilometer, and we waited again for four hours, until 3:00 a.m., when a van came. Fourteen of us got into a seven-seater van; it was so tight we couldn't breathe. The windows were tinted and we couldn't see anything. We were on a country road and got to a village. The road was uphill and the car broke down. Once again they left us in the rain.

My brother and I were the only Iranians there. The rest were Pakistanis. We stayed under the rain for a couple of hours and saw some ruins far away; we decided to go there. We went inside an old church and made a fire to warm us and dry our clothes. The Pakistanis went in and out of the church a lot, and after a couple of hours, a villager saw them and called the police. The Pakistanis ran away but we couldn't bear this anymore. We gave ourselves up to the Macedonian police. They took us to a camp and sent us back to Hotel Hara the night after. They brought us near the border but didn't send us through the main gate. They dropped us off and made us walk a bit. On the way, they hit us to scare us into not coming back, then sent us back through a break in the fence.

We were so disappointed to be back at the Hara Hotel. We didn't want to try again. We stayed there about two more days and spoke to the guy in Athens about what we should do. We wanted to go back by plane because we were really tired, but he offered another suggestion: there was a car that could take us to Hungary and drop us there, because we really couldn't walk the whole way. We accepted and paid the money. We went again to Thessaloniki and got ready to get into the car with about sixteen other people. From there they took us by taxi. All sixteen people got into the car and went up the hill. They dropped us off in a forest hut.

About fifteen people were already there before us. It was a nine-square-meter hut filled with thirty-one people. We stayed there for two days without any food or water. It was really hard and too dirty, without any toilets. We couldn't do anything: we couldn't make a fire in case the police would see it, and we didn't know where we were.

The second day at 10:00 a.m. we started walking through the hills and forest in the rain. We walked until midnight to reach a safe point where a car was supposed to pick us up. We sat there for about four hours. We pulled the sleeping bags over our heads but water leaked in anyway, and we got wet from head to toe. It was a very bad situation. We could handle it, but there were families with us who had little kids who were having a hard time. We stayed there for about four to five hours until a minivan came, then all of us climbed into the minibus. After forty minutes, the driver said there were police coming, so he dropped us off again. The same process began, all in the rain.

After two hours another car came for us. It was an Audi. Nine people got in: two to three people in the trunk, five to six people in the backseat. Each time the driver took a group to the Serbian border, it took forty minutes. We stood in the rainstorm for hours.

z We were in the first group to get in the car, and there were about thirty of us. The storm was very harsh. We were soaked, and with the wind, it was a horrible situation. The driver brought everybody near Serbia, five or ten kilometers away from the Macedonian-Serbian border. We set off around 4:00 a.m. on foot and passed the border at 6:00 or 7:00 a.m. It had rained on previous days, so the ground was muddy. There was an Afghan family, a mother and her three kids, who were having a hard time, so we helped them reach the Macedonian border, but after that they were exhausted. The only thing we could do for them was to take them near the road so the police could see them.

When we reached the Serbian border around noon, we could see the customhouse on our left. We continued walking. They told us that if we walked for one more hour, we'd reach a house where we could rest, and then a taxi would take us to Belgrade. I think we walked about eight hours instead of one hour—about 300 kilometers altogether.

About thirty of us were walking along the road in a line. Suddenly a car stopped up the road. I think they were the border patrol. We'd heard that the Serbian police would deport you just like the Macedonian police. For three hours we ran away from the police, despite our exhaustion, because we didn't want to be deported. After three hours of being chased by the police, they took some of us, about five or six people. The rest of us were held for three to four hours in the police station. They gave us a permit to stay for seventy-two hours and freed us. We were so happy. It was the best news when I saw the passes. I understood the difficulties had ended because the hardest part was at the Macedonian border.

We stayed the night at a camp. The next morning our contact brought us to Belgrade by car and dropped us somewhere near the beginning of the city road. I think all the migrants were there. He brought us to a very dirty inn, and the next

morning he bought us bus tickets to the Hungarian border. We got on the bus, and after two hours we arrived. We walked for two to three hours to the fence. We were waiting for them to cut the fence.

Then we heard the police and we all freaked out. We ran away, and then the smuggler came and told us that the police wouldn't make any problems and to go ahead. We moved toward the fence. Suddenly the police shined the light on our faces with their car lights and flashlights. There were women and kids with us and many families. The Hungarian police kept saying, "Go back to Serbia." We said, "No go back," and every time we said, "No go back," they fired tear gas at us. We couldn't breathe. Tears streamed down our cheeks. The police didn't let us pass and told us to go back all the way. We had to go back to the forest for half an hour.

The guy traveling with us who knew the way was supposed to bring tools to cut the fence, but he forgot them. We've all been played by smugglers, hearing their lies all the time. They made us sleep in the cold forest, all thirty of us, until 5:00 or 6:00 a.m. When it started to get light in the early morning, we were sitting there thinking about what we should do. Suddenly the smuggler called to us and said, "Run over here; the police aren't here." We saw that they had pulled the fence up forty or fifty centimeters from the ground. We passed under the fence and entered Hungarian soil.

Ahead of us was a swamp that took us an hour to get through. We were on our way when we found that we were surrounded from both sides by police. The police took us to the station and asked us some questions. We explained our story and they put us in detention and took our fingerprints and pictures. They held all of us, including the families. We slept on the floor. There were no blankets, but we were so tired that we all passed out. In the morning, they woke us around 3:00 a.m. They took us to the immigration office, where they asked more questions and matched our fingerprints. They gave us another document and told us that we'd be sent to a camp.

The camp we're in now gives us two meals a day and a pass by which we can enter and leave. All we try to do is talk to the smugglers to continue our way by any means necessary to reach our destination.

AW You're waiting to go somewhere else?

M Yes.

Z Yes.

AW Germany?

M Yes, yes. But the reality is that no smuggler speaks the truth. We heard many lies. You pay for the car, but there is no car and you have to walk. They say there's a house, but we didn't see any house. We're paying for nothing. The smuggler just knows the way. He doesn't do anything for us. The way is so hard, very hard.

AW Why did you leave Iran and why are you going to Germany?

z We left Iran because we had some problems there. We're Christians. The situation was hard for us there. We packed our things at night and set off. I was banned from leaving the country because of military service. We were scared to leave. We were scared that the authorities had our names and would come for us.

M And Iranian intelligence agents will deal with this matter. We live in Mashhad, where they closed all the churches. There are also police in Tehran churches.

You have to be born Christian to enter the church. You get checked, and it's not an open atmosphere. You have no right to choose, and as soon as they find out you've converted to Christianity, you're sentenced to death. Many of our friends had problems like this and they're still in prison. We had to escape for our lives. You were born Christian or you changed your religion. We were at the level of investigating Protestantism, Catholicism, and Eastern Orthodoxy. We were looking into these things so we could choose to be believers, but this happened.

We arrived in Urmia at night and found a smuggler who brought us through the mountains. The Turkish police found us and for seven days we stayed in a border camp, in a police station. We had to lie and say we were Afghans, because if we said we were Iranians, they would've brought us back. The smuggler had to pay to release us from the police station so we could continue our journey and go to Istanbul, then İzmir, and from there by rubber boat to Greece.

AW And Germany?

M Our relatives are in Germany. My aunt has been there for thirty years and we haven't seen her. Many countries could be safe for us but my uncle, cousins, and aunt are there. We could've stayed in Greece because it's a safe country, but our relatives said to go to Germany so they could support us.

[Two weeks later]

z Our last conversation was in Hungary, in Bicske camp near Budapest. There were a few smugglers inside the camp who were staying there for a long time. They demanded a lot of money to take people from different nationalities to Austria or Germany. I think they've been living inside the camp for almost a year.

When we entered Hungary, the police imprisoned us for two days. Then they sent us to Bicske camp, near Budapest. The situation there was so horrible. Many of the people were from Pakistan and they pretended to be Afghans. There were a few Iranians there. The majority were Pakistanis, Iraqis, or Syrians.

There was a big steel building and all of its rooms were full. It seems that they only give rooms to families. We got there at 4:00 a.m. and had nowhere to sleep while waiting for our transit cards that would allow us to enter and leave the camp. It was around 6:00 a.m. when we got our cards. We fell asleep for an hour and they woke us at 7:00 a.m. They took us into a steel house like a big gym. It was such a dirty place, and nobody took care of it. We stayed there for a couple of days.

We knew smugglers who were offering to take people to Austria or Germany, and each of them had different prices. One of them was asking 500 euros, the other one 600 euros, and one of them just 300 euros for Austria. There were many offers. They'd say there was a car, but there was no car. My friend tried it three times. On the fourth attempt, he made it to Austria.

On the fifteenth day the smuggler said that he had sent a person. A man called us around 7:00 or 8:00 p.m. We put on our clothes, packed our stuff, and ran away from the camp. We walked for about twenty minutes and reached a train station in Hungary where we bought tickets for Austria; the train was supposed to be there in five minutes. We got on the train and got off after two stations, then waited for another train that would take us directly to Munich. The smuggler was with us. We found an empty compartment with two other German guys and sat there with them. We entered Austrian soil—very easy.

Our train stopped for two hours in Salzburg. I don't know why, but we stopped there for two hours. A few minutes before the train's departure, police arrived and knocked on each compartment's door asking for passports and other documents. When he knocked on our door both of us were stressed. We had seen them take some people who looked like refugees off the train. Before the police got to our compartment, the smuggler gave us two cards and said to show these to the police.

We took them and put them in our pockets. The policeman knocked on our door and asked for our passports. I think we were lucky because there were two foreigners in our compartment and we looked relaxed, but we were so stressed inside. The two gentlemen showed their cards and so did we.

The policeman took our cards, glanced at them, and gave them back. The moment he left I was so happy that I didn't know if I should laugh or stay silent. I was checking my mobile phone location all the time. When we arrived in Austria, I was so happy. When we were in Salzburg, a couple of steps from the German border, we looked at each other and laughed. We looked at each other and smiled several times, checking our location on our mobiles and showing it to each other. When we arrived in Germany there were no stops until one just before Munich. We were so happy, and we couldn't sleep at all from the moment we got into the train until the nine-hour ride was over.

When we got to Munich, the smuggler was still with us. He was supposed to book the tickets to our final destination, but he left us and we had to book the tickets ourselves. However, we were satisfied that we got to Munich. We got there so easily, we didn't believe that it had actually happened. I thought it was a dream.

M We got to Munich about 6:00 a.m. We happily got off the train, and as we hadn't eaten since the night before, we bought something and filled our stomachs. We asked for the departure time to Hannover because one of our friends was living there. We booked the ticket forty minutes after we arrived. There was a departure for 6:45 a.m., so we booked the ticket, got on the train, and arrived at 11:20 a.m. Our relative picked us up from the station and was so kind. On the way to their home, I couldn't believe that we were here. We suffered many difficulties to

get here, and in spite of all those difficulties, everything was so much easier once we got here. It was so enjoyable and sweet.

We're now searching for a city that best suits our profession and our future. We're researching these matters, but I'm so happy that I'm now somewhere safe where we can freely talk about our beliefs and opinions. There's nothing else to say, but I'll just make a wish. We saw many things in Iran: women and children that had to remain midway in the jungle because they were too tired to continue; there were many families in our camp in Macedonia and some of them drowned. I get goose bumps when I talk about those events; they were so horrible.

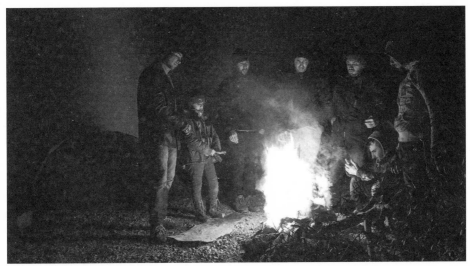

Moria Camp, Lesvos, Greece, 2015

040

Anonymous, Turkish Citizen
Dikili, Turkey, 2016-04-02

A I've been living in Dikili for seven years. I'm so happy to live here. But after refugees came here, we've been very uncomfortable. They can bring disease. They steal everything. Our backgrounds are different. We don't want them here under any conditions.

AW Have you come to express your opinion?

A Yes, I have for sure. This is a summer resort. We can no longer eat the fish. We can't eat the fish because of dead bodies in the sea.

AW So what's your suggestion? How can things be better?

A We don't want refugees here. They've destroyed Turkey. I'm seventy years old and I don't fear anyone.

AW Do you have anything else to tell us?

A Yes I do. My son and grandson ran away to America because of the refugees. We can't live here anymore. I won't remain silent. I won't. When you remain silent, they take more.

041

Mustafa Toprak, Mayor of Dikili
Dikili, Turkey, 2016-04-02

MT We recently heard speculations that a refugee camp will be built here, but we can't find an announcement about it. As the mayor of Dikili, I don't have any information about it. Locals were naturally concerned. That's why we invited all NGOs, site managers, and politicians to discuss this topic. We started the Dikili Platform for this purpose, and the platform asked me to speak publicly about it. We need to explain why a refugee camp shouldn't be built here for logical, commonsensical reasons. Therefore, we need to make a statement to the press about our concerns.

AW What are your reasons?

MT The refugees have already escaped from many coasts. When you can't stop their escape, how will you protect them? How will you educate refugee children? Health care is another concern. We don't even have a full-capacity hospital here, so how can we take care of their health problems? We only have local hospitals, which aren't enough for serious diseases.

AW The first refugee group will come next Monday. What do you think?

MT As our previous conversations were based on speculation, we'll still conduct our conversation around speculation.

AW Do you have anything else you want to say?

MT Yes. We don't want to be misunderstood. Dikili isn't opposed to refugees. From the beginning we've provided them with humanitarian aid. But we don't want to change Dikili's demographic structure. Apart from that, the most important thing is that the refugees who come here risk their children's lives to cross Europe. Nothing can stop people who risk their children's lives. Even if you fill the sea with NATO ships, neither Turkey, nor Greece, nor Europe can stop those people. There's only one solution: peace in the Middle East.

042

Zaharoula Tsirigoti, *Lesvos Police*
Lesvos, Greece, 2016-04-04

AW There's a Greek-Turkish agreement for readmission, correct?

ZT Correct. The agreement of March 18 between the leaders of the European Union and Turkey. The previous readmissions took place from the land borders at Kipos [the land border between Greece and Turkey in northeastern Greece].

AW So you return people regularly?

ZT We returned about 800 people to Turkey from January 1 until yesterday.

AW Of which nationality?

ZT Pakistanis.

AW From the land border?

ZT From the land border. What's new is the way they've been returned.

AW Are there anymore returns for today?

ZT No, we're finished. During the week we'll coordinate with the Turkish side for the next returns.

AW How many policemen are expected as reinforcements from other countries?

ZT We're expecting around 400 policemen in the coming days. At the hot spots [Greek reception centers] on every island it's the same. Registration, screening, and mapping of the aliens takes place. All of them are asked if they wish to apply for asylum. These are the rules of the EU, and we adhere to them.

AW UNHCR has left the camps in protest of the EU-Turkey deal.

ZT No, it's still there. The UN is a partner of the EU.

AW But you've been harshly criticized over the agreement.

ZT That's a political decision.

AW Do you know what's going to happen to the people you're returning to Turkey?

ZT If they ask for asylum, they'll receive it in Turkey. Otherwise, all the migrants we've returned to Turkey are from Pakistan, Bangladesh, Algeria, Sri Lanka, and Morocco. They're economic migrants.

AW Were any Syrian refugees returned?

ZT We have only two Syrians. They wanted to go back voluntarily.

043

Nadim Houry, Human Rights Watch
Beirut, Lebanon, 2016-04-06

NH Lebanon is in a particularly challenging position these days. It's very unstable and has experienced one crisis after another. The civil war ended in 1990. Then we had the Israeli occupation of large parts of southern Lebanon until 2000. We also had the Syrian Army in Lebanon until 2005. While foreign armies pulled out after 2005, the country has remained divided and polarized. We've seen other armed conflicts with Israel, shorter, internal armed conflicts in 2008. Since the Syrian refugee crisis, Lebanon now hosts the highest per capita number of refugees in the world. Almost 25 percent of the population in Lebanon consists of refugees. Historically, we had 400,000 Palestinian refugees who escaped Palestine in 1948, and now we have almost 1.2 million Syrian refugees registered with the UN Refugee Agency, though the actual number is a bit higher.

AW Are all the people who come here from Palestine—or, more recently, Syria—registered as refugees? Do they have refugee rights?

NH Unfortunately, Lebanon never ratified the 1951 Refugee Convention. Refugees aren't recognized as such under Lebanese law, and Lebanese officials often prefer to use the term "displaced people" or "migrants." At the same time, Lebanon allows UN agencies that recognize refugees to operate here. For the Palestinians, it's the United Nations Relief and Works Agency for Palestine Refugees in the Near East (UNRWA), which historically has assisted Palestinians, and for other refugees UNHCR, which actually registers refugees. But it's not sufficient for them to have legal status in Lebanon. That's why today, for example, many of the Syrian refugees who are registered with UNHCR don't actually have legal status in Lebanon. In the last year we've seen that 60 to 70 percent of Syrian refugees are registered with UNHCR, but at the same time they could be arrested if they're walking on the streets of Lebanon.

AW So they basically become potential criminals?

NH Exactly. Lebanon knows that they can't arrest 600,000 or 700,000 Syrian refugees who don't have legal status in the country. We've talked to the Ministry of the Interior about this, so they know. Lebanon's prisons can only hold 8,000, and they're already overcrowded. But they've made it harder for Syrian refugees to keep their legal status. They ask each Syrian refugee above the age of fifteen to pay an annual fee of $200 to renew their residency. But many Syrian refugees no longer have the means to pay. In the last statistics we've seen, 70 percent of Syrian refugees live below the poverty line and 90 percent of them are already in debt. So many of them have lost all legal status, particularly the men, who are most afraid of being arrested. Many of them don't leave their homes. We have many checkpoints because of the security situation, particularly in areas where they live: the Beqaa and in the north in Akkar and Tripoli. They're worried about leaving their homes and getting arrested.

What do they resort to? They send their children to work, because children have a

lesser chance of being arrested or harassed at checkpoints. It's really a very difficult situation. That's why many Syrian refugees in Lebanon would like to leave, but many of them are unable to. Most doors have now closed in their faces. But leaving and escaping is also expensive.

Families now get into debt to help one person in the family try to make it to Europe. It costs between $5,000 and $10,000 for one person. This is why the refugees trying to make their way across are determined not to fail. That's why they try against all odds—they know their family has gone into debt for this chance. Meanwhile, the families, the wives and the children, stay here, waiting. Waiting for news, waiting for their husbands to make it to Europe and to bring them over.

AW Do people just enter from Syria across the Lebanese border?

NH Syrians and Lebanese have always been very close. Even before the conflict in Syria, many Syrians used to come to Lebanon, particularly to work in agriculture and construction. They were migrant workers. When the conflict started in Syria in 2011, many of them started bringing their families and relatives, and the numbers increased. These Syrians were mostly coming from areas initially affected by the violence in Syria: central Syria, areas like Homs, Hama, and around Damascus. Many of their towns had been destroyed, or they had to escape arrest and torture. Even to this day when we sit down with them, they'll say, "We're too afraid to go back because we may get arrested, we still have detained sons, we still have husbands who've disappeared that we don't have news of."

The border with Lebanon was wide open until early 2015, and most refugees arrived before that. In January 2015, Lebanon imposed new regulations at the border. Syrians had to fit one of six categories to be able to come into the country. They had to show that they had a hotel reservation or some money. This reduced the number of Syrians. But Lebanon has also made it harder for the 1.2 million Syrian refugees already in Lebanon to keep their legal status. In the last year, we've seen a dramatic worsening of the situation for the Syrian refugees.

AW How about the Syrians who arrived earlier, and the Palestinians? What's their situation?

NH We talk about Palestinian refugees but actually the majority of these Palestinians were born and raised in Lebanon. You still have people who escaped in 1948, but most Palestinian refugees today are actually their descendants. Lebanon has always treated them as a separate category of people. They don't have citizenship rights. There's discrimination against them in the jobs they could access, registering their real estate, and in terms of their ability to participate in Lebanese life.

Some of it has to do with Lebanese fears about the country's demographic balance, but some of it also has to do with the civil war, because Palestinians were part of the civil war and some Lebanese felt that the Palestinians were their enemies. There's a heavy historical legacy. Most Palestinian refugees today live in urban slums. They've been marginalized, set aside, and to this day, the Lebanese experience with the Palestinians colors the official Lebanese response to the Syrian refugees. For instance, you'll often hear Lebanese officials say, "We don't

want to absorb the Syrian refugees or allow them to stay longer, because they'll become like Palestinian refugees. They'll stay here."

When the Syrian refugees started arriving, Lebanon, unlike other neighboring countries like Jordan and Turkey, didn't set up any Syrian refugee camps. To this day, there are no official refugee camps for Syrian refugees. Basically, Syrians are spread across Lebanon. They're renting, depending on their economic condition: middle-class families rent in good neighborhoods and others rent in abandoned factories, slums, any space they can find. In more rural areas like the Beqaa, they've set up informal camps. They're not official camps. They're actually renting land from Lebanese landowners who are making money by letting their agricultural land for Syrians to set up their tents.

AW In other words, Lebanon has created another class that profits from this refugee situation.

NH Some Lebanese have benefited because they're renting and selling certain things, and sometimes they're abusing their situation. I don't know if you can say that Lebanon has benefited as a whole; Lebanon as a country has also lost out. When 25 percent of your population is refugees, there's more cost for electricity and water, and there's pressure on the infrastructure and the job market.

Lebanon is now effectively an isolated country because of the conflict with Syria. In the south you have Israel, and in the east and north you have Syria. It has a real economic crisis as well. Many Lebanese, particularly poorer Lebanese, have also suffered. The absence of an official state response to welcome Syrian refugees meant that each community has had to find solutions at the local level. Most Syrian refugees have gone to some of the poorest areas in Lebanon because that's where they could afford to rent.

The pressure on these poor communities has increased dramatically. As an example, the Palestinian refugee camps were already in some of the poorest areas in Lebanon. Many Palestinians from Syria who escaped to Lebanon have gone to these Palestinian camps. They were already overcrowded, with very few services, and now they have tens of thousands of additional inhabitants without any increase in assistance. So we've seen poor communities being dragged down, and even competition between different communities. Whether Lebanese, Palestinian, or Syrian, all of them are marginalized, and all of them are now increasingly competing for scarce jobs and resources.

Who's to blame? There's clearly blame on the Lebanese government in terms of not having a clear strategy. But also, Lebanon, already a fragile, poor, very unstable country, was never going to have the full answer on its own. There hasn't been enough international solidarity. We see that now with the European crisis in terms of resettlement positions, in terms of real burden-sharing. The Lebanese economy can't create jobs to absorb all these job seekers.

AW How would you compare Lebanon with Turkey? Turkey is another location that hosts many refugees. They call them guests. But those guests have no rights. Their children don't receive education and there's very basic medical care.

NH I'd say the situation is difficult today for Syrian refugees across the region. Neither Turkey, nor Jordan, nor Lebanon recognize Syrians as refugees. Originally, Turkey, a bigger and richer state than Lebanon, presented a very organized response for the early wave of refugees. They set up camps and tried to provide support, though as the conflict has continued and the numbers have increased, we've seen major cracks in Turkey's response. I'd still say that Turkey has adopted better policies than Lebanon. For instance, they're looking into allowing Syrians to access certain jobs. But in practice, just given the numbers, their response is still not enough.

In Lebanon, the situation is even more precarious. Again, while Lebanon probably has fewer refugees than Turkey in terms of absolute numbers, it's much higher in terms of per capita numbers. Unlike the Turkish government, which has tried to come up with a response, here the government hasn't come up with an official response at all, so Syrians here have even fewer rights than in Turkey.

The one advantage in Lebanon is that they speak the same language, so this is easier for Syrians. Many Syrians have contacts with Lebanese and other Syrians who've been in Lebanon for many, many years. But the situation is really dramatic. Almost 200,000 Syrian kids aren't going to school. The Lebanese Ministry of Education has been taking some steps in the last two years to improve the situation, but it's still well below what's needed. And even when new places are made available in public schools, many Syrian families have become so poor that they actually need their children to work, even if the schooling is free.

After five years, we realized that the problem is getting more and more complex. Resources are dwindling. The government needs to adopt more progressive solutions or tackle issues that are still taboo in Lebanon. For example, the right to work for Syrians is something that the Lebanese officials don't want to talk about. But the truth is if the Syrians are unable to work, and there isn't enough international aid, they have to pay rent every month, so we'll continue to see children working in the streets of Lebanon. We'll continue to see Syrian families increasingly going into debt. And we'll see increasing numbers of Syrian families trying to make it to Europe, regardless of the many risks along the way. We've also seen Lebanese families in situations that have become so bad—particularly in poor areas around Tripoli and in the Beqaa—that they're trying to make it to Europe by pretending to be Syrians. They also see no future in Lebanon. This is quite dramatic.

AW There have always been refugees throughout history. What's the most characteristic feature in human rights violations?

NH I've been interviewing refugees from various conflicts for ten years: Iraqi, Palestinian, Syrian, Afghan, Sudanese. I'm always struck by two things: they search for security for themselves and their families, and they also search for hope.

Refugees are some of the most compelling characters. Yes, they're escaping death, but they also love life and want to give their children a better future. What does this mean in terms of rights in particular? When they talk about security, they want legal status. They want to know that no one's going to come and knock

on their door in the middle of the night and arrest them. They want to know that if they walk outside, they're not going to be arrested at a checkpoint on the street.

But they also want hope. The adults want to be able to work, because they didn't leave their country just to sit in a refugee camp and do nothing all day. They want to be able to provide for their families. They always tell me, "We didn't escape certain death to face slow death." They want a fresh start. And these days they're finding this very hard in places like Lebanon, Turkey, and Jordan; that's why so many of them are trying to make it to Europe. Many of them will tell you, "Maybe it's too late for me, but it's not too late for my children."

AW Many European countries shut their borders and made all kinds of policies and deals in trying to cope with the situation.

NH The European Union's new policies are shameful, and there are a number of European countries like Hungary and others that aren't being true to their history. The 1951 Refugee Convention, in large part, was adopted as a result of the Second World War and what happened in Europe. Entire European populations were displaced. The 1951 Convention provided these displaced Europeans a chance for a fresh start. The Eastern European countries that are now closing their borders and building walls are the same countries from which refugees were escaping forty or fifty years ago.

I think Europe has to find its spirit again. Building Fortress Europe isn't going to protect Europe. I'm not just talking about violations of international law but also about key values and principles that were at the heart of the European project. Given the wealth and population of Europe, they should be able to tackle this issue. It's not an easy issue, but it's not unprecedented.

It's a bit like a multinational corporation that outsources its problems to another country. We don't want to pollute the environment here, so we'll outsource the polluting activities. This is how Europe is thinking about it, and they're doing it by paying Turkey. It's not just against international law; I think there's a real shameful aspect to it. Ultimately, it will weaken Europe.

AW Why has "human rights" become a term that people don't even want to mention?

NH It's the politics of fear. It also explains why someone like Donald Trump is gaining popularity in the US. In part, we live in an age of rapid change. Globalization has many positive aspects but it also creates anxieties. People feel overtaken by events, and refugees are probably the weakest link in all of this. But this kind of fear and uncertainty has allowed populist politicians in so many countries to rise by pointing the finger and telling people, "Oh, your problems? They're all coming from these refugees."

But this is scapegoating, because the politicians don't want to tackle the more difficult issues of equality, sustainable development, and integration. This wins elections and gives easy answers to people's anxieties, but unfortunately, these answers aren't honest.

AW We're going backward in terms of protecting the very basic values that Europe set up. What will this lead to?

NH For us, the struggle is now. This is why we've been working day in and day out. This is why we've been deploying researchers and staff to many of the hot spots, so they can describe what's happening on the ground. We believe there are still people in Europe, including politicians and political parties, who realize this isn't the answer. We have to fight for it in Brussels and with national politicians. But we also have to fight for public opinion. This isn't just a battle of policies or laws; it's a battle of ideas.

The agendas of some of these far-right European parties aren't just about refugees. Today they're using the refugees to gain points. Tomorrow, they might talk about nationals with foreign names or immigrants. So this isn't just a battle about refugees—it's a battle about values, ideas, and fundamental human rights.

The battle isn't over. Now is the time to struggle, to push for these ideas and build alliances, because we can't turn back the clock. Frankly, we've seen time and time again that you don't stop human flows by building walls. You can't just build walls and say, "Now this is Turkey's problem" or "Now this is Greece's problem." No, this is a global problem. In addition to Europe, countries that are far away, whether the US, Canada, or Australia—or even rich countries in the region, like the Gulf states and others—also have a responsibility.

AW What will happen with the Syrian war?

NH Predicting what's going to happen in Syria is very difficult, because it's a local and regional conflict as well as an international conflict. While the conflict hasn't stopped, there has been a de-escalation in some parts of Syria. But people who escaped don't feel safe enough to go back to Syria yet. They're still afraid of the Syrian regime. Many of them had family members who were detained, tortured, murdered, or who died in prisons.

Of course, the ultimate solution is to restore peace to Syria and to create conditions that would allow these refugees to return home. The Syrian refugees are often the ones who are most keen to go back, you know? They miss their old life. They miss their homes, their routine, their friends, their family members. But this situation needs global support for finding peace.

AW What do you predict for the future with such major landscape changes?

NH This is the big question: What future are we heading toward? Is this going to be a future where we see the rise of more xenophobic discourse in many countries, the rise of far-right nationalism, the closing of borders, and more discrimination? Or are we going to see something like what happened after the Second World War? After the Second World War, the challenges were even greater, the destruction was more widespread, the number of people displaced was higher, and the world was much poorer—and yet people, countries, and leaders came together and created the United Nations. After killing one another for five years in one of

the world's worst conflicts, the European leaders created the common European project.

I think we can go in different directions today. It's going to require leadership from the political class and public awareness by citizens about their concerns and values. Today, fundamental values that we thought were accepted in certain parts of the world, including Europe, are coming under fundamental attack. One has to protect them, push for them, and remind people why they were adopted in the first place.

AW What are the most urgent issues at hand?

NH I'd say the illegal pushback of refugees from Europe to Turkey without proper interviews and the opportunity to seek asylum. There's an urgent need to open borders around Syria to allow people to escape death, destruction, and violence— and to explain to people that those escaping death aren't the real risk.

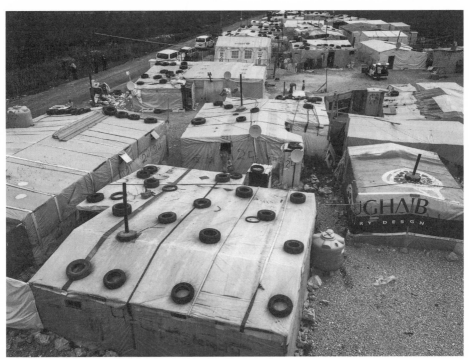

al-Telyani Camp, Beqaa Valley, Lebanon, 2016

044

Maha Yahya, *Carnegie Middle East Center*
Beirut, Lebanon, 2016-04-06

MY There has been a lot of media focus on the people who left Syria, partly because of the rush to Europe this summer, but there hasn't been sufficient attention to people who were forcibly displaced within Syria. We're talking about 7.6 million people. Approximately 4 million people have left the country, but 7.6 million have been internally displaced because their homes were lost or because there's a systematic targeting of communities on the basis of their identity. We've seen this in Syria but also in Iraq. I wrote something recently about how Syria is actually a repetition of what we saw in Iraq from 2003 till today—but greatly amplified.

Another long-term concern is the militarization of identities, as people are targeted on the basis of their ethnicity, sect, or religion. This was very visible, for example, with ISIS in Iraq enslaving Yazidi women, kicking out the Christians, and killing the Turkmen and the Shias. But they're not the only ones doing this. They were doing it the most flagrantly and openly, but other groups fighting in Iraq and Syria have also been doing this. The result has been a dramatic down-turn for this region. This is a region that's very proud of its 7,000 years of history of coexistence among very diverse social groups. There's great concern that we're losing the region's pluralism and diversity, which is one of its most important characteristics. There's a lot of concern among communities, the sense that people need to take up arms to defend themselves. If this isn't addressed quickly, it will have very significant long-term implications for the region.

AW Could you share your insight into how Europe is dealing with the refugee situation?

MY Europe is turning its back on its own values. As you know, the governance system of Lebanon is based on power-sharing between the different religious sects in the country. The Lebanese president has to be a Christian Maronite, the Lebanese prime minister has to be a Muslim Sunni, and the speaker of the Lebanese Parliament has to be a Muslim Shiite. The idea is that this kind of power-sharing arrangement would ensure that the social diversity of this country would be preserved and that no one group would gain control over all the key positions of power.

There have been suggestions for moving away from this technical form of power-sharing, but they haven't materialized. Today the big concern in Lebanon is that the arrival of a million refugees, most of whom are Muslim Sunnis, is completely transforming the demographic balance on which this power-sharing structure rests. One group is gaining a clear demographic majority in the country, and there's a lot of concern that we're seeing a demographic unraveling of the state systems that emerged after the Second World War.

In Lebanon this is fueling preexisting concerns among different sectarian groups that their positions are being eroded or that the nature of the country is being transformed. We hear this among the various groups: "the Sunnis are coming to

get us" or "the Shiites are coming to get us." There's a lot of fear-mongering. This obviously didn't only come with the refugees, but the refugees' arrival has aggravated a preexisting crisis, one that is also linked with the tug-of-war that we see today between Saudi Arabia and Iran. They're both playing the card of Sunni versus Shia rivalry, which uses religion for political ends and for the consolidation of political power—no more, no less.

This also comes on the heels of the longest refugee crisis in this country, actually in the world, which is the Palestinian refugee crisis. Palestinians were driven from their homes in 1948 and 1967 when the state of Israel was established. Many of them came to Lebanon at that time, and a large number of them remain in camps. The UN estimates that there are 450,000 Palestinians in Lebanon today. These are families that initially came from Palestine—and who still hold the keys to their houses—and their descendants. Because of this particular balance in the country, there was a lot of resistance against giving Palestinian refugees Lebanese citizenship or even employment and basic civil rights. The Palestinians themselves were concerned that the granting of these rights might mean that they'd lose their right of return to Palestine.

As a result hundreds of thousands of people live in limbo today in Lebanon. They're unable to work and live in refugee camps; you'll see them if you visit Sabra and Shatila. This camp was the site of major massacres in 1982. The majority of Palestinians there are Sunnis, so when another million Syrian Sunni refugees enter the country, this exacerbates fears that these people aren't going away and we're going to have another long-standing crisis. The state can't cope with the services or infrastructure needed to support such a large number of people.

More critically, there's the sense that this will alter Lebanon's identity as a plural society. There are Lebanese politicians who haven't been able to agree on a garbage collection scheme, yet they collectively agree that the Syrians can't stay in Lebanon. They weren't able to agree on a plan for the refugees, but they all very much agreed that they couldn't build refugee camps for them and that the refugees couldn't stay in the country. It's taken a lot to bring them to the table and say, "Okay, let's stop thinking in terms of just one year. Refugees are going to be here for at least the next three to five years, so let's deal with the next three to five years." If you mention to them that refugees may stay here for a longer period, it becomes very traumatic for many of our politicians.

This is fueling the xenophobia and irresponsible statements made by some politicians. They're really building on this idea of the "other," that the refugees are coming to take away their jobs, their security, and their way of life. Of course, there are microchanges on the ground, but the refugees didn't create these problems. They're victims who fled a war that they didn't want, and they shouldn't be victimized again for being victims in the first place.

It's our duty as the human race to address the reasons why they're leaving their home countries. Nobody leaves their home unless they're forced to. Nobody puts their own child on a boat or decides to march thousands of miles in the wilderness unless they're forced to. I think it's very important to remember this and

actually work to resolve the triggers that are forcing people to leave their homes in the first place.

In the case of Syria, this would be actively finding a just political settlement to the conflict. A political settlement that maintains the current president in power will not entice people to go back. Syrian refugees will only go back home if they feel safe, if they feel that they have homes to go back to. They were running away from barrel bombs dropped under the command of their own president, from chemical weapons used by their own regime.

AW Lebanon has experienced decades of civil war prior to the refugee crisis. How do you think this has affected Beirut as a city?

MY The memory of the war is still very much alive, and it's part of the fabric of the city today. The civil war hasn't gone away. It ended on a kind of blanket amnesty, the idea that all atrocities committed during the war would be forgotten and forgiven and we'd turn the page. This happened by law. It also happened in the way that the city center we're actually now sitting in was reconstructed. There was no attempt to preserve the social memory of the city through its architecture. A real estate company was created that erased major portions of the city's history in this particular area, and the city center where we are today was the green line or the no-man's-zone between the warring parts, between East and West Beirut.

This blanket amnesia also included the integration of the war militias into the government. Almost all of the key political leaders today were active heads of militias during the Lebanese Civil War, so when they became ministers and members of parliament they tended to treat the state institutions almost like war bounty. This was what they gained out of making peace.

What this means is that the civil war is still very much a part of the lives of Lebanese citizens today because of the reverberating conflicts between these different leaders and the way they carried on with their business. Alliances shift on a regular basis. The arrival of one million Syrian refugees on top of the preexisting Palestinian crisis has also stoked fears that there will be military fallout from the Syrian conflict. The Palestine Liberation Organization (PLO) was very central in the flare-up of the civil war in 1975, and then an instrumental part of the war itself up to 1982.

For many Lebanese, the arrival of one million Syrians reawakened those memories and the concerns that we're in another situation with a conflict next door, and that this resident refugee population may trigger another conflict. I think this is a very erroneous approach. The PLO was created for the liberation of Palestine, so it's a very different set of historical circumstances; the analogy doesn't stand.

The other falsity is that in order to have conflict, you have to have somebody who's willing to fund this conflict and pay for guns. Until now I don't see any indication that there's an interest in funding conflict in this country. Even more importantly, again, these people are fleeing horrors in their own home country. The Lebanese fled to Syria during the successive Israeli wars in this country. It's important to remember that these aren't people who are coming here because

they want to destabilize Lebanon or have any interest in taking up arms. If they wanted to take up arms, they would've done so in Syria; they're here because they need sanctuary.

Another concern is that if the Syrians are maintained as a vulnerable population, they could be exploited and radicalized. If this happens, it won't be widespread. It'll happen perhaps among select groups, but I think this is where the Lebanese and the international donor community have a responsibility to make sure that people aren't pushed in that direction. If refugees don't have recourse to justice, it opens them up to abuse by landlords, employers, and security services. Human Rights Watch and other organizations are documenting some of these abuses, so I think this is where the responsibility of the Lebanese government lies, to make sure that refugees do have recourse to justice. This at least mitigates the potential for marginalization and radicalization. Marginalization doesn't always translate into radicalization. It can translate into many other things: petty crime, hopelessness, and lack of productivity.

AW Is there any solution for this refugee situation? What can we learn from it?

MY Fundamentally, we need a just solution to the Syrian conflict. People shouldn't be forced to go back, but they should be given the opportunity to go back. In the meantime, I think Lebanon and Jordan are missing out on a great opportunity to utilize the arrival of a million skilled individuals who are able to contribute to the betterment of this country. For example, Sweden has an aging population, and they've realized that they're going to run out of pharmacists, so they've given priority to Syrian refugees who have a background in chemistry and are able to work as pharmacists.

We need to understand the skill set that the refugees bring. This really requires a survey of their skills and background. Some are unskilled but could work in areas like agriculture, as one example. There are going to be many infrastructure investments, which could provide another area in which refugees could make a living. They could also work in sectors with labor shortages, or we could think more creatively about economic sectors that haven't yet emerged. For example, there's been a lot of innovation in Ghouta, Syria. The electricity is gone, so how do we get solar power? How do we make biofuels to generate our own power, because we're no longer able to depend on the state? If we look at this immense human capital as a positive opportunity, there are going to be artists, actors, architects, engineers, and mathematicians.

AW There's such a lack of imagination and trust in humanity in the political and bureaucratic spheres.

MY I totally agree. We forget that some of the greatest thinkers of the twentieth century were themselves refugees from Europe. These are people who wouldn't have had that opportunity had they not been able to leave Europe and move, mainly to the US. This includes Albert Einstein and some of the most brilliant thinkers.

Abou Ahmad, Refugee
Shatila Camp, Beirut, Lebanon, 2016-04-07

AW How long have you been in Shatila? What's your story and what's the story of the camp?

AA We're the Palestinians of 1948, from Haifa. We came here when we were expelled from Palestine. Some people went to Jordan, some to Syria. We came to Lebanon. We worked, and until the 1970s, our days were really beautiful. Our problems started in 1975. Some people died, some survived, and some are still living. What can I tell you? There are many things. Our camps were besieged and there was a massacre by the Jews and by Saad Haddad and Elie Hobeika [militiamen responsible for the 1982 massacre in the Sabra and Shatila camps].

I can't remember everything. The siege of the camps was a conspiracy against us, the Palestinian people. This is our life. I can bring you someone else who can talk about it. I get bored when I talk a lot. It's a miserable life. The massacres happened from this street to the other. Just like that, they started shooting the people and hitting them with heavy sticks and knives. This is our catastrophe. But there were no arms in the camp. The Lebanese army entered the camp and collected all the weapons and put people in prison.

AW Why did the war happen?

AA It was an order from the Syrians. The Syrian regime, together with other allied Lebanese factions, besieged the camps and tried to burn them down with cars full of fuel. They didn't want Fatah [the Palestinian National Liberation Movement] or the PLO in the camps.

AW What happened?

AA Syria pushed the Amal Movement [a Lebanese militia associated with Lebanon's Shia community] toward us, and the camp was totally besieged by the sixth brigade and the Amal Movement from 1984 till 1988. We couldn't go out at all. Clashes started with them, and all the factions who were here collaborated with us. We kept fighting for two years; we lived in a war zone.

AW How did it end?

AA It ended because the Amal Movement ended. There was a cease-fire and the war ended. People started to go back to work and live normally.

AW This was part of the Lebanese Civil War?

AA Yes.

AW How long did you stay?

AA For three years, and then we went out on cattle trucks to Sidon after the cease-fire. We lived in Sidon, in Ain al-Hilweh [the largest Palestinian refugee camp in Lebanon] for two years. And then, little by little, we went back to Shatila.

AW How could you stay here in the camp for three years?

AA We survived. For years before that, Fatah used to distribute food to everybody, to the civilians and to the military. At the end, the food was finished. When the food was finished, we started to eat bulgur and cats. And then we went to Sidon.

AW How many people were buried? How many children?

[AA shows AW a table of names written in Arabic]

AA In total, 1,200 people were buried here. We couldn't get every name. For the ones we got, we included photos—1,200 martyrs of the camp war, us and the Amal Movement. Five to six people were always buried together. We buried children, women, young people, and old people. You'd see six or more bodies on top of one another. We laid down a plank, put a body on it, and buried it. This guy in the big picture is Mohammed Abu Khdeir, who was burned by the Israelis, the Zionists, in Palestine, in al-Quds. We put his picture here. Those who burned him burned his house as well.

This is my child.

AW Your son?

AA Yes. I have five people on this list. My three brothers and two sons passed away in the camp war.

[AA walks and sits down in a market street in the Shatila camp.]

AW Tell us the story.

AA The massacre happened in this street and the street below, where we were a while ago. They came from the city. Their military attire had the words "Lebanese Forces" and the Lebanese cedar logo on them. They had thick sticks and swords. They came and started shooting; they killed anyone they saw. They broke into stores. They shot a woman in the stomach who was four months pregnant. It's something that the mind can't imagine. You could find dead bodies here, there, and down the street.

AW How long did this phase last?

AA We were bombarded for three days. Five old men wanted to go to the Jews and tell them, "We don't have weapons, and if you want to get in, just get in." The old men went and they were slaughtered. The killing period lasted three days: Thursday, Friday, and Saturday. And then the Red Cross entered and took the dead bodies and buried them.

AW What was the scene like?

AA People started to run, barefoot and in bloodstained clothes, to the al-Dana Mosque, the streets of Sabra, and Omar Hamad, and to the shelters. Many stayed in the streets for three days.

AW Tell me more about the resistance and how you survived that long.

AA It started at 5:00 p.m., and I went out about midnight to Dana. This happened on the second day. They gathered the young survivors and took them to the Sports City in al-Rihab. They kept them there, under the sun, from morning to late evening. They stamped the IDs of those who went out with an Israeli stamp.

AW Why did they get the young ones out? What did they want to do with them?

AA I don't know why. They just released them. I wasn't with them. I escaped to the Hamra quarter and kept moving till the Jews left and went to Dana. I saw a Jewish checkpoint, and they said, "Where are you going?" I said, "I'm going to bring bread for my children." They said, "Go to the city and get your ID stamped." I said, "Okay." But I didn't go because there were masked people with them. I didn't know who they were, so I just left and didn't get a stamp on my ID card.

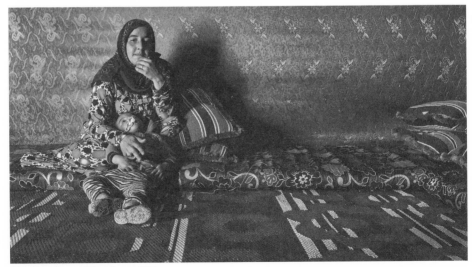

Zahle Camp, Beqaa Valley, Lebanon, 2016

046

Mohammed al-Khatib, *Museum of Memories*
Beirut, Lebanon, 2016-04-07

MK The artifacts that you see here in the museum were collected from the outskirts of the Palestinian zoo. People brought these items with them after 1948. It's nice to collect these items, as they reflect the Palestinian lifestyle before 1948. These items say, "There we were. Our people were there. Our people were pushed out of their lands, by force, from their territory." As you see, the people in the camp lead a miserable life. But even though we have a casual life, in some instances we can respond to the Israelis about what they did. They took the land by force and now they're trying to steal our heritage, the Palestinian heritage, the Arab heritage. So we have to conserve our heritage, as Palestinians and as Arabs, to respond to their lies.

AW Your people have been here for so long. People are born here who've never seen Palestine. Do you worry they'll forget about their history?

MK Never will a Palestinian or an Arab forget their history or their land; it's in their genes. Remember, this history was contested by many other countries and civilizations: the Greek, the Roman, the Byzantine, and even the European Crusaders. The people were under their rule for centuries, but after that they left. We belong to this land and this land belongs to us as any other country of the world belongs to their people and not to a foreign entity. Israel is a foreign entity, so Palestinians will never forget, even if Israelis stay 1,000 years or more. I'm sixty years old, and maybe I won't be alive in a few years, but I assure you that what I see in the young people is tremendous. Even if they haven't seen Palestine, it's in their hearts and minds.

AW You have about 1,000 Syrians in this camp. Why do they come here if they're not Palestinian?

MK The Syrians come here because it's cheap, they may know somebody, and maybe they feel safe with the Palestinians. The Palestinians, throughout history, don't differentiate between religions. We're Palestinian Arabs, Syrian Arabs, so we're together. For that reason I think they feel safer here, economically, socially, and so on.

AW Lebanon has kept the Palestinian people excluded from society for so many years. How do you feel about the Lebanese state and its response to the Syrian refugees?

MK Unfortunately, the Lebanese government has separated the Palestinians. They don't have the right to work or many other rights, not even to own a house. It's impossible for the Syrians to settle here. They'll stay for a while, but they have to return to their country when there's peace in Syria.

AW When do you think they'll be able to go back?

MK I think some of them can go back now; there are places where there's peace. And who's responsible for the war in Syria? First, Israelis benefited from the war in Syria. Second, there are international interests, like the countries supporting terrorism in the region. They're responsible for this war. This isn't a normal war; it's the destruction of a country, of its economy and society. It's ridiculous. And some of the Gulf countries and Turkey are playing a great role in this war.

AW Do you think that the Western world is afraid of Muslims?

MK No, no, the real Muslim doesn't make anyone afraid. You're Christian and I'm Muslim. Why should I be afraid of you? You're a human being. We have tongues and minds to speak. The hand is there to write and eat, not there to hit. So why be afraid? If we have differences, we can speak and we can judge, if our minds are clear. The foreign countries aren't afraid of real Muslims. You and I, both of us are afraid of terrorism, and both of us have to struggle against it. Terrorism has no religion. Those who are committing terrorism aren't Muslims. A true Muslim can't kill and cut off heads and say, "Allahu Akbar." What God? Which Allah ordered them to kill? But you and me, with your intelligence and my intelligence, we can sit and discuss and oppose terrorism. If the foreign countries want to fight terrorism, they have to join hands with us, the real Muslims. I know that there are terrorists, but they're not true Muslims. They're fanatics manipulated by other ideologists and other countries who serve destruction.

AW How long will it take for the Palestinians to return to their country?

MK Nobody knows, but for sure we'll return, even if it takes hundreds of years. The governments don't believe in discussions and rights and justice. They believe in force, and they take everything by force. A country is like a person: it's born, it rises, and it falls. All throughout history, first they are young, then they are great, and eventually they decline. These countries supporting Israel will not be there forever. Israel is a foreign body.

We need to serve this Earth. You're my brother, and on this Earth, you're my friend. I want to live at your side. When you feel bad, I come to treat you, and when I feel bad, you come and treat me. We don't kill each other. We're human beings, not animals. We all have to live together—all peoples, all nations—in peace and justice. Let's make this Earth prosperous. The Americans and Russians have been planning for hundreds of years to go to Jupiter. Let's work together to make this Earth better, free of poverty, sickness, and ignorance. Let's love each other. Let's love together.

047

Walid Joumblatt, Lebanese Druze Leader
Moukhtara, Lebanon, 2016-04-08

AW I see so many maps drawn by different people over different periods of time. They interpret the world very differently. There are so many ways to tell the same story as an artist—and, as they call me—an activist. Humans flow, people move for different reasons in history, and now people are shifting because of territory. Of course, for this nation it's nothing new. For me, it's truly a learning situation. You're a very important politician, and for generations you and your family have devoted yourself to this land and this culture. I'd like to chat with you about how you look at the history of this nation.

WJ Geography comes first, because geography imposes history: We're part of the Arab worlds. We're Arabs. What does it mean to be Arab? That's something else. There's no Arab race. We're of an Arab culture that comes from a long time ago, an old culture. Before that there were the Jewish and Christian cultures, but we're of mixed culture.

At the same time, I'm a politician. I represent the small community of Druze, scattered between Lebanon, Syria, and Palestine. I was born to protect the interests of the Druze, but at the same time I'm Lebanese. My father was killed by the Syrians in 1977. Nevertheless, forty days after his assassination, I went to Damascus and shook hands with the one who killed my father. This was because of geography, because I'm an Arab, and I needed support from Syria against local enemies that we allied with against the Israelis. That's paradoxical, but that's the fate of geography. I've been in politics for the last thirty-eight years, and now my son is taking my place. He's the first Joumblatt to take office in front of his father. My father was killed, my grandfather was killed, and now there is a successor. It's feudal, but at the same time, we have to live with it.

I've been through terrible times. Once you're involved in war, your hands and your spirit are stained with blood. I can't predict my future, but once you have blood on your hands, it's like your fate, your destiny, to be somewhere. Maybe in this life or another, my father used to be a believer. We believe in reincarnation, and in this life or the afterlife you have to succumb to your past deeds. I don't know what will happen to me, but I can't say that I'm living miserably. But sometimes, somewhere, there are ghosts, because we had seventeen years of civil war, terrible war.

AW What were you fighting for?

WJ It was a fight for our existence because of long history, long feuds, and at the same time peaceful relations with some Lebanese. Let's say with the Christians, but not all of them. We had three civil wars. The last one ended in 1991, so I had to fight for my own survival as a Druze. This is why I had to go to Syria. I needed training camps and weapons, and I went to the Soviet Union. Lebanon was divided between Soviets, Syrians, Palestinians, Americans, and Israelis. This small country was divided by greater interests, and we were in the middle. We were

tools, but once you're in the middle, you don't think about what you are. You're just in the middle of an event, and you're lost.

AW You're in the middle of everything, and then you survived; you lived peacefully for a while. I'm sure you learned so much, and still you devote yourself as a politician. What's the most important lesson about the war?

WJ Maybe it's too late now, but the most important lesson about war is to end the violence. I was terribly violent a long time ago. I was a warlord. But you learn lessons about how war is bad. Now my main concern is for my people not to go into bloodshed, to have a safe Lebanon. When you see what's going on in Syria, in Iraq, there are terrible wars there.

AW Today, when we drove to the border near Syria, our driver said that our neighbor has no problem there.

WJ Yes, he's right, but not all the Lebanese politicians understand that. We have to compromise at any price. Dialogue is important in life, much more so than anything. In this new world of total uncertainty, nobody knows where this is going. Assad has managed to displace ten million people in five years in Syria, and it's not finished yet.

AW Can you describe in your own words what happened in Syria?

WJ The Assad family ruled Syria for the last fifty years. But at one time the people wanted to have freedom and dignity. You can suppress people for decades, but at one time something happened. They crushed the people and they thought it would be quick, but their calculation failed. It started in March 2011 and now we're in the fifth year, entering the sixth.

AW What's the solution?

WJ They can't stay. Now the major powers are negotiating Syria's future. I don't think it's possible for the Syrian people to accept the Assad family in power. The son of Hafez can't stay, but knowing him and the father, they won't leave until they're dead. In the meantime, the killing continues and Syria is like a theater of influence between the Americans, Russians, and Iranians. Everybody is there.

AW With all these superpowers interfering in a regional problem, do you think it's possible to end the war?

WJ I don't think so. The war will continue for a very long time. The Arab world is in total turmoil. The Syria, Iraq, Palestine, and Israel of today were unfortunately designed a hundred years ago. They called it the Sykes-Picot Agreement when the Ottoman Empire was divided, and after a hundred years, this world is being divided again. I know that the violence will continue. Terrible violence, with a lot of bloodshed.

You don't have guidelines anymore in this world. If I compare this period of time with the Cold War, during the Cold War the world was divided, but now we don't

have rules anymore. It's like the jungle, the rush for capitalist interests, the rush for oil, the rush for minerals everywhere in Africa, in the Middle East. In the Middle East we're doomed because of oil. We have a lot of oil, and it's a curse.

You have to believe in destiny and going back to our own scale of trying to preserve peace and survive. Lebanon is small; it's a country of eighteen communities of Christians and Muslims. We have to preserve it and not think about the past, to see the future and to forget about our old hatred. Most of us hate each other, most of the Palestinians—they pretend to love each other, they pretend to understand, but somewhere in our subconscious, we hate each other.

Lebanon is a nice country, it's a cosmopolitan country, and when you compare it to the other Middle Eastern countries, we have the spirit of freedom. We love freedom. It's reflected in our own behavior, in our individualistic behavior in arts, in expression, in writing, in the press. This is good because most of the Arab world was totalitarian. Now it's changing. It will change, but at what price?

AW And for a very small nation, you take in so many refugees—the Palestinians from the 1940s, and now the Syrians, in addition to your civil conflicts.

WJ We have some xenophobic people here and parties that don't want to hear about refugees. This was one of the reasons for the civil war, when the right-wing parties wanted to chase out the Palestinians. They failed, and now they say the same thing about the Syrians. If the Syrian war stops, the Syrian refugees will leave.

The Palestinians have nowhere to go. Their lands, villages, and cities were occupied by settlers. You have a new nation there, and most of Palestine has no nation. This is what some xenophobic Lebanese don't want to understand.

AW The Palestinians have already been here for sixty years. Do you believe they'll have justice?

WJ It's going to be a long story. There used to be a peace camp in Israel. Maybe the only one left promoting peace is Uri Avnery [founder of the Israeli organization Gush Shalom]. He used to believe in a two-state solution. One day maybe others will believe in it, too, because if you don't have a peace camp among the Jews, among the Israelis, and you have this crazy right-wing tendency like Netanyahu's, it's going to be endless wars.

AW How do you view the international community, especially in dealing with refugees? Lebanon has taken refugees for a very long time, but that seems to be ignored.

WJ In the West, the German leader Angela Merkel took a very courageous stand, but Europe might crumble now because of a million refugees. There are 500 million Europeans and now one million people are scaring them. Additionally, there were the terrorist attacks in Brussels and Paris. But where can the Syrians go? Lebanon, Jordan, and Turkey. So Europe is now helping us; they want us to keep these refugees. They want to give us money so we profit, to educate the Syrians, to

make them work so one day they might go back to Syria. But now Europe is pouring money into Jordan, Lebanon, and Turkey. They don't want to hear about refugees anymore. That's the new policy. It's quite a hypocritical policy, but this is a fact.

AW Europe sacrificed its values, a very core value of human rights.

WJ It's not easy because this is a clash of civilizations. I don't see the Europeans afraid of Russians or Poles or Ukrainians. There's a clash of cultures because most of the refugees are Muslims, and now being Muslim has the connotation of being a terrorist. This is the general media approach, the general cultural approach, as Samuel P. Huntington said.

AW It's obvious that if you see 4,000, 5,000 people have drowned in the ocean, this is unacceptable in any circumstance, but because they are Arabs . . .

WJ At the same time, if we blame Europeans, we also have to blame ourselves. Not Lebanon but some Arab countries did reject Syrian refugees. They claim that they have hundreds of thousands in the Gulf, but they don't. They have the original Syrians that went to the Gulf to work a long time ago in Kuwait, Abu Dhabi, and Saudi Arabia, but very few newcomers. Egypt also adopted a very aggressive policy.

AW You can see the whole world is broken.

WJ There's no more foundation. Look at what's happening now: the Turks have taken back economic refugees from Afghanistan, Pakistan, everywhere. In exchange they're sending some Syrians to Germany or to Sweden. This is very unusual because they got billions in money. It's so nasty.

But people are good; we can't blame people. I've seen movies about how the Greek people used to greet Syrians, and they were very humane. And this is the country that has been most affected by the capitalist banks and their greed, but they're very good toward the Syrians. The leaders of the Poles and the Hungarians are horrible. Viktor Orbán and the other one, I forgot his name, the guy in Poland—the fascist.

AW Is there something else you want to say about our future?

WJ Well, what else can I tell you? I had big dreams during my childhood. I don't have anymore dreams. I hope my son will succeed. My only dream is to help people and at the same time caution people not to resort to violence, because I've been violent and I know what it is. This is my only message.

AW You've been a very strong voice in supporting the Palestinian people.

WJ I still am, but it was also a big dream at that time with Yasser Arafat. I used to know the guy, a great leader, but he was rejected by the Israelis and by the Arabs because even the Arabs who claim to support the Palestinians didn't want this independent Palestinian state. So you could say he was crushed between the Arab

hammer and the Israeli sickle. But he was a great leader, and I think one day the Palestinians will have their future in their hands, but it's a very long ways away. And they need a counterpart; as I said, an Israeli peace-minded guy, tolerant, liberal, like Uri Avnery. There's a brilliant journalist, Gideon Levy from Haaretz, in Israel. People like that can build peace.

AW So it takes a courageous politician, a vision, and wisdom.

WJ Yes, but we don't have an environment of tolerance anymore. We're again in the Arab world, settling old disputes between the Muslims that go back 1,400 years. At that time, after the death of the prophets, there was a political dispute about their successors, and that later became a theological dispute. We're still living it. It's a political question, and this is why Muslims and Arabs are killing each other and sending each other car bombs and suicide bombers everywhere.

AW How do you assess American politics in the Middle East?

WJ They care about oil. They care about the safety of Israel and selling their weapons, and they don't care about Arab aspirations or Palestinians. For decades they supported kings and dictators. The so-called American approach to freedom or to democracy is just bullshit, just a big lie. They supported our neighbor Hafez al-Assad at that time. He came to Lebanon, thanks to Bush, and he crushed the aspiration of the Lebanese, of my people. The Americans, in a way, are responsible for the murder of my father, Kamal Joumblatt.

But the Americans are like an elephant that comes into a glass shop, or a big bird who comes into a glass shop—they destroy everything and fly away. We saw this experience in Vietnam, Korea, Afghanistan, and Iraq. Nobody speaks about the tens of thousands of Iraqis killed during the American invasion.

AW I think they learned something. They don't want to interfere that much, but still they're part of the Syrian landscape.

WJ They're now in Syria and also in Iraq because they're supporting local regimes to fight this monster called the Islamic State. And they're in total coordination with the Russians. I don't know if they'll stay later, or if this area will be united or divided. In the meantime, nobody is speaking about Palestine, which was the main cause that I was raised with. I lived with the Palestinians, I supported the Palestinians with my father, and we fought with the Palestinians. In the seas and mountains, there is Palestinian blood side by side with Lebanese blood, fighting the right-wing parties of Lebanon. We'll never forget the Palestinians who sacrificed themselves with us.

AW You talk about preserving our memory. Why is this so important?

WJ Without memory, you're nothing. Memory is part of your history, and history is part of your geography. We're Lebanese, but we're a part of the Arab world, a part of the Arab geography, and in this geography, one of the biggest injustices was done to a certain people called the Palestinians in 1948.

AW Do you believe in fate?

WJ I'm not a strong believer. I'd like to end my life believing in something, I mean in ideals, of course. I believe in fate, yes, leave it to your fate.

In politics and in life, you have to take a side. I've taken sides, wrongly or rightly, at one time with an Arab dictator. At that time, thirty-nine years ago, I was forced to go to Syria for the survival of my small community in Lebanon. After the killing of Rafik Hariri, I took sides against the son of the dictator, and I'm still on this side. You have to take sides. It's a choice, and every choice implies a sacrifice.

You can't calculate how much you gain or lose. If you do, you become very cautious and afraid. Leave it to fate; what will happen will happen. My father used to say that it's in your karma, your destiny.

AW How much did your father influence you?

WJ He was a very courageous guy, an intellectual and very honest guy. I'm not like him. He didn't want to go to war except for small skirmishes. He was an exceptional figure, and in a way, I'm trying to take revenge. The word sounds harsh, but why was such an intellectual, distinguished guy killed by these thugs?

AW You've done what you have to do. That's also a problem for life. Where will the peace come from? You're a warlord and you've fought with enemies and have seen a lot of death. Where will the peace come from?

WJ The peace comes from inside. It comes from your own behavior. It doesn't come from outside. It's up to you to be convinced that peace is a must; it's up to you to suppress the animal instincts inside you. We have a dual personality between being animals or criminals and being peaceful. This is why I still have some hope in the years I'm still living. It's my responsibility to tell my son to suppress the animal instinct. It's very easy to go there.

048

Tanya Chapuisat, UNICEF
Ain al-Hilweh Refugee Camp, Lebanon, 2016-04-09

I'm Tanya Chapuisat, the UNICEF representative here in Lebanon. Today we're here in the Ain al-Hilweh camp, which is one of the most densely populated areas in the world. There are approximately 100,000 people living in an area of one square kilometer. This camp has been here for more than sixty years. Generations of children have grown up within its walls.

In Lebanon there are about twelve camps and more than forty settlements around the camps. This camp has more light than others I've been in, because there seems to be more space going upward, so the alleys are larger, but it's highly populated. When 42,000 Palestinians from Syria arrived, buildings that were already three stories high became four or five stories as people built on them and tried to give room to the new arrivals. The situation continues to get more cramped as more people arrive. They're absorbed into the health and education systems and all the services are provided for them.

As in most Palestinian camps, the principal service provider for the Palestinian population is the United Nations Relief and Works Agency for Palestine Refugees (UNRWA). In this camp, the schools, clinics, and different services are actually provided by UNRWA. What UNICEF has done over the years is to provide additional support, early childhood development, and teacher training. We adapt schools, provide school materials, and, very importantly, also support the different health clinics with immunization and all the necessary items for children and their health.

We also see children in this camp, which has a history of violence. Only a few weeks ago there were renewed clashes. We also provide safe spaces for children. Today we visited a kindergarten, literally an indoor playroom, so the children can sing and dance and swing in safety, despite the violence within which they live. Within those same centers we also provide very structured psychosocial support to children who experience violence in the family and on the streets. They've seen far too much for their age.

In terms of the Syrian population in Lebanon, we have more than a million refugees in a country of four million, so practically one in four or five people in this country is a refugee at this point. While there is no mechanism like UNRWA (which has been around for sixty years) to respond to them, we've been working with all the partners to respond through social services to provide the necessary support. We're paying school fees for children to go to school in the public education system, training teachers, and providing school supplies and psychosocial support for children suffering from war trauma and families experiencing long-term stress.

We also help with water and sanitation. Lebanon has a huge garbage problem, but it also has a huge sanitation problem, so we're supporting the government here. But we're also trying to strengthen the infrastructure. When we reach out to the

Syrian children, we're reaching out to the vulnerable Lebanese children, and we're expanding our program for Palestinian children. We have a strategy to reach all vulnerable children across the country, which is critical not only for issues of equality but also for long-term stability. Ethically, if we're going to help one, we have to help the other, to make sure these children all grow up together with the same opportunities.

There are also refugees who didn't go back to school and are now fifteen and working in the fields, or who lack other opportunities. We're trying to work with different organizations to give them vocational training, life skills, microfinance, and opportunities to run innovative projects. We're looking to scale this up at a massive level. It's still small, but all the partners are conscientious that we need to address a very vulnerable group of people. But we also need to be careful, because we know that in Lebanon more than 30 percent of Lebanese youth are unemployed. So we can't have a response just for refugees; we need a response that touches all the people.

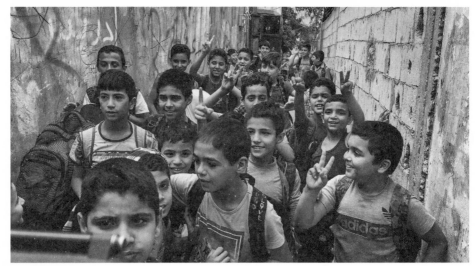

Ain al-Hilweh Camp, Sidon, Lebanon, 2016

049

Paul Yon, Médecins Sans Frontières
Ain al-Hilweh Refugee Camp, Lebanon, 2016-04-09

AW Lebanon has approximately as many Syrian refugees as all of Europe. Can you talk about the unique challenges this poses for a country like Lebanon?

PY About 20 percent of the Lebanese population are Syrian refugees. With the Palestinian refugees, this rises to maybe 25 to 28 percent. We're talking about one to 1.5 million people, and it means that the available health services are inadequate. Basically, you've got a huge number of people scattered in all these informal tented settlements, which isn't making things easy for the international community or for humanitarian workers.

You've got two different problems here. One is that the health system in Lebanon is a private system. The state doesn't have a full range of free health services. In the last five years it's worked hard to ensure that people have access to health care. In Médecins Sans Frontières (MSF), for example, we're basically family doctors who see about 200,000 people per year. We've developed three maternity clinics, and we're working in a different way in Lebanon. For example, we've developed some noncommunicable disease components in our projects, as many people have chronic diseases such as diabetes, hypertension, asthma, and so on.

AW Could you describe the situation facing most refugees in Lebanon?

PY What's complicated for the Syrian refugees in Lebanon is that before the crisis, Syrians had a pretty good level of health care. When they arrive in a place like Lebanon, they're likely to fall ill quickly, often in desperate situations.

We have many different problems. Many people don't dare move from one place to another or from one village to another. It's not that the authorities would arrest them, but it's more psychological: they think that they might run into problems because they don't have the right papers. We're trying to do some outreach; if the patients aren't coming to us, then we'll go to them. This makes it logistically complicated, because all these informal settlements are scattered throughout the country—we're talking about 1,200 different settlements.

AW Compared to a country like Jordan, where you have big camps and access to quality care, the situation here means people aren't getting enough care. Is there governmental and institutional support for this problem?

PY I'd say that the government in Lebanon is actually doing a lot. First, they accepted refugees, who now make up 20 percent of their population. That's huge. And then in settings like in Jordan or Turkey, or even Iraq, there are official camps that look much more like towns, with shops, restaurants, and so on. That's not the case here. When you're in the Beqaa Valley, for instance, you visit a place with twenty families, then you need to drive for fifteen minutes to reach five to thirty families. All the coping mechanisms that the population found in neighboring countries become much more complicated in Lebanon.

AW How would you compare the situation facing your average refugee in Lebanon compared to the rest of the Middle East?

PY I'd say it's different. In camp settings in other countries, things might be a bit easier for the humanitarian community. In a setting like Lebanon, everything is becoming much more complicated because, logistically speaking, you don't have access to a population gathered in the same place. Then, down the line, after five years of crisis, it's also complicated because the reports say that the health situation, for example, isn't that bad. I think it's wrong to say, "It's going pretty well, so we can just stop." As soon as one organization stops providing services, education and nonfood items very quickly collapse. Today, the health indicators, for instance, are at green. But they can very quickly go to orange and to red. And specifically in places like these informal settlements, where the hygiene isn't that good, and where there's no sewage system, you could very quickly end up with diseases such as cholera and scabies. Scabies is widespread in the settlements. It's very complicated, because to treat scabies you have to treat the whole family, the whole settlement. Otherwise it's a catch-22, where you're basically treating one person while the rest of the community is still affected.

AW Could you talk about Lebanon's sectarian component?

PY Lebanon is a mosaic of sectarians, not only religious groups but also families. It's true that the Beqaa Valley is a place where this is even more pronounced. You would meet someone, and the person would tell you his family name and expect you to know who he is. It's not that easy for non–Middle Easterners. Sometimes you're just having talks and trying to understand something, and five minutes after a meeting someone tells you, "Okay, you were talking with that person so it means this, and this, and this."

What we're trying to do is to go beyond all this sectarianism, which is very complicated. We keep saying, for instance, that our clinics are open to everybody. There's no way we'd make a distinction between origin, families, clans, and so on. If you open a clinic somewhere, you'd normally expect to have people only from this community or another, but we have thirteen different entities and health premises in Lebanon, so we're able to welcome everybody.

We're in the Palestinian camps in Saida and Beirut. We're also treating many Lebanese people in Tripoli, and, of course, many Syrians, mainly in the Beqaa and in the northern part of the country. The medical needs are huge. We're definitely expanding our activities, and I'd say we're actually treating everybody because of our clinics' locations.

AW Can you tell us about Arsal's political context and importance?

PY Arsal is a very interesting case inside Lebanon. We're talking about different types of communities, religious communities, even long before the crisis. We basically have a minority village of about 30,000 people where things were going well before the crisis. We're talking about many farmers, a lot of people harvesting and working with the seasons, because the weather conditions are quite harsh. Winters are very cold, with snow, and summers are very hot.

The border was open from the beginning of the Syrian crisis back in 2011, 2012. All the refugees were coming to Lebanon. Arsal went from a small city of about 30,000 people to more than 100,000 people. People were just looking for a normal life, trying to get basic and vital things, such as a few nonfood items, shelter, accommodation, food, and health care.

Little by little, the authorities in Arsal started to have crime-related problems, different types of problems, like shops set on fire and smaller incidents. Then, little by little, the local authorities in Arsal were losing ground in controlling the situation. It's not that the city was 100 percent under the influence of two radical groups but more like gangs, like a group of people who'd just tour the city in pickups and decide on their own mischief or justice in one way or another. For example, a very serious event happened to a former colleague. Her husband was killed in the street just because he attempted to ask some of these groups to let the families live as they had been living, quietly and without any trouble. These were the types of things that were happening on a regular basis. Then you've got the Lebanese government, which is also complicated, because today there are still soldiers around who were kidnapped from the Lebanese army. I wouldn't say it's a status quo, but it's been a rotten situation for one and a half years. Sometimes it's difficult to bring drugs and medicine into the clinics because there are many military actions happening in the area, which definitely doesn't help us get access to the population.

There have been many different conflicts in Syria between the opposition groups and the government that caused more refugees to arrive. Unfortunately for Arsal, we're talking about a huge amount of people. And then what happens is that some extreme groups actually gather and say, "Well, we'll go into that place. We'll have power and control over Arsal." This could've happened in any other place, but it happened in Arsal. Bad luck, I'd say, for Arsal. That's exactly what's happening in many places in the northern parts of Syria, where an ultraminority of people took over control of daily life.

We talk a lot with our patients and they tell us how much things have changed in the city. There are places where you can't listen to music anymore. Women had to change the way they dress. In parts of Arsal, things are getting even worse.

There are also tensions between different radical groups. You end up having people who basically think this radical group is better than the other one. The civilians basically have to choose between the plague and cholera. More people are saying, "Well, after all, these guys are better than these other ones." Mosul was the same back in 2014. When the Islamic State arrived, we had mobile clinics in its outskirts. People were saying, "Whatever is happening is better than what we had in the past." We talked with people and asked if they were really aware of what new radical groups in town would mean, and they'd say, "No, that's not possible. Don't worry, everything will go well."

It's not exactly the same in Arsal today. Actually, when you dig a bit and talk with the people, they very quickly say that what's happening from one group to another is exactly the same.

AW Who are these groups exactly?

PY We've basically got two groups: Jabhat al-Nusra, which is basically like al-Qaeda, and the so-called Islamic State. One group is older than the other, and because the younger group is even more radical and more extreme, the first is actually becoming more acceptable. People will say, "Well, you know, Jabhat al-Nusra isn't too bad; the other ones are really bad guys." So you feel that not only in Arsal but in the whole region up to northern Iraq, you've got this very strange trend where people are getting used to the situation. We see this everywhere in the region. We don't know where it's going.

Just to give you an example, back in the 1980s and 1990s in Afghanistan, it was very interesting to read the articles in Western newspapers about the jihadists who were against Russia. People were saying, "They're great! They're wonderful; they're fighting against Russia." This is actually what's happening here now, but with different groups. I always encourage people not to make quick analyses of this time in history. Down the line, after five or ten years, you see that it's not as clear-cut as that.

This is beside the point for MSF. For us the most important thing is to have access to the population. Sometimes people say, "Well, you're not only treating civilians." From our side, we say very clearly that a wounded combatant is a patient. Our imperative is to treat the wounded, no matter who they are.

AW Is Arsal an isolated case or does it have some lessons for, or parallels to, the larger situation?

PY I wouldn't say that Arsal is a good sample of what's happening to the refugees in the country at large. About 90 to 95 percent of the refugees are actually in a situation that is unlike that in Arsal, where refugees are able to move and seek employment. They're trying to get a kind of normal life, even if it's very complicated.

Arsal is much more like an enclave, like some places inside Syria, and things are more complicated there. It's true that people who left a terrible situation may be at risk of being in the same situation in Arsal. It's much more heartbreaking, but it's still a small percentage of the Syrian refugees.

AW Is Arsal the worst place in Lebanon to be a refugee?

PY This might be a bit provocative, but I'd say that the worst place to be a Syrian refugee today is in Europe and definitely not Arsal. What's happening in Europe is definitely a shame. History will definitely judge the people there. But maybe one of the worst places for a Syrian to be today is Syria, in places where fighting is still occurring.

I definitely believe that the worst that could happen to someone today is to arrive in Europe and basically be told by the Europeans, "Well, we're sending you back to Turkey because we have a deal with Turkey." And then Turkey says, "Well, in that case, we'll send them back to Syria." And this very shameful deal is a result of the European Union reconsidering Turkey's accession to the Union.

This same situation happened back in 2003 in Iraq. Bush invaded Iraq, then the war was over. But afterward, some Iraqis in the UK or in the US were just sent back to Baghdad. When that happened, I felt really ashamed to be European. I'm French, and each time I see what's happening in Europe, I'm really ashamed, because we're basically talking about such a small part of the population. These are people who could've definitely been valuable to Europe, but even beyond this, we're talking about people who had left their country because of a terrible situation.

When you've been working here for years, trying to get the people a bit of health care and basic needs, sometimes you feel that some morons in Brussels are just sitting behind their desks signing papers that destroy the work of hundreds of thousands of people who are trying to make the life of a refugee a bit better. It takes a long time to open a clinic. It's a huge amount of work. It's a multidisciplinary team working with many hurdles. We just opened a maternity clinic in the Beqaa Valley two months ago. Opening clinics makes us so happy. It's so easy to do a bad action, but it takes much longer to try to do a good action.

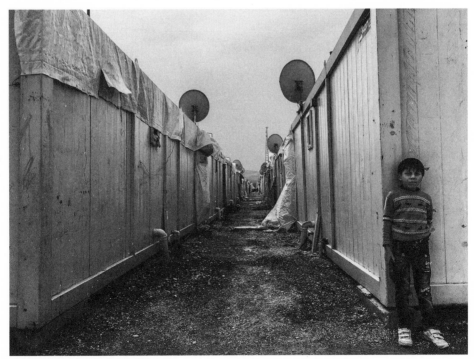

Nizip Camp, Gaziantep, Turkey, 2016

050
Andrew Harper, UNHCR
Amman, Jordan, 2016-04-11

AW Did the world pay enough attention to the Syrian crisis before refugees started to show up en masse at Europe's door?

AH I think what happened in late 2015 was a shock for Europe. They thought they'd been largely isolated from the disaster that was unfolding in Syria, that the regional countries were basically absorbing the shock of one of the largest humanitarian disasters since the Second World War.

But the ignorance and lack of attention to the situation eventually culminated in Syrians deciding that they needed to move elsewhere. They needed to find a place where they'd be safe and could get help, and they couldn't find it in the region, so they moved out. I think the fact that more than a million people moved toward Europe meant that the international community wasn't providing sufficient protection and support to countries in the region. More attention should also have been paid to resolving the situation in Syria itself.

AW Have you seen a change in that political calculus because of the refugee crisis? Is there now a more concerted effort to bring this war to an end?

AH Once we saw the influx of Syrians toward Europe, there was certainly renewed interest from Europe. Countries often try to quarantine or isolate conflicts, but the situation in Syria was so dramatic that the consequences couldn't be contained. As a result, it became an international conflict. In the last six months more countries have become involved in providing weapons and actually flying into Syria and bombing cities. Now other countries in the region and beyond are dictating Syria's future. If the war is to be brought to an end, those countries need to be serious about negotiating peace. At the moment we haven't seen much determination to bring it to a halt. The people who are suffering are the Syrians and their neighbors.

AW With all the attention on the arrival of refugees in Europe, what does that narrative miss about the reality that most of these people are ending up in countries like Jordan, Turkey, and Lebanon?

AH Since the end of 2015 we've seen a focus on refugees arriving from Syria and how dramatic and terrible this is for poor Europe. What people aren't seeing (or acknowledging) is that the conflicts forced the refugees to leave. The Syrians are fleeing terrorism, war, and destruction. They're fleeing from the lack of hope, and unless you can actually address the basics of human dignity—shelter, food, and water, and the desire of families to ensure their children's safety and the promise of a future—people will continue to flee.

We're seeing borders being put up around Europe, but we've seen time and time again that fences don't keep people out. People will find ways to protect them-selves and find a future for their families. It's far better to invest in people, peace,

and human dignity, preferably in the country from which they come, but if they can't go back straightaway, then in the host countries, such as Jordan, Lebanon, Turkey, and Iraq.

AW Is the move back toward Fortress Europe, particularly the EU-Turkey deal, sustainable?

AH People will always move to where they feel safe. There are about twenty-four million people inside Syria. Four million of those have now left. Another eight to ten million are displaced within the country. These are enormous figures. Europe will not be able to stop a population movement unless it addresses the underlying reasons for movement.

A lot of the refugees who do move toward Europe are often the ones who are in the best position to move. They have education, skills, and the initiative to move. It's extremely unfortunate for Syria that the best and the brightest are actually being lost to Europe.

AW Can you talk about the strain that this influx of people has placed specifically on Jordan?

AH Jordan is a relatively small country. Iraq's probably got twenty-five to thirty million people, Syria's got twenty-four million, and Israel and Palestine probably have about ten million. In this context, with a population of seven million, Jordan is relatively small. Despite this, it had to deal with wave upon wave of refugees, first the Palestinians, then the Iraqis, and now the Syrians.

All in all, Jordan is actually hosting some forty different nationalities who've fled here. There's only so much countries like Jordan can do. It doesn't have very much in the way of resources. Its trade routes to the north, east, and west are limited, and the support it's received from the international community hasn't been sufficient to compensate for the additional demands on the country.

Even before the Syrian crisis, Jordan was suffering from a lack of investment in its schools, health facilities, and infrastructure. It was struggling to get gas and electricity from Egypt and elsewhere. On top of that, a population of 650,000 or more has arrived in Jordan, so everything is stressed. The international community can often provide short-term support, but what Jordan needs is long-term support. As long as refugees are going to be here, the international community needs to be committed to providing that support. Jordan is providing what's called an "international good." It's basically compensating for the inability of the international community to resolve the situation in Syria. Until this is resolved, Jordan's going to have to pay more and more out of its own pocket to cover these refugees. Maybe if the international community was forced to pay more to deal with refugees, then it would be more serious about resolving the reason why refugees have become refugees in the first place.

AW Despite the hospitality of Jordanians toward refugees, can you tell me about some of the problems faced by refugees?

AH Jordan has a very proud and generous history of providing support to refugees. But it has its own concerns about stability and security, which is obviously its priority. First and foremost, they check the security of refugees, of Syrians who are coming in. We'd obviously prefer that more people come into Jordan, but at the same time, we have to acknowledge that Jordan has taken more than its fair share.

The hundreds of thousands of school-age Syrian children who come into Jordan wanting to go to school has put enormous pressure on the Jordanian schools. There's pressure on scarce water, electricity, and health care centers. This is a population that was unexpected for Jordan, which was already struggling to provide sufficient support and services to its existing population. Then all of a sudden there is a 10 to 20 percent increase in the population. This decreases the ability to secure additional economic resources because the trade routes to Syria, Iraq, and elsewhere are cut. It's almost a perfect storm.

The Palestinian refugees who came to Jordan in the past haven't gone home. Jordan is saying quite legitimately, "Fine, we'll provide protection and assistance for the refugees, but for how long? How long is the international community willing to provide funds for us? Is it for the next twelve months? Twenty-four? What happens then? We'll still be expected to provide this assistance to refugees."

We've got to look at changing the way in which we deal with the refugee crisis because it's less and less likely to be short-term. Refugees have fewer options to move out, particularly if countries in the region and Europe increasingly put up barriers and fences. In the past, maybe refugees would've gone to Syria itself. Syria's got a very rich history of providing protection. Or they'd go to Lebanon. Lebanon has 1.5 million refugees. It's full. It's more difficult to get into Egypt, and Libya is struggling. Jordan represents one of those few safe locations in the whole region where people gravitate for protection. We're trying to provide as much support to Jordan as we can, but it's never enough.

AW Jordan isn't a signatory to the 1951 UN Refugee Convention. Why is it taking these responsibilities so seriously?

AH Jordan isn't a signatory to the 1951 Convention or the 1967 Protocol of the Refugee Convention. And it's not the key element for me as the head of UNHCR in Jordan. What's more important is whether people abide by the spirit of the convention. Many countries in Europe and elsewhere may be signatories to the convention but don't abide by it. Jordan is a country that has basically accepted wave after wave of refugees since its inception. I also don't think countries like to be told what to do because of a piece of paper. They want to say, "This is our tradition, this is our culture; we've been doing it since we were around." When you get down to it, many people within the Middle East have been refugees, or their parents or their grandparents have been forced from places during their history. Many people know what it's like to have suffered this way.

AW Last, you mentioned that this is the largest mass migration in the region since 1948. How has history shaped the present and, in particular, Jordan's realities?

AH Every country's response to a refugee crisis is based on its history. Jordan is no exception. Back in the 1920s, the first Syrians came across because of the French fighting in Syria, the Circassians before that in the 1870s, the Armenians in the early to mid-twentieth century, Palestinians in 1948 and 1967, then the Iraqis, and now the Syrians again.

Unfortunately, Jordan, Lebanon, and other countries in the region see that they've often had to deal with the consequences alone. The fundamental reasons for the displacement have not been addressed. So when Jordan makes a decision relating to the admission of refugees, it doesn't mean they're coming in for six or twelve months. Once they come in, Jordan basically has to provide support and protection until they can go back. With the Palestinian and Iraqi situations, they've seen that the refugees could be here for decades. It's a very big decision for a country like Jordan, which has limited economic ability to provide support even to its own population. And it's a bit much when the international community asks Jordan to take in more refugees, particularly when you see how much the international community spends on other things, such as the military and propping up the banks.

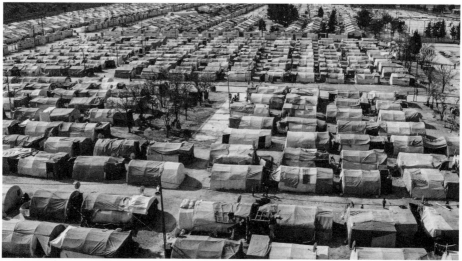

Nizip Camp, Gaziantep, Turkey, 2016

051

Princess Dana Firas of Jordan
Amman, Jordan, 2016-04-12

DF I'm involved in the world of preservation, culture, and heritage, so my knowledge will not be as thorough or accurate as many others you'll see in Jordan. Historically, Jordan has truly been a crossroads for peoples, whether with caravans from antiquity or today as a host for people from throughout this region. It's really very unfortunate that our region has been plagued with conflict, wars, and human tragedies over the years.

We've always prided ourselves on a sense of openness. Jordanian hospitality defines who we are. We've tried to play a role in keeping an open door, enabling people to find refuge here and to retain some sense of dignity until they're able to return to their homes. The average stay of a refugee is about twenty-five years. We've truly been home to waves of people coming from throughout the region as a result of the Israeli-Palestinian conflict, the wars in Iraq, and, most recently, the tragedies across the border in Syria.

There are two sides to the changes that are occurring here. Many people fear change, as it can be very difficult. But I think if you look at the assimilation of different people coming to our region over the years, it has enriched our society in many ways. The art movement, for example, saw a revival in the aftermath of the Iraq War with these incredibly talented Iraqi artists coming to Jordan, making a home here, and producing incredible works.

We always try very hard to link identity to culture and to the various civilizations and peoples that have come through Jordan and passed through this region. When your identity is rooted in your history, it allows you to blossom and to see a different future, one that's richer and more diverse, which always produces a better human being.

AW I think this is easy for one person to say but extremely difficult for a nation to really implement.

DF I don't ever want to underplay the difficulties. Security concerns for Europe and many nations trump other considerations. People's fears sometimes rule their minds much more than their hearts. In many ways, as difficult as the decisions are, you can see how some countries prefer to have a less open border policy than Jordan. But we're part of this region.

Yesterday you said you were walking in the Amman neighborhood Weibdeh, and if you looked at the houses in Weibdeh, traditionally one was built by a Palestinian, one was built by an Armenian, a Circassian, a Syrian, an Iraqi—that's the community of Amman. Our roots go back to all of our neighboring countries. There are hardly any families who don't have a Palestinian, Syrian, or Iraqi relative with roots in different countries. I think that's probably why Jordan is so open to people wanting to come and make a life here.

But there's room for a lot of policy. We listen to His Majesty's speeches, and he's always speaking about Jordan as an open country, welcoming people. That's where you get a sense of national identity. I think this humanitarian side is very, very important. You must always hold on to humanity. The more immune we are to people's suffering, the more dangerous it is. Our region is very challenging. We have difficulties in every direction you look. I think it's critical for us to maintain this humanity for the health of our own society.

At the Petra National Trust, for example, we're very deliberate in our programming. We have this education program in public schools where we introduce history and culture as a critical component to human identity. There's a Neolithic site in Petra, in Beidha. It's 10,000 years old, and that's where architecture started. The shapes of houses went from round to rectangular, relating to the shape of houses that you see today.

For us, it's this idea of a continuum of human history, of an assimilation of all cultural identities and peoples who have come through Jordan. Once you see yourself as one building block of this structure that's made up of Neolithic, Byzantine, Nabataean, Ottoman, and more modern people, Syrian, Iraqi, all of these different identities come together to form who you are as a Jordanian. It immediately makes you a person who's able to appreciate and celebrate difference.

AW You have a very profound understanding of humanity, and such calmness. Tragedy is happening in every direction, so that must also affect the economy here.

DF From a peak of about a million tourists in 2010, we've seen a drop of more than 50 percent over the last few years, from 400,000 to 600,000 tourists annually. Tourism plays a big role in the economy. It's 14 percent of the GDP and it's a major part of the employment sector. If you look at the Petra region, for example, the loss of livelihood is palpable. The closure of restaurants and hotels is truly felt on a very personal level by many people who are unemployed and suffering. When something bad happens in Syria, it impacts tourism in Jordan, and people cancel their reservations in hotels. That's one aspect of falling income. The other aspect is rising expenditures, because you have to house and educate refugees and provide electricity and water.

AW How would you describe Jordan's position on the Palestinian and Syrian conflicts?

DF Jordan's position on the Israeli-Palestinian conflict has always been very clear. I think we've always believed that the solution has to be a two-state solution, living in peace and security with one another. That's really in the best interest of both Israel and Palestine. Conflict isn't sustainable. And it's truly a tragedy to have generations of young children growing up in this very difficult environment that is so centered on hatred and conflict.

I feel very strongly that the rights of the Palestinian people have to be recognized. I think it detracts from our humanity as an international community if we don't acknowledge the daily suffering that the Palestinian people go through.

All of us in the region regarded Syria as practically the start of civilization. It was the oldest inhabited city in the world, with an incredible heritage and culture. Aleppo, Damascus, Palmyra—it's incredibly difficult to watch the destruction of the monuments, standing examples of human ingenuity and creativity, shared human values, and shared humanity. It's incredibly difficult to see it all destroyed so brutally.

AW How many refugees are in Jordan?

DF Jordan has taken more than 1.2 million refugees. I don't know the current numbers. There's a large number of Iraqis, Syrians, Palestinians, even Yemenis. A World Bank official told me a few days ago that we have almost 600,000 Yemenis in Jordan.

Some Palestinian refugees have been settled in Jordan and have full citizenship rights. But there are still some Palestinian refugees who are in camps with refugee status. They have a special Jordanian passport but retain their refugee status. And there are people of Palestinian origin who are now Jordanians and enjoy full citizenship. It's almost impossible to distinguish between a Palestinian, a Jordanian of Palestinian origin, and a Jordanian, because there are many links and intermarriages. Many people are a mix of all of that.

AW Do you think there will be a day when some of them will return when peace comes?

DF Some will, yes. And some won't. They've become citizens of other countries and they've made homes in other places. I think it's important to give them peace, and to let them make that choice.

052

Sanaa Ahmad Ataullah, *Refugee*
Zaatari Camp, Jordan, 2016-04-16

AW How are you?

SA Thank God, I gave birth a while ago and I'm a bit tired.

AW Please introduce yourself.

SA My name is Sanaa Ahmad Ataullah, and I'm from al-Ghouta, in the east. We left the country. The air force bombed us and we fled to the forest. We stayed four months in the wild. They started to bomb there, too, so we escaped to Jordan. We entered here with no Syrian documents. They let us in; my husband is mentally ill, and I'm responsible for the family. I had just given birth back then, and we entered with a little baby.

AW Were you able to pack and bring belongings?

SA No. I came with nothing, with no clothes for me and my children. We weren't able to bring anything with us because Ghouta was so heavily bombed. In the beginning we couldn't leave. We were trapped. Then we left and came to Jordan.

AW How is life here?

SA Life isn't much. Our situation is zero. My husband and I can't work, and these kids need to live. Life isn't only about eating and drinking; you need clothes and have expenses.

When we first entered the camp it was so hard, then we got used to it. We wake up, wash and pray, make breakfast for the kids, collect and transport water to the barracks, and clean the tents. That's it.

AW And then?

SA Then we go to the food aid center, and if we have vouchers we receive aid. We go to the hospitals when the children are sick. I go alone because of my husband's illness. I do everything by myself.

AW Since your husband has a mental disorder, how did you get him here?

SA A car brought us. We paid the fee and they got us to Ruwaished. It was my first time in Jordan. We were surprised when we entered Jordan. They escorted us here and said, "This is Jordan." They tossed us out of the car and said, "Enter from here, and the Jordanians will take care of you," and that's what happened; I don't remember much. We've been in Jordan for five years.

I just gave birth eleven days ago. We wanted to register the baby girl, but we had no family documents. There's no proof that we're Syrians. I only had my Syrian ID

from the bombings. Everything in Syria was gone, and my daughter died there. My daughter and all the papers were gone. The UNHCR asked for a marriage contract, which costs 200 dinars. My husband doesn't have the money, and he's sick and can't work. I went out to seek help and ask for donations.

AW Where did you give birth?

SA In Jordan, in Amman. When I was in labor, I went to the women's hospital here. They asked, "What's happening?" I told them that the baby hadn't moved for three days. They did an ultrasound and said that my water had dried up. I had a Caesarean in Amman and stayed three days in the hospital.

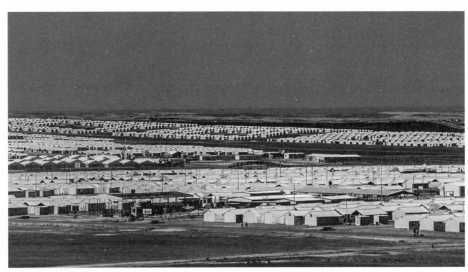

Azraq Camp, Zarqa Governorate, Jordan, 2016

053

Mustafa Enver, Refugee
Urfa Province, Turkey, 2016-04-18

God shall give well-being.
I hope we will go back happily to our country.
I hope God will give remedy to all oppressed people.
I hope that God blesses us.
God bless us.
I hope we will return happily to Syria.
God bless you and them.
They worked for us.
I hope God blesses us.
I hope we will be saved.
Our country will be rebuilt, and we will return to our country.
God bless all of them.
God bless all of them. I hope God will give remedy.
I hope they will give you a salary.
If they give you a salary, you can raise money.
God bless you and them.
I hope they will give you a salary.
Thus, you do not have any difficulties.
You are twenty-six years old.
You can't walk. You can't get married.
If they give you a salary, you will be comfortable.
I hope they will give you a job.
I hope they will give you a job and a salary.
I hope God will make us happy.
I hope we will go back happily to our home and country.
This year or next year . . . But we will go back there.
All doors are open.
We have no protector. We have no country. We have no property.
We are poor and oppressed, oh my God!
Oh God, bless us.
We have no protector. We have nobody to protect us.
We have no country, or anything.
We are poor. We have no protector.

054

Fadi Abu Akleh and Hanna Abu Saada, Documentary Fixers
Bethlehem, Israel, 2016-05-09

HS This is the Dheisheh refugee camp, and there's the latest settlement, Efrat.

AW If the refugees come through here, do they also have to go through that checkpoint?

HS We can't go to the settlement; only Israelis can.

AW What are they going to do here?

FA Who, the settlers?

AW Yes. They just live here?

FA The settlers believe that this land is for them. The government built this settlement for them to stay in. Efrat is one of the biggest settlements in the West Bank. It's on the way to Hebron, in the south of Palestine.

Now they're expanding the new buildings you see down there. They always take high hills. It's about 50,000 inhabitants in this settlement, 50,000 Israeli Jews. They made a special road for the settlers through Bajra, a town near Bethlehem, and they dug a special tunnel under the mountain so they could come safely and directly to the settlement. They dug under a Palestinian town near Bethlehem. In the past the only way to go to this street was through Bethlehem.

After the intifada started, the Israeli authorities put a fence around the Dheisheh refugee camp and all the refugee camps on the main roads between cities to avoid attacks on Israelis passing to Jerusalem. For example, the Israelis who are living in the south, in Hebron and other places on the way, used to cross Bethlehem in order to go to Jerusalem because it was the only way. So they put up a high fence and a small checkpoint, which is still there. The Palestinians left it as a reminder of how the army used to treat them. It's there like a symbol, a small fence and a gate at the entrance of the Dheisheh camp. We can see it now when we go there.

AW How big is the population here?

FA About 14,000 in the camp. Dheisheh is the biggest refugee camp in Bethlehem. It's bigger than Aida, where we're going now.

AW This is the biggest one?

FA This is the biggest one, yes.

AW You're fifth generation there?

FA Yes, yes, a long time. They told the people in 1948, "You'll come to this place, stay for a few days, and go back to your house when we've solved the problem."

HS And until now they have the keys.

FA The keys of their house.

AW Who has?

FA The UN; the UN is taking care of them now.

AW So they lied to those people?

FA Yes. Since that time they've been asking and waiting for the right of return. They want to go back to their houses.

AW Where are their houses?

FA Their houses are spread in the north of Israel, near Nazareth, Haifa, Jaffa—all of these places. There are small villages that you can visit, like Bahurim and Ikarit, for example. They're from different places. Some families were divided when they were moved. A part of the family came to Bethlehem, a part to Jordan or Syria. They split.

AW And now they can't get back together.

FA No, never. The refugees have a simple way of life. As you see, the houses aren't even well repaired.

AW That's a nice way to say they have a simple way of life . . . like a Buddhist.

FA A simple way of life. They just ask, "Who built this? Why is that wall here? Why can't we go there?" It creates hatred and distance between people. How can they want peace if they separate people from each other? How we can meet? How we can talk?

For example, if you ask a Palestinian kid to draw you something, his imagination is limited to the wall and soldiers and guns. He'll draw a soldier. The whole situation creates something inside the Palestinians. I'm against killing and stabbing, but you have to wonder why these people are stabbing in Israel. No one does that unless he has something very, very big inside him that pushes him to do so. I can't imagine ever doing this myself, but sometimes I think, *Why are these people doing that?* They are Palestinians, the same as me.

AW They're desperate.

FA Or they lost their family, or their whole family died in Gaza, or only one stayed alive. What do you want this kid to do in the future? To love Israel and make peace? We don't have a patch of land or weapons. We're a simple country. Everyone is playing with us. And in the end, we're human. We're not animals.

When I travel I feel like I'm not treated like a human. When I travel, crossing the checkpoint, the borders to Jordan, it's not—it's not humane. You can't believe how we travel. It's very bad.

AW Which checkpoint are you talking about?

FA I'm talking about the borders between Palestine and Jordan.

AW Where?

FA It's near Jericho. [Pointing] It's there, you see the mountains . . .

AW People do this every day?

FA Not every day. If they want to travel, they have to cross the borders.

AW I have to film that.

FA It's not allowed because it's the border.

AW Border?

FA A border between two countries, Jordan and Israel.

AW Why isn't it allowed?

FA Because it's borders. Borders also have security. If you talk about a checkpoint, it's different from a border. Checkpoints are between Palestine and Israel. Borders are between Jordan and Palestine.

You can go to the Bethlehem checkpoint; it's called Checkpoint 300. You can go in the early morning and see all the Palestinian workers. You see a big queue of people waiting to go to work. They have to go at four o'clock in the morning to reach their work by eight. You can also go to Qalandiya Checkpoint between Ramallah and Jerusalem. You can see the suffering of Palestinian workers because there are a number of Palestinians who have special permits to work in construction in Israel.

AW What else do you think we should film about Palestine that deeply hurts you?

FA Hebron, but it's difficult to go there. Hebron is a different situation because of security.

AW Israeli security?

FA Yeah. Listen, in Hebron, the difference between Hebron and other Palestinian cities is that the settlers came and took over houses in Hebron because the Ibrahimi Mosque is there. And Abraham is a prophet for Jews, Muslims, and Christians.

AW This is most symbolic.

FA But the main point is that the settlers are living above Palestinians. They took the houses above. Palestinians are living underneath, and there is a fence in between. So if you walk in the Palestinian area, you look up and see an Israeli flag, and in between there is a fence. And there are checkpoints.

AW Have you been there?

FA Of course. It's twenty to thirty minutes from Bethlehem.

AW It's in the West Bank, right?

FA It's in the West Bank, but you cross an Israeli road and then you're in Hebron; it's still the West Bank, but above that is Israel. You know Area C? It's a mix of Israeli and Palestinian. I'm talking about the old city of Hebron, because the main area of Hebron is very big.

You never see other Palestinian cities like it. Settlers are living above Palestinians. There are stories about settlers trying to provoke Palestinian kids.

AW Have you been to Gaza?

FA It's not normal for a Palestinian to have a permit to go to Gaza. I'm thirty-one and have never been to Gaza. I live in Palestine, and in that time, I've never been to Gaza. I can't go.

AW Do you want to go?

FA Of course, I would love to visit Gaza. It's a nice place. You can go to the beaches, things we don't have here.

AW But you can go through the tunnels.

FA No, it's dangerous to go through the tunnels. As Palestinians, we aren't even allowed to go to Egypt. It's difficult to get a visa for Egypt. Only people who are older than fifty can go. I need a permit even to go to Jerusalem.

AW You can't even go to Jerusalem?

FA I can't travel through the Ben Gurion Airport. I have to cross the border to Jordan and travel from there to where I want to go. You can enjoy my country more than I. You can go wherever you want. You can rent a car and drive in Israel and in Palestine. I can't. I can only drive in Palestine. My car is forbidden in Israel. It's a Palestinian car. We can't cross checkpoints.

If I have a permit, I can go to Jerusalem by taxi or on foot. We get this permit only twice a year. For Christians, it's Christmas and Easter; for Muslims, it's Ramadan and Eid al-Adha—that's it. And that's also for the business of Israel. When we have this permit and go there, we help the economy. When we go, we spend a lot of

money. And they give us only a limited period of time; on the permit it's written, from seven o'clock till ten, then you have to come back. The same goes for the date. It's a complicated situation. But it's all for the security of Israel.

AW So why did you grow up in this kind of condition?

FA We're used to living this kind of life. We're always hoping for the best, but it's getting worse. But we still have hope. We don't want to kill hope. Before, there was no checkpoint. We were hoping for the best, but then the wall and checkpoints came. But we've been hoping for a solution since 1948. And we believe in God. We're happy.

AW God is so far away, but the helicopters are very close.

FA Very close [laughing]. But God is inside. Much closer than helicopters. Religion here is important to people. That's why we always talk about God.

AW And how do all the people in here survive?

FA We have a good business. Of course, we have problems with the economy because we're not like a real country. But you'll never see homeless people in Palestine. No one will sleep without food. We have security, we don't have thieves, and crime is very rare. We have our own security, army, and, all in all, we have good lives in Palestine.

I can't say we're dying here. Many people in the world suffer much more than Palestinians. But we've suffered a lot in a different way. We've suffered in our lack of freedom. And we passed through a very difficult period as kids, teenagers, and old people. We had a very bad time in the 1980s and back in 2002. I believe that many Palestinians have psychological problems because of this situation. We don't live like normal people, with freedom, where everything is open. Here, everything has a limit.

I also see that the new generation is a problem for the future. They're growing up with a wall, with checkpoints, and what they see. They never meet with Israelis. They haven't known the area before the wall was erected. So when they grow up, never having met an actual Israeli but just hearing about them, they tend to form stereotypes about them. This is true of both sides. I knew the area before the wall and the checkpoints.

055

Munther Amira, Aida Camp Youth Club
Bethlehem, Israel, 2016-05-09

AW Can you tell us how young Palestinians feel today?

MA I think the nation has reached a state of depression. The Palestinian nation today feels no hope. The occupation leads youths to lose hope in life.

AW What do people see and witness every day?

MA Demonstrations are held here in the mornings in Aida camp about four days a week. If no one goes out to throw rocks at the Israeli camp next to ours, Israelis call on loudspeakers in obscene terms for us to come; then they throw gas bombs and attack the camp. This is from morning till afternoon. At night they attack the camp, raiding the houses and arresting kids, both girls and boys. This is what happens every day in Aida camp.

AW How do you involve the youth in nonviolent resistance?

MA I think our role in the camp is to try to awaken the youth inside the camp. But again, the Israelis don't let anyone give them hope. This camp is sixty-six acres, and 5,500 people live here, surrounded by a wall on three sides, a camp on the other side, and a military barrier on the other. Peaceful resistance doesn't work inside the camp.

Youths in secondary school are trying to leave, but we insist that they stay. We provide leadership courses for them to be active in society. After pursuing education and entering universities, you don't free Palestine by throwing rocks. With an education, you can become a doctor or an engineer, free your land, and make a change in your reality. Change comes only from the youths when they grow up.

AW Israel says that they need this wall behind you for security. What do you say to that?

MA Israel can't prevent everyday incidents that happen in the green-line territories or inside the 1967 borders. I guess Israel put the wall here as a lie. Everyday incidents happen in Jerusalem, stabbing and people getting run over. This all comes back to the Palestinian youths. They tend toward violence because Israel wants them this way. You trap 5,000 in Jesus's holy land in Bethlehem—around 220,000 live in the area of Bethlehem; they get up to two million visitors a year—and surround them with a wall. I lived in prison for four and a half years. Now I live inside the camp, which is just a bigger prison.

AW What were you arrested for?

MA I was arrested for peacefully resisting when the occupier started building this segregating, racist wall. We used to come demonstrate, unarmed, and say, "If you

want peace with soldiers here, know that this wall brings no peace. It brings war." They used to hit us with open fire, gas bombs, and elastic bullets. After that they arrested me at night. I was in prison for four and a half years because I obstructed them. This was the accusation—that I obstructed the IDF [Israel Defense Forces] from doing their duties because of this wall.

I used to believe that only peaceful resistance would get us results. But I don't believe that anymore.

AW What time did they arrest you?

MA They arrested me at 2:00 a.m. It was March, and it was snowing. They arrested me while I was asleep, in my T-shirt and barefoot. They covered my eyes and trapped me. They walked me out onto the snow in the cold. I walked about two kilometers barefoot till I reached the military jeep where they took me to their camp. The entire way, around seven to eight kilometers, I was on the floor of the jeep and they were hitting me. They interrogated me. It was so humiliating. You get beaten and assaulted with obscenities and insults. I was interrogated for about fifty days for shootings and something I didn't do. At the end they sentenced me under the Israeli security law to four and a half years. In prison I lived in a cell of three square meters with no toilet. You're allowed out only three times a day: to shower and to go out to walk for ten meters twice a day for one hour. The rest of the time, you're trapped in the cell. If you asked for the simplest rights, if you needed hot water, the administration didn't agree to such requests. They used to come and throw powders and gas at us from the little windows in the cells, and you couldn't resist; you'd pass out. It was terribly hard. The assaults, the bus you ride in to go to court, the humiliation you get while in plastic cuffs; if you moved your hand, you'd be severely injured. We were so humiliated.

AW Will there ever be peace between Israelis and Palestinians?

MA I think Israel had a great chance in 1993 to attain peace but it didn't commit to the agreements between Israel and Palestine. As a young refugee in this camp, "peace" would be me returning home to my land. I want Palestine from the sea to the river. This would be peace for me. Before 1917 Muslims, Christians, and Jews used to live on this land under a state called Palestine. I have no problem with Jews living with us in the state of Palestine; other than that, I guess there will be no peace.

056

Hagai El-Ad, B'Tselem
Jerusalem, Israel, 2016-05-09

HE In the minds of most people living here, Gaza could be on Mars. It's as distant as it can be: out of sight, out of mind. Yet it's barely an hour's drive from Tel Aviv. In that way, geographical proximity doesn't define closeness; in fact, it can be the other way around. This is one of the most extreme examples of that reality.

AW As a human rights defender, your organization has been a forerunner in the Israeli and Palestinian human rights situation. How do you describe democracy and the human rights condition in Israel?

HE I move uneasily on the chair because you use the word "democracy." I was born a few years after 1967, and for almost fifty years Israel has controlled millions of Palestinians under military rule who don't participate in political decisions about their future. When I vote, I vote for the future of Israel, but I also vote on their future. So, to call such a situation "democracy"—I don't think that's the appropriate word to describe reality. Of course, there are many democratic attributes in Israeli life: free press, open elections, and so on. But there is a distinction between a formal democracy, going through the motions of what looks like a democracy, and having certain functioning attributes in a real democracy. Now it's been fifty years in which about twelve million people between the Jordan River and the Mediterranean haven't been participating in decision-making in this place. They're not part of the politics of this country. That's not a democracy.

AW How do you describe the situation? As some kind of temporary stage?

HE It's difficult to think of it as temporary. The legal term of Israel's control over Palestinians is "temporary belligerent occupation." I think any person would say that occupation for fifty years stopped being temporary a very long time ago. At one point during the last fifty years, the word "temporary" completely lost its meaning. But it's a concept that is used very effectively by Israel in order to perpetuate the current reality: temporary, as you know, as we've proved, can go on for a very long time, but it's just temporary, so you don't need to worry about it. Some Israelis also care about the situation, and a significant minority of people reject the occupation. But if it's temporary, then maybe we can be more patient regarding it. If it's temporary, there are things that are maybe acceptable in the meantime, and it's also used effectively to convince the world not to get too involved, not to push too much for many consequences in order to change the reality. What Palestinians would occasionally get is some language that will condemn the reality here. I think that's significant, and it's better than silence, but at the same time, consecutive governments and the public have grown to understand the difference between talk that is cheap and action, which never happens.

AW Do you think the voices about the Israeli-Palestinian conflict have been growing stronger?

HE I think there are two processes happening in opposite directions. There's a growing voice, both domestically and internationally, that's calling Israel's bluff, that says temporariness is nonsense, as the guise of legality by which Israel keeps violating the Palestinians' human rights in a very intricate, sophisticated way. More and more people see through this. Maybe the people that are now graduating in some capitals around the world will become decision-makers in a generation, and things will be different. There's also another process that a significant percentage of the Israeli politicians are betting on: that the world, especially the West, will finally "get it": they'll finally understand that this is the frontline Judeo-Christian bastion against Islamic extremism and terrorism, and that we're fighting here what Europeans don't want to fight there, so they need to support us. People that object to the occupation abroad are being presented as anti-Israeli. I don't think that's being anti-Israeli; I think that's being human and decent and also good for the future of the people who live here, both Israelis and Palestinians. But they're basically continuing to give Israel a green light to advance its interests over Palestinians' rights, and they see signs that make them optimistic in the rise of ultranationalist parties in some European countries. So they're betting that actually no Europeans will get it. I'm not confident about which process is going to win eventually.

AW As a strong and active politically liberal voice, to what extent do you represent the Israeli perspective?

HE B'Tselem has been documenting human rights violations of Palestinians in occupied territories for more than a generation, more than twenty-five years now. I think in many ways B'Tselem has become synonymous with human rights in Hebrew. For many people, we're by far the best-known human rights organization in the country. But, of course, there's a huge difference between being known and being liked. We're probably one of the most domestically hated organizations in the country. Unfortunately, because such a huge part of human rights violations in this part of the world are violations against Palestinians, then defending human rights has become synonymous with defending Palestinians, with defending the enemy, with hating yourself, with being antipatriotic, and all that protofascist language. We've seen all that gradually happening in more and more extreme ways over the years. Still, even in the current political climate, we know that there is a significant minority of the Israeli public that identifies with our values, supports our work, rejects the occupation, and so on. But at the same time, "human rights" isn't about being popular. It's not about getting to 51 percent. It's about telling the truth and doing that in an effective way. And in that sense the audience for the reality that we're exposing isn't only the Israeli and Palestinian public but also a global audience. The issue of what's happening to Palestinians living under Israeli occupation is an issue of great international consequence, and under any circumstances, human rights are a universal issue that knows no borders.

I caught myself saying "even under the current political climate," and feel that I need to qualify that, because someone might hear that and think that the occupation, settlements, and human rights violations of Palestinians are all just the results of a right-wing government. Yes, we should give Netanyahu and his government a lot of credit for this reality. But we should also be reminded that

occupation, settlements, and the dispossession of Palestinians were not the result of the right-wing governments. The settlement project was started by Labor, the occupation began with a left-wing government. And the reality is that during those fifty years, there have been left, center, and right governments, and basically all of them besides the government of Yitzhak Rabin were part of propagating this project of Israel in the occupied territories.

AW Are these developments about religion, about humanity? What have you learned through this longtime struggle?

HE I think the reasons are mixed, and I don't think they're the same for all people. For some it's history, for some it's religion, and for some it'd be security, which is a real issue here. It doesn't explain or justify what Israel does, but it's used very effectively as an excuse and justification, and not all people see that under all circumstances.

There's also another factor that we need to take into account: this is normal. We can think that it's crazy and unjust and disgusting and historically and morally unacceptable, and we know that it'll end and must end. But this is the way things have been for a very long time, and there's very little reason to think it's going to change anytime soon. It's like the sun rises and reality continues. If something changes, that would be a dramatic shocker and a huge change in reality, and it would certainly come with significant costs, risks, and internal fighting. And who knows how that's going to play out? So yeah, there was that moment in 1967, but so many years have passed since. As a credible source, we saw it as our responsibility to tell Israelis about the reality in the occupied territories. Apparently we haven't done such a bad job at that. People know, but knowledge doesn't automatically translate into change.

AW Is there going to be a change? If there is change, will it be one state or two states or something else?

HE It's really difficult to imagine, and I'm using the question as an opportunity to poke and turn a bit, because I think different people mean very different things when they use the terms "one-state solution" and "two-state solution." It's like when people do polls here, they'll tell you very quickly a solid majority of Israelis continually support the two-state solution, and yet it never arrives. Right there—that should make us pause and wonder. You know that you're supposed to give this answer. Of course I'm for the two-state solution, sure, why not, right? But are we willing to do something for it? That's a very different question. And the second issue is, what do I actually mean when I talk about that? Jerusalem as the shared capital of Palestine and Israel? Where will the borders be? What will happen to Palestinian refugees? People have been discussing these core issues forever. Palestinians are talking about one thing when they say "two states," and Israelis are thinking about something quite different.

When "one state" is invoked among progressive circles, they're thinking like a real democracy—one politic, one country, everyone an equal citizen, everyone participates in the voting—it'll be fair and equal. That's the fantasy. But there are also other people here who talk about one state, and what they mean is some-

thing much closer to the current reality. It's just the formalization of certain aspects. What they mean is total Israeli control over the entire territory besides Gaza, which they wish would fall off the face of the earth. Also, for demographics' sake, it's better not to count Gaza. You get rid of 1.8 million Palestinians just like that. And then the details become murky. So it needs to be one state, and it needs to be okay, so everyone needs to be a citizen and vote. But the citizen of where? And vote for what exactly? Maybe they'll live here but they'll vote for a parliament in Jordan and that's "one state?" What's wrong with that? So there is "one state" and there is another "one state"—they can be very different realities. But, in fact, I think it's undeniable that we've been living in a one-state reality for quite a long time. There's one government, the Israeli government, that controls all of the people living between the Jordan River and the Mediterranean. We treat Jews in one way and we treat Palestinians in many different ways, whether they're citizens or permanent residents or Gazans or whether they live in Area A or B or C in the West Bank: various degrees of control, various degrees of humanity.

AW Human rights, gay rights, minority rights, women's rights, religious rights—how do those relate to the political struggle within this society?

HE I think it's something that informs every individual: issues of identity and what the world's values are and what we decide to do or not to do in our lives. So for me, being gay and growing up as a minority, I have a sense that comes with responsibility. And I think the gay minority in Israel has been quite successful. After that, it really becomes a question of whether you're done when you're happy. Or do you have an extra responsibility, because you're a part of a relatively successful minority, to say that this is the way it needs to be for everyone? On the good days I hope that's what informs my decision-making in life and in my work.

Of course, the issue of gay rights in Israel also became very political. Again, in the context of the occupation, I think the politicians have a deep, sophisticated understanding that it's essential to continue marketing Israel as a liberal democracy around the world so that we're allowed to continue with the occupation. And there isn't much currency that we can throw around globally to demonstrate that liberal democracy. Now, most of the rights the gay community fought for and gained in this country weren't given by the government. People had to fight and litigate and demonstrate in order to get them over the course of years. So these are the achievements of the gay community, often in the face of the opposition of government policy. But now it's a complete nonissue for the government to come and say that this is one of the shining beacons of Israeli democracy, look at gay pride in Tel Aviv. Hopefully when you do that, your eyes won't veer farther to the east and you won't see the separation wall, or the refugee camps, Gaza, the homes of Palestinians being demolished all over the West Bank, the thousands of Palestinians that were living in Jerusalem that have lost their status in this city, and many of the other mechanisms in which we control the lives of Palestinians. But gay pride—that's awesome.

AW Most politicians think they're very practical. What do they think about keeping this occupation and very harsh treatment of the Palestinians for the past decades? What do they think they can gain from this, and what are they afraid of?

HE The alternative—trying to fix this is very difficult. And also dangerous and compli-
cated.

AW What's the danger? Why is it complicated?

HE We had violence in the past. It could happen again. There's been accumulated,
even justified hatred and fear over many decades of violence—I'm talking also
about state violence, violence by Palestinians, and so on. I mentioned previously
that there was an attempt by the Rabin government in the 1990s, a good faith
effort at least in part. Rabin eventually paid with his life for that effort. There are
no assurances of success. Just try to imagine the amount of privileges that the
Jews in this country would need to give up in order to have equality and decency
in whatever political arrangement, if you rearrange reality for the people living
between the Jordan and the Mediterranean. That's a dramatic departure from
everything most of the people here have known.

Let's go back to Gaza for a second: those 1.8 million people that are our neighbors
live in conditions of a third world country on the way to collapse. There was a UN
report that said in 2020 Gaza will become uninhabitable: there are already
people there who don't have electricity for many hours a day. The quality of the
water is deteriorating. We're talking about the most basic of human needs. This
isn't the result of a terrible natural disaster, this is man-made, and it isn't hap-
pening on the other side of the planet. These are my neighbors, the neighbors of
the start-up nation. So try to imagine a reality in which the lives of the 1.8 million
Palestinians in Gaza would be decent.

I think the politicians understand that. So let's try to think in a cold-blooded
analysis of the reasons why and how to really try to fix this, with all of these
difficulties and with no assurances of success. Now, continuing the status quo
isn't only cruel and unjust but also insanity. It's totally clear how this is related to
increased levels of violence, fear, and danger. This is already very bad for Pales-
tinians, and soon also for Israelis. So, we might as well try and go in a different
direction, not just because of fairness but also because of common sense. But in
the meantime, if you're a politician thinking about four years: Where is the
incentive? Why bother, why risk it, why pay a huge domestic political price?
These opinions aren't very popular in this country.

At B'Tselem we've tried for a very long time to tell Israelis about this reality. But
again, facts and compassion alone don't drive the change. Interests eventually do
drive the change and the one nonviolent factor that might change that equation
of convenience is the way the world treats the occupation. And also the way
Israelis think—"Is this really working for us?"—in this immediate sense.

AW Do you think you can see that day happen?

HE I hope so, but honestly I'm not sure. I've been working for B'Tselem for two years
now, and one of the thoughts that I had in my mind before starting was that
fear—I'm in my forties, slightly younger than the occupation. I lived all my life
along the occupation, and I wish a long and good life for myself. There's very little
that suggests that things will even start moving in the right direction. So I'll look

back at some point, and I'll have to ask myself, what have I done with my life so that it's not this way when I'm seventy-five?

AW We're living in a very different world with the Internet and much more freedom of information, for people to be easily informed and communicate. What do you think of a new generation who grows up with this Internet age and freedom of information? Or does that not really matter?

HE It's a blessing in disguise, but one that I'm also suspicious of and hesitant about. On the one hand, for us this makes it possible to get the data, information, and analysis to a lot of people very quickly while circumventing old media, newspapers, TV channels, and so on. That's extremely important, especially in the reality in which the media in Israel exists. We spoke before about democratic attributes in this country, but most news media, besides *Ha'aretz,* will just self-censor. The bombing of Gaza in the summer of 2014 was a good example. With social media we can tell the story directly to people. So it's very helpful for us, especially with this decline of real openness of the free press, to tell the deeper story of the reality of the occupation, especially at times of intense violence. Having said that, and with all due respect to the great potential of social media, I think nothing is ever going to change the activism of people demonstrating in the streets and doing those kinds of things, not in a virtual sense, but really doing them. There's the fear of activism being transformed into a "just online" phenomenon, which isn't sufficient.

AW I think that Israel is a quite highly educated society. People love art and culture. Can education make a difference about opinions, about freedom, in a liberal society?

HE Apparently not. I mean, the facts speak for themselves. I agree that this is a relatively educated society, and also one very aware of its own history, so these facts are all there. But does that translate into a deep understanding not of formal democracy but a real democracy? Apparently it doesn't. And the shallowness of the conversation here sometimes makes you want to scream. The occupation is allegedly democratic because we voted, or there are other pieces of legislation that would be blatantly racist, but it's democratic because the majority has decided. That's kind of the conversation you often get.

We don't need super-advanced political science degrees to understand plain decency. Sometimes people get the sense that discussing human rights has somehow become dispatched to attorneys litigating. Actually, most of the time, these are very basic situations in which you look at things and ask, "Is this fair? Is this equal? Is this just?" You don't need to be a judge or a lawyer or a political scientist to identify, as a human being, that what you're looking at is injustice. But what we see here is a reality that functions in a different way, with endless layers of denial, justifications, blindness, and so on and so forth. I wish that education was the silver bullet, but it's not.

AW What made you become a human rights activist?

HE It was a gradual process. My background is in academia. I was studying physics and hoping to become an astrophysicist in my twenties. At the same time I was

volunteering for gay rights at Hebrew University, which was a very meaningful experience for me, but still something I was doing on the side. Then I went to the US for a few years and studied there and volunteered in fundraising and networking for what later became the Jerusalem Open House, the gay center in Jerusalem. Then my three years in the US kind of ended and I had to decide what to do. I had my thirtieth birthday midlife crisis and the center was looking for an executive director for the first time, and eventually I decided that that's what I wanted to try to go for. So I was the director of the Open House for six years, and after that I moved on and became the director of the Association for Civil Rights in Israel (ACRI), which is a large human rights civil liberties organization that works on the entire spectrum of human rights issues and also on social-economic rights, freedom of speech, and equality issues in general in Israel and the occupied territories. Then a couple of years ago I moved, and I'm now working for B'Tselem, which is completely dedicated to the one issue that is the largest, most extreme human rights violation—the occupation.

AW Why were you interested in astrophysics?

HE I loved *Star Trek* as a kid, so I think it's just logical that you'd want to study astrophysics. I was looking at the distribution of galaxies in the universe and focusing on voids, places where there are no galaxies. So it's really a PhD about nothing. Apparently there are quite a few places where there are no galaxies, and this is important in the context of cosmology. If you want to try and chart the history of the universe, then the fact that you have these huge volumes of space in which there are almost no galaxies is a very important limitation in your understanding of that history, because we know that the universe started in an almost completely equal level of distribution of matter in the very beginning. You start with something that is almost completely the same and you end up with huge places where there are no galaxies and then clusters with many galaxies. You need to be able to explain that history, that lack of uniformity in the universe.

AW We have so many studies on those fundamental questions about how believable our human rationality is.

HE I think it's quite convincing; it's exciting and it's great. But now, imagine a Palestinian village in the West Bank; I'm thinking now about Umm al-Khair. People were deported there by Israel in 1948 or after, and they've lived there ever since. There's a settlement nearby where the Palestinians live with almost zero infrastructure, in a place where they were pushed many years ago, and now they're suffering from demolition again. There's a bulldozer coming, not to all of the places at the same time, because that would be too much, and there might be an international outcry. So Israel does this piecemeal, gradually. I think about that very painful connection between the wonderful, really awesome things that human beings can do, like understanding the universe—great and beautiful things—and then the terrible things that we do to each other.

AW You're not a religious person, are you?

HE No, I'm not. I care a lot about Jewish identity and it's an important part of who I am, but I'm not religious.

AW What would be the positive aspect of religion in this society?

HE I think it can be a source of comfort and identity, family and community. Clearly, this is a very strong part of many people's lives, especially in a city like Jerusalem, and a part of reality here. Religion has also been a very powerful driving force of past, present, and future, specifically in this city, but like any other idea that human beings come up with, you can do both wonderful and terrible things with it. I think this city has seen both. Religion is used by everyone in order to justify and propagate hatred, fear, and violence. But you've also seen very courageous examples of people of faith that insist that their spiritual life is something that brings them closer to very different people.

People like to talk about diversity and tolerance; I think it's much easier to practice tolerance and celebrate diversity in the absence of diversity. When you live in a place where everyone is like you, you can be so open-minded and liberal—easy. Jerusalem is really such a diverse city with very different people, and you see it strongly on the religious spectrum. It's really a place where you can see whether diversity is something that people are successful in living with or failing at.

AW How do you understand the Palestinian identity?

HE I think of being Palestinian as a national identity. Most Palestinians are Muslim but certainly not all of them; there are also Christian Palestinians. And, of course, Palestinians are Arabs; they're part of that bigger context.

AW If you think about its national identity after being a nonexistent nation or one denied status for sixty years, that's really something very impressive.

HE Absolutely, and of course you know Palestinian national identity didn't begin in 1948. It's interesting when you read earlier history about ownership and rights between Palestinians and Jews. Who can call it their motherland? Already decades before the occupation these were questions, even before 1948, concerning the establishment of the state of Israel, the Nakba, the creation of what has become the Palestinian refugee problem.

I think it's interesting to see the understanding of Jewish leaders, Zionists—their understanding of Palestinian identity, ownership, presence, history, and so on—from that time they came here and built the aspiring nation that eventually became the state of Israel in 1948. It's interesting, because the way they were talking about Palestinians at the time, they would be considered traitors, ultra-leftists, in 2016 Israel. How could they accept Palestinian space and understand Palestinian resistance to more and more Jews coming into Palestine under the British Mandate in 1948, after the First World War? But Jews were still a minority in this country then, so maybe there was much more need for sincerity with regard to reality at that time. Things have changed very much since, not only regarding ownership or who runs this place but also to the spectrum of what's acceptable in the discussion of human rights here.

AW How do you evaluate the Palestinian struggle?

HE It's difficult for me to answer that. Basically, I feel it's inappropriate for me as a privileged Israeli to judge the Palestinian struggle. Of course, like anyone here I have my own opinions, and I think anyone can look at the bottom line and see the way in which Palestinians live; clearly, they haven't been successful. But I think in other ways maybe we would come to different conclusions, in the sense that the conditions for failure were even more extreme, so the fact that people are holding on and continuing to fight, especially in nonviolent ways, is remarkable. It's not necessarily about the headline—the big national struggle for freedom and so on—but sometimes really thinking about specific individuals in specific situations; you try to put yourself in their shoes, and maybe you'd have given up. I would've given up a long time ago if I had to endure such a situation.

I go back to the issue of home demolitions because it's such a cruelty and also such a fact of life. This is something that Israel has been doing to Palestinians for a very long time as part of an ongoing strategy. It's not just the terrible day in which the bulldozer comes and demolishes your home, but it's also the fear of all of the years before that. You know that it can happen, so you live in constant fear. Or maybe you're in a situation in which they'll not connect your village to running water or to electricity, again with all sorts of legal excuses. A lot of people live under these conditions and fears for a long time, but there's a voice you'll hear in many places that says, "Israel can come and demolish my home as many times as it desires. I'm not going anywhere."

AW Are you allowed to go to Gaza?

HE No, in general Israelis aren't allowed to enter Gaza except for very specific cases, and most internationals aren't allowed to go into Gaza either. We have researchers all over the West Bank and three of them are in Gaza right now. As the director of an organization, it puts me in a weird situation. Think of a staff meeting: We can't have a staff meeting anywhere in Israel because they can't come here, and we can't have it in Gaza because they can't go there. If B'Tselem wanted to have a staff meeting, the only place that we could theoretically do it is somewhere else on the planet. We would all need to somehow go abroad, which would be very easy for me, forty-five minutes to the airport and that's it. But it would be very difficult for my staff from Gaza, because they'd need to wait for a good day on the Rafah crossing between Gaza and Egypt when maybe they could get out, then make the long drive to Cairo and fly to somewhere in Europe or Jordan. And if they succeeded in going out, they wouldn't know how long they'd have to be abroad before they could go back to their families, because sometimes you can be stuck abroad for months. Just think of the personal situation, family, small children; maybe you don't have a visa to stay for such a long time, but you can't go back. So again, this is crazy, but it's the way things are, the way things have been for a long time.

AW Thank you. Do you want to have another drink?

HE Yes, absolutely.

057

Ayman Odeh, Israeli Politician
Jerusalem, Israel, 2016-05-09

AO I'd like to start with a story I like by the author Emil Habib. Emil Habib says that once he took a cab in Cyprus and the driver asked him, "Where are you from?" He replied, "I'm Palestinian." The driver asked, "But Palestinians are all over the world; where are you from?" He told him, "I'm Palestinian from Israel." Emil Habib says that the taxi driver was so surprised he almost swerved off the road.

This incident puts our situation into perspective. We, the nationals, stayed in our motherland despite the Nakba and the politics of transmigration. Israel was built on our nation's rubble. We didn't come to Israel; Israel came to us. In 1967 they occupied an additional part of our land and nation. This is a difficult situation. Nevertheless, the solution lies in implementing global and just values that offer a moral, democratic substitution. This applies equally for Arabs and Jews.

AW There's been a powerful occupation since 1967. Palestine isn't even recognized as a state, and the settlements have marginalized so many Palestinians. Could you please give us some background on this situation?

AO The events of 1967 exacerbated the Nakba, but it also further manifested the clear purpose of Israel as an enemy of the Arabs. But before 1967 came the 1956 war. Any sane human being would think, "What did Israel need from Egypt in the 1956 war?" We might understand that [the former Egyptian president] Abdul Nasser nationalized the Suez Canal and wanted to cancel British and French privileges. But what led Israel into the war? Nationalizing the Suez Canal wasn't against Israel. This proves that Israel played the role of a cat's paw for imperialism, that Israel is a European representative in the region. What else could explain the events of 1956? In 1967, we saw the occupation of the Egyptian and Syrian territories. In the end, everyone understands that the logical and possible solution should be the termination of the 1967 occupation and the establishment of a Palestinian state next to the Israeli state.

AW There are about four million Palestinians in Israel, but the total population of Palestinians is about eleven million. As a politician, you represent the interest of Palestinians. How do you think the people of this land relate to the Palestinians outside of Palestine?

AO It's clear that there's institutional racism against the Palestinians in the media and in the educational system in Israel. Every Palestinian is demonized to justify segregation and racism. But there's also a structural policy from the right wing. The right wing knows that we represent 20 percent of Israel's citizens. If we become legal citizens and part of the political process, we'll need an extra 30 percent from the Israeli community to reach 50 percent of the nation. The right wing won't stay in power if we're legalized. This is why they work on demonizing us from the racist point of view as a political strategy.

AW How strong is your voice as a political leader in the Israeli parliament?

AO The strength of our position is that we were elected by our nation. We were not only elected, but we have thirteen parliamentary seats, which has never happened before. We've become the third-largest party in Israel, which is also new. Our power comes from the fact that we were elected. We represent this nation. The Israeli government acts irrationally and claims that we don't represent our nation. This is offensive to us and implies that our nation doesn't know how to vote and doesn't know whom to support. Basically, they imply that the voters are irrational! We represent people not only on a national level but also in terms of their everyday concerns.

AW You've been very optimistic and positive about the political struggle. Realistically speaking, do you think it's possible to end this occupation and achieve a two-state political status?

AO I'm really optimistic. My optimism originates from my deep faith in humans. There's a saying, "Every human carries a little racism inside of him or her." I've changed this to say, "Every racist carries a little human inside of him or her." And at a certain point, this human could grow. I don't mean this in a separate reality. History proves that what I'm saying is credible.

Once I gave an example of two Frenchmen resisting the Nazis in Paris. While they were underground, one said to the other, "Within seven years we'll establish a shared European market with Germany." In 1944 he should've gone to a mental hospital, but his thoughts became reality! A few months ago I was in a Kreisky center in Austria [named after Bruno Kreisky, chancellor of Austria from 1970 to 1983]. After twenty years of Nazism, when most of the Austrians supported the tragedy, a Jew became the Austrian chancellor.

If we saw Malcolm X in 1960 and told him that in fifty years a black person would be the president of the US, he would've considered this statement insane. But we don't even have to go so far back. Look how Rabin wanted to break the Palestinians' bones two years before Oslo. After only two years he stood next to Yasser Arafat in the White House for the agreement that sparked the beginning of the Oslo peace process. I remember the time of Oslo and how the relationship developed between the two nations. Therefore, my optimism isn't separate from reality or from history. It's a conscious optimism about nations' ability to unite.

The main problem is the racist mentality in Israel, especially the right wing's consecration of the occupation. But I do believe that in the end, peaceful values are going to win, because they achieve the true interests of both nations. Israeli and Palestinian interests aren't contradictory. In fact, equality would bring a real democracy, real security, and a better Israeli economy.

We say that there is no democracy without equality. Whoever wants democracy has to support equality among Arabs, not only in theory but also in practice. For example, there are Arab villages in the south of the country that aren't recognized. They must be recognized for the Arab Palestinians. But it's essential for Jewish residents in the Negev desert to recognize that the Negev is the poorest and most underdeveloped area in Israel. This is especially true when there are forty-six unrecognized villages lacking electricity and water, and insufficient

education for the entire region. Only 32 percent of our women are part of the labor force. If we increase the percentage to 42 percent, this would be good for Arab women and for our society. They get to be an essential and productive part of society, which benefits the economy in general.

Therefore, I emphasize the main idea of common and not contradictory interests. This is why we present an ethical, valuable alternative for everyone. We don't only talk about Arab rights but about the rights of all oppressed people. In recent elections when addressing the Jews in the east, I said, "Vote for whoever you want, for any party. But we in the Joint List will support your social case in the Knesset." We used to say to people with special needs in Tel Aviv, "Vote for whoever you wish, but we in the Joint List will vote for the people with special needs." In every new settlement, we used to say to the victims of Nazism, "Vote for whoever you wish, but we'll be with every new law that protects your rights and your dignity." This is why we present a valuable alternative for everyone, and this is key to eventually winning.

AW What kind of support for the Palestinian struggle do you think you can get from the Israeli politicians or the liberals in Israeli society?

AO We don't believe in the misconception that all Jews are against all Arabs or that all Arabs are against all Jews. We believe that there's a common Arab-Jewish struggle against the 1967 occupation, against racism, and against national discrimination against Arabs. This position is crucial because it values a person for what he is despite his background; a person doesn't choose his nation, religion, color, or sexuality. A person chooses his positions, and we value a person for his positions instead of relying on narrow affiliations that he didn't choose.

All strategies that presented common resistance as an ethical alternative for all parties have succeeded. In the US, Martin Luther King Jr. believed in common black-white resistance against segregationist policies, unlike Malcolm X or the Nation of Islam, which believed only in black resistance. Nelson Mandela believed in the African National Congress (ANC) and the importance of the joint black-white resistance against apartheid, and not only the black resistance, despite the ANC or the groups that forwarded black consciousness. Who, in the end, won a common ethical alternative through representation for blacks and whites alike? It's the same in our case. It's our duty to carry a common Arabic-Jewish resistance and to present an ethical alternative for everyone in this country. This is the only successful way, and I'm sure we'll win in the end.

AW How long do you think the Palestinian struggle will take to create a Palestinian state? How united do you think the different groups and political agendas of the Palestinian community can be?

AO First, this can be accomplished through the global dimensions I mentioned earlier. The second step is to establish all components of the state. These would be two major successes for the Palestinian nation. Those who'll establish a Palestinian state aren't from the international community but rather from within the national resistance against occupation. In the end, the occupied nation will

choose the method of resistance, as it knows the conditions more clearly than I do. My duty is to support this just resistance against occupation concerning the natural presence of many parties. The opposition to any occupation always consists of different parties and different methods of resistance. My duty isn't to lecture the Palestinians, because they know their situation. The bigger crime is the Israeli occupation, and only the occupied nation knows how to properly resist and defeat this criminal occupation.

Palestinian refugees have suffered a lot since 1948, since the Nakba. How could a human rightly be expelled from his own land and forbidden to return? I have to support the just resistance for Palestinian rights. The refugees live in the worst conditions in the camps in Lebanon and in the West Bank. But the nation, displaced since 1948, has never given up its right to return, even sixty-eight years after the Nakba.

The former Israeli prime minister David Ben-Gurion was attributed with the saying, "the eldest will die and the young will forget." In reality, the young aren't less demanding of their rights. You'll see hundreds of thousands of children who demand their legitimate rights. This right can never be overlooked. That's why all the Israeli attempts to avoid discussing this case only furthers the argument that they're looking for a half-solution instead of a solution. Whoever desires a genuine, deep, strategic peace has to face all these issues and not run away from reality.

AW Do you think there's a possibility that one day Israel will make the Palestinians disappear?

AO Rabin once said that he wished Gaza would drown in the sea. Instead, Gaza drowned the occupation and this fascist dream, which will not happen with the Palestinian nation's resistance. In the end, the Palestinian sun will shine over Gaza, the West Bank, and eastern Jerusalem. This day is coming very soon. An entire nation can't be eradicated.

AW What did Palestine learn through this longtime struggle?

AO The Palestinian nation encountered a vast struggle where opinions and attitudes sometimes shifted, and these changes were considerably moral, as was the case for many of the resisting nations. Lenin, for example, or Nelson Mandela, who stood clearly, ethically in front of the African summit and said, "Nothing requires your astonishment." I've changed my positions not because of opportunism but because I studied reality and wanted to present an ethical alternative for all citizens. The Palestinian leadership has always demonstrated its moral clarity and presented options that are fair for all. But then the leadership saw that the entire world supported dividing both states, and that the Arabic countries also supported this after the 1967 and 1973 wars, along with the Lebanese War of 1982. After the fall of the socialist camp and the first Gulf War of 1990, the Palestinian leadership was convinced of the necessity of a Palestinian state beside the Israeli state in the 1967 territories. In my opinion, this solution has some justice and could be achieved in reality.

One point I wish to mention is that I don't support the killing of any citizen, whether Jewish or Palestinian. This is a valuable moral position that we must stick to. Apart from this, it's imperative to clarify that the occupation is at the origin of all problems. Israel denounces one Jewish death but doesn't care about the killing of hundreds of children in Gaza. The 2009, 2012, and 2014 aggressions are all crimes against humanity. Anyone with humanity would denounce them. The killing of a Palestinian is equal to the killing of a Jew. Yet you always remember the true criminal: the Israeli occupation.

AW As a parliament member, can you freely visit Gaza yourself?

AO This is a complex matter. In some cases, it would be right to visit, but it could also stir up trouble. So, in principle, yes. We're supposed to do all our duties, but we also have to be politically conscious.

AW Is there anything else you'd like to say about the Palestinian struggle?

AO I'd like to say that we didn't come to Israel; Israel came to us. It would've been natural for migrants to ask for equality from the locals. We're the patriots and the citizens. We struggle for equality with migrants within our country. This isn't normal. When we struggle for equality with migrants, we're called extremists! This is a moral crime that can't be reversed, but we must persist in seeking for an alternate, moral solution, a valuable democratic solution, for all citizens. Equality between Arabs and Jews will win at the end of the day.

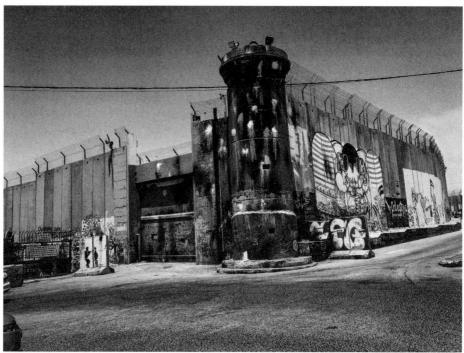

West Bank Barrier, West Bank, Palestine, 2016

058

Mukhaimar Abu Saada, Al-Azhar University
Gaza, Palestine, 2016-05-10

MS Is this your first visit to the Gaza Strip?

AW Yes, it's my first trip. We're doing a film on refugees. We've covered many different camps and different nations. Could you please give us an in-depth analysis of the Palestinian condition in relation to Israel and the past and present struggles?

MS About two-thirds of the Palestinian people have been displaced since 1948. The early days of the Palestinian refugee crisis started with the Nakba on May 15, 1948, when the United Nations issued Resolution Number 181 to partition Palestine into two states, one for the Jewish people and another for the Palestinian Arabs. The Palestinians and Arabs rejected the partition, and finally Israel declared its independence on the British Mandate for Palestine on May 15, 1948. As a result of the war between Israel and the neighboring Arab armies, two-thirds of the Palestinian people were expelled from historic Palestine into other parts of Palestine that are now known as Gaza and the West Bank. More than half of the other Palestinian refugees were pushed into the neighboring Arab countries, mainly Jordan, which houses the majority of Palestinian refugees, and Lebanon and Syria. The majority of Palestinian refugees who live inside Palestine are in the Gaza Strip. We have a number of Palestinian refugees stretching from the north of Gaza beginning with the Jabalia refugee camp all the way to the Rafah refugee camp. Two-thirds of the two million Palestinian people in Gaza are refugees and the descendants of Palestinian refugees who were expelled from Palestine in 1948.

After the Palestinian catastrophe in 1948, the UN established a UN agency called the United Nations Relief and Works Agency for the Palestinian Refugees (UNRWA). This UN agency has been responsible for the welfare of the Palestinians over the past sixty-eight years. The Palestinian refugee situation has been disastrous since the Nakba. On top of the disaster that took place in 1948, most Palestinian refugees still live in refugee camps established by UNRWA and other UN agencies. Most of the Palestinian refugees in Gaza are still poor, unemployed, and barely living on UNRWA assistance. They're very dependent on UNRWA and other international agencies for their daily affairs, education, health care, and relief services. The Palestinian refugee camps are very crowded and considered one of the densest areas in the Gaza Strip. Poverty, unemployment, and other unbearable conditions are very normal there. Let me just mention one incident that happened three or four days ago. Three Palestinian children in the al-Shati refugee camp died as a result of a fire started by a candle. This was a result of the lack of electricity or the electricity blackout in the Gaza Strip.

AW What led to Gaza's condition today?

MS Historically speaking, Gaza is a small territory. It's only 365 square kilometers, which is only 1.3 percent of historic Palestine. It houses two million Palestinians

and is considered one of the most densely populated areas in the Palestinian territories and even in the world.

A number of things contributed to the disastrous situation for the Palestinians. One is that the majority of the Palestinians in Gaza are refugees and descendants of refugees. Second, those refugees, when compared to the local, original Gazan residents, are deprived of land ownership and private businesses and entrepreneurship. Making things even worse, in January 2006 Hamas ran for the Palestinian elections and won with a majority, which led Hamas to establish its own government in March 2006. That led to Israel and international powers isolating Hamas and the Palestinian government. A year and a half after that, in the summer of 2007, clashes erupted between Hamas and the Palestinian Authority (PA), led by Fatah. As a result of internal fighting, Hamas was able to drive off security forces belonging to the PA, and that led to Hamas taking over the Gaza Strip for the past nine years. Israel classified Hamas as a hostile entity in September 2007 and established a regime of siege and blockade against Gaza, which has made Palestinians' daily life catastrophic. This is collective punishment of the Palestinian community instead of Hamas.

AW What's your assessment of Hamas and its political position? Clearly, it's different from earlier parties like the PLO.

MS Hamas is an Islamist Palestinian group that was established in 1987 when the first Palestinian intifada erupted against the Israeli occupation. Hamas is dedicated to the eradication of Israel and the establishment of a Palestinian Islamic state, not only in the West Bank, Gaza, and East Jerusalem but over all of Palestine. Hamas considers Palestine a sacred land. In their eyes, the Palestinian people have no right to give part of Palestine to the Jews or the Israelis. Consequently, Hamas rejected the conditions to recognize Israel and to accept a Palestinian state in the West Bank, Gaza, and East Jerusalem alongside Israel. As a result of that position, Israel and the international community politically isolated Hamas and imposed a regime of siege and blockade against Gaza. Over the past nine years Israel waged three wars against Gaza because of Hamas's resistance against the Israeli occupation. Hamas vowed to continue its fight against the Israeli occupation, which led to more than 5,000 Palestinian deaths in the last three wars. A high level of destruction was inflicted on Gaza and the Palestinian civilian population during the last Israeli offensive in the summer of 2014. At least 10,000 housing units were completely destroyed, another 10,000 units suffered major damage, and about 60,000 housing units suffered minor damage. As a result of Hamas's ideology and its hostile relationship with Israel, we continue to see clashes and eruptions of violence between Hamas and Israel.

AW Would it be possible for Palestinians to reach a two-state solution or a one-state solution? What's the process that would lead to those goals?

MS Since UN Resolution 181 of November 27, 1947, which decided to partition Palestine into two states, the two-state solution is the only possible solution to the Israeli-Palestinian conflict. Back in 1993, when the PLO recognized and engaged in direct negotiations with Israel for the first time, the international community sponsored the two-state solution as the only one on the table. But over the past

twenty-three years, since the signing of the Oslo Agreement, Israel tripled the number of Jewish settlers to almost 700,000 in the West Bank and East Jerusalem. Israel also erected a separation barrier between Israel and the West Bank, which also confiscated about 12 percent of the Palestinian land of the West Bank and East Jerusalem. As a result of the rise of the Israeli right-wing and extreme right-wing in Israel, most Palestinians don't believe that the two-state solution is possible any longer. They've lost confidence in the two-state solution and in the peace process because twenty-three years after Oslo, instead of an end to the Israeli occupation and the establishment of a Palestinian state alongside the state of Israel, what they've seen is more Israeli settlement expansion, more Israeli measures against the Palestinians in the West Bank and Gaza, and also the Israeli siege and three wars against Gaza.

If you talk to the Palestinians, they're ready for the two-state solution and would love to put an end to the Israeli-Palestinian conflict on the basis of the 1967 territory. Even Hamas, who is opposed to recognizing Israel, is ready to accept a Palestinian state in the West Bank, Gaza, and East Jerusalem as a temporary solution. But the Palestinians don't think that the Israelis are ready for the two-state solution. Netanyahu and the right-wing coalition in Israel are very much interested in greater Israel. We believe that they're on their way to annex parts of the West Bank, which will be the last nail in the coffin of Palestinian statehood in the West Bank, Gaza, and East Jerusalem.

This has now created a new political situation among the Palestinians. Some are no longer happy with the two-state solution and are advocating one state for two peoples based on equality and democracy. But we believe that if Israel doesn't accept the two-state solution because it would like to keep the Jewish character of its state, Israel will never accept the one-state solution with two peoples. Without international intervention, I don't think that we're approaching any peaceful settlement to the historic, ongoing conflict in the near future.

AW Why has there been such a lack of international support for Palestine?

MS I believe there's international support for the two-state solution and support for the creation of a Palestinian state alongside the state of Israel. That was characterized by the voting of 130 countries in the UN General Assembly on November 27, 2012, when Palestine gained nonmember observer status at the UN General Assembly. A majority of countries support creating a Palestinian state within the 1967 borders, but the problem is that the international community is unable to impose a solution on Israel.

There are a number of reasons for this. First, many countries, especially the US and the EU countries, still feel guilty for what happened to the Jews during the Second World War. They don't want to push Israel into a settlement that doesn't satisfy Israel's security needs. Second, there's a very influential Jewish lobby in the US and part of Europe that's blocking Europe and the US from advocating the establishment of a Palestinian state. Third, I'd say the chaos and political upheavals taking place in many Arab countries—Iraq, Syria, Yemen, Libya, and other Arab countries—is causing the international community to focus more on those regional problems instead of the Israeli-Palestinian conflict at this moment.

AW There are large numbers of refugees now fleeing Syria, Iraq, and Afghanistan. How would you relate the Palestinian struggle to the larger refugee crisis?

MS The eruption of the Arab Spring in January 2011 caused political upheavals and civil wars in many Arab states. There was bloodshed, killing, and destruction in many Arab countries, mainly Syria. As a result we saw refugees from Syria and other Arab countries flooding into neighboring countries like Turkey and also Europe. Some of those refugees are Palestinians, because in 1948, when the Nakba happened, some Palestinians were expelled to Lebanon, Syria, Jordan, and other Arab countries like Iraq and the Gulf states. The Palestinians have been displaced many times—first in 1948; second in 1967, when Israel occupied all of Palestine; and now third, as a result of the civil wars in Syria and the political instability in Lebanon. Part of what's happening in the Middle East is also related to the Palestinian refugee crisis, which has gone unresolved for the past sixty-eight years. The Palestinian leadership has proposed that Palestinian refugees living in Syria and Lebanon be absorbed in the West Bank and Gaza, but Israel has rejected that proposition as it doesn't want Palestinian refugees to come back. At the end of the day, Israel is very concerned about the demographic factor, as the Palestinians would become the majority between the Jordan River and the Mediterranean Sea.

AW It's a very complicated issue with no clear solution. Do you still have hope?

MS That's a very difficult thing to answer. Personally speaking, the past nine years have been disastrous for most of us here in the Gaza Strip. We're under extreme Israeli siege, and what made things even worse is that the Egyptians have closed the only crossing between Gaza and Egypt. The Rafah border crossing was only open for twenty-one days in 2015. This year, 2016, it was only open for three days. It's supposed to open tomorrow and the day after tomorrow for another two days. We're talking about a big prison for the Palestinians in Gaza which two million Palestinians are unable to enter or exit.

When you look at poverty levels, according to many UN agencies, 70 percent of the Palestinians of Gaza receive food, aid, and support from UNRWA and the World Food Programme (WFP). Unemployment among the Palestinians is about 43 percent in Gaza, and it's more than 50 percent among Palestinian youth, especially college graduates. We have about 100,000 college graduates who are unemployed. Over the past few days, we've become aware of a number of Palestinian graduates who are protesting their daily conditions. In addition, over the past few months many Palestinians have committed suicide, setting themselves on fire to protest their daily conditions.

Generally speaking, I can say that the situation in Gaza is on the edge of collapse, as a result of nine years of siege, blockade, restriction of movement, an electricity crisis, and lack of potable water. If you talk to the average Palestinian citizen in Gaza, the only dream they speak of is migration. The majority of Palestinians don't believe that this place is livable any longer. The UN issued a report back in 2012 in which they stated that Gaza wouldn't be a good place to live in 2020 as a result of the continued daily crises in education, health care, electricity, potable water, sewage system, and so on. What made things even worse was that the last

Israeli offensive against Gaza two years ago led to the displacement of 100,000 Palestinians. I'd imagine more than half of the Palestinians in Gaza, given the opportunity, are ready to leave and find another place to spend the rest of their lives and their children's lives. This is a very sad thing to say.

AW What will happen to Gaza if it continues like this?

MS I can't speak for the overwhelming majority of Palestinians in Gaza. Personally speaking, I have a permanent, well-paying job, and I live in a nice neighborhood, so I think it wouldn't be just for me to speak on behalf of the overwhelming majority of the Palestinians who live in refugee camps, are unemployed, live in poverty, and suffer from a lack of electricity and potable water.

In my opinion, I think we're about to see more social unrest in the Gaza Strip. We've witnessed this over the past few months in terms of a rise in suicide cases, the rise of social tribal problems, and more friction between Hamas and the community. I'm not exaggerating when I say that the situation is on the verge of collapse and something is probably in the making. Many media reports are saying that the situation is unsustainable and is going to explode, whether in the face of Israel or that of Hamas. But the Palestinians are exhausted and unable to live this way any longer.

Erez Checkpoint, Gaza, Palestine, 2016

059

Hanan Ashrawi, Palestinian Politician
Ramallah, Palestine, 2016-05-10

HA We're undergoing a very difficult period right now, but Palestine has always undergone difficult transitions. This time, however, we're seeing fundamentalist Zionism coming to a head in the sense that the occupation is on the rampage. There's a deliberate escalation and intensification of settlement activities, land theft, and resource theft, which are destroying the very foundations of peace. It's also destroying the requirements of the two-state solution. We're seeing the emergence of an extremist, hard-line, racist Israeli government that relies on power politics and acts with full impunity without any accountability or intervention. That's really creating a situation not only of tremendous hardship and difficulty for the Palestinians but also adverse conditions for achieving any kind of peace. Of course, the international community has given Israel the time, place, and opportunity to continue with its violations without any accountability or intervention. So this is where we are now in a nutshell, trying to rescue the chance for peace.

AW The right wing has been ascending globally in the US and in Europe.

HA Yes, we're seeing the global reemergence of populism, racism, and xenophobia, a sort of self-enclosed system that's exclusionary and exclusive. Israel epitomizes this attitude of racism and entitlement, but the same thing is happening around the world because of the issue of refugees, instability in different countries, and the rise of nonstate actors, particularly in the region. The rise of violence and extremism has led to an increase in distrust of the other. This has given more ammunition to people who do have racist tendencies and who do want to sort of hunker down, circle the wagons, and refuse to deal with the rest of the world. This is a very shortsighted and irresponsible approach, because if you want to have stability and security within your own borders, you must be open to the rest of the world, and you must participate in resolving the causes of instability, violence, and extremism.

AW Do you think that Israel will survive this kind of high-handed oppression and unjust treatment toward Palestinians?

HA I think Israel thinks with this sense of exceptionalism, this entitlement, that it can do whatever it wants and get away with it. I'm convinced that this government coalition thinks that it can exist outside and above the law as a rogue state in many ways. But by creating this system of exclusionary politics based on a sense of superiority, and by perpetuating the occupation by resorting to power politics and control, they're creating a situation of tremendous danger, not only for the Palestinians but for Israel itself, because short-term greed, extremism, and fundamentalism are trumping the requirements for strategic peace and long-term stability. By resorting to the use of live ammunition, militarism, power politics, extrajudicial executions, and ideological language, including religious absolutist language, they're making any kind of resolution difficult because they're creating an either-or situation rather than one of mutual accommodation and peace.

In the long run, this policy is extremely dangerous, as it will backfire and destroy Israel in many ways. No state in the twenty-first century can create a fortress and live there—perpetuating injustices against a captive, defenseless population—and hope to get away with it forever. There are changes taking place in the world, movements of solidarity and attempts to create systems of accountability for Israel that didn't exist before. Public opinion is on the move, and social media is making facts available. You can't continue to exploit the ignorance of others by propagating a false narrative about the Palestinians or about reality. People are beginning to see the truth, and that's why I think that the current conditions are untenable.

AW Palestinians have been struggling for their own land and adapting for the longest time. Now with the global refugee situation, especially with Syria in recent years, we see a similar situation of massive numbers of people being pushed out of their homes. I visited many camps in the world, including Palestinian camps in Jordan and Lebanon. What do you think about this global refugee situation?

HA Being a refugee is much more than a political status. It's the most pervasive kind of cruelty that can be exercised against a human being: uprooting a person from their home, depriving the personal community of all forms of security and the most basic requirements of a normal life, challenging not just the narrative but the identity of that person, and cruelly placing that person at the mercy of very inhospitable host countries that don't want to receive them. You're forcibly robbing this human being of all aspects that would make human life not just tolerable but meaningful in many ways. So you strike at the very core of the existence, identity, self-definition, and security of this human being or of this community as a whole.

This is what's happened to the Palestinians. The Palestinians have suffered from multiple injustices, but the refugee issue also suffers from systematic distortion— the distortion of the narrative, of what happened. We were the victims of a myth, of a land without a people, as though our very existence has been denied. Also, the narrative of the refugee has been distorted by saying that Palestinians got up and left, or that somehow the Arab countries told them to leave, instead of really understanding the fact that there was a forcible and violent expulsion and dispersion of the Palestinians, that they were subject to systematic terror in their villages and homes and had to flee a cruel assault on their lives.

Eight hundred thousand refugees wouldn't leave their homes just because Arab governments told them to leave, or just because they decided to pick up and leave. The horror of the refugee narrative hasn't yet been fully recognized. The new historians in Israel are talking about this now that the intelligence archives are available and people can tell what really happened to them. What adds insult to injury isn't just the denial of the narrative and the distortion of reality, but that they're being treated as an exceptional case outside the law. All international laws, conventions, and charters dealing with refugees apply to other people but not to the Palestinians. If you talk about the right of return, this is regarded as something horrible, as though you're negating the very existence of Israel. They want all Palestinians to negate their own rights, to violate the law, to deprive themselves of the protection of the law and to become Zionists, to protect the exclusive Jewish nature of Israel.

We believe that the Palestinian refugees have the right to return, but before that they also have the right to be acknowledged, to have their narrative admitted and Israel's culpability to be recognized. Then there is the applicability of international law to the refugees, the right to return, and, of course, ultimately, the right to choose. These things have been consistently denied them since 1948. At the same time, there's a new paradigm that Ilan Pappe [Israeli historian and activist] called the "displacement-replacement paradigm." These aren't just refugees who were expelled but they are deliberately being told that another nation has taken over, not just their geographic place but also their culture and history. It's a very comprehensive, pervasive form of injustice, and it has to be resolved. There can be no peace, no security, and no stability—not just in Palestine and Israel but in the region—without a just solution to the refugee question.

AW This injustice is global. Europe, the UN, and other nations, such as China and Russia, all live in this global condition.

HA Yes, you're right; we should mention the other refugees. We don't have an exclusive monopoly over pain, displacement, or dispersion. The refugee problem isn't just in Syria; it's also in Libya, Yemen, Iraq, and even in Lebanon, where there are vulnerable people who are being targeted, who are leaving as a result of intolerable conditions, threats, and danger to their lives. But this isn't a normal state of affairs. The Palestinians have suffered multiple exiles in the sense that they were expelled from Palestine and then later expelled from other countries as a result of upheavals and disturbances in those countries, whether Iraq, or Kuwait, or now in Syria. The very tragic conditions in the refugee camps are the result of multiple waves of refugees. Now the whole region is undergoing this instability, this massive victimization of entire populations, and the ripple effect is being felt directly in Europe.

In the US, there are all sorts of horrible, racist, xenophobic statements against entire populations, ethnicities, or religions being made very publicly without any human consideration. With a US president who talks about expelling an entire group of people based on their religion, or excluding an entire national group from the US, or building a wall on the Mexican border to keep people out, it's no wonder that US citizens give themselves license to dismiss whole groups of people based on their ethnicity and religion. They can try to justify it in a variety of ways, but the emergence of this type of populism is dangerous to humanity because it distorts systems within nation-states and within borders. We don't live in isolated, self-contained entities anymore. Borders aren't closed, and whatever happens—geographically, demographically, or even intellectually and politically— has serious implications for humanity as a whole. This is why we need global institutions that can think responsibly and deal with human security in a comprehensive way, and that can challenge this fortress mentality that is emerging in many different countries.

AW Why do you think Palestinian rights are still not clearly supported by the global community?

HA I think the unique case of the Palestinians is due to the nature of our oppressor. There's a historical sense of guilt in the West, and in Europe, about the way they

treated the Jewish populations. Anti-Semitism is a Western and particularly European phenomenon. Israel claims preferential treatment on the basis of how the West mistreated the Jewish population in their own countries, and therefore the Holocaust has proved to be one of the obstacles against holding Israel accountable, against allowing the Europeans in particular to challenge Israel as a state. There's no separation between the horror and inhumanity of the Holocaust and between Israel as a state that is claiming preferential treatment and exceptionalism.

In other countries, like the US, Israel is given preferential treatment because it's seen as a strategic ally for many reasons. Israel is also a domestic issue in the US, where it affects internal political realities and election campaigns, where the dominant narrative on Israel has been one of blind financial, military, and political support. Whatever Israel does is fine, but this is changing. My question is, how long will it take? How many more lives and how much more suffering? We don't have time, because in Israel we have a government coalition that is extremist, racist, and violent. It's destroying the chances for peace and perpetuating a situation of pain and injustice on the Palestinians.

We need serious intervention and engagement of a positive nature in order to provide alternatives to this lethal situation. Though governments have been reluctant, with more knowledge and information available, individuals and global public opinion are taking a stand. Universities, intellectuals, and academics don't want to be manipulated or deceived anymore. However, there's always a time lag between recognizing the situation and actually implementing policy positions that will bring real change.

AW What has changed after sixty to seventy years of the Palestinian struggle?

HA We're still living in a state of dual injustice. We're living in a state of occupation where we have no rights, freedoms, or protection whatsoever. The other half of the population is living in exile, again totally vulnerable and at the mercy of inhospitable host countries. So this situation persists. The tragedy of what we call the Nakba, the catastrophe that took place in 1948, is still running its course. The Palestinians were living on their own land when the state of Israel was created; they didn't have a hand in what happened to them. The international community created Israel on Palestinian land, so this ongoing injustice has to be resolved in a way that recognizes not just the Palestinian reality and narrative but Palestinian rights as being equal to the rest of humanity. We can't be cast outside the course of history and told that not only do we not exist in some cases, but we don't have any rights or the protection of the law.

We need a solution that is based on legal, political, moral, and human considerations. The situation is a wound in the region, in the Arab world, and in the world at large. It can't be allowed to continue, because abnormal situations generate abnormal actions and reactions. This must be solved on the basis of international participation and multilateralism.

We can't negotiate with the occupier, or get permission from Israel to be free, or guarantee the security of the occupying army. We have to be treated within the

comprehensive protection of international law and international norms of human behavior. The Palestinians have been deprived of the right to develop as a nation, to join the rest of the world as equals. We can't always be treated as a subhuman species, as people who have no rights. We're always put on probation. We have to prove that we deserve our freedom, our dignity, and our rights. Palestinians have the right to their own state, to self-determination, to live in peace, dignity, and freedom like everybody else. But the means by which the mechanisms for this can happen have not yet manifested. There's a lack of political will, a reluctance to hold Israel to account. As long as Israel is given time and space to continue, it will persist.

AW Are the Israelis making an attempt to negotiate or are they just ignoring the whole situation?

HA Unfortunately, I haven't seen a situation that's so polarized and lacking real communication. We went through several stages of dialogue, discussions, solidarity, activism, political talks, negotiations—about six, seven, eight different types of negotiations. But now we've arrived at the point where even the most basic communication is withheld. It's not just the physical wall that you see, this horror, this ugliness that separates both peoples. There are lots of psychological and political wars where the Israeli public is told that they don't have to see what the occupation is, they don't have to deal with the consequences of the Israeli policy. This isn't conducive to any type of human communication or understanding, and that's extremely serious, because you're preventing people from dealing with reality. If Israel thinks it's imprisoning Palestinians behind the wall, it's also imprisoning its own people behind the wall. It's preventing them from coming to grips with reality as a whole, understanding the reasons for insecurity and fear, and from recognizing the humanity of the other. When you dehumanize the other, there's no room for any form of constructive communication or recognition.

AW Realistically, do you think it's possible to end the occupation and give Palestinians a chance to reestablish their homes?

HA Realistically, it has to happen, because the Palestinians aren't going to disappear. We're not going to go away. We're not going to commit collective suicide or have collective amnesia and forget our rights, our history, and our culture. We're here, we'll persist; generation after generation we've been here, regardless of the cruelty and injustice we've suffered. We aren't just demanding our rights but affirming our humanity and attempting to join the international community as equals. So I think we'll get there in the long run.

Physical realities aren't irreversible. Settlements can be and should be removed, even though most people look at the settlements and the wall and say there's no chance of a two-state solution or no chance of a viable Palestinian state. People think that there's going to be a de facto one-state solution that'll ultimately become a Palestinian state. I don't think that's the case, and I don't like de facto solutions. I think there should be human agency here. The international community has to intervene in the injustice and provide a solution that's just and workable. In the long run there has to be vindication for the Palestinian pain and suffering but also a redemption of history. Once the Palestinians are free, once

our rights are recognized, once we join the rest of humanity as equals, it'll be the beginning of the process of historical rectification. We want to release our energies in a positive way, in a constructive way. We don't want to constantly be victims and try to find ways around our own pain and victimization.

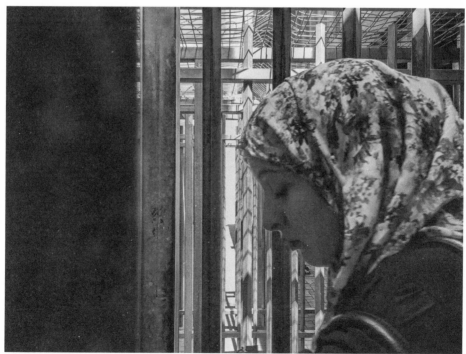

Qalandiya Checkpoint, West Bank, Palestine, 2016

060

Mohammed Daoud, *Refugee*
Rafah City, Palestine, 2016-05-11

[At the Rafah crossing from Gaza to Egypt]

MD It makes you pity this elderly woman.

AW Is she going to stay in Egypt?

MD I'm going to Germany to visit my only son. He's studying medicine in Mainz University.

AW And that's your mother?

MD No, no, she's an old woman and her son is away. I'm helping her because this is our duty.

AW And will she go back to Gaza?

MD I think so; she's going for medical treatment.

AW It's going to take months, no?

MD Maybe three months. The crossing won't open for another month. Most of these people are leaving Gaza for treatment because they're sick. Most of the others are going as students to continue their studies. None of us are going for tourism. We know what it means to leave our home, to leave Gaza and go outside. We can't return for at least three months. Everybody travels for tourism or for entertainment, but we travel for suffering.

AW How long has the border been closed this time?

MD Exactly eighty-five days. This is the first opening since the last time, eighty-five days ago. At that time, I was in a bus at the Egyptian gate. We had to go back and wait for eighty-five days until they gave us another chance. This is the problem—it's closed for eighty-five days and now it's open for two days. You know what I mean.

061

Ahmad Muhammad Osman, Refugee
Urfa Province, Turkey, 2016-05-11

My job in Syria was to buy and sell land and offices. I had a real estate company. We heard that there was trouble. "What's the trouble?" we asked. They said, "Something is happening in Damascus." There was a construction project waiting. We were just holding on.

It was said that ISIS was coming to Manbij, to Kobane. It was said that Daesh was about to come any day. After this, many people came from Iraq, Aleppo, and Damascus to Kobane. Things got worse. Prices went up. Oil, diesel, everything became more expensive. Afterward it was said that things would get better. At the same time, the people who had money left Syria and poor people like us had to stay and stop all our business affairs. What we had—cars, houses, livestock, land—wasn't worth anything anymore. We couldn't leave. Where could we go? The gates to Iraq and Turkey were all closed. ISIS was advancing; it was impossible to go to Jordan, Lebanon, or Damascus. So we were captive for two years in Kobane. All the world was against us. The children were saying, "What will we do?" Our workers were also looking to me. I was responsible for fourteen family members. Trade had stopped. When my child asked what would happen to us, I said, "We're in the hands of the gods. God may open a door for us." Day by day our burden was heavier. This was what we went through. There was no food. We went to the baker and there was no bread. People were about to eat each other's flesh.

We were watching the war in the city. ISIS was shooting at Kobane with tanks from a village north of Kobane. Pillars of smoke were rising over Kobane. They were also shooting from Kobane toward the village. We were told that ISIS had entered Halinch, east of Kobane. They'd entered the side of Haleta Seyda, Mikten, and Halinch. Afterward, we were told that in only one night, tens of thousands of ISIS militants had entered Kobane. It was our fourth night at the border. We saw women from ISIS who were cleaning tablecloths, and their children were with them. We saw it with our own eyes. Their women, children, families—all were there with them in Kobane.

After this, my children told me that our neighbors said that people were going from Kobane to Turkey. They were going through Jarabulus to the Karkamis border gate with their passports and into Turkey. But we didn't have passports; Damascus hadn't issued us passports or ID cards. The authorities told us not to go. They said, "Where are you going? Don't leave the city." We said, "We're starving to death. What else can we do?" No bread, no work, nothing. Everything is so hard. There were no workers to work, there was only armed conflict. The way to the Euphrates River was closed to us. In the southeast of Aleppo, people were waiting in Tal Abyad.

All the people from Raqqa were coming to Kobane, and all the people who came to Kobane stayed there. At night my children woke me up and told me that ISIS had entered the town. My wife said, "Take the children; run away with them and leave me here." I said, "How can I leave you alone here?" So I said, "No." They said

that ISIS was taking all the girls. I said, "If they're attacking our girls, let them kill us all." And then I took my wife on my back and we started running.

We stayed at the border for four days. We couldn't go to the city to buy bread. The neighbors' animals were also there. They were waiting at the border. While we waited, we milked them, heated the milk, and shared it as a meal. There wasn't even water.

For four days we lived in torment. We were hungry and thirsty. Every day we thought that we could cross the border that day. Then we were told that the vice governor would come, or the governor would come, whatever. When they said that ISIS was coming, we ran to the wire. Two of my children, Muhammed and Berkel, crossed the border despite the soldiers. They were running, the Turkish soldiers were shooting, and they crouched down. They crossed the border, but we stayed on this side. We said to the soldiers, "It's better to die than to stay here." How could they shoot at our children? We thought we'd not be able to run away from death, from those cutthroats. How could we find our two children who'd crossed over? We had no telephone to reach them or ask them where they went. We couldn't go anywhere; there were barriers and barbed wire. Who would bring them back? They didn't know anybody; they couldn't speak the language. Thank God, someone there took them in and sheltered them.

After four days we crossed the border and tried to go to this village to find our kids. The people in the house where they were staying told us that we looked like nomads. We said, "God, what we can do, we are facing rainy days." We were on the other [Turkish] side of the border, but we didn't know anybody there. My wife had a stroke; she was lying on the ground. Someone from the Red Cross told me that they would organize a car to bring us to Suruç, but I don't speak any Turkish. They said, "We'll send you to Suruç," but we didn't know where Suruç was. Or they said, "We'll send you to Urfa," but we didn't know how to go there either.

The people told us that if we didn't have a place to go, we could stay in their house. They hosted us for ten days. They called us "these refugees," and when we asked for a house to stay in, they'd tell us that they didn't have any. But there were empty houses everywhere, so it was a lie. We're also human beings; we had to flee with all these kids. Finally someone told us, "Come, you can stay in my cellar." We stayed for six months in that cellar. After six months, we were sent here [to Urfa] and we stayed for ten months. Two days ago, we were told that they wanted to repair the house so we were asked to leave.

But where can we go? We have all these kids. My wife is sick. They said the medicine would come but it hasn't. All my children are still young; I have nobody who can work for me. We used to have land, a house, and money. All of it is lost; we don't have anything left. They told us that there were NGOs that help people. But nobody helps; nobody brings a car to take my wife to the hospital. Once I paid 20 lira for a car, and I took her to the hospital. They took an X-ray and gave her medicine. They said it cost 15,000 lira. I said, "I have fifteen children. If I can sell each of them for 1,000 lira, maybe only then can I pay for just three months of her medicine." They said, "Okay, go to the vice governor's office." We went to the

vice governor's office. He said, "There is no aid." We went to a foundation, but again, no aid. Then I came here.

I wanted to get a pass issued to go to Gaziantep. They asked me to copy my documents and some other things. They asked if all of these children were mine and I said they were. Finally, they said, "Go home. God willing, we'll find medicine for your wife." One year has passed. They told us it would take two months, and we're still waiting for the medicine. We call them, but no one picks up. We've asked for our reports and documents. They said that our papers would come and that we had to be patient.

All of our friends went to Europe through the Mediterranean Sea. If I could find medicine, I wouldn't be so regretful that I didn't go. If my wife died, I'd know that she was dead. If she dies in front of me, I'll regret it. There's medicine in Europe. They say there are human rights and humanity here, but we've never seen human rights here, nor any aid. Nobody gave us a hand.

After we were in this situation for a long time, I called out to God, "If they're humans, if they have hearts, they'll see and hear us." Even if we go back to our country, there's nothing there waiting for us. Everything has been destroyed. When we watch TV, we understand that we have a long way to go. The landlord of the house where we're staying told us, "You'll take care of my trees and my daily work."

I have many children, but they can't go to school. We don't speak the language. There's no work. Today all these children are like shepherds. They haven't been to school for five years. We tried to register them, but we were told that we're from Syria, so there's no school for us. At least they could learn to say numbers in Turkish, but they just told us to go back. They said, "We don't have your schools here and you can't enroll in the Turkish schools. You are guests, you are refugees." Then what can we do?

When we first arrived in Turkey we stayed in the village of Almasar for six months. The house we stayed in didn't have a door; it was a ruin. Then winter came. When it snowed, the snowflakes fell directly on us. After we had suffered in this way for six months, two youngsters came and said, "Kobane is being reconstructed; come back." I said, "Okay, take all my kids and my wife and then we'll go." But they looked at my wife and then said they couldn't take her and the kids. I said, "Why not?" They said, "There aren't enough supplies there; only you are needed there." I said, "What can I do in Kobane?" They said, "You can drive an excavator or tractor. We need your help, as you can drive." I said, "Okay, but only if I can bring my family there later on, because my wife is sick, and there's nobody to take care of the children." He said, "Okay," so I went. We were put in a house and told not to go out. They said, "They are attacking Meshtanur and you might be killed." We only went out of the house after seven days, and we saw that there was nothing left. Nothing. All the concrete was gone. I thought about it and then said, "I need to go; my wife is sick and there's nothing to do here." They told me, "As you wish." So I came back to care for my wife and children.

After I came back, I told my children that we didn't have a house in Kobane anymore. They said, "Father, where we will go?" I said, "God's land is big, if only he shows mercy on us."

We went to the city. There was a jewelry store and I saw the mukhtar [headman], whom I knew, and I asked him, "Mukhtar, aren't there any empty houses? We've been living for six months in a ruined house and there is no work. There isn't even water around the border. We're dying in misery there." He said, "Okay, there is a house." We stayed there for two months, and then the owner called from Germany and said he was coming for a vacation. So we left and went to another house. We stayed in it for three months, and they also told us that they were going to repair the house, so we must leave it. "Where will we go?" I asked. He told me, "Troubles are chasing us here, you are Kurds . . . go where you go, God help you." I asked him to give us time to find a place, but he didn't, so we left.

Our children were hungry. We were looking around desperately. The children were collecting firewood and piling it in front of people's doors. Nobody thought that these children needed food. They just said, "Thank you." "Thank you?" I said, "Children, this town isn't a place to stay. Let's go to the city. Maybe they'll pay attention to our miseries and give us a hand."

We were still watching the war every day. Each time we thought that planes were bombing our house, my heart burned with pain. We knew our people were dying there. We knew that the families there had died. Airplanes, ISIS, and cannonballs were all bombarding the area, and smoke was coming up from the ground. It wasn't enough just to save ourselves. Our sisters and brothers were dying there. We couldn't do anything. Now, when we remember these days, we can't stop our tears. Every day we were going to the border to look at our houses and our people there. We were going to the border and crying with our neighbors.

My cousin Ahmet died. My niece and the family with ten children died. ISIS slaughtered them all. It was this time last year, around Mesraf, when ISIS entered Kobane. At that time I was about to take my children and go to Kobane. I came and told my children that our house had been destroyed but that we could pitch a tent. My child said, "Father, let's wait for two or three days." On the same night, we were told that ISIS had entered Kobane from the direction of Mesraf. Osman and Hasa brought their family to Mesraf. Their house was in the Mesraf side of Kobane. The whole family was slaughtered: the son and his wife, their mother, father, brothers, and sisters. My nephew was there. He was Ahmet, son of Bilal. He was slaughtered too. We don't know how many people died from our family. We don't know each other's telephone numbers.

Of course I miss my country. Who wouldn't? But our country smells of blood. It hurts us. We could return if we still had a house. They told us that if we returned, they'd pitch a tent for us. But how can we live in a tent? We can't live here either. The cities of our country are destroyed, but our country is so nice. One's country is dear to him. But small children can't live there. If they were older, they could live there, find a job, and work. But they don't know anything other than how to eat. They open their eyes in the morning and look for food. My wife is still sick. She thinks that if we wait patiently, maybe her medicine will come. We can't leave

because of this hope. She says, "If my medicine comes, maybe I can live a few years with my children."

The story of my wife's family is tragic. First they went to Iraq, where there was also war, so they couldn't stay there. Her father has two brothers. Her father and uncles came to her and told her, "My little one, I wish you could walk, so we could take you with us, but we can't, because you'll hinder us. So we say goodbye; one never knows what will happen. We'll go over the sea, and we may die in the sea, and you may die here. One's loved ones are so precious, we may not see one another again." They went safely there.

To my knowledge, two of my brothers went to Germany, and maybe a third one as well, but we don't have any information about one another. When the deaths started in Kobane, I said it was good that we didn't go. We couldn't have fled as a family.

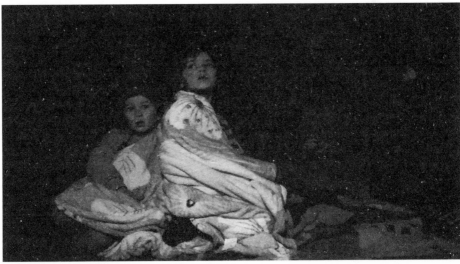

Moria Camp, Lesvos, Greece, 2015

Mohammed Oweida, *Gaza Zoo Director* **and Abu Bakr Bashir,** *Documentary Fixer*
Khan Younis, Gaza, Palestine, 2016-05-11

MO Look! This is the scar from the tiger bite because I used to put my hand inside the tiger's mouth. I have a close relationship with animals. I go near the hyena without a stick even when he's hungry. I sometimes play with the crocodile. The animal world is very beautiful, but when you come close, it can be dangerous.

It was a good time for business, and we had more than forty-two workers, plus thirteen others in administration.

AW Forty-two workers?

AB Yes! Now, nobody takes care of the animals.

AW Is it very hard to clean?

AB Today there's no one to clean the place. You're alone here, right?

MO I'm the director, the trash man, the PR person . . .

AW Maybe there's somebody from our studio who could work here. We could also pay somebody to work here.

AB To do what exactly?

AW To clean, to wash, to feed the horses, and so on; to work here every day.

AB For how many days?

AW For years! As long as this zoo exists.

MO It's okay; I do this job every Thursday.

AB Hold on . . . listen to this!

MO We're doing this job! We can do it.

AB Hold on, and try to understand. He's talking about someone who could take care of the animals and clean the zoo. He'll pay someone to do this.

MO No thank you. It's no problem.

AW He doesn't like the idea.

AB No, he says okay.

MO I don't know what to say!

AB Say, "Okay!"

MO Okay, we'll hope for the best. The ministry was supposed to fund us. I used to have forty-two workers. There were thirteen of us, not including my siblings.

AB Right. What are you supposed to do?

AW Don't let the animals die.

AB Work harder for that.

AW If they die, part of us dies.

MO I hear you.

AB Just make sure to take care of the animals.

MO But there's no support!

AW You're responsible because you brought them here, no?

MO We brought them here in much better times economically.

[At the cage of Laziz the tiger]

AW Where is this animal from?

MO Egypt. When we had tunnels, years ago, it was easy to smuggle animals through them, in addition to other things entering Gaza. Animals like these were brought from Africa, through Egypt, and then to Gaza through the tunnels.

AW And Egypt has tigers?

MO In Egyptian zoos, yes, but they brought this tiger from Africa. They moved it to Egypt, then from Egypt to Sinai, and then to Gaza.

They used to have two tigers. This is the only one that survived. The other died during the war, though not because of a direct attack. This tiger's not that healthy because sometimes we can only feed it every two days.

063

Ten Young Women from Gaza, Students
Gaza City, Palestine, 2016-05-12

Amjad Moghary Don't worry, I'm like Shakespeare in exams.

Hind Nahed You left university because of this?

Amjad Moghary We have to attend seminars at nine.

Huda Alkahlot Is your notebook with me? So much sun.

Haneen Khalid Gather yourselves.

Amjad Moghary There's someone missing.

Asmaa Al-Buhaisy Who?

Amjad Moghary My friend is in class.

Nidaa Muhammed Six and four here; let's get it over with.

AW Why are you all here today?

Amjad Moghary A little picnic.

Mona Khalid Kurraz For fun.

Samah Nabil It's the end of the semester, and we'd like to spend time together. We're graduating, so it's the last time we're together here.

Amjad Moghary I don't think it's the last time.

Mona Khalid Kurraz It's the end of the semester, and we have upcoming exams.

Amjad Moghary And there's no other entertaining place but here, by the way. The only resort is in Gaza.

Mona Khalid Kurraz In the big prison of Gaza. The siege [made it like] a big prison.

AW Why do you like it here?

Amjad Moghary It's nature. This is the only natural place here.

AW Tell me something about Gaza. Do you love it?

Hind Nahed Yes, yes!

Asmaa Al-Buhaisy No, we don't.

Amjad Moghary Yes, we love it, but our generation faces lots of difficulties.

AW Why is it difficult?

Amjad Moghary In every aspect. First, the occupation makes it this way. The governments pressure us. And all the world is against us. There's pressure only on Gaza, as if there's nothing but Gaza.

Mona Khalid Kurraz The siege and life in general. There are no job vacancies. Anyone who wishes to leave can't. The crossing is blocked from all sides. Gaza is closed. No chance; it's so difficult living in here. But still, we love it.

Amjad Moghary There are also many challenges for women here in Gaza. Tradition, culture, and customs are oppressing women. "Don't go out," and so on.

Huda Alkahlot Specific jobs.

Amjad Moghary Everything is prohibited. I can't even take part in some jobs and study programs, just because I'm a girl. Women here are very oppressed.

AW As university students, have you visited some other places outside Gaza?

Nidaa Muhammed No.

Mona Khalid Kurraz No.

Samah Nabil No.

Amjad Moghary Yes, I've been outside Gaza. I've experienced life outside of Gaza. That's why I can't cope and adapt to life here. Having been outside, I see the big difference between here and there, about how people outside see women, and the freedom they have. There are many differences. In Egypt, for example, it's normal to go out. Here, you can't. Even us sitting here might be seen as a big mistake. Some people are going to say our gathering here is wrong, skipping classes . . .

Hind Nahed . . . and they'll gossip . . .

Amjad Moghary But thank God, I don't care what people say. As long as I'm doing nothing wrong against God's will, I don't care what people say. It doesn't affect us in the end.

AW You're here looking at the ocean. It's open to all the world. But all other borders around here are closed. Here, even the ocean isn't free.

Amjad Moghary It's a big problem that we're restricted to Gaza. Even the sea is open to all the world and all benefit from it. Our benefits are so meager. They're limiting us in all possible ways, even from the sea.

Huda Alkahlot Let us hear your voice.

Haneen Khalid She's the official representative.

Amjad Moghary My only dream is to travel by a boat through the ocean. But this is, of course, so difficult.

Nidaa Muhammed Impossible.

Mona Khalid Kurraz My dream is to travel the world, but that's also impossible. I'd like to travel, and go, and return outside Gaza. It's not that I hate Gaza; I love it. But I'd love to go and return to Gaza at the end. I want to see the second world outside and how people are living, to see other places than Gaza. We love Gaza. But what are people like outside?

Amjad Moghary At least to go to Jerusalem . . .

Mona Khalid Kurraz . . . which is our right. We can't even see it. My life dream is to go to Jerusalem—even more than to visit Mecca. It's easy to go to Mecca; people go to Hajj. But not to Jerusalem—it's much harder.

Amjad Moghary Even when you travel, it's so hard. So many difficulties, and the crossing! Of course, we tried it. You hate the day you travel, you regret it. You say, "I want to go back."

Abeer Khalid Yes.

AW You've experienced so many wars.

Amjad Moghary Of course, there's huge fear and apprehension. We're afraid for our future. Even if I didn't die, I could lose a precious person. My workplace could disappear; my university could disappear.

Mona Khalid Kurraz We entered the war at age twenty, and we left at age eighty. War wasn't a piece of cake.

Samah Nabil It made us grow older.

Amjad Moghary It made us live in another generation. We're not like the others of our generation. Abroad, people like us are concerned with playing and having fun, going shopping. But we're worried. I want to be employed after graduation.

Mona Khalid Kurraz Our only goal is to survive. We don't know if we'll survive till tomorrow. When would a bomb explode and take us?

Abeer Khalid In war, we'd die several times a day from all the death and destruction we saw. Every one of us felt like they'd be next. I could die tomorrow, or I could lose a member of my family.

Amjad Moghary This is such a hard feeling. Pictures we've seen in the war—injured and dead children—are stuck in our heads, stuck in our memories. It can

never be forgotten, ever. Especially when you've seen it right in front of you, someone dying, and you're afraid and unable to help. You could've been in his shoes. This is so difficult. And we don't know. Maybe a war is coming up—"All that is on earth will perish"—so I hope we'll be relieved.

Hind Nahed We're expecting that.

AW You're now graduates, and most of you want to become teachers. Some of you would choose different paths. How do you see the future?

Abeer Khalid Very bleak.

Mona Khalid Kurraz Nothing.

Amjad Moghary Currently it's very tough. Mainly I'm afraid that I won't find a job. If I were employed by the state, I'd have to work additionally as a private tutor just to make ends meet. I'd borrow money to be able to commute to work every day. Seriously, what salary would cover transport expenses? The only chance we could achieve is through an agency, and still it's almost impossible.

Abeer Khalid They already reduced their services.

Mona Khalid Kurraz Where it's super challenging to get a position.

Haneen Khalid We'll just be labeled—"This person is educated; she has a degree."

Amjad Moghary Not more than that.

Mona Khalid Kurraz We're only studying so people can say, "Oh, this woman is educated." An educated woman gets an educated man. That's why we're learning. But certainly we're not expecting a job. We studied just to earn a degree and that's it.

Amjad Moghary We don't have hope of getting jobs. We're just avoiding the pressure of people saying, "Oh, an uneducated person." No, I'm educated. But the government is to blame, not me.

AW As women today, under such difficult conditions, how do you see the way Gaza is dealt with politically?

Amjad Moghary Oppression.

Abeer Khalid Nobody is dealing with Gaza at all.

Huda Alkahlot Yes, powerful oppression.

Amjad Moghary Everyone is watching us, even Arabs themselves, as if Gaza is outside this world, removed from the map. Wars happen, sieges. Nobody bothers to think about us at all.

Mona Khalid Kurraz Everyone closes their borders.

Amjad Moghary Egypt, Jews, and Jordan. Even if we died, they wouldn't look at us. The sea is closed. All around, it's a bit like a big prison. We're in a big cell, nothing more. But even with all this, we're smiling.

[Women chorus in English, laughing] "We're smiling!"

Amjad Moghary I mean, here's a small example: I don't know if you've heard about the children who were burned because of a candle a few days ago.

Mona Khalid Kurraz Yes, there was no electricity, so they lit a candle.

Amjad Moghary The mother is to blame. She didn't take good care. But still, how did all this help? They cut off our electricity all the time. We're suffocating. [Laughing] I swear, we're fed up. Only six hours of electricity in the last twenty-four hours. Seriously, it's too much. I'd want to scream, "Halas, Haraam [Enough]," go ahead—scream!

Mona Khalid Kurraz They're cutting off so much. There's nothing left to cut off but air.

Amjad Moghary Except for the taxes; there are taxes on everything [laughing]. Everything! Taxes, taxes. Pay and pay. But they support nothing. You don't pay me, so how would I pay back?

AW What would you say, not to the politicians, but to the young people around the world that are your age. What would you tell them?

Amjad Moghary Don't spend your life shopping and wasting time. Plan for tomorrow. Because we're a nation in Gaza that was forced and put under so much pressure.

Mona Khalid Kurraz Honestly, I say enjoy your lives. You're living the life that none of us can even dream of.

Amjad Moghary No, but they have to plan and think of the future.

Mona Khalid Kurraz All these young people around the world are living a life that we don't have a quarter of. So, enjoy your lives, appreciate what you have.

AW Last question, please answer one by one: What's your hope?

Asmaa Al-Buhaisy To live a good life, just that.

Samah Nabil My hope is to get a job after I graduate. That's my highest hope.

Huda Alkahlot To improve our situation, and Gaza's situation, and to find a job. The graduates' situations are pathetic.

Abeer Khalid A thousand graduates are just sitting at home. My biggest wish is to live in freedom like everybody else.

Amjad Moghary Simple, just a few words: to live. We just want to live.

Haneen Khalid We wish to live like all people.

Mona Khalid Kurraz Honestly, my goal is different. I want to graduate and get a job in my major field, but not just a job. I wish to do scientific research, create something, to develop and achieve, and experience the many things that my field has to offer, such as discovering and creating new drugs. But here in Gaza there's no chance for such ideas. If only I could go abroad to achieve all these goals. I don't just want a position. I want something bigger; I want to be something. Let me grow high in my desires.

Mariam Alshekh Aly We have similar dreams. To live, find jobs—these are our simple dreams.

Asmaa Al-Buhaisy It's not a worthy life in here.

Huda Alkahlot Open the borders.

Mona Khalid Kurraz Get rid of this siege.

Amjad Moghary My goal is to make a better life than mine for the next generation.

Hind Nahed To develop Gaza.

AW Tell me one main goal, again, from each of you.

Nidaa Muhammed We want a decent life.

Mona Khalid Kurraz We want to live peacefully.

Asmaa Al-Buhaisy A decent life.

Haneen Khalid To live in peace.

Amjad Moghary That's it. To live in peace.

AW Look at this camera and say it together on the count of three.

[All women, laughing] To live in peace. To live in peace. To live in peace. To improve our situation. Find job opportunities.

AW It's getting very hot. Let's take a photo together.

064

Anonymous, *Student*
Gaza City, Palestine, 2016-05-12

A I want to specialize in children's education and give teachers modern teaching strategies. My ambition is to finish my dissertation abroad.

I have a bachelor's degree in education from the Islamic University. I recently finished my basic education. I studied for a master's in math education from Al-Azhar University. My defense was on March 21, 2016. Before that I was a member of the Ibdaa Foundation in the Islamic University, where we participated in animated shows, theater, and drama.

After I was done studying at the university, I became a member of the Palestinian Artists Association. I participated in a movie, *The Gun Admirer*, which is about jihad in Palestine and the role of the resistance, and in several others. I wrote scenarios about war, violence, and terrorism. I also post on Facebook about the crimes, the occupation, terrorism, wars, and assaults happening in our nations.

Currently my ambition is to achieve a PhD. I'm not satisfied with my education, and I'm eager to achieve more. My dissertation would be in the educational field, focusing on new teaching strategies using art, theater, and drama. I'd supervise and introduce drama and suspense, and give teachers methods and strategies to help them adapt to different aspects of teaching kids.

That's my future goal: to combine education with art, where education represents art, not just taking in piles of information. This isn't available in Gaza. We can study only up to a master's degree level. I'd like to specialize in such a field in either Jordan or anywhere abroad. It's a broad, inspiring, and deep field. It also requires a lot of time, support, and thoughts—it requires individual space.

AW How do university students and young people think about their future in Gaza?

A I'd work for my country, for Gaza. I want to deliver a message to Gaza's youth. They're deeply depressed because of our harsh, everyday living conditions: the wars, assaults and violations, and the siege. People may attempt suicide because of negative thinking; I want to encourage them and share my hope with them. As long as we're breathing, we're alive. We're healthy and we have common sense. Life doesn't end at one point. We must continue, even after many failures, until we achieve our desired goals. No one succeeds the first time.

I'd like to present a hopeful message. We need support for political activities, demonstrations, and projects targeting Gaza, especially for our youth. We're rich in youth. They have ambition, powerful energies, and genius, but 80 percent are without jobs. We have artists, politicians; we're full of potential. We're not lacking anything in the fields of art, theater, fine arts, and much more. We also have vocational workers and professionals.

But we don't have any support when we're looking for jobs and projects. There's nothing, no foundations, no corporations, local or international. No sharing from abroad, no factories, no universities to support the huge number of applicants and graduates. Projects go to waste; there's no chance to apply skills. There's no financial investment or motivation. The country is falling apart.

At least we're still alive. We'll be models for those in other countries in our hope, self-confidence, and ambition. All that is good in life, take it and learn from us, because everything is available for you. Here you reach a stage where you barely have a cup of water at home, but still you're full of hope and positive energy.

I know students who are geniuses, but they have no material or financial support to go abroad, and the crossings are blocked. Traveling is impossible. It's impossible for me to leave this country, as if I were a person living in a big shell. You stretch your hand out, but no one sees it.

AW Where would you like to go if you had the chance to travel and study abroad? Do you think your right to travel is being violated?

A First, concerning my studies, I'd like to obtain a PhD from either Jordan, the United Arab Emirates, or Saudi Arabia. But travel isn't possible, because even if I go tomorrow and register to obtain a passport and submit all my papers, I still won't be able to travel the next day. That's the biggest violation. In other words, the idea that the borders might actually open doesn't exist at all. I might get accepted and have the chance to study, but the borders will be closed, and I'd stay here for years. Then after three to four years, my name would appear on the waiting list, but by then it would be useless, and I'd be so frustrated because I couldn't achieve my goal. Instead, I'd feel very down. If you want to establish a project, you'll fail. If you're planning to travel, you'll fail. If you want to apply for a job, you'll fail. Even if you're motivated and ambitious, you'd be depressed.

Many lose hope and never regain it. Some will try again and again until they reach their goals. I'll never lose hope until I finally achieve my goal. May God be with me.

065

Mahmoud al-Zahar, *Hamas Politician*
Gaza City, 2016-05-12

MZ My name is Mahmoud Khaled al-Zahar. I was born in Gaza in 1945. I'm a surgeon and have worked in different fields. Currently I'm a politician, a member of the Hamas Political Bureau in occupied Palestine, and I'm responsible for the cultural committee. I've published six books. I'm married and I had four boys. Two were martyred facing Israel, one is at the university, and the other works in the Ministry of Foreign Affairs. I have three girls: an engineer, an English teacher, and an accountant in the Ministry of Health.

AW Tell us about Gaza's situation today.

MZ I'd say the refugees are part of the problems that have affected people, always and everywhere. Everyone has four unchanging values. The first is that the human is of the ultimate, highest value, and the Qur'an says, "We've honored mankind," so mankind is honored for the creator. The second is that humans' earth, their land, doesn't change. The third is humans' belief and religion, whether Muslim, Christian, Jew, or atheist. The fourth is the sacred Holy Land.

A Palestinian refugee has lost all four fundamentals. He's lost his right to have a land, left Palestine, and lived in one limited place, Gaza, with his brothers and family scattered all over the world. Second, he's called a "refugee" in Palestine, and his Holy Land was taken from him. The occupiers claimed 60 percent of the West Bank in the 1967 borders. Gaza is less than 2 percent of Palestine and holds two million Palestinian residents. Third, he's accused of terrorism because he's a pious Muslim. Fourth, his Holy Land has been targeted. The al-Aqsa Mosque can be entered by every Jew, by everyone. Thus, a man with his beliefs and sacred land were violated. The Palestinian refugee is the victim of the loss of these four fundamentals. He doesn't live on his land or in his house. He's not able to reach his sacred possessions, is violated for his beliefs, and is accused of terrorism. A Palestinian presents a universal injustice by being here in Gaza.

AW How do you imagine the future of Gaza and the refugees?

MZ Not anywhere else but here. A refugee's future depends on his own view in handling the crisis that caused all of this. The reason for this refugee situation is the people who came from Europe and the US, from all over the world with the force of arms, occupied his land in 1948.

If a Palestinian or a refugee reacts as if this is an eternal occupation, he'll stay a refugee forever. If he reacts to this as an illegal occupation and keeps resisting it, he'll return to his land. We represent the second option. Mahmoud Abbas represents coexistence and acceptance with the occupier, whereas we reject and deny this occupier. We don't recognize him, nor his rights, and we've resisted in all peaceful ways possible, as we did in the uprising of 1987. Today we resist with arms in all possible ways, and we express it loudly with our tools and strategies. If we had military powers developed to a level where we could remove this

occupation, we'd expel all who came to occupy our land. We'd take back the four fundamentals that we lost, and instead of being refugees, our people would be citizens living in their land, from the north to the south of Palestine.

AW I understand from you that the core of the resistance has emerged not in opposition to Judaism but from the idea of refugees.

MZ First, we're not an atypical phenomenon in history. When the Nazis occupied France, what was the French position? In the Second World War, a part led by the Finnish constructed a security cooperation with the occupying Nazis. De Gaulle [the French officer and statesman who led the French Resistance during the Second World War] resisted the Nazis with armed force. Who do you consider a hero now? De Gaulle or the Finns? We're not an unusual phenomenon. All the countries that were occupied by Britain, for example, expelled it and gained their independence. Pakistan was occupied by the British; Egypt, Tunisia, Algeria for 130 years by France; Libya by Italy. So the phenomenon of expelling the occupier is the solution. About the problem of how to achieve this: when we've failed by peaceful options, we return to armed uprising. It's not a strange phenomenon. It's in all the world's agreements that the human who has lost his land, life, or position has the right to defend himself in all possible ways.

AW Palestinians have been refugees for sixty-seven years. Now they're born refugees. What about the idea of refugees' right to return? Does it vanish over time?

MZ You talk about a period of sixty-seven years. Why not of eighty-two years, since the Egyptian occupation? And 130 years of the French occupation of Algeria? And a hundred years of the British occupation of India?

Time will not change the pattern of resistance. We used to be very small in Gaza and in the West Bank. In Jordan, people lived on the hope that the international community would bring them back to Palestine. When they were certain that there was a conspiracy with our Israeli enemy, they resorted to arms. Time changed the tools and the options for potentially better solutions. We used to rely on primitive weapons like rocks or knives, like the situation in the West Bank. In Gaza, over time we could develop tools to defend ourselves, where we push the Israeli army and expose them to a catastrophic and unexpected defeat.

A Palestinian man in Gaza, in the West Bank, is a martyr by holding just a knife, a stone. Time has convinced the Palestinian refugees that the international community will never act in their interest. Thus they resort to basic tools of resistance.

AW What's your opinion about a political solution in the future?

MZ Political solutions have been tried. There was the Oslo Agreement of 1993, which some Palestinians and parts of the Palestine Liberation Organization agreed with. Nothing was achieved from this agreement. Hamas, the Islamic Jihad, many nations, organizations, and leftists admit that there is no possible political solution. A military solution is the only resort.

As we've spent sixty-seven years of failed political options, the political choice is that he who has left his country and occupied ours should return. What justifies Ethiopian Jews to occupy my land, or for a German, Russian, or Italian to occupy my land? Their land is enough to fit them all. Netanyahu has his US passport. His father lived there; he can go back peacefully. That's the political solution. If he doesn't agree, then we only have armed resistance between us.

AW Are these the only options?

MZ The only option is armed resistance. I'll give you a small symbolic example. Ariel Sharon said that Gaza is strategically as important as Tel Aviv. After weeks of resistance, he fled Gaza in 2005. So as a result of resistance, we could hopefully achieve eviction of the Israeli occupation and convince the enemy that it's our land, that we won't give up on it. The idea of evicting the occupation by resistance is also the best solution for the refugees themselves.

Let me give you another example. Jews decided to divide the al-Aqsa Mosque, temporally and spatially. Women and children went out unarmed in peace and demonstrated in the mosque, then to carrying stones, then knives and slingshots. After that, was the mosque divided spatially? No! Therefore, our experience is that when there's armed or peaceful resistance against the occupation, you ruin their plan and impose a new reality. We'll free Palestine sooner than you can imagine. Very soon, we'll free Palestine; there will not be a single Jew here.

We're against the occupation and not against Jews and Christians. We're not opposing anyone because of their beliefs. We're claiming a nation that was occupied and whose expelled citizens are suffering. No one can handle this historical oppression of sixty-seven years of suffering. We can't pay the price of the Jewish case. Jews have lived in all of Europe and they were expelled from all its lands. That's why we'll represent Europe's role in expelling Jews. In 1253, France expelled Jews from the country. In 1280, Jews were expelled from Britain. There was an endless series of Jews being expelled. There isn't a single European country that hasn't expelled Jews. We'll expel them—like everyone else has done throughout history—from our land, which they occupied in 1948.

AW After sixty-seven years, the homes of all the refugees have long been destroyed. Yet they hold on to the keys of their homes and all the proof and documents of owner-ship, knowing that they'll never get their homes back. Can you comment on this?

MZ The Palestinian doesn't change concerning the basics. He appreciates the value of his land, his belief, his creed, and what's sacred. This is Hamas's belief. It would be impossible to give up al-Aqsa Mosque. We're devoted to resisting the occupation in all possible ways, because the Qur'an tells us, "And prepare against them whatever you are able of power and of steeds of war." A person's devotion proves his basic beliefs; in spite of having his land taken from him, he retains his complete rights. He wasn't made to live as a refugee within the limits of the 1967 borders. A Palestinian wouldn't willingly give up one square centimeter.

Look at what's happening in the West Bank and Jerusalem at the moment. Married women, children, the elderly—all elements of society—are rebelling and

resisting occupation. The Palestinians are closer than ever to achieving freedom. The proof is that Hamas developed its military capability alone. With our hand-made tools, we can now reach more than 160 kilometers from Gaza. If this capability develops further and moves to the West Bank, I assure you that Israel's age would be limited to a few years.

AW What makes a Palestinian refugee different from the rest of the world's refugees?

MZ The Palestinian refugee experience is the worst experience in human terms. For example, the Syrian refugee comes from a homeland that is full of Syrians. When a reconciliation takes place, he'll return to Syria. But the Palestinians can never return to their original homeland. Palestine isn't occupied by Arabs, Muslims, or Christians but by foreign Jews. The Palestinian refugee has no passport. If leaving from the Israeli side, he'd only obtain a personal identification document. So he has no passport, no possibility to return, no privilege to benefit from his land, no options even to visit. Thus, in human terms, he's the worst-case refugee, experiencing an occupation by a landlord who could be Ethiopian, German, American, or French.

AW Was Palestine's image ruined worldwide? If yes, what and who ruined this image?

MZ There are two parts to the distortion of the Palestinian image: the Palestinian part and the non-Palestinian part. The Palestinian part is the Palestine Liberation Organization, which considered a security deal with the occupier. Mahmoud Abbas said that Israel is sacred, contrary to the Palestinians who resist and want the occupation to end. This ruined the Palestinians' image. What retained it is Hamas's ability to put up armed resistance to injure Israel and expel them from a part of our land.

Palestinian refugees also suffer unimaginably from the European-American hypocrisy. Human rights are blessed and overrated to all who are non-Palestinian, for example, the small child [Aylan Kurdi, the three-year-old boy who washed ashore in Turkey] who drowned while fleeing. Everyone talked about him. How many Palestinians have died in homes that have been destroyed? No one mentioned them. We suffer from global hypocrisy because of Israelis' money and influence in politics. So the Palestinian refugee suffers the most from the world.

AW What would you like to deliver as a message to the world?

MZ We don't trust what's referred to as "the international community," led by the US, because in 1947 Harry Truman, an isolated candidate, came to the Jews and they gave him two million dollars. He won the election, and the first decision he made was to acknowledge the state of Israel in 1948. Therefore, what's referred to as "international legitimacy" is an American legitimacy controlled by Jewish funds. Another example: During Netanyahu's last visit to Washington, DC, when he gave an unofficial speech in front of the US Congress and President Barack Obama, he was given twenty-nine standing ovations. This reflects that Jewish money in the US and Europe is the decision-maker, not morals, ethics, or the Charter of the United Nations.

Everything is just a tool for Israel. We don't trust this hypocritical international community, so we have nothing but our hands to defend us and our land. The surrounding Arab nations are also under the influence of the international community. Whether it changes completely depends on the intentions and capabilities of the resistance to achieve its goals. We've been through four wars against the occupation: in 2006 for two weeks, in 2008 and 2012, and in 2014 for fifty-one days. Not a single country resisted the Israeli occupation for more than a few hours. We resisted for fifty-one days, and they couldn't enter more than 2 percent of Palestine. The international community pays with their dignity, their credibility, and their conscience for Israel's benefit, but in the end, Israel will lose.

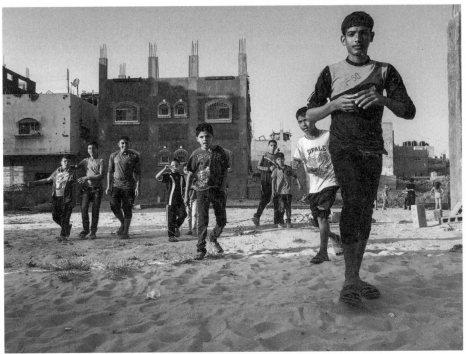

Kuba District, Gaza, Palestine, 2016

066

Yehuda Shaul, Breaking the Silence
Hebron, Palestine, 2016-05-13

YS When we talk about the Israeli-Palestinian conflict, we usually talk about 1948 and 1967 as the most important events in the historiography of the conflict. The establishment of the state of Israel and the Nakba, as the Palestinians call it, occurred in 1948. The Six-Day War, when Israel occupied Gaza and the West Bank, was in 1967. But when we come to Hebron, the most important event is further back in history, about 3,700 years ago, when Abraham bought the cave in which he buried his wife Sarah. Later on he was buried there with his grandson Jacob, Jacob's son Isaac, and Jacob's wives Leah and Rachel. Basically, the biblical matriarchs and patriarchs are buried in Hebron in what we call the Tomb of the Patriarchs and what Palestinians call al-Haram al-Ibrahimi [the Sanctuary of Abraham], the Ibrahimi Mosque. So, in a way, it's the Tomb of the Patriarchs that gives Hebron historical religious significance. Long before it became a nationalistic story, it was a religious story.

Throughout biblical times, Hebron was a very important place for the Jewish people. This is where King David started the capital of the Judean kingdom for seven years before he moved to Jerusalem. We're not in Bible class, so we don't have to go through all the examples, but we get the idea of what's important. Now I'm skipping ahead a few hundred years to the fifteenth century.

The reason why I start from the fifteenth century is because that's the beginning of the modern Jewish community in Hebron. Toward the end of the fifteenth century, Jews were expelled from Spain, and a bunch of families settled in Hebron. There were Jews present here from about the twelfth century, but it was in the fifteenth century that they became a community with institutions and political standing. They were called Sephardic Jews (meaning from an Arab-Mediterranean background), spoke Arabic as their first language, and were very much integrated into the city.

Of course, they weren't treated equally, because no Jew was treated equally in the fifteenth century. The concept of equality didn't exist yet, but, ironically, back then Hebron was a relatively good example of coexistence. In the nineteenth century, there was another wave of Jewish immigration. This time it was the Ashkenazi Jews, European Jews from Eastern Europe. They came here before nationalism, before Zionism started. They came here because of the Jewish historical significance of the city. They had a different dress code, different culture, and different language. They didn't come from an Arab-Mediterranean background, but they were still more or less integrated into the city.

That reality of living together in Hebron came to an end in the second most important event in the historiography of Hebron, the massacre of August 1929. That was part of the national struggle in Mandatory Palestine. There were a few waves of violence before 1948, in 1920, 1921, 1929, and 1936. In August 1929, there was violence all over the country, and the Jewish community in Hebron was the community that suffered the most. Sixty-seven Jews were murdered and

more than a hundred wounded. There was mass destruction of property and a very brutal massacre against the Jewish community in Hebron. About 350 Jews were saved by their Palestinian neighbors from being slaughtered.

These are the dry facts and numbers no one can dispute. What's important for us today is to understand that it was a 1929 massacre that brought about the end of the organized Jewish presence in Hebron. British forces evacuated the survivors to Jerusalem, and that was the end of the organized Jewish presence. They made a few attempts to return in the 1930s, but they didn't succeed.

So there are two main reasons why we have a settlement in Hebron today and we don't have one in the middle of Jenin or Ramallah. One is the Tomb of the Patriarchs and the town's historical and religious significance. The second is the massacre of 1929, reclaiming Jewish property from before 1929, rebuilding a Jewish community that was destroyed in a massacre, and reclaiming our national honor and pride.

In 1948 Jordan occupied the West Bank. No Israeli Jew lived there then. In 1967 Israel occupied the West Bank. Right after the war, a group of children and grandchildren from the massacre of 1929, basically children and grandchildren of the refugees from Hebron, wanted to return to their land. The government refused for a very simple reason: no one wanted to open up the Pandora's box of refugees from 1948. If we allowed Jewish refugees to return, what would we tell Palestinian refugees? The box was better left shut.

The story of the settlement here started in April 1968. The first Passover since the Six-Day War was over. A bunch of students, led by Rabbi Moshe Levinger, asked permission from the Israeli army to celebrate Passover near the Tomb of the Patriarchs. They were granted permission only for Passover. On Passover they came here, rented a Palestinian hotel, and after Passover they refused to leave: "We're here to inhabit the city of the patriarchs."

That moment in history started the political pattern that continues up to today. It doesn't matter which party rules the government in Israel or whether it's what we consider right-wing, center, or left. Any Israeli government will surrender to almost any demand by the settlers. The government negotiated with the settlers, and the agreement was: "You'll leave the hotel you took over; we'll move you to a military base, the headquarters of the army in Hebron; and we'll build you a neighborhood inside the military base." That's how the settlement started.

In 1970, Kiryat Arba, the settlement we drove through on the way here, was built. That was the third settlement in the West Bank. Kiryat Arba was built because there was a bigger plan by Yigal Allon. Yigal Allon was a minister in the Israeli government, from the Labor Party, who devised the Allon Plan. What was the Allon Plan? The question was: What the hell should we do with this huge amount of land we just conquered in the Six-Day War?

The plan was very simple. We'd take the entire West Bank and cut it into two strips from north to south. The western strip was supposed to be the future Palestinian autonomy; the eastern strip, close to the Jordan River, was supposed

to be annexed to Israel and serve as what Allon called a "security belt." This accomplished two things: moving the eastern border of Israel from the green line to the Jordan River, facing Jordan, Iraq, and Syria, and disconnecting the Palestinians from the Jordanians so they couldn't join forces against us. Yigal Allon built settlements along Road 90, the north-south road along the Jordan River. He also built another road on the ridge over the Jordan Valley, more inland and westward. It's called the Allon Road, and he built settlements on the road.

So the name of the first settlement on the road is Allon Road. It was very strategically done then. The idea was that we couldn't take the land with just a few settlements on the borders, on both edges of the belt. We needed a stronger hold over the land. So the training facilities of combat units were moved. The red dots you see here [indicating on a map] are military bases. We basically had settlements in between military training fields.

The villages we're going to see later on in the south of Hebron are under threat of demolition. The army wants some of their fields for training. Allon thought we should build a big city, a Jewish city, an Israeli city, east of Hebron, control the demographics, and annex Hebron down to the east, to the security belt. This is why Kiryat Arba was built in 1970 as part of the Allon Plan. The settlers left the military base and moved to Kiryat Arba, and throughout the 1970s we didn't have a permanent settler presence in Hebron.

Now, I want to simplify the story because we don't have much time. In the 1970s we had the Yom Kippur War in October 1973. That's quite an important event, because after the Six-Day War in June 1967, there was euphoria here. We defeated all of the Arab countries around us in six days. We took Sinai, Golan Heights, the West Bank, and Gaza. In 1973 we were surprised by an attack by Syria and Egypt. Even though we won, it was a very costly war. More than 2,000 Israeli soldiers were killed. It was quite the wake-up call.

That's when some people in the Labor Party started to talk about land for peace. And that was a problem for the settlers. Within four months of the war, the national religious community started the settler movement. Until 1973 you didn't need a pressure group because the Labor government was building the settlements. In 1973 the Labor government was starting to think about the change in policy. So where did the settler movement go? They went to the north of the West Bank, the big chunk of land where there weren't any settlements yet. Throughout the 1970s, Ofra, Kedumim, Elon Moreh, Beit El, Neveh Tsuf, all the legendary settlements from the 1970s were up here—until 1979, when things changed in Hebron.

Something huge happened in 1979: the Camp David Treaty, the peace agreement between Israel and Egypt. In part of the Camp David Treaty, there was a discussion about Palestinian autonomy. The settlers didn't like that. What's the best way we knew to fight the threat of peace? Facts on the ground.

In the middle of the night, women and children from Kiryat Arba, outside of the city, marched to downtown Hebron, broke into a building called Beit Hadassah, and started a new settlement. Beit Hadassah was a medical clinic built by the old

Jewish community in 1893, before the massacre of 1929. But in 1979, the building was empty. Women and children broke in and started a settlement. Now this is illegal, but it was only women and children, not the real thing, so why make a fuss? Just leave it this way. Sound familiar? What we hear today throughout the West Bank about outposts was the same here in the 1970s.

In the 1980s there were three important events: On January 31, 1980, Yehoshua Salome, a Yeshiva student from Kiryat Arba, was murdered by Palestinians in the old city of Hebron. A few months later, on May 2, 1980, a Saturday afternoon, a bunch of Yeshiva students standing outside of the Beit Hadassah were ambushed and six were murdered. After these two attacks, the Israeli government decided to teach Palestinians a lesson: You kill us, we don't run away and, in fact, we do exactly the opposite—we build more. So, between May 1980 and August 1984, the four main settlements in Hebron began: Avraham Avinu, Beit Romano, Beit Hadassah, and, in August 1984, Tel Rumeida.

In the 1990s there were two important events: On February 25, 1994, Dr. Baruch Goldstein from the nearby settlement of Kiryat Arba entered the mosque and the Tomb of the Patriarchs during Friday morning prayer, during Ramadan, and the Jewish festival of Purim. He opened fire and massacred twenty-nine Palestinians and wounded more than 120. The Goldstein Massacre is the most important event in the historiography of Hebron, when you want to understand why the city looks the way it does today.

The second important event in the 1990s happened in January 1997 when the Hebron Protocol was signed. The Hebron Protocol was part of the Oslo Agreements throughout the 1990s when Hebron was divided into two, H1 and H2. H1 is 80 percent of the city—120,000 Palestinians lived there under the management of the Palestinian Authority. The remaining 20 percent, H2, is under complete Israeli control with 35,000 Palestinians and 500 settlers. If you look at it, H2 is the eastern strip of the city close to Road 60, the main road we drove on. H2 also has a block that partly reaches into downtown Hebron. Of course, we're not going to give the Palestinians the Tomb of the Patriarchs; that's why we're here. And of course we're not going to give them our settlements, right? Nor the old city, the cultural and trading center of the city.

In the 2000s, the second intifada started in September 2000 and faded out in 2005. In April 2014 a new settlement started in Hebron during the last round of negotiations sponsored by John Kerry [US secretary of state from 2013 to 2017]. This shows you what we thought about his negotiations. It's the first new settlement in thirty years in Hebron. It's important to mention the Tel Rumeida settlement, which began in April 2014, just two days before Passover. So everything started in Passover 1968, and now we have a new settlement in Passover 2014.

I said earlier that 35,000 Palestinians live in H2. These were the numbers for 1997, when the city was divided. Today, we don't know how many Palestinians still live there [40,000 as per 2019]. The latest figures we have are from 2007, when the two largest Israeli human rights institutions, B'Tselem and ACRI [Association for Civil Rights in Israel], came to downtown Hebron, did a house-by-

house survey, and came to the conclusion that about 42 percent of families from downtown Hebron have left their homes. So, 1,014 families are gone because they couldn't continue to have any kind of ordinary life. There's no comparison to that throughout the occupied territories where thousands of people just disappeared from an area. Hebron became a ghost town. We're in the center of the largest Palestinian city in the West Bank, not including East Jerusalem, and you barely see Palestinians around.

The most important thing is to try to answer the question of why Hebron became a ghost town. We usually talk about three reasons. The first and most important is the Israeli army's big strategy here. How do you protect 850 settlers in the middle of 200,000 Palestinians? You create sterile buffer zones between both communities. When I said earlier that the Goldstein Massacre in 1994 was the most important event to show why Hebron looks the way it does today, it's because that's when the sterilization started. A settler massacres twenty-nine Palestinians in the Tomb of the Patriarchs. What's the response? The Israeli army puts all of the Palestinians in Hebron under curfew for two months. Curfew means you're not allowed to leave the house day or night. The rationale is very simple: if you want to prevent revenge attacks against the settlement, you put the entire Palestinian community under house arrest for two months.

Once we lifted the curfew after two months, the al-Shuhada Street, which used to be one of the main streets where the central bus station used to be, was shut down for Palestinian cars. What used to be the meat market of Hebron, in front of the settlement, and the vegetable wholesale market were announced as sterile buffer zones where the Palestinians couldn't even set foot. And since the beginning of the second intifada, there were three levels of sterilization (those are the weird colors on the map).

Purple is the first one. Purple means that no Palestinian vehicles are allowed to drive in that area. We came down out of Kiryat Arba settlement, took a left turn, and came up to here. We're not Palestinian, so we can drive here, but Palestinians can only go by foot. The concept is very simple: no Palestinian vehicles, less Palestinians; less Palestinians, less friction; less friction, more security for the settlement.

As we get closer to the settlement, the level of sterilization and segregation is higher. The second one is the brown, yellow, or yellow-purple. Yellow means no Palestinian shops are allowed to open. So what used to be the trading center of the town is completely shut down. About 1,800 shops closed. All the trading life—goodbye. A few hundred of these shops were shut by military orders, another few hundred because there were no customers left. The highest level of sterilization is the red roads that you see on the map. That's what we call in the army "tzir sterili," sterile road. This means that not only can Palestinians not drive on the road or open shops on the road, they can't even walk on the road.

If you're a Palestinian family living on a sterile road, in most cases your front door is welded shut. So your way to work, in and out of the house, is to climb onto the roof and take a ladder and go a back way. This is the first reason that Hebron is a ghost town. By now you understand that it's not the most pleasant life in

these restricted areas. The second reason that Hebron is a ghost town has to do with the day-to-day behavior of the military. This is more or less the bread and butter of Breaking the Silence: what the army does on a day-to-day basis.

I don't have the time to talk about everything, so I'll give you two examples. One, curfew. Curfew means you're not allowed to leave the house day or night. Throughout the intifada, Palestinians in Hebron suffered the most from curfew compared to any other place in the occupied territories. In the first three years, 2001, 2002, and 2003, the Palestinians in Hebron were under curfew for 377 days. That means no school, no university, no business. You couldn't leave the house day or night. The longest period of continuous curfew was six months. During these long curfews, the curfew was suspended once a week for two to three hours so people could get supplies, and then it started again.

Another example is what we call "making our presence felt" in the IDF [Israel Defense Forces]. The army's concept is that if Palestinians get the feeling that the army is everywhere, all the time, they'll be afraid to attack. How do you make them feel this way? You make your presence felt. In different parts of the West Bank, it manifests itself in different ways. In Hebron you have three patrols 24/7. You start your night shift patrol from ten o'clock at night to six o'clock in the morning, an eight-hour shift. You walk in the streets in the old city of Hebron and the Kasbah and barge into a house. It's not a house you have intelligence about, just a random house.

The officer, the sergeant who leads the patrol, chooses the house, barges into the house. You wake up the family, men on one side, women on the other. You search the place. You can imagine the dynamics of what happens when the military enters your house. They finish searching, go out to the street, knock on some doors, make some noise, run to the other side of the street, invade another random house, wake up the family, search the place, climb on the roof, jump from one roof to another, go down from the balcony, wake up the family. And that's how you pass your eight-hour shift. Twenty-four hours a day, seven days a week, from September 2000, since the second intifada started, up to today, they haven't stopped for one second.

You had a good night's sleep last night? Twenty, thirty families were woken up here. The idea is very simple: every Palestinian has to feel that the military is right on their necks. You never know when we're going to show up, how it's going to start, when it's going to end, how long it's going to be. A good friend who was a researcher for Breaking the Silence for a few years served there in 2008. He says, "We go out on a patrol, and one day we decide the way we're going to make our presence felt is to cross from one side of the old city to the other one without touching the ground. Jumping from one roof to another, through houses, on roofs, into other houses."

A friend who's now a member of Breaking the Silence was an officer here three years ago. He says, "I start my afternoon shift from two o'clock to ten o'clock at night, an eight-hour shift. I decide the way I'm going to make my presence felt today is to walk to the main market in Hebron, downtown, and I'll physically search at least 300 random Palestinians." He goes out and starts: "Give me your

ID, count one, two, three, two hundred, two hundred ninety-nine, three hundred. Next." It's to do what we call in the military "Litzor Tchuschat Nirdafurt Etzel Ha'Achlusia Ha'Falestinit," to create the sense of being chased, of the entire Palestinian population being persecuted. That's the mission. That's the second reason why Hebron is a ghost town.

The third is settler violence. The Hebron settlers aren't the most violent settlers. In the north of the West Bank, around Nablus, northeast of Ramallah, they're way worse. In the south of Hebron, they're more violent. But still, Hebron settlers are pretty violent.

But actually talking about settler violence alone isn't understanding the story. Because the story isn't that you have 500 mad settlers who do whatever they want. The story is that the government doesn't do anything to enforce law upon them. The numbers in Hebron today: 200,000 Palestinians, 850 settlers, 650 combat soldiers. That's almost one soldier per settler. Why isn't the law enforced?

And that's where we get to the important part of the story. The lack of law enforcement in the West Bank on settlers is built into the law. I know that what I just said sounds absurd, but I'm going to explain. We aren't in Israel. Even our most right-wing government ever, which is the current government, never annexed Hebron. Israel's sovereignty has never been extended here. The sovereign power here is the Israeli army. By international law, by Israeli law, the army is supposed to protect the people here. As soldiers here, our orders are to protect the settlers. If we see a settler attacking a Palestinian, it's not our job to intervene. It's the job of the Israeli civilian police. The best thing we can do is call headquarters on our radio and ask them to call the headquarters of the Israeli civilian police to send a police car to take care of the matter.

I've stood here tons of times during my shifts while Palestinians were attacked in front of me and my orders were not to intervene. I couldn't do anything. The problem is that the policemen don't do their job—not because they don't want to, but because they don't have the political backup to do it. They're not supposed to.

But this isn't everything. The discrimination is also integrated into the legal system. The rights that you have under military law are less than what you have under civilian law. So, for example, let's say I'm an Israeli, you're a Palestinian, we both throw stones at each other, and we both get arrested. As an Israeli throwing stones, I committed a criminal offense. As a Palestinian throwing stones, you committed a security offense. I'll be tried in a civilian court in Israel, while you'll be tried in a military court in the West Bank. I can demand to see a lawyer before my first interrogation. But we can hold you for thirty days before we call a lawyer. We don't even need a judge to agree to that; an officer just needs to sign a paper. If they want to keep me in custody, within twenty-four hours they need to bring me in front of a judge. But we can keep you for about four days before we bring you in front of a judge. This goes on and on.

So sometimes, there are two families living in the same street, where there are two different legal systems being enforced by two different executive branches. The army enforces military law on Palestinians. Israeli civilian police enforce

Israeli civilian law on settlers. When you put these things together—the restriction of movement, the behavior of the army, settler violence, and lack of law enforcement—you understand why Palestinians have fled the area.

AW It's amazing to see this wholesale design. You can really see the mentality behind it: a completely inhumane operation.

YS But this is the story. A lot of people don't get our criticism. Very deep inside we don't believe the problem is the army. The problem is the political mission the army is sent to carry out. Any army in the world with the mission of ruling 4.5 million Palestinians, or any other people without rights and dignity, for more than fifty years will behave this way. The only way to rule people against their will is to get them to fear you. And once they get used to a level of fear, you have to constantly increase it—it's a bottomless pit.

The only way to come out of it is to end the occupation. You can't send the army here and hope for moral behavior, because the mission itself is immoral. There's no way to be here and not be here simultaneously. There's no way to serve in the occupied territories and view Palestinians as human beings equal to you.

Back then as a soldier it made sense, because it was the only way to keep them quiet, the only way to maintain the status quo. It's only when you take a step back and say to yourself: *What the hell? Intimidating an entire population 24/7 just because they were born Palestinians?* There's nothing that a Palestinian can do in order not to be intimidated. Even his or her own house isn't a safe place.

One of the things we did in the army is what we called "mapping." You would go into a house and draw a map of the entrance, the rooms and where they were located, who lives there, their ID numbers, where they work, their cell phone numbers, and so on. Sometimes we took photos of the family. Now, you think to yourself that the map is a great tool for intelligence, and that if you put all the info from the map into a database, you really have all the intelligence. But in the vast majority of the cases, the paper was just thrown into the garbage afterward. It was just another form of making your presence felt.

Another example of tactics used in the military was to perform mock arrests. That's actually something we heard from testimonies of soldiers, more so in the last few years as opposed to my time in the army. I served during the second intifada, and things were dangerous then; you didn't play games. But today things are relatively quiet, so you have more of these types of things. A mock arrest is just as it sounds—it's not a real arrest. Say you had a new unit in town. They've finished basic and advanced training, and it's the first time they're out on a tour of duty. You wouldn't want the first arrest operation they lead to be the real thing, so you'd choose the most peaceful Palestinian village in your area, open up an aerial photo of the village (every structure has a code number), and choose a random house. Then you'd pick up the phone and call the Shin Bet officer responsible for the area to make sure that the guy living in the random house that you've chosen is an innocent person and that by targeting him you're not interfering in intelligence-gathering operations in the area.

Then you come in the middle of the night and surround the house as if it's a real arrest. You grab the guy, handcuff and blindfold him, search the place, and take him with you (though sometimes you don't). After five to twenty minutes, someone goes on the radio and says, "End of exercise." You stop the jeep, release the guy, go back to the base, and go to bed.

Soldiers know this isn't a real arrest, so they ask their officers why they have to do this. The first reason is for training. Training is better if it's as close as possible to reality. So if you can do it with a real Palestinian man, in a real Palestinian house, in a real Palestinian village, good. The second reason is that it's just another way of making your presence felt. You go into the village at two o'clock in the morning and everybody wakes up. They see the army arrest someone, and they start to ask questions. "Why did you arrest him?" And then they see he's being released. "Why did you release him? Is he a collaborator?" Yes, no, they don't have the answers, so they're even more afraid. The lack of logic is the perfect logic. The lack of order is the perfect order, because you want to intimidate people. If you know what's waiting around the corner, you can calculate if you want to play games with the regime. But if you have no clue what's going to happen, that's when you're really, really scared.

AW Who are the settlers and how do you define them?

YS They're Israeli civilians who live in the occupied territories outside of Israel. The settler community, by the way, is diverse. The settler community in the West Bank is more or less divided into three groups. One third are secular people, meaning secular Israelis who live mainly in the large settlements and in the big cities, like Ariel, Maale Adumim, around Jerusalem, and so on. Then one third are ultraorthodox. They're mainly in two settlements: Beitar Elit and Modein Elit, very close to the green line, about two kilometers deep into the West Bank. As you get farther down to the south and the north, you get to the national religious communities, and as you get farther away to Jerusalem on both sides, you get to the more extremist ones. The more violent ones are in the area of Nablus, northeast of Ramallah, and in the southern Hebron hills. So again, one third secular, one third ultraorthodox, and one third national religious. In Hebron, everybody is religious.

067

Sarah Giles, *Médecins Sans Frontières*
Vibo Valentia, Italy, 2016-05-10 and Sicily, Italy, 2016-09-30

AW Please introduce yourself and tell us about Médecins Sans Frontières' activity on the *Aquarius*. What kind of support is MSF providing to the people who arrive on the *Aquarius*?

SG The *Aquarius* is a joint operation between MSF and SOS Méditerranée. We go out on the small orange RIBs [rigid inflatable boats]. We have a cultural mediator who speaks many languages. She keeps the refugees calm and tells them what to expect. We have a medic (me or one of the nurses on the other RIB) who checks to see who needs immediate help, and then we bring people back to the ship. Once they're on the ship, we give them food and clothing, register them, and attend to their medical needs.

AW Generally, what are the medical conditions of the people that you find on the boat?

SG In general they're really scared, tired, and dehydrated. They may have some fuel burns from the diesel mixing with seawater, which can burn the skin. And they're all very traumatized. We often find skin infections and respiratory infections, but we also see signs of trauma. We see broken limbs and wounds from beating. We also see a fair number of people who've been sexually assaulted and women who are pregnant as a result of rape.

AW Where are these people coming from?

SG The makeup of one boat can be completely different from the next. About 16 percent of the people we rescue are women, 23 percent are under the age of eighteen, and about 90 percent are traveling alone as unaccompanied minors. Kids as young as ten are traveling by themselves. In terms of where people come from, it's important to understand that this trip across the Mediterranean is the end of a very long journey. They could've started in Eritrea, Mali, Côte d'Ivoire, or Nigeria.

AW You said these people have often suffered traumatic experiences. What kind of support can you give them in this short time on the ship?

SG The first thing we can do is treat them like human beings. They're people with stories, and they're not just a number. We're kind to them, feed and clothe them if they need it, and keep them warm. One of the questions I ask all of my patients is, "Are you alone?" I asked this of a woman in her twenties and her eyes welled up with tears. She said, "I started this journey with my husband, my sister, and my aunt. We were living together in Libya when men with guns stormed into our house and murdered my husband and aunt." They started to burn her hands and her sister's hands over the flame of the stove, and you can see the burns in between her fingers. While that was happening, they raped her younger sister. She had a chance to escape by diving out a window. She said, "I don't know what happened to my sister. I don't know if she's alive or dead. So I guess I'm alone."

AW How did this experience on the *Aquarius* affect you on a professional and personal level?

SG Through my work with MSF, I get the chance to experience the best and the worst of humanity. The journeys that our patients tell me about have exposed me to the worst of humanity. I've heard of things done to people that I had never dreamed of: the rape of women who are nine months pregnant; a sixteen-year-old boy who was beaten so badly that three months later his testicles were still swollen. In the worst places where I've worked, in civil wars and conflicts, I've seen people with gunshot wounds, but I haven't seen this level of psychological trauma ever in my life. That's new to me.

We don't have a lot of time with the people, and sometimes I'm just listening to the stories and telling them that they're safe while they're on the ship. I can't guarantee what's going to happen to them in Europe. I really worry about them in Europe, because they had such a long journey with so many bad things happening. They get to the Mediterranean, which has a lot of media coverage, and we treat them well here. But I don't know what's going to happen to them next.

AW Can you describe the situation on a refugee boat?

SG Every rescue is different. We have two types of boats. We have the rubber dinghies, which you and I would reasonably put twenty people in, but we see 140 or 150 people in them. When you see the boats from a distance, they're just little white specks. When you get closer, you start to see that the specks are heads, and then when we start handing out life jackets, you realize that you just went through a bag of twenty, and another bag of twenty, and another bag, until you reach 150.

The men sit along the edges of the boat, and the women and children, who are the most vulnerable, are in the middle. Often we see them last, because you have to be quite high up to see them, or you only see them after the men have cleared off. We had a wooden boat that had 350 people on it, which was just unimaginable. It was two layers, so there were people under the bottom as well. There was water coming in and it was very stressful. It's almost like a crazy clown car where people just keep coming off, and coming off, and coming off, and you can't believe that there are that many people on it. You can't believe it's still afloat. And then you wonder how many have gone down that we didn't see, because it definitely wouldn't take much.

068

Mohammed al-Samaraei, Refugee
Berlin, Germany, 2016-06-01

My name is Mohammed al-Samaraei and I'm from Baghdad, Iraq.

The journey was very hard. It was an unforgettable day. It was very rainy, with thunder and lightning. We took a rubber boat from İzmir and stayed in it for four or five hours. In the middle of the sea, the boat malfunctioned and we were waiting for someone to save us. All of our belongings were lost in the sea, and there was a lot of suffering, especially for the children and women. All we could think about was that we were going to die in the sea. Then a big ship, I think it was a Greek ship, came and saved us. They gave us a ladder to climb from the damaged boat to the ship, and we were saved. Thanks to Allah for everything.

After that we also suffered many times on the road. We got to Mytilene in Greece, then to Macedonia, Serbia, and to the Croatian borders. We stayed in Croatia for a full day and then moved on to Bulgaria. They put us in the train, and from there we went to Vienna and Germany. That was our journey. In short, there was a lot of suffering.

My country, Iraq, has been in the midst of war since 1980, so for thirty-six years. Our Syrian brethren have lived in war for five years and have suffered a lot. But in Iraq, we lived through a kind of suffering that no one has ever lived before. When I was eight years old, I remember the war with Iran in 1991. Iraq invaded Kuwait, and then there was a big war against Iraq. There was an economic blockade and we suffered a lot. Thanks to Allah, in spite of the suffering, I completed my education and I worked hard. Our only wish was for Iraq to be stable and to live in peace, just like any other country living in peace.

We fled our country to find peace and we came here. We were welcomed and we found peace, and thanks to Allah, the citizens helped us a lot. They're helping us as much as they can, are teaching us the language, and have given us a place to stay. But this doesn't mean that we're not suffering. I got engaged three years ago and my fiancée is in Canada. I don't know when I'll get to see her. I dream about being with my fiancée and having kids and a house. I've only seen her once in the past three years. She came to visit me when I was still in Turkey. Now I'm waiting for her to come and visit for two or three months, and then we'll be married.

My brother also came here with me. He and I are mentally exhausted. I have an appointment with a psychiatrist because of my bad psychological state. I stayed in my room for almost a month, not going anywhere except to the bathroom. I don't talk to anyone, and I feel more comfortable alone. I don't like to socialize because there's pressure to engage in conversation. My brother and I get psychologically tired. We need stability and peace. My brother's wife has had to go to the hospital in Iraq frequently because she has deep vein thrombosis. My brother cries a lot and drinks alcohol now. In Iraq, he didn't touch alcohol, but now he's in a very bad state.

As for me, my mind is always with my parents and other family members. My father and sister are still in Iraq, where there are many bombings. Every month there are thousands of casualties because of bombings. In Iraq we don't know who the enemy is. Walking, sitting, or talking to a friend, we don't know when or where a car bombing will occur. We've suffered from bombings in Iraq for a long time; they're our biggest threat. Every time we hear the news, we hold our breath, fearing that one of our loved ones has been lost. Every morning we wake up not knowing if our parents are alive or dead. When I hear my father's voice in my mind, I can't bear it.

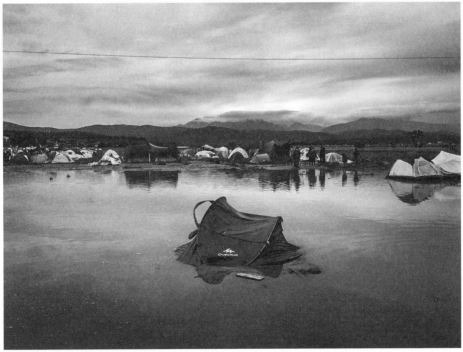

Makeshift Camp, Idomeni, Greece, 2016

MOHAMMED AL-SAMARAEI

069

Mohammad, *Refugee*
Berlin, Germany, 2016-06-06

I'm Mohammad from Syria, of Kurdish origin. I have small children. I had to take them and leave the country so nothing bad would happen to them. We went to Turkey and suffered so much on the way. We worked there for three years and saved some money. We heard that in Germany they were welcoming and helping Syrian people and giving them homes. Reaching Germany was like reaching heaven. We met a smuggler who took $5,000 from us, but he only took us as far as Greece. We encountered some dangerous situations along the way, but thankfully we arrived safely in Greece.

We continued our journey from there, passing through seven to eight countries. For twelve difficult days, we faced hunger and were near death, and then we arrived in Germany. When we first arrived, I felt that it wasn't a nice country because there was a German officer speaking to us in German. We couldn't understand what he was saying, but it seemed as if he was attacking us. A child, about a year old, was crying, and he said, "Put your hand on his mouth and shut him up." But he was just a little kid, how could he know? The officer raised his voice and kept yelling at us, in spite of the fact that we couldn't understand what he was saying. It was then that I knew we weren't welcome in Germany.

Our fingerprints were taken and then we were supposed to come here to Berlin. They took us to a field to live in for three months. We felt that we'd rather be suffering in Syria and not in this situation. They set us up in tents in a sports hall along with other people, and they served us inedible food. Nothing was good. We suffered there for three months.

After three months, we had a problem and they expelled us. We wanted to make coffee in this little heater. They said that it wasn't allowed, and they kicked us out with a written document. We went to the social welfare office and they brought all eight of us to this prison. Whoever sees this living space can see that it's a prison. When we arrived in Germany, they asked me if my family was big. They said they would give us two rooms instead of one, or an entire house. What house? I wish I'd stayed in the war instead of suffering humiliation here.

I tried so hard to return to Syria. I went to the social welfare office three times, but they said, "You're Syrian. We can't help you or send you back. You have to go back at your own risk and expense." I had 10,000 lira, around 3,000 euros, and had to spend it all to arrive here. I don't want to be here anymore. At least I'd like to return to Turkey. The Syrian is honored in Turkey. I never felt that I was an intruder or a stranger while there. But here in Germany, not even the sleeping places are adequate. It's very humiliating. The food is terrible. They put bracelets on your wrist and make you feel like you're suffering from something. Very few people here like foreigners. Let any German and his wife and kids live here for just one day. If someone would help me, I would immediately return to Syria. I'm ready to go back and die in the war.

We escaped from our country because of war. We left assuming that Germany helps people. Is this what help is? In Lebanon there was war and the Lebanese came to us. The Iraqis also came to us. Our government didn't help them, but we as a nation opened our homes to them. We shared our food and homes with them.

I travel on the subway here in Germany. The last time I was traveling, I was sitting across from a young German adult who stuck out his tongue at me. I was surprised. Then he started speaking German, raising his voice and insulting me. My wife has also encountered some troubles in the social welfare office. There was an Arabic employee there who said to her, "You shut up. Keep your mouth shut." What is this? We came here to get help, and the Germans humiliate us and insult us.

My wife and I both think about suicide sometimes. I brought my family from the war to safety, to give them a good living here and not to live like this; this is a prison. I told them at the social welfare office that my family has eight members. I don't ask for much—just an extra room. If my wife wants to change her clothes in the room, it doesn't make sense if there's a strange man in the room. They said, "We have no space." If there's no space, why are the Germans still receiving all these people? I want to ask the German government, "If you have no place for us, why are you letting us in? Close the borders and don't welcome anyone then."

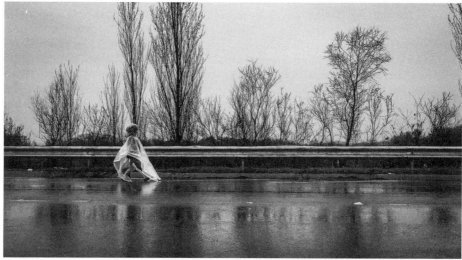

Near Idomeni, Greece, 2016

070

Sukriye Cetin, *Refugee*
Yüksekova, Turkey, 2016-06-10

sc My name is Sukriye Cetin and I'm fifty-six years old.

Our life before the war was good. We lived in a rented house for seventeen years. My children were small. My husband has two wives: the younger one has eight children and I have ten children, five sons and five daughters. My son Mehmet Tekin did his military service in the Turkish army. After he completed his military service in one and a half years, he came here. After one year he was arrested and sentenced to five and a half years in prison. When he got out of prison, he came to stay with us for about a year, and then he said, "Mom, I'd like to move out." I said, "Good luck with it."

So he rented a house. We said, "We just built this house," but our son wanted to live in a rented house. Just two months later, he was denounced [by the Turkish authorities] and went underground. After that, he didn't come home anymore. Two months later, Turkish forces set a trap for him and a bomb exploded under his feet. He and a very young friend of his, both around eighteen years old, shattered into pieces.

After we built this house, our younger son moved in. But the police didn't leave him in peace either. Every night they were moving around the house. We didn't know who they were; were they MIT [Turkish National Intelligence] or spies? We were living upstairs and we moved downstairs when the situation got worse. It was winter and the war had almost started. There were barricades in all the streets.

When the war broke out, all the people moved out. Some carried their stuff while others just locked their doors and left their homes. They spread all around. Some went to İzmir, some went to Van, and some to Istanbul. As the war broke out, they told us to leave our homes, so we took our children and went to Colemêrg [also known as Hakkâri].

Some of our children went to Van and others to Mersin. We left here as well, and after we arrived in Colemêrg, the war began. The intelligence officers, agents, and people, armed by the government, shelled our houses by collaborating with the Turkish government, the AKP [Justice and Development Party]. They bombarded our houses.

We can't accept these things. It's enough. We as mothers sue for peace. Let there be brotherhood. Let there be no war. Let all people in the world deal with this issue. Let America, Europe, and Ankara discuss the Kurdish problem. They're bombarding Kurdish cities—Cizre, Silopi, Şırnak, Sur, Kerboran—all of them are under bombardment. We want to make peace. Our children were killed and injured. Our houses were set on fire. They didn't leave anything for us. There were no beds, no dishes, and all our housewares were burned. Some of them were stolen.

They shelled and burned our houses. They have to rebuild them. We'll sue for our damages and for what they did to us. And we'll never leave our land and property. Even if they kill all of us, we won't leave our land and we won't move out. We'll live on whatever they reduced to ash. Let the president and ministers of Turkey and Kurdish members of parliament sign a brotherhood agreement. Let there be peace. It's enough that brothers kill brothers. We can no longer stand this. All our people went somewhere else. Some of us are in Mersin. We didn't even have a blanket to sleep on.

See our persecution. I have a request. I'd like to send my kindest regards to the honorable Kurdish people, and especially those Kurds who are resisting and all mothers whose children were martyred, who were guerrillas, who were arrested. I would like to send my kindest regards to all of them.

AW Could you tell us what happened during the war?

SC The streets were bombarded. When they set up barricades in the first days of March, people left their homes. Only a few people remained in Yüksekova. Then we were told that the authorities would announce the curfew and that everyone was free to decide whether to stay or to leave. After the curfew, only a few stayed. We left as well in the beginning of March.

After we left the city, the war broke out. When we were here, the fighting wasn't as strong, but after we left, the government shelled our houses with heavy weapons. Some people didn't leave the city and their houses were shelled.

So we request: Stop this war. Stop brothers being killed by brothers. We expect that the families of soldiers and policemen will also say, "Stop this war. It's enough." Let there be peace. Whatever they do to us, we won't give up our land. Kurdistan is here. We want our rights, to be known as Kurdish. That's all we want.

AW How did you feel when you returned and saw your house?

SC When I returned, I saw that everything was burned. Our home had been set on fire, and my son's home as well. My neighbors' homes were destroyed. My heart bled when I saw them. I lost consciousness. It tore my heart out. Wherever I looked there was a house burned, ruined.

We don't want this persecution. All these people are poor and desperate. Our neighbor right there is so poor, he has nothing. When he moved out of Silopi, he didn't even get a blanket. He was struck with paralysis, and a couple of days ago, he came to sit on these ashes. His heart bled. He left and didn't come back again. There was nothing he could do with this ash.

We don't want a life like that. Let there be no more war. The blood of our children is still on the rooftops. We can't live with all this pain anymore. Stop the agents, stop the intelligence officers, stop the government-backed forces; let them remain at home. People armed by the government kill their brothers as demanded by the Turkish government. They should also stay at home and say "enough" to the killing of their brothers.

AW How were your children during the war? Were they scared?

SC For sure, our children were terrified. Even now they suffer severe trauma. They can't sleep well. They're startled all night just because of the wind. They lived under bombardment. When refugees came back home and heard a sound like a boom, they were scared. It's our life, if we can say it is a life. We live in these ruins. There's no water, no electricity, no food. It's enough.

AW What are your expectations for your future?

SC In this situation, we can't expect anything good because there's nothing good. There's no job, no life for us. In the past it was good; we were living somehow. Then the war broke out. This war changed everything. People who came back here can't even find a house to host their children. They could've searched our houses. We only have housewares and food. If they found something, they could carry out their procedures. If not, why did they destroy our houses? There are no windows, no doors, no beds—nothing is left. They didn't leave us a life. To carry out genocide on us is better than this life, which is full of persecution.

AW Could you tell us about your son? How did you know that he was killed? How long did you wait for his funeral?

SC One day he came here, in this house, with his friend. They stayed until dinner. After we ate, he said, "Mom, I'll go home." I said, "It was a great pleasure to have you here; be safe." After he left, we knew that he wasn't going to his house, because he was wanted by the police. We didn't hear from him anymore. The date and time he was killed is written here: "He was martyred on September 28, 2012, at 11:45 p.m." He remained in Malatya for seventy-four days for an autopsy. We buried him on December 12, 2012.

It was about 12:15. We heard the boom, but we didn't know where the bomb had exploded. Everyone went out to see what had happened, and we followed the crowd. I saw that people went down, so we followed them. Then I saw a dead body. It was blown to pieces, with only the side of the chest left. But I remembered the clothes. Then I recognized my son Mehmet. It was a disaster. I lost consciousness. My son was gone—just like that. He was at home that night and then he left. I saw him and his friend martyred. We don't know how it happened or who did it.

AW Where did you bury him?

SC [Pointing] There's a graveyard right over there, behind that block. I can show you. People asked why we wanted to bury him there. His father said, "He was made a martyr here, so we will bury him here." After we buried him there, other people who were martyred were buried there too. So that part of the graveyard was divided between martyrs and other people who died. During this war, the AKP government destroyed the graveyard on purpose. All the graves were blown to pieces.

AW During this war, your home was burned and your son was killed. Do you have a message for the world?

sc I want my orphaned grandchild to come back here in good health. We want our children to return home. We just want our rights: to be known as Kurds and to speak in our mother language. We don't want the mothers of police to cry. We don't want the mothers of soldiers to cry. We don't want the mothers of guerrillas to cry. We have a bond of brotherhood between us. We're all Muslim. We don't want Kurdish cities to be bombarded. It's a sin. People are still stuck in their basements in Cizre, in Silopi. Children, the elderly, and women are all stuck there. Many cities of Kurdistan are under bombardment. People are hungry and homeless. God doesn't accept that people should flee and live somewhere else without food and shelter. It's our request to God. We request them to put down all their weapons: soldier, policeman, and guerrilla. Let there be peace between Kurdish and Turkish people.

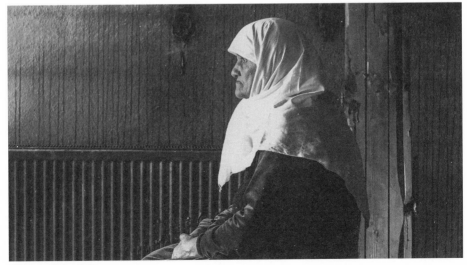

Yüksekova, Turkey, 2016

071

Hamid Sidig, *Afghan Ambassador to Germany*
Berlin, Germany, 2016-06-28

AW We'd like to talk to you about the situation of the Afghan refugees in Germany and about those returning to Afghanistan.

HS Many Afghans, specifically young Afghans, are coming to Europe and other countries. The main reason for this refugee crisis is security. The security in Afghanistan has deteriorated. Refugees aren't leaving Afghanistan because of poverty, unemployment, or because they don't want to stay in their own country. The neighboring countries are harboring and training terrorists. They have their madrasas on their own soil, and they're giving weapons to the terrorists, sending them to us. It's time to address the real problem of Afghanistan. Afghanistan is just a country with a population of twenty-five million. It's not a huge country, but it's a rich country. We should give our government the opportunity to rebuild this land.

Everybody knows the real problem. The international community knows. Why are they closing their eyes and doing nothing? If I talk to the young Afghans coming to our chancellor's department without any identification cards, all of them say the same thing: "I'm coming here because of security, because security has deteriorated." Why? Because of our neighboring countries. Which neighboring country? I think we have to talk directly with Pakistan. Pakistan is the country from which insurgents come to Afghanistan. They're destabilizing our country, and our government isn't able to rebuild because of these insurgents. If the international community wants to help Afghanistan, maybe it's time to hold a conference on Afghanistan, to convince our neighbor to leave Afghanistan alone.

AW Do you think the international community hasn't done enough for the refugees who fled Afghanistan?

HS The international community did a lot to help us. We're very thankful to the international community for its contributions and assistance, even for helping the Afghan refugees. But my point is that the international community should put political pressure on those countries that are sending us these insurgents. The entire region is unstable. If you think about it, even China is unstable. Its western border, the Xinjiang border, isn't stable. Where are the training camps of those people who are entering our countries? In our neighbors' land. China and India have the same problem we have here. We have to convince the countries who are training terrorists and then sending them elsewhere to leave us alone, so our regions can develop positively.

I understand the German government and the German people. This situation causes enormous pressure. Despite my enormous respect for and gratitude to the US and Canada, they're far away. All the pressure is on Europe. The US accepted around 4,000 to 5,000 refugees in this whole crisis, but there are millions of refugees in Europe. We should understand the European perspective. If the international community wants to solve this problem, they should have a conference and recommend problem-solving solutions for taking in the refugees, or

they should bring peace to the refugees' countries so that the refugees can return to and rebuild their countries.

AW The problem has to be addressed at its source. Could you speak about the Afghan refugees in Germany and why they often choose to go back to Afghanistan?

HS About 99 percent of the information reaching Afghan youths is false. They are told that if they come to Germany, everything is waiting for them: jobs, education, homes, and so on. But this isn't the case. Every country has their own system. If they come to Germany, they should be registered; if they're registered, they should wait for their interviews. The young people from Afghanistan are getting bored waiting, and then they're getting depressed and sick. Some of them have the patience to wait and some don't. I spoke with many of them and I encouraged them to go home. In the past six or seven months, we've had around 3,300 people who voluntarily registered to go back to Afghanistan. We helped them and gave them the laissez-passer [pass or permit] papers so that they could peacefully return of their own will.

AW Do you have any contact with people who go back?

HS Yes, of course. One time, 125 Afghans took a chartered flight to Afghanistan. I went from Berlin to Frankfurt to talk to them. I was at the Frankfurt airport until the last minute, talking to them and encouraging them to go back to Afghanistan. We need these young people. After all this struggle with a new government, this is the new first and second generations. They've been to school. Many of them speak very good English. We need these young people in Afghanistan.

But, unfortunately, I return to my point that they come here because of the lack of security. Our neighbors should understand and realize the difficulties in their neighboring countries. When peace and prosperity come to Afghanistan, the neighboring countries also benefit. We don't wish anything bad for our neighbors. But it's painful for me, as an Afghan politician, to see so many young Afghans suffering in Iran and Pakistan, and those who are unhappy in Europe too. We should find a solution for a peaceful Afghanistan so that they can go home and rebuild their country.

AW Realistically, how do you think that's going to happen?

HS Unfortunately, in the past four decades Afghanistan hasn't been a peaceful country. I was in Afghanistan for the past fourteen years, and I witnessed a very bad situation. I traveled twenty times with high-level delegations to our neighboring country [Pakistan], and I witnessed all their promises. In the end, nothing was delivered. This is why we ask the international community to convince our neighbor to leave this country alone. Give us a chance to recover from all the bad things we've experienced in the past four decades. We never get the chance. We should give this right to these young people so that they can find a peaceful spot and build their own lives. We aren't even in the position to use our own resources. Afghanistan is a rich country, but outside investors aren't coming to invest in Afghanistan because of the lack of security. The international community and diplomats can't take their families to Afghanistan because of security issues.

AW What advice would you give to young refugees who choose to go back to their home countries?

HS First, my advice to them is to not leave their homeland. Second, if they're already outside of the country, they should try to pursue their education, so that if they return home one day, they'll have something to share with their country. They should learn the language and get some kind of education or employment—for example, as a mechanic, engineer, or technician—so that they can help their homeland when they return. I'd tell them to study and not lose sight of their goals—and don't just hang around.

AW You became the ambassador to Germany in 2014, two years ago. What were your main challenges in those two years?

HS Afghanistan is, unfortunately, a land of problems, and not problems that we created for ourselves. Our neighbors created the problems for us in the name of religion. But it has nothing to do with religion. Nowhere in Islam will you hear that you should kill innocent people and commit suicide. Even the mosques and the schools aren't safe now. Just recently, a bomb exploded in a mosque during Friday prayers and killed even the imam of the mosque. This phenomenon under the name of religion has nothing to do with religion. Those people who are doing this don't understand anything about religion. They know that in our language, what they're doing is "haram," forbidden; you're not allowed to do what they're doing. These people should be cut off from support. Without support from neighboring countries, no insurgent could survive in Afghanistan. You know what happened when the Red Army attacked Afghanistan. Even the past British wars with Afghans didn't achieve anything. The other countries should leave Afghans alone. We're a peaceful nation. We want to live in prosperity and friendship, and have good relations with all our neighbors.

In 2001, when I first traveled from Rome with the former king [Mohammed Zahir Shah] to Afghanistan, Kabul was like Berlin after the Second World War. Now look at Kabul—it's rebuilt again. Afghans weren't originally extremist. Look at the life of Afghan women in the 1960s and 1970s, and even in the 1940s and 1920s. I'm sure that the young generation of Afghanistan will be able to rebuild their country. I'm absolutely positive about this.

072

Mohammed and Hasmira, Refugees
Bangkok, Thailand, 2016-07-03

M My name is Mohammed Jubair and I'm from Buthidaung, Myanmar. Our life there was difficult, and we didn't have enough food to survive. Our lands were confiscated by local Buddhists in Rakhine State. We couldn't work or leave our villages. We heard people were being killed and burned in other villages.

We couldn't survive, so we left Myanmar for Thailand. From Buthidaung, we went to Sittwe, then to Yangon, and then to Mae Sot, where we entered Thailand.

H My name is Hasmira. I came here first. In Myanmar, we couldn't breed chickens or ducks, as the soldiers would take them all. If we complained, they'd come into our houses and beat us. My brothers couldn't even bring bamboo from the forest to sell for rice, because the Rakhine would rob them.

People were fleeing because they were being slaughtered by the Rakhine Buddhist people. We fled on a boat—I jumped into the river to board it. We suffered for one and a half months on the boat. The traffickers gave women only one meal a day. The men didn't get food, and if they fought back, they were beaten and thrown off the boat. When we landed, the traffickers kept and then raped two of the women.

From the boat, we were brought to a forest, where we spent ten to fifteen days with traffickers. There was a lot of suffering. The traffickers threw some people into the river. Some were half dead and some had head wounds. I saw all this. There were about twenty to forty women. The traffickers didn't pay attention to me because I was smaller and younger, but they raped other women. They gave us some rice but no water for six days. We all thought we were going to die and we cried.

Then the traffickers brought us by boat to a jungle, where we also suffered hardship. After prayer time I didn't go close to the men. I saw some approaching women, but I didn't see rapes. They only searched the women's bags and took things. Small children cried for their mothers.

Mohammed's father helped release me from the traffickers by borrowing money from others. After all this hardship, life is a little better here in Thailand. I didn't know where my siblings, parents, and relatives were. Now I've heard that my elderly parents are sick. I can't see them; I can only talk to them on the phone. They said life is very hard. They don't have enough to eat, and the Rakhine are killing people. They don't have anywhere to go.

M I left Myanmar and had to bribe traffickers to get here. The Rohingya aren't legally allowed to leave Sittwe. The traffickers sent me from Mae Sot to Yangon by bus. I had to pay a lot of money to do this. Then my wife and I got married in Thailand and had a child. When she had the baby, the hospital charged us a lot of money. At that time I could work, and I borrowed some money. Now, nobody will lend me money as I can't work.

We live in a small house near the Londa Puri mosque with our baby. We struggle with the rent. If we can't pay it, the owner tells us to get out. He's not patient. The rent was due three days ago, and he fined us three days for each day we were late.

We've been here for one and a half years and still have many troubles and difficulties. We can't sell anything or do any other business, so we can't eat. If we go out and seek work, we're arrested. The police say, "This isn't your country," and "You can't sell things without permission." If we do, we're arrested and fined. In the past I could work a little, save money, buy rice, and pay rent, so we managed, but now we don't know whether to spend our money on rent or food. How can I pay rent if I can't work? I want to work and give my child an education.

We were suffering in Myanmar and we're still vulnerable here. We'd like to leave. We'd like to go to America or Australia; we heard a lot of Rohingya are going there now and getting help and benefits. If we could work there, we could survive and send our children to school. Our own lives have passed, but we think about our children's future.

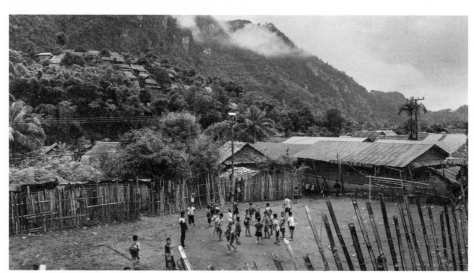

Mae La Camp, Tak Province, Thailand, 2016

073

Maung Kyaw Nu, *Activist*
Bangkok, Thailand, 2016-07-03

MKN My name is Maung Kyaw Nu. I'm the chairperson and elected president of the organization Burmese Rohingya Association in Thailand, also known as BRAT. BRAT was formed in 2004 by some Rohingya activists in Thailand. I joined in 2011 and was twice elected as president by the Rohingya living in Thailand. In 2012, the ethnic cleansing in Arakan started. Many people were injured and killed, many houses burned, and many people were uprooted. Nearly 200,000 Rohingya were internally displaced. They lost their belongings and their lands.

We worked tirelessly, day and night, organizing press to highlight our suffering. Arakan and other parts of Myanmar, before its independence, were our homeland. It was taken by the Burmese in 1784, more than 200 years ago. Many refugees started leaving the area, as they feared for their lives. They left on boats, and now they're known as the boat people. Many of them arrived in southern Thailand. At that time, in 2013, about 1,000 people got thrown into the sea. There were many more undocumented cases.

As soon as these people arrived in Thailand, some organized trafficking groups tried to exploit them. Many people were kept in a secret camp in the jungle. Thanks to our requests, the Thai government finally raided the camps. Many people ran away and some were arrested. Then the Thai government kept them in immigration detention centers in the south. In 2004 there were thirteen of these centers in Sadao, Ko Phangan, and many other areas. Some women and children were kept in the care center under the Shinawatra administration. Some lost husbands, fathers, and mothers.

Here I got some practical knowledge and experience. I saw children under sixteen who have never been in school. I asked them why and they said because of the two-child policy in their country. I was impressed by what I saw, and this compelled me to work for these people. At that time, my daughter was studying architecture at the best university, Asunción University. My son went to the Sarasas Ektra School, a very expensive and good bilingual school. I was very busy and didn't have time to take care of them. I thought I might become the target of the Burmese government because I was opposing it.

My sense is that it's a terrorist government. Due to them we became the boat people, and our people were trafficked. That's why we take our work so seriously. We're highlighting the news on the ground because Thailand and Myanmar are very near, and we've got very good contacts. But in Myanmar, for example, they don't have good access for sharing information. We do, and that's why we've demonstrated and spoken out more than fifty times since 2012. We went to the Burmese embassy and the United Nations, not just to protest but also to highlight certain things and ask the governments to intercede for us, especially the European Union and the US, because they have a very good relationship with the United Nations Security Council [UNSC].

From the very beginning, the case should've been solved by the UNSC, because this is a kind of genocide. Scholars and universities say this is genocide. We lost many lives, and it's government policy to eliminate the names of the Rohingya. They try to eliminate our population with the two-child policy. If you have more than two, they can't be included in the family list, and the children can't go to school.

It was very hard when the genocide started. They killed and uprooted people. My family had a big plot in Sittwe, in the municipality, just near the high school and middle school of Nasipara. The land belonged to my grandmother. Her name was Alimuneesa and she was from Maungdaw. My father was also a big landowner, and according to some documents, we knew that my grandmother's land was also seized by the government. Around sixty or seventy houses were seized and two or three people were killed. My children and I are lucky because our family is still alive.

Some Buddhists just give their lives over to the monks, because they forget that everything they do should be for religion. I don't want to compare myself to this, but my life is working for these people. I had a stroke, but by God's grace I'm still okay. My colleagues are there now, and some friends are going around the world; it's our duty to highlight that the Rohingya are the only community in Myanmar with nothing. It's very interesting. Previously, we used to have armed struggle, something like a revolutionary group. But nowadays the Rohingya don't fight against the government; they don't have any revolutionary committee or armed groups. We want to talk peacefully to the president. Even though we're one of the most persecuted people in the world, we raise awareness through our pens and our speech. We want friends, students, professors, and civilian societies around the world to know about our suffering and stop such acts for all the oppressed people around the world.

AW Could you briefly tell us about Rohingya history and culture and why they're so discriminated against today?

MKN Rohingya are actually the bona fide citizens of Myanmar. They have political ties to India. In Burmese we're known as the Rakhine. We're sons of the soil. A few days ago some students interviewed me, and I told them, "Please go to Arakan and see the architecture and archaeology there. We have graves and a mosque built by Shah Shuja, the son of Shah Jahan from India. One of his sons fled to Arakan for political asylum and built this mosque. Before that, there was Sandhi Khan, one of the generals, who came to Arakan. And then another general, Narameikhla, came from Bengal to help the Arakan restore power there; he was uprooted by the Burmese government. You understand from this history and architecture how long we have been there."

But we were there even before that. Muslims came to Arakan as early as the eighth century, some Arabs and Persians; they also went to Malaysia, Thailand, and Indonesia. We didn't have many problems with the Buddhists. The problem arose in Myanmar when the military generals seized power in 1962. We lost our democracy at the army's hands, and since then the country has been ruled by the army. When Aung Sang Suu Kyi was elected, she couldn't become the president.

The military would like to govern the country by dividing it, and we have become their political tools.

During these fifteen years of military rule, the government didn't have any philosophy or constitution. Then they organized some Buddhist monks, Bengali-Rakhine from Bangladesh. They donated money to them and built monasteries for them. These Buddhist monks were known as Ma Ba Tha. But real Buddhism isn't like that. This group, some racist Rakhines, and the government joined together against the Rohingya. They'd like to uproot the Rohingya, delete our name, and make us second-class slaves in the country, especially because in these past few years, the military saw that people voted for the civilians. They don't like Aung San Suu Kyi, and she also has a problem with the military. They create these conflicts to preserve their power.

AW Could you tell us something about the situation of the Rohingya in Thailand today?

MKN We had three main waves of Rohingya arrivals in Thailand. The first was economic refugees who crossed the land borders as long as twenty years ago. The second wave started seven to ten years ago, when the Rohingya began to perceive discrimination on our national religion cards (ID cards), which marked us as foreigners. Many young Rohingya were sneaking into Thailand over the land border or going to Bangladesh and then maybe India. The third wave was in 2012 when they started their ethnic cleansing, and many fled to Thailand by boats on the river. There are around 7,000 to 10,000 Rohingya, but the Thai government doesn't offer us any legal status or documents. Ninety-nine percent of our people don't have any documents in Thailand, so some of them went to Malaysia, because in Malaysia at least they could get some kind of refugee document from UNHCR.

I personally don't wish to get resettled in another country. Most of my colleagues here have already been resettled with US, Canadian, or Australian passports. I always want to go back to my country, to do something for my people and all the suffering people around the world. I love to live near my country, even though I'm now very sick and need good medication. I once met Dr. Mahathir, the ex–prime minister of Malaysia, and I asked him to help Rohingya refugees enroll as students in Malaysia. Malaysia doesn't offer education to refugees. I showed him two kids who came here by boat without any documents. I said, "Please help these students; they deserve to learn something." Last year, the two brothers got permission to study in Thailand. Thais don't discriminate in education, which is very good. We're also very free here as Thais don't discriminate against us so much. They love foreigners and are very sympathetic toward them. They love the Rohingya because they know of our suffering.

In general, however, we're in a compromising position. Thailand doesn't recognize the Refugee Convention of 1951 but it has done a lot for the refugees; there are 150,000 refugees here from Myanmar, Vietnam, Laos, and Cambodia. Our problem is that as Rohingya, we're not recognized by our own country, so we don't have any documents. All the Burmese minorities, including the Rohingya, love Aung San Suu Kyi. That's why she won last year's election with a landslide victory. But then she changed completely. Just before she came to Thailand last

week, she met with John Kerry from the US and said it was better not to use the word "Rohingya," as it was too controversial. And she said the same thing to Yanghee Lee, the UN Special Rapporteur on Myanmar, that it was better to use the "Muslim from Rakhine State," or "Islamic people from Rakhine State," or something like that.

There are many conspiracies by the so-called civilian government in Myanmar to strip us of our property and our rights. China is the second-largest investor in Myanmar. They would like to make another Singapore in my country, a big international free port or something like that. They have geopolitical interests. We oppose it. We'll fight for this to our last drop of blood.

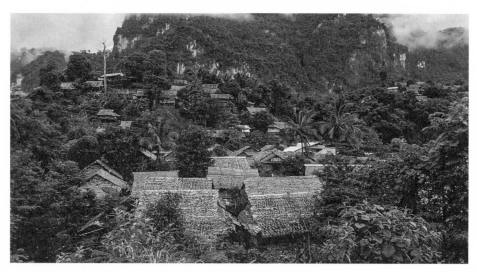

Mae La Camp, Tak Province, Thailand, 2016

074

Sally Thompson, Thailand Burma Border Consortium
Bangkok, Thailand, 2016-07-04

ST I'm the executive director of the Thailand Burma Border Consortium. We were established in 1984 to respond to refugees fleeing from Burma into Thailand. We've grown from being a volunteer organization of one to a staff of a hundred today. We're responsible for food and shelter in the nine camps on the Thailand-Myanmar border. Around 250,000 refugees have come into the camps and sought protection in Thailand. Of those about 100,000 have been resettled in third countries, predominantly in the US. Around 100,000 remain in the camps at the moment. As for the other 50,000, some of them went back in the mid-1990s under the bilateral cease-fire agreement. Others have found their own ways to migrate to Thailand, and yet others have found their own informal or formal ways to go on to third countries. It's been thirty years of refugees in the camps, and that's a long time. Nobody should live confined to a camp for thirty years. We hope they may return home in the near future.

AW Please tell us about the history and demographics of the refugees currently in the camps.

ST The refugees in the nine camps come from southeast Myanmar, from a range of ethnic groups from the Kayah, Kayin, and Mon states, and the Tanintharyi region. That was their homeland for decades. They fled as the Burmese army was launching offensives against them because they were close to the border, taking control of the resources in those areas. Over the years refugees were forced to come to Thailand. The majority, well over 80 percent, of refugees in the camps are Karen. But there are a range of ethnic groups: Karen, Mon, Isan, and some Burmese. We have Buddhists, Animists, Christians, and Muslims all living together in the camps.

AW What are the conditions in the camps?

ST They're very basic, like a very large, overcrowded village. People live in houses made with bamboo on very small plots. In terms of access to services, the camps themselves are pretty urban. The refugees have access to health care and education up to high school; the options beyond high school are very limited. Our organization provides access to food, and refugees have also established small shops and markets in the camps. As the years have gone by, the camps have become more crowded. People came, fleeing from the Burmese army. So in the camp sections around the original villages, you largely have people who came as family units. There are very few single people, and generally people are from rural, subsistence, and agricultural backgrounds. They don't have access to large areas of land in the camp.

The policy here in Thailand is that refugees are confined within the camps. Refugees are technically not allowed to go outside and find work. That limits what they can do. One thing has always been very clear: whenever you meet refugees, they say, "I have hands, I can work." They don't like being dependent on aid. But they've been confined to the camps over the years, and so their dependency has

built up. If I reflect on the last thirty years, I think all refugees and all the migrant communities want to work, to provide food for themselves. Here in Thailand the camps are by and large community-managed. They're responsible for implementing services, and they have their own committees for health workers and teachers. They take care of goods, storage, social welfare, administration, and justice, which over the years has worked toward aligning with both Thai national law and international law. There's some work available through these avenues, but refugees aren't earning a sustainable income from this. They essentially get a small stipend for their day-to-day responsibilities.

AW What's the exact legal status of refugees in these camps today?

ST Their exact status is that of illegal migrants whose deportation has been temporarily suspended. They're considered de facto refugees while they're in the camp. If they go outside the camp, they're considered illegal migrants and are subject to arrest, detention, and sometimes deportation. This happens a lot, because people are going out, looking for ways to help their families, trying to find work, and they get arrested.

There are a lot of differences between refugees and migrants here. Refugees fled as a result of a conflict. They lost everything, so they don't have a home to go back to. Most of the migrant communities in Thailand still have a home. In fact, if you look in the southeast of Myanmar today, it's estimated that more than 70 percent of households there have someone working in Thailand to support the family back home. This is a fairly strong indicator for the current lack of jobs and opportunities in southeastern Myanmar.

There's a registration process for migrants in Thailand, but it's lengthy and costly, with different phases of documentation. But it does mean that people working in the migrant communities can be verified by the government and register as migrant workers. The government has gradually formalized procedures to bring everyone into one system, but there are hundreds of thousands who aren't registered. I guess the life of a migrant worker is very much subject to exploitation, whereas when refugees are in camps, there are a lot more watchdogs and organizations with mandates for protection who are in contact with those communities on the day-to-day level. By contrast, the migrant community is by and large dependent on informal labor organizations, so it's a very tough world, particularly for young men and women. They're exploited and abused and they put themselves at risk by being out there. As the system gets more regulated, it's moving in the right direction, but it's got a long way to go.

AW Recently there's been a lot of media coverage about illegal trafficking.

ST Most people are at risk of trafficking during the journey. The camps have been established for a long time, so people there are more aware of the risks, and they have stronger networks and more information. People are really at risk when they cross borders and get into a kind of no-man's-land and they're not sure where they're going. That's really the time when they're most at risk of trafficking. It's a very complex, dangerous world that is controlled by many different agents on different levels.

AW Do you share the opinion that many migrants and refugees who are coming across the border don't have good information, and that's why they often end up in the hands of traffickers?

ST I think the information is available. But I also think people are driven by hope and chance; maybe it's a chance to do better, to have a life, to try something different. So regardless of the amount of information you get, no matter how negative it is, if you think there's a possibility that you can do better, then people are willing to take that risk. It's about being aware about what may or may not happen to you.

But it's very difficult, particularly in areas of internal displacement in Burma, where you're more likely to see people at risk of trafficking, because the families have nothing—no opportunities, no livelihoods, no homes. Then they become more desperate to look for other means, so perhaps they take risks they might not have taken in a more stable community. Trafficking in the region is getting worse. The potential for exploitation is increasing; it's such a resource for each area in Asia. So there's a lot of temptation for companies to get rich quick. The border with Myanmar is 2,000 kilometers long, and it's one of the poorest borders. How do you really ensure regulations for people who are crossing borders? It's a huge issue and it needs more policies and more regulations, but they've also got to be implemented. People have to see that there's recourse to justice, otherwise they'll lose faith in the system. It's very difficult for the migrant workers in Thailand to access justice.

AW Could you comment on the media's role in informing the international community about refugees in Asia? There's been so much attention on the refugees going to Europe, and the Rohingya have been in the media a lot. By contrast, the Karen refugees haven't really received much media attention.

ST The difficulty is that the refugee situation is not news. It's been a low-intensity conflict for decades in the southeast of Myanmar, and it doesn't make news anymore. The media is always looking for something new to hook on to, to raise interest. Now there's more international attention once again, since the National League for Democracy had a landslide victory with the bilateral cease-fires and sweeping reforms happening in Myanmar. Does the media bring about policy change? I think the media is a catalyst; in itself it doesn't bring change, but it is a catalyst that supports change. There must be the will from a critical mass to make it happen, and the media can really reinforce it. In the case of the Rohingya, it's not enough just to have the shocking footage of people at sea on boats that collapse. There's so much going on in the world that tomorrow something else overtakes it, unless there's that body of people working on the issue on the ground, so that we can use the media exposure to support them.

AW Your organization has been on the ground for decades, so you're familiar with the challenges of dealing with all these different factors. What would you say are the main challenges that the Thai Burma Border Consortium has faced in its work?

ST In a refugee situation, the challenges are unknown. When the camps opened, Thai authorities originally thought it would be a few months and everyone would go

back home. And then a few years went by and now thirty years have gone by. I think the main challenge is really that people are confined to a camp. They want to provide for themselves. People can contribute to communities; they don't want to sit here and do nothing. They fled from their countries, but they're not allowed to be a part of the host country. So they're living in this very artificial world. How do you make sure that people don't become dependent, and how do you give access to dignity, self-worth, and value, when what they really want to do is being dictated by the international community?

At the moment we've had cease-fire negotiations, and we've got a very nascent peace process happening in Myanmar. The refugees want to be part of these discussions. That's one of the key challenges: how to keep people who have fled engaged in the decisions about that country. For those people who crossed to Thailand, they wanted to go back. It's their heart, their home, their identity, their culture. And one of the challenges is how you let people hold on to that and yet respect, integrate, and adapt to the host country and its culture. They've got to adapt to all these different policies coming at them from the international community. Everyone has a different way of looking at what they want to do with the money that's being invested there. So, in a way, the refugees are some of the most creative and flexible people, because they just have to deal with everything that's thrown at them and make the best of it.

AW Obviously, there are people who have been born in these camps and people who are very young and that's mostly what they know. How would you say their identity has changed with this experience?

ST Half of the population is under nineteen, and 30 percent were born here in Thailand. What's home for them? When they talk about return, for them it's not return, it's about going "home" for the first time. They get their identity through their parents, so a lot of what they relate to is maybe a world that existed twenty years ago, not what's there now. It's very difficult for young people to really go back to rural subsistence and agricultural communities when they've been living in urban settings. It'll be a real challenge for them. If they're going to look for work, it's more likely that they'll look for work in Thailand, because they have an understanding of how local Thai culture functions. Whereas if they go back to Myanmar and look for work, they're going to have to migrate farther into the towns and big cities to seek work, because there's nothing in the rural areas. That's perhaps more foreign to them than it would be to work in the migrant community here in Thailand.

These are enormous challenges for the families. Will they hold together? Will you see generations starting to split? Will the old generations who fled still want to go back home? Maybe they'll go back home, and maybe the young working popula-tion will perhaps go back and then return to Thailand, leaving their children with their grandparents, so you'll see split families as the working people try to find ways to support their families once they go back. Yet, in the camps, they lived for many years with their families in these very tight, close-knit communities. When they go back, they're going to have to integrate into communities where people will stay behind with people who lived through the conflict.

There's a sense among the people who stay behind that the refugees have it good. They see that they have protection, access to education, and skills, so there's a concern that when the refugees return, they'll retake their land and jobs. Particularly young people who go back want more; they're used to more than rural subsistence agriculture. They're used to the market being at the gate, not a day's walk away. They're used to the school being within walking distance, not three hours' walk or more. So we need to manage the gap in expectations so that when communities do come together, they can work together and integrate. The refugees built up a whole range of community organizations, and some of those organizations will no longer exist when they go back. But what they have is a lot of skills from many years of taking responsibility for their own people.

I think the international community has ridiculous expectations in terms of time frames. When we think of things like the cease-fire and now the elections, we think everybody can go back in two years for a happy ending, but peace processes take years. We're looking at people who fled from conflicts, who lost everything. Every family suffered atrocities, so the mistrust and suspicions run deeply. It takes years for people to build trust; it's made up of very small steps, and maybe it'll take a lifetime. So it's going to be very difficult whenever the return happens. They're going to have to start from basically nothing and rebuild their lives.

AW In your opinion, what's a best-case or realistic scenario for the refugees and internally displaced people in Thailand in five to ten years?

ST I really hope it won't be in ten years. The big issue for refugees is that the military is still in their villages. They want to see real changes on the ground at the local level, not something signed above in Naypyidaw. I think they really want to see troop withdrawal and demarcation of land mines; much of the southeast is very heavily mined.

075

Muhammad Noor, Rohingya Vision
Kuala Lumpur, Malaysia, 2016-07-07

MN My name is Muhammad Noor and I'm a Rohingya. My parents were born in Myanmar and both migrated to Bangladesh, then to Pakistan, then to Saudi Arabia. I was born and raised in Saudi Arabia. I did my primary education in Saudi Arabia and Pakistan, and later on in Malaysia, where I graduated. We started to work in the field of social work for Rohingya issues. Being Rohingyan, we see a lot of day-to-day atrocities in Myanmar and countries where Rohingya live in exile, like Thailand, Malaysia, Saudi Arabia, and Bangladesh.

I wrote a book called *The Exodus* in 2000, which was just published in Malaysia and then in the US. It's about being a child refugee and how I was raised and educated like any citizen in their country. Along the way we did many social projects, like how to start a radio station for the Rohingya. Being a persecuted minority, we have no privileges in many ways. We can't say if even 1 percent of the entire Rohingya are educated, because we were persecuted by Myanmar for seventy to eighty years, and so we were dispersed all over the world. A little bit of demographic information: We have more than 400,000 people living in registered and unregistered camps in Bangladesh. We have people in India, Saudi Arabia, Thailand, Malaysia, and other countries. There are about 1.5 million back in Burma. Most of them don't have access to the Internet, media, or radio stations. We face a lot of difficulties on a day-to-day basis. I'm summarizing these things so that you understand the very important need to magnify this issue and give a voice to these voiceless people.

I'm the founder of Rohingya Vision, which was started in Saudi Arabia in 2000 with the aim of reuniting the regional natives and promoting our case to unite the Rohingya. Though Rohingya Vision's website and weekly reports are in English, most of the Rohingya don't know how to read and write in English, so the only way to reach the target audience is through multimedia, videos, and audio in their language. That's why Rohingya Vision started with the vision of uniting Rohingya and publicizing their cause on the international stage.

In June 2012 a huge massacre occurred and countless people died. Many people were tortured and imprisoned, many left the country, and many drowned in the sea. The Burmese military government not only tortured Rohingya and committed atrocities, but instead of telling the truth, they lied to the international community, saying that the Rohingya had started the fight. Also, as usual, the international media blamed Muslims and labeled them as bad people, so the truth hasn't been revealed.

Rohingya Vision's aim is to tell the other side of the story. Until today, Myanmar claims that only 180 people have died since 2012, while the UN recorded more than 130,000 displaced in one city, Sittwe, in Arakan. Just imagine the rest. There's no access to the media for international investigation teams. No one can go there. We have people all over Arakan and use every possible technology—telephone calls, WeChat, WhatsApp, and so on—to collect this information and

put it up on a website where we post daily news in the Rohingya and Burmese languages. We also put up an English documentary to inform the entire world, and this is why we have quite a good track record. Every day we have more than 50,000 online visitors on YouTube, not counting people who download videos and distribute them through Facebook and other social networks. We're the only source where people can get information in a language they can understand, so a lot of people brand us as the BBC or the CNN of the Rohingya. We get the information out in very simple words, and we also participate in many events to share our evidence. That's our vision. At the moment we operate in quite a few places around the world: Saudi Arabia, Malaysia, Pakistan, and Myanmar, and soon we'll be broadcasting in Europe and other countries as well.

AW How do you operate in Myanmar?

MN We have people in almost all the cities and in all the main camps where Rohingya are concentrated. Some work full-time with us, some part-time, and some are volunteers.

AW How many staff do you have?

MN We have a full staff of about twelve people in Malaysia. In Saudi Arabia we have around six, in Pakistan we have six or seven, and in Myanmar we have many people as well, including volunteers. We can easily say we're a team of sixty to seventy people, including the volunteers.

AW Could you tell us a little bit more about Rohingya culture? What really makes it special and unique?

MN I'd like to give you a brief history of the Rohingya. Myanmar claims that the Rohingya are foreigners who just came from Bangladesh. Bangladesh didn't exist even fifty years ago. My father is sixty years old—older than Bangladesh. My grandfather's and great-grandfather's graves are there. Rohingya have existed in this land not for decades but for centuries. We ruled that country in 1800, then the Burmese government, under King Bodawpaya, captured Arakan. Arakan isn't even a Burmese word. It's actually a Persian and Arabic word that came from the Rokn in Islam, meaning "the pillar." The Burmese changed the name from Arakan to Rakhine. History says that Arakan was ruled by two nations, one of which was Rohingya. Once we were a country, but now we're assimilated into the state of Burma and are seen as the minority of another country. We became stateless in our own state and ancestors' land. We don't have papers or documents. Many of our women have died in childbirth. Many people can't leave their own country, and those who do leave can't come back. All these instances are huge disasters, not only for the Rohingya but for all of humanity. We call this a civilized world, but no one is taking proper action to safeguard the Rohingya people at all.

Rohingya culture and language speaks about our history and civilization, its complexity and beauty. In the field of social relationships, we have a word for each relative and each relationship, like "Mummy" is the mother's brother's wife and "Nana" is the mother's father. We have specific words for relationships

because they mean a lot to us, and there are words for friendships. We also have very specific games that are played in a specific area, place, and time [such as during the seasons in the year]. There's Boli Kéla—it's something like Japanese sumo wrestling, but it's only played within the Rohingya community. And then we have food that we cook specifically during Eid, such as a dish made of rice and a special type of fried chicken that we give to our son-in-law. When a daughter is pregnant, the mother sends her a special food; when a person is sick, we send a special food. We have many words for the seasons and we have different wedding traditions. When the bride and groom's families arrive, they must sit in a special area with a very specific setting that befits their dignity.

All this indicates that the Rohingya were a civilized nation with traditions, culture, and history. Today most of it has been destroyed, and everybody thinks that we're just a bunch of poor, ugly people floating around in Southeast Asia. But we were very civilized and cultured, with traditions and historical attachment to our land. Every state, every town, every village is named with our language; they're not even named in the Burmese or English languages because they were ruled by the Rohingya people. All of that indicates that we're deeply rooted in our land. That land is our land, and we'll keep struggling and fighting for it until we get back our rights.

AW Why do you think that the Burmese government is persecuting the Rohingya so intensively?

MN There are a few reasons. First, Arakan is geographically located in a very strategic position on the Indian Ocean, which is an access route to the international community, especially for trade. Second, Arakan has huge resources of gas, gemstones, a thick type of Oudh [agarwood], and other natural resources. Third, international players, especially the US and China, have huge interests in Arakan. China has been facing problems with sea routes for many decades because they always buy petrol. It has one of the largest populations and consumer markets in the world, so it needs a lot of petrol and other resources. Most of the petrol is in the Middle East—Iran, Saudi Arabia, Qatar, and all those countries—so they buy it there, and then it travels from all these countries to the Indian Ocean, and then it has to pass through the states of Malacca, Singapore, the Philippines, and all the way to Hong Kong. As all of us know, China and the US are major players in the South China Sea. There are a lot of American ships in Singapore and the Philippines.

China has been facing this problem for a very long time. They found that we represented the most direct route for oil coming from the Gulf straight to Arakan. Today China operates one of the major pipelines in Arakan. There are two pipelines, one being the Shwe gas pipeline [linking the Shwe gas field in the Andaman Sea with China via Myanmar]. They've been operating it for the last ten years. They buy the oil, which they dump in Arakan and pump all the way to China. By doing this, they've saved money and especially time, and they've saved the trouble of passing the American presence in the Philippines. Arakan is more important to China than Myanmar itself. Unfortunately, it's our land. Now it's a fight between two superpowers over resources.

A final reason concerns the Rohingya being Muslim. Buddhists have this sentiment about the Buddha's land reaching from Afghanistan to Indonesia. Now Indonesia has become one of the largest Muslim countries and Afghanistan has also become one of the extreme Muslim countries. So they have another project that is called the "Buddhanization" project, driving out the Muslims. One can always find some Muslim or Christian terrorist, but unfortunately the media made the Muslims look very prominent. In fact, they're tiny minorities. So a tiny minority of Buddhists are taking advantage of Buddhism to spoil the name of other Buddhists by conducting this operation of driving out the Muslims.

Thus we have four major problems: resources, geography, politics, and religious tension. Myanmar found a solution: "This is a huge land, and these people are a small minority of 1.5 million. If we can drive them out, this entire land will be totally ours: resources, control, and access to the Indian Ocean." Nobody cares about humanity; it's all about resources. Look at the results today: more than two million Rohingya are dispersed all over the world, some in Indonesia, some rotting in the sea, some dead, some buried, some imprisoned in Indonesia and in India. Many people say it's about religious tension, but I'd like to say that it's not about religious tension—the tension is over resources and power, as in any other country.

AW Can you tell us something about the other Southeast Asian nations' response to the Rohingya crisis in 2012?

MN Many actors are involved in this problem. We have a neighboring country, Bangladesh, that mostly doesn't favor us in terms of political asylum, protecting the refugees, and so on. And then, when we talk about Southeast Asian countries, you have Thailand, Malaysia, Indonesia, Singapore, all those countries. The Asian states have a sort of pact among themselves, like a noninterference policy by which they don't interfere in one another's affairs. Noninterference is fine, if it's in your own country, but these people have already flooded many neighboring countries. There are many people in Thailand, Indonesia, Malaysia, and, to a certain extent, Singapore. But now there's no question of noninterference. These people use their own resources in terms of economy and power. Some countries have raised their voices, but to me, they have to raise their voices even more. Why? Because this is a matter of humanity. If your country goes into war and chaos, your economy won't run; you'll become a failed state. All your industrial resources are going to be depleted. Economic interest is one aspect, but when it comes to humanity, all humans, regardless of religion and race, should stand together. What's happening today to me might happen to you tomorrow. Today, this Southeast Asian nation is a very harmonious society. Now Buddhists are launching attacks in Myanmar; tomorrow this might happen in Thailand, and then in Indonesia. People spark anger among themselves. The regional Arakan problem can spread beyond Arakan. Everyone, especially governments, must take this very seriously before it gets out of control.

AW Could you tell us something about the legal status of the Rohingya in Southeast Asian countries and other countries?

MN The question of legality isn't even relevant for those who don't have a state. The Rohingya don't carry any sort of documentation. They don't have ID cards or

passports. Whatever little they might have mostly comes from other countries. When it comes to legal issues, no country legally recognizes the Rohingya, especially Southeast Asian countries. They're giving some sort of humanitarian assistance but not a proper legal framework. Humanitarian assistance means that you can stay and work here, but not legally. If you work illegally, you can't claim anything. Many of the workers are being exploited. Employers bring them in and they work for a year for a salary of two to three months, but they can't go to the police or file a complaint. No country has taken any initiative whatsoever at a governmental level to put the Rohingya in a legal framework where they can earn a living, where their children can go to school, and their wives and daughters can go to hospital. But, of course, Malaysia, Indonesia, and Thailand are very sympathetic. Malay and Thai people are very generous. All the public support makes life a little bit better for the Rohingya, but it could be better with governmental support.

AW Can you tell us about the types of occupations that Rohingya have in most countries today?

MN In Malaysia, most of the people work as laborers: gardening, grass cutting, fertilization, plumbing, electricity, and stuff like that. They can't graduate to higher levels, because again we return to the problem of documentation. If you want to get a proper job, you need some sort of qualification. In some other countries, like Thailand, they work in the fishing industry, and in Indonesia they are buying and selling a few things. In India it's also mostly day labor. But if you go a little bit farther to the Middle Eastern countries like Dubai and Saudi Arabia, those people have been there for almost four or five decades, so they're more established. Every year there are Islamic festivals like Ramadan and the Hajj, so we see some businessmen and shop owners buying and selling goods and bringing goods from different countries. We also see a little bit of trade in Malaysia. But the numbers are low. There are also very small numbers of people working in IT, software and website development, and, very rarely, in engineering.

AW A lot of attention has been on the Middle East with the Syrian crisis. Do you think this has detracted from the Rohingya?

MN We Rohingya also believe that the Syrian refugee crisis is really huge. It's a human disaster; more than six to seven million people are displaced across the globe. We understand they're in a major disaster. Our hearts are also with the people in Palestine, because the Palestinians have a very long history of suffering atrocities. But the media plays a very important role, and sometimes it's very biased against us, especially some of the Western media. Maybe this is for economic reasons; it might not benefit their advertising or something like this. But to be fair, I believe we have enough exposure on social media.

But that's only the media part. When it comes to the international community, of course there are a lot of countries who are really serious about us, especially countries like Turkey, Saudi Arabia, Qatar, from the Muslim part of the world, and also Malaysia and Indonesia. Countries like the UK and the US are also really pushing our case, as is the United Nations. Yanghee Kim and Tomás Quintana

have been working on this case for a very long time. But now, talking to the Burmese government and just seeing the situation worsen without any reaction has proved that the international community has failed to protect us. They've failed to give us support and they've failed to convince the Burmese government to return the rights that were taken from us. So when you ask if the international community is doing anything, I think they're doing something but not enough. They could've done more, but they might not have because the economic interests aren't there. And by the time they wake up, maybe our race will have vanished. The Burmese will have succeeded in their project of genocide. They're already in the last phase of it.

AW How do you see the future of the Rohingya across the world in the next few years?

MN The future is extremely dark. The situation is getting worse and worse. Many people, including the international community, hoped that when Aung San Suu Kyi came to power she might fix this problem, but now she's actually carrying out this project of extermination and genocide. The previous government tortured us in every possible way, but they didn't force us to take another name. My name is Muhammad Noor. Who are you to tell me to change my name? I have the universal human right to name myself, and I'm not going to change it because you don't like it. So when you ask about the future, I think it's extremely dark. We're like the sunset of this century: everybody is just watching and we're slowly dying, one by one. The last government used a slow genocide, and this lady in the new government is implementing a soft genocide. But this disaster can be stopped; it's not a natural disaster but a catastrophe made by humans. Somebody must stop it. Otherwise this nation will take its last breath from the earth.

AW Could you talk a little bit about your personal work and your capacity as CEO of Rohingya Vision?

MN Rohingya Vision is very controversial in terms of our struggle with Myanmar, and it'll always remain so as long as Myanmar continues to lie to the world about the Rohingya. We keep getting attacked at an organizational level. As a recent example, we posted a document called the Rule of Law against Aung San Suu Kyi on Facebook. Facebook deleted this video and warned us that our account could be blocked because such videos created controversy in Myanmar. So even Facebook is on their side; I don't know why. There are also a lot of hackers who are trying to attack our website on a daily basis. They tried to block our YouTube account many times because we have a lot of subscribers. We face a lot of challenges.

We also have some internal issues. In every community we always find people who exploit or misuse photos of the Rohingya people. They also personally attack us, saying that we're creating conflict within the community. And, of course, we have a funding problem because all of us are highly qualified people working for our vision. If our staff went to any other place to work as an anchorperson or a cameraman, they might get paid more, but we accept the lowest pay just to get our voices heard by the people. We face a lot of difficulties in terms of finance and logistics on a personal level, especially when trying to raise our kids and paying for our own expenses. But at least we have a roof under which we can sit down,

and if we can't eat three times a day, we can eat one time. There are many people who are sleeping on the road without a roof, and there are many people who don't have even one meal in a week. That's the spirit that makes us go further.

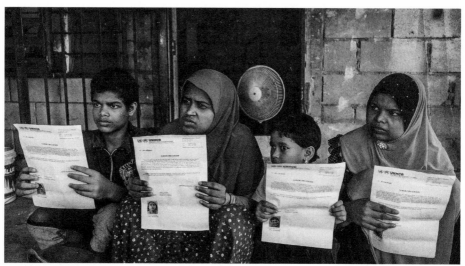

Kuala Lumpur, Malaysia, 2016

076

Rafik Ustaz, Activist
Kuala Lumpur, Malaysia, 2016-07-08

My name is Rafik Siah Bin Mohd Ismail and I'm forty-one years old. I came here with my mother, father, and five siblings from Rakhine State, Myanmar, about thirty-five years ago. We've lived in Malaysia for more than thirty-six years and attended a regular school, not the national or government schools.

I'm not sure why my family had to leave Myanmar. I was young and didn't understand what had happened. When I asked my family why we needed to leave our home, they told me we couldn't stay any longer because my grandfather had been killed. My parents' family was killed by the military junta of Myanmar, and our villages were burned in 1982 and 1983.

I still remember when my father was forced to take our family in a van and leave. He drove for about an hour. During that journey, shots were fired at us. Luckily, nothing happened, and we made it safely onto a boat.

From Sittwe we headed to Thailand. When we reached Thailand, my father's associates were waiting for us. My father was in the gemstones business. He had an associate in Bangkok who saved us and offered us refuge in his house for six months. It made my father very sad to think about his many family members who hadn't escaped and who had been murdered. During those six months, we couldn't do many things. My father had a discussion with his Thai friend, and he suggested that we should go to Malaysia if we wanted to be safer.

Through his Thai friend, my father took us all to Malaysia via the Kelantan-Thailand border known as Golok. We then reached Pasir Mas, Kelantan, and stayed there for about a year. My father started to look for a job. He had had his own business and wasn't used to working for someone, so he started to sell children's toys and slowly learned that business. As he was traveling to sell his wares, he made it to the state of Pahang. It seemed like a better place for our family to reside, and that's how we came to live in Temerloh in Pahang.

We stayed at Temerloh and Mentakab for about ten years and then moved back to Kuantan. I received informal education, not from the national or religious schools. My mother taught me religious studies, and later I continued to study with religious teachers until I could read and write. Unfortunately, my other four siblings weren't educated. They managed to read and write only a little. My father found teachers to homeschool them.

When I was in my twenties, I gained a lot of knowledge, praise be to God. I started to learn why we had to leave our motherland, and I got more information from my friends. I came to Kuala Lumpur with my father, and he introduced me to fellow refugees. I witnessed the many hardships they had to endure. I wanted to help them, and that was how I started teaching them a bit of Malay so that they could move more easily from one place to another. I didn't have money to give, but I could share my knowledge.

I then stopped teaching for quite a while because I had to take care of my own family. There were eleven of us altogether. Six of my siblings were born in Malaysia. The first child born in Malaysia is now thirty years old.

In 2000, I noticed that the problem was becoming worse. The killing continued in Myanmar. I decided to help the Rohingya in Malaysia by advising them on how to communicate with the locals and how to behave so that refugees wouldn't have a bad image, and how to avoid problems in this country where we're seeking refuge.

In 2012, the "boat people" started to come via the South China Sea. I had sleepless nights thinking about it. I watched and read news about it almost every day. I couldn't bear to see the situation and decided to act. Later I found out that the refugees were everywhere in the world.

The Rohingya were dispersed due to the cruelty of the Myanmar junta, which is heartless and inhumane. It was cruel to the Rohingya in many ways. The Rohingya weren't free to practice religion or access culture, education, or health care, and they didn't have freedom of movement. New rules were introduced to oppress them every day.

What was it that made the junta so angry with the Rohingya? According to history, the Rohingya have lived in Myanmar for 1,500 years. We were considered indigenous people. The junta government labeled the Rohingya as "Bengali," but I disagree with this term. How is it possible for the Rohingya to change to Bengali ethnicity? We have our own language, culture, cuisine, and philosophy. How is it possible for us to become Bengali? Even the Bengalis don't accept the Rohingyas as Bengali.

I'm also upset about another issue. Rohingyas and Buddhist Hmong never had any problems with each other. Up to today, there was no record of us rebelling against the government. The conflict has been going on for seventy-five years. We have no guerrillas or weapons, and we don't resort to violent methods to defend ourselves because we believe we have rights.

All of our ancestors' lands have been taken away. Our livestock has been confiscated. There's nothing left. Thousands of Rohingya women were raped and killed. Even then, we remained loyal and didn't want to resort to violence because the Rohingya are pious Muslims. Islam doesn't allow us to use violence. Our belief is still strong. We don't have anything else.

We are as human as others. We have feelings. We feel the need for peace.

Today, Rohingya refugees are in Malaysia, Thailand, Indonesia, and a few other countries. After we left Myanmar and took refuge in Asian countries, the situation didn't change. People are still fleeing the country. We're thankful to Asian countries such as Malaysia, Indonesia, and Thailand, as we know it's not easy to provide temporary refuge for refugees.

In Malaysia, the Rohingya have faced a few problems, such as not having legal status, which would enable us to work. However, we still manage to find illegal

work. UNHCR needs to help us more by providing us with the UNHCR card. We can't afford to pay for health care, which is quite expensive. Pregnant women can't afford proper medical care. We also hope the authorities will provide education to Rohingya children here in Malaysia.

There isn't a lot of information in the media about refugees or about the Rohingya in Malaysia. I've read a few articles about crimes, where they found some traffickers and rapists, and discovered mass graves in Malaysia last year. We also heard that there might be a camp. These human trafficking victims came from Sittwe. Many of them were detained by traffickers in the illegal border camp in Thailand, and many died there. These traffickers are very cruel. Women were raped, including pregnant women. Young boys were also raped. These refugees were confined without any food. Many children died violently. Before that, there were many who died in the boats. I was informed that as many as 13,000 people left the country recently but only half survived. Some died at sea and some in the camp.

According to Malaysian law, they should be detained and brought to court, jailed for two months, then taken to a temporary immigration depot to await the next legal step. The Malaysian government and UNHCR work together in this process to separate the legal from the illegal, but this usually requires time. Not much happens until they're released from the camp.

Generally, Malaysians are very kind and tolerant. Based on my experience of being here for more than thirty years, there aren't many issues. We're from different races and there are minor misunderstandings, but that's not unusual. We have a different language and culture but we share the same religion. We're able to use the same mosque for praying and listening to sermons.

I think Malaysians would always appreciate more information, such as "Who is a refugee and what does he or she need?" They aren't sure which people are refugees and which people are illegal immigrants. We need to find ways to deliver this information.

Rohingya ethnic refugees didn't get the chance to be educated. They don't really have many skills. They'll take any kind of odd jobs in order to support their family. Most of them reside in the Klang Valley region, near Selayang, Gombak, Jalan Ipoh, Sentul, and Rawang. Those farther away live in Klang, Puchong, Serdang, Ampang, Cheras, and so on. These are based on recommendations by family members and friends. In terms of jobs, some are now working with municipal councils as contract workers. Some are with Selayang and Kuala Lumpur municipal councils as general workers or street sweepers. I was informed that nearly 20 percent of Rohingya refugees are working there. About 10 percent of them work in the construction field and 25 percent work as laborers.

If the Rohingya are given the choice of considering their children's future—based on possibilities for education, citizenship, and recognition—I'd say they'd choose to go to Europe. Their relatives and contacts in Europe tell them that it would be best to stay in Europe for long-term benefits. We definitely want to return to Myanmar, but we'll be killed if we do. We'll be betrayed and labeled as the country's traitors.

I urge the international community to take the Rohingya issue seriously and help solve the Rohingya migrant crisis. We've been oppressed for a long time now. We're among the most oppressed ethnicities of the world. Sometimes we feel so ashamed by the labels people put on us: stateless citizens, boat people, drifters.

I'm worried about what will become of the future generation. What will happen to those in Malaysia, Indonesia, and Thailand in ten or twenty years? Without strong support from international communities, I believe we'll still be drifters, and the Rohingya will disappear. I'm also concerned about the many generations of Rohingya who haven't had the chance to be educated. Nearly 85 percent of Rohingya can't read or write. When they reach other Asian countries, they can't communicate in English and therefore aren't able to explain their tragedy to the world. This is one reason why the world hasn't received accurate information about the Rohingya issue.

UNHCR asks refugees to email and fax them. I don't see how UNHCR can request this when it's readily apparent that most Rohingya are illiterate. In our home country, we were intentionally denied the right to be educated; we were purposefully left illiterate. This is why being denied the opportunity to be educated in our host country is especially painful. Still, we patiently wait for peace.

One thing that makes us very sad is the NLD Party (National League for Democracy) led by Aung San Suu Kyi, fondly known as Aunty Suu. The NLD was supported by a majority of Myanmar citizens. We put all our trust in her. We helped with funding when they first started. All of us Muslims supported her, hoping to see political changes. Sadly, since the new NLD government took over, there hasn't been much difference.

We hoped that all ethnicities in Myanmar could enjoy equal rights, rights to citizenship, and the right to be educated. We're native citizens. It was very upsetting when Aung San Suu Kyi didn't try to find solutions or even agree that the Rohingya be called Rohingya. This oppression is appalling. We aren't extremist. If every year, every five years, or every ten years our villages are attacked, we're forced to defend ourselves. We were called names by those who refuse peace. We've never asked for independence from Arakan or to be separated from Myanmar. We still want to be under the government of Myanmar, one that can protect all ethnicities with equal rights. We don't ask for more than that.

The Rohingya hadn't left the country for many years. We lived peacefully and were able to survive. We could plant our own food. We didn't want to leave. If safety and peace were promised in Rakhine today, I strongly believe that all Rohingya would return. We would build up the state and the country.

Although there don't seem to be major conflicts now, the killing continues on a daily basis. The army oppresses Rohingya from the remaining villages. Those remaining in Myanmar have no money, as they're no longer allowed to work or plant food. Their livestock has been confiscated. Refugees overseas work really hard to earn money, saving every penny so they can send money back home when possible. However, once the junta finds out, they go to the families' houses and confiscate the money. The junta catches and detains family members

without trial. This happens every day. Whenever a family member falls sick, they can't reach the hospital but have to ride in a small boat across the river to Bangladesh to seek treatment, which is expensive.

It's not easy for Rohingya to communicate, because phones aren't easy to get. There are a few brave ones who are willing to keep their phones. When there are international calls, these people go among the houses to deliver messages from their families. Money is delivered through an agency in Bangladesh that contacts the refugee family in Rakhine. It charges double fees.

There's very little email or Internet access. Of course, now we have WhatsApp. International media isn't allowed to operate freely in Myanmar. There are some who work in UNHCR in Arakan who know how to use the Internet, WhatsApp, WeChat, and so on, and they help those who need to contact their families abroad.

My organization gathers information and advises refugees. The first step is to advise them to be on their best behavior; it can be quite challenging to manage those who aren't educated. For example, you can ask them to queue and stand in line today, but they may fail to follow the same rule tomorrow. This is just one example among the many small challenges. The bigger challenge is how to get funds for health care and medicine, because many of them have health problems. Some have chronic health problems that require operations that can cost up to 20,000 to 30,000 Malaysian ringgit. We feel defeated when we're forced to face this type of issue. We don't know how to solve it, especially when urgent operations are needed.

I'm also a bit depressed when others slander us. When we do something good for others, people sometimes get jealous and try to tarnish our reputation. I've learned to ignore all this bad talk, although I've had many sleepless nights.

I hope the international community will put pressure on the government of Myanmar to accept resolutions. For example, UNHCR could give rights of citizenship to the Rohingya. We don't have leaders to represent us internationally. Most of us aren't highly educated and able to speak and stand before the international community.

077

Majuna and Noor, Refugees
Kuala Lumpur, Malaysia, 2016-07-09

My name is Majuna and my husband is Noor Muhammed. We have five children: here are Shajeda, Abdul Amin, and Mohammed Yunus. We had troubles in Myanmar. We're from a village in Buthidaung. The majority of villagers were Muslims. There was conflict with a Rakhine village. The soldiers mistreated us, forced us to work, and extorted our money. If we couldn't work, they took the girls and women, dragged them into the forests, raped them, and then killed them. We came here because we couldn't live safely anymore.

We came here by boat. There were about 250 or 300 people on our boat and about 800 people on the other boats. It was hard to get water and rice. If we spoke, the traffickers would beat us. We had many troubles. There was no oil, and they made a hole in the bottom of the boat and destroyed it. The captain and other traffickers left us. About 250 people died on the boat. People were starving. They drank saltwater, and some got sick and died.

We arrived in Langkawi, Malaysia, after about three months. When we landed, immigration officials arrested us. They kept us in the camp for three days and then brought us to Blantik camp. It was a two-story brick building in the jungle with a concrete floor and four rooms. The fences were made of steel and the roof was iron. Men and women stayed in separate parts. It was so hot and dirty. There was no fan or facilities. They left six people with us who cooked and took care of the children.

We were there for one and a half years. They gave us two sets of clothes. They burned all our belongings, even our bags, photos, and Burmese ID cards. We heard that foreign countries had donated food for us, but we didn't get any of it. They gave us a bowl of rice, an unwashed fish with scales, and one piece of bread. There were insects in the fish and eggplant, and the rice was overcooked. They gave us water only twice a day, even during Ramadan. We had to keep it in plastic bags, and if the bags leaked, they beat us and threw the bags out.

They kept us under the sun and beat us. The male guards beat the men and the female guards beat the women. Some bled so badly that they couldn't take their clothes off. After the beating the guards poured water on us and brought us out, into the sun, and kept us there until prayer time, around 1:00 or 2:00 in the morning.

It was hard to pray. People were very scared at night, but they didn't say anything.

I was sick in the camp. If we told them several times that we had a fever, they gave us some tablets. If we didn't tell them, the female police beat us. They beat us a lot. We had to bathe once a day and sit as they ordered. If we weren't dressed properly, they'd beat us. They didn't give us any soap or toothpaste. There were about 200 Rohingya women, 60 Rohingya children, 800 Bangladeshi men, and 500 Burmese men in the camp. Two men died in the camp from illness.

The UNHCR came to check up on us after three months. They gave us ID cards and some cash and then we were freed. Immigration officials harassed us. They said that the traffickers had been arrested and imprisoned for one and a half to three years. Six of them are now in prison.

We would like to go to another country, maybe America.

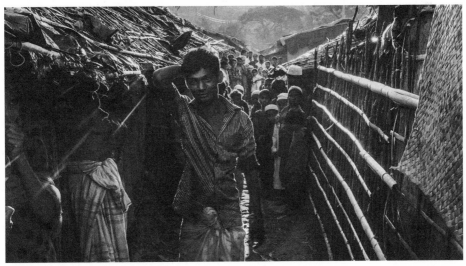

Nayapara Camp, Cox's Bazar, Bangladesh, 2016

078

Hussain M. F. Alkhateeb, Iraqi Ambassador to Germany
Berlin, Germany, 2016-07-29

AW How many Iraqi refugees are there in Europe?

HA I don't have the European figures but only the number that we have in Germany. We have a mix of Iraqis, those with German nationality, others who are waiting for their papers, and the new asylum seekers. In 2015, we had about 122,000 asylum seekers coming from mainly north of Iraq, Mosul, the areas occupied by Daesh. This is the total number that we have from the federal statistics office. But at the same time we have many Iraqis wanting to go back to their country. Since mid-2015 our counselor sections in Berlin and Frankfurt have issued more than 6,000 laissez-passer for Iraqis voluntarily wishing to return to their country. As you know, the Iraqi asylum seekers aren't fleeing from their government but from the terrorists, from Daesh. We're providing all the support we can for these people to return easily to Iraq.

AW What kind of help is given to them specifically?

HA At the beginning they're only seeking the counselor's help for papers enabling them to return to Iraq. We're accepting photocopies or other forms of Iraqi nationality papers, and we're issuing, within hours, temporary passports and laissez-passer for them to return. This is what they're actually asking for at the moment, because the German government is helping by providing air tickets for them to go back to Iraq.

But we, as an embassy, have formed a committee concerned with helping Iraqi asylum seekers. I'm head of this committee and I have two counselors and other members with me. We've visited Iraqi refugees in several places where they reside. Although my people have been prevented from going to these places because they say that legally it's not allowed, I've informed the German ministry that I'm sending my diplomats, my people, to these areas to visit the asylum seekers and see if we could provide any help. We're willing to do that, and I didn't get any objection from the German ministry, so we're informing our German friends of our activities. We've even volunteered to supply clothes and other supplies. Sometimes I send women to talk to female asylum seekers. We also cooperate with NGOs to provide support.

AW There are many child refugees. How do you identify them with papers?

HA We don't reject anyone who comes to the embassy and says that he's Iraqi. He came here seeking asylum and he wants to go back. We welcome him, find many possible ways to support him, and won't send anyone back unless they voluntarily wish to return. We don't support forcible repatriation. We said that frankly to our German colleagues: the policy of the Iraqi parliament is that we don't cooperate with any forced repatriation.

AW So could I announce tomorrow that I'm an Iraqi refugee and be returned to Iraq?

HA No, you'd need to provide us with some sort of ID, even a copy. We have two or three Iraqi IDs. For registration, you'd need the national certificate, plus a certificate to that certificate, plus the Iraqi passport. You'd need to provide us with one of these three and a paper from the German authorities informing us that you're an Iraqi asylum seeker and you were just there at that camp or center. These are the papers we need. If you provide us with these papers, we're obliged to make it easier for you to go back to Iraq. But don't worry, we'll also check on your identity after giving you these papers.

AW So it's also about looking at me and thinking, *That guy, he's Chinese and not Iraqi.*

HA No, we don't do that. We have some Iraqis married to others from different nationalities. We welcome them in the new Iraq, the new democratic Iraq after 2003. We respect human rights, and our constitution gives a wide range of recognition to Iraqi children of one Iraqi parent. Regardless of whether the father or the mother is Iraqi, the children are considered Iraqis and are supplied with all Iraqi nationality papers.

AW And with asylum seekers, after they've been put through so much difficulty and after some of them paid a lot of money and risked their lives to come here, I assume most of them don't get refugee recognition. What's the strongest reason for them to go back?

HA When this wave of asylum seekers started coming to Europe in 2015, the majority were people genuinely deprived of a normal life by Daesh. There are some others who were tempted by prospects of better lives in Europe, and these people joined the refugees and came to Europe seeking asylum, but after coming to Germany, they found that the situation isn't what they dreamed of. Or they went to other places but it's the same thing. It's not so easy. There are controls; they're checking to see who's a genuine asylum seeker and who's not. This is one reason I think some of them have decided to go back.

Another reason is that the Iraqi security forces and the popular mobilization forces have scored a lot of successes by freeing many areas occupied by Daesh. Recently Fallujah, Al-Qaim, other places near Al-Qaim, and successes like these have encouraged people from these areas to return to their regions. As you know, all of these areas have been liberated from Daesh, starting from the province of Salahuddin, then the province of Anbar. The IDPs [internally displaced persons] have started to go back to their homes. Nearly 90 to 95 percent of the Salahuddin people are back home. Now, we have tens and hundreds of thousands of families going back to Anbar, Ramadi, and Fallujah. So some of these people who came here seeking asylum are going back because their regions have been freed and they can return home.

AW Yesterday or today, Chancellor Merkel spoke about German policy regarding asylum seekers and that she firmly stands by her policy. She said that we can't let fear rule.

HA Did you read my CV?

AW I read it. You're a chemistry scientist, just like Chancellor Merkel.

HA No, I meant the other part of it. I was a political refugee in the Netherlands, which is why this is a subject very close to my heart. For more than twenty years, I was head of the Iraqi human rights organization in the Netherlands, and sometimes I was also consulted by the Dutch justice ministry on refugees and asylum seekers. For three years, I was giving letters of support to refugees and asylum seekers to get their start. I got my recognition as a political refugee after two and a half years of staying in the Netherlands. So this subject is very close to my heart, and I always follow it closely with interest.

AW When were you a refugee?

HA I sought asylum in the Netherlands in 1998. Before that I was a university professor in Libya. I studied in Britain and then I went to Libya, but the situation was a bit difficult for me. At that time Gaddafi was becoming closer to Saddam Hussein, and there was a warning that I should be careful, so I had to leave Libya and seek asylum in the Netherlands.

That was about twenty years ago. In 1989, many of my family members disappeared or were kidnapped. I counted seventeen of my family who had been either executed or disappeared without a trace by Saddam's regime. Some of them were close relatives, some of them distant. I was eighteen years old.

AW You experienced the entire reality. Many people say, "Yes, Saddam was horrible, but not as bad as today's situation." So many people are dying today in the war because of ISIS.

HA Many people are dying, but in Saddam Hussein's time, Iraqis had no freedom. Freedom is your dignity. A human being who's not free can't say anything, can't criticize the government, can't express his feelings in public. He's deprived of his humanity, so regardless of the electricity or security situation, I've lost my humanity. I'm not a human being. I have something missing that's very important and essential.

So I find it really impossible to understand that any person could say that Saddam Hussein wasn't evil. He killed his closest relatives upon the slightest suspicion. Nobody was certain when he went to bed at night that he'd be sleeping beside his wife, by his family, in the morning. At any time, people could come to his home, pick him up, and he would disappear. I could tell you stories of my relatives, of my family. They only refused to be members of the Ba'ath Party and they disappeared. They had nothing to do with politics. They belonged to a certain sect that was considered not very loyal to the regime. So anybody from that sect who wasn't Baathist was a suspect, and for the slightest issue he'd disappear.

Now we have about forty television channels, and I assure you that about thirty of them are criticizing the government daily. We have about one hundred and fifty to two hundred newspapers and news media. Almost all of them criticize the government openly, and nobody is being punished for criticizing the president,

the prime minister, or any official. We have four general elections for parliament and four local elections for local authorities in every province. The province is governed by people elected by the people, themselves the inhabitants of that province.

So this is freedom. At least I'm free to breathe, to say what I want to say, to travel, and to marry whom I want to. These were all restricted in the time of Saddam Hussein, and these are basic rights of human beings. How could anybody say that we're not better than what we were in Saddam Hussein's time? They talk about electricity. My family says that in Baghdad, they had two to three hours of electricity per day. Basra, Amarah, Nasri, they had no electricity at all! So in any case, we're better than the time of Saddam Hussein.

I'm sorry, but this subject touches my heart. I remember when we were in the Netherlands during Saddam Hussein's time, and other Iraqi exiles used to send just fifty dollars to their family to live on for one month. Fifty dollars. Now the minimum income of Iraqis is nearly $400. Life is better. I remember looking at television reports from Iraq before 2003 and seeing that all the cars on the street are at least twenty to twenty-five years old. Now you don't see such old cars in Iraq. People have money and there are more jobs. We certainly have poor people, and we still have to do a lot for our people, but we are much, much better than what we were before.

Now we have our humanity back. Now we can walk with our heads up and say what we want, choose where we stay, choose the country we visit, and choose where to travel and when to travel. These are basic human rights. We're much better off. If we're fighting terrorists, the whole world is fighting terrorists too. Terrorists have attacked Germany in the last few days several times. They've attacked France, the US, Belgium, and many other countries, but we're on the forefront fighting terrorism and its core. It's in Iraq and Syria, and we're proud to do that.

AW Thank you for your statement. You made a strong point about ISIS and terrorism. How long do you think it'll take Iraq to finish the job, to really get rid of ISIS?

HA All Iraqis think that it should be done as soon as possible. Some estimate that we could even do it this year. This is what the allies are now agreeing upon. Before they used to say that the Iraqis were exaggerating when we said we could liberate Mosul by the end of the year. Now they accept that it could happen, but we need to do more after liberating these areas. We need to rebuild these areas, to bring calm, peace, and harmony to the areas that were occupied by Daesh.

The problem isn't only the occupied land. The challenge is to win the hearts of the people of these areas. After 2003, when the change happened in Baghdad, it wasn't to many people's liking. Some people lost interests, some lost jobs, and it was a little bit chaotic at the beginning. But now things are starting to be put in order. We have a national unity government, where all Iraqis take part in the government, in the parliament. As you know we have a Sunni president, a Sunni Arab head of the legislative branch, of the parliament. We have a Shia prime minister, so all are taking part. All sixteen Iraqi provinces have elected their

candidates for the parliament, so they're represented in the parliament, in the Iraqi legislative body. We have a united government, but we need to win the hearts of the people. Daesh was able to steal the hearts of some by claiming they were fighting for the rights of the Sunnis, which they proved by their deeds they were not. To the contrary, look at what happened in the last few days. Iraqi forces approached and reached south of Mosul. At least 20,000 families fled these areas within days, going to the Iraqi security forces, which means that they now believe that the Iraqi government is their protector, not Daesh. This is a huge change from the situation two and a half years ago. We need to build on that, listen to the people, and provide them the necessity of a good human life. Then we'll have harmony and peace in the area. Military victory is the first stage and winning the peace in the area is the second stage.

AW Some argue that ISIS will spread to the West, that we'll see huge terrorist attacks on civilians in Western capitals.

HA I think so. The security forces, the allied countries, and other experts estimate that the terrorism will not end soon. But at least if we break the backbone of terrorism in Iraq and Syria by bringing peace to Syria—which is essential for that purpose—I think in that stage we'll have done our job. We need to continue because there are signs that these terrorists might go back to their old strategies, which they're very good at, by sending their sleeper cells to different countries and committing terrorist deeds.

We also expect that to continue for a while in Iraq and in other countries because, as you know, volunteers from a hundred nations unfortunately have been able to go to Iraq and Syria under our neighbors' closed eyes. These people have already started going back to their countries, some forced and some voluntarily. If they're not taken care of and reeducated, there will always be risk elements in their communities. That means risk in a hundred countries in the world. That's something that's recognized by most nations, and this is why the international coalition supports Iraq and fights terrorism. We're grateful for the support of all nations, but frankly, we need more support and we think they should do much more. We're very happy with what happened in the conference in Washington lately. They've committed billions in support for bringing civility to the liberated areas, and we hope they'll really live up to their commitment and pay what they promised. We need more military support, as we have a financial problem due to the drop in oil prices.

AW I think the international community already owes a great deal to Iraq. Recently they openly announced intelligence that proved that the Iraq War, which caused such vast damage to Iraq, was in fact not necessary. What do you think about that?

HA We're proud to be in the forefront of fighting terrorism, and we're sacrificing more than any other nation in the souls and the blood of our people. Nothing is more precious than the souls and blood of human beings. In Islam, our prophet says, "A drop of blood of a Muslim is more valuable than the Kaaba [shrine at the center of Mecca's holiest site] itself." This is a very strong statement that shows how valuable a human being and human soul is. We've suffered not only by losing our

men and our land but by terrorists targeting our culture, heritage, and history. We've unfortunately not received the support of the entire community to protect these areas, because it was clear that one day when Daesh occupied Mosul, they started demolishing historical mosques and very valuable places.

Nothing is being done to protect areas while sometimes special operations are executed to save the lives of one or two human beings. Of course, this is very important, but it shows that other operations are needed to save these areas. Iraqis are willing to send units to protect these areas, but we don't have the means. When we started this war, we didn't have airplanes or helicopters, so Iraq had to go shopping, even buying used airplanes. We started with used MiGs [aircraft] from the Russians, and now the situation is better. But it shows how desperate our situation was. I think the international community could do much more to help us protect these areas. We're now receiving good support from Germany. I should say that Germany is at the forefront of countries trying to support Iraq and protecting its cultural heritage, because Germans were historically involved in excavation and protecting these areas.

AW Iraq has such a long cultural heritage to be proud of. To what extent has this war destroyed culture in Iraq?

HA It has destroyed part of our historical culture, which is mainly located in the area occupied by Daesh, but as you know, Iraq is full of historical heritage from the top to the bottom, from the Gulf to the Turkish border. All areas were inhabited by human beings for many thousands of years. We lost part of what's in the north, and we can't estimate exactly how much now because we need local inspection. But the news is that the loss is tremendous, and we need the international community to also help us trace artifacts that have been smuggled out of Iraq to be sold on the international market. We know, and our friends and other countries also know, that Daesh and other terrorists are trying to finance their activities by selling artifacts and historical pieces on the market.

AW Thank you very much. I'd like to visit your nation. Is it possible to get a visa to pay a visit?

HA It's certainly possible. You're welcome. We'll be happy to have a person like you in Iraq.

079

Wella Kouyou, UNHCR
Nairobi, Kenya, 2016-08-10

WK My name is Wella Kouyou, I'm the deputy representative of UNHCR Kenya, and we're in the UNHCR Kenya office. I've been here since February 2015 working for UNHCR's refugee operations.

My daily tasks include supporting the representative in managing this office. We have two suboffices in Dadaab and Kakuma. We also have urban refugees. I oversee all sectors in managing operations, financial resources, and whatever is put at our disposal. Currently I'm in discussions with the Kenyan authorities, negotiating with implementation partners and donors, organizing meetings, and making sure that refugee management in Kenya is well improved.

AW This is a very big task. We know Kenya is the nation in Africa with the most refugees. Can you give us a general description of where all those refugees come from?

WK Kenya is a very generous and open country that has been hosting refugees for more than twenty-five years. They've been hosting Somalis, South Sudanese, Ugandans, Rwandans, and Burundians. Some refugees even come from as far away as Asia. Historically, Kenya has been in between unstable neighbors. You don't choose your neighbors, but neighboring countries such as Somalia have been very problematic in terms of security and are producing refugees. People continue coming to Kenya. Kenyan society has been very good, and UNHCR appreciates that they're still willing to open their door to refugees.

AW You look good.

WK I look good?

AW Yes.

WK [Laughs] Thank you.

AW What is your mission here as a UNHCR officer?

WK The primary task for UNHCR is to protect refugees. The first responsibility of protection lies with the host country that accepts the refugees. We also have the side role of ensuring that the 1951 Convention and other protocols and international laws for refugees are respected by those who have signed them. So we're here to make sure that refugees who've been accepted by Kenya have their rights respected, and we assist in building the country's capacity.

AW Could you give a general description of the refugees here? Where are they coming from and how is their condition today?

WK I'd say that refugees' condition in Kenya is very good because we're receiving donor support. We also collaborate with the Kenyan authorities, and we're in

daily discussions with donors, briefing them on what's going on in the refugee camps and those refugees in urban stations. Our responsibility is also to make sure that Kenya has a law that protects the refugees and that those designated to protect the refugees do so. We help them understand what a refugee is, what their rights are, and what their duties are, so we can work together to improve refugees' lives in Kenya.

The majority of refugees in Kenya, about 500,000, come from Somalia. We've started verifying counts so that we get accurate totals. The second-largest population in Kenya is Sudanese or South Sudanese, and the third largest is the Ethiopians. You've been in the camps and you've seen that the majority of refugees are women and children. We're looking at the various groups using the "gender diversity mainstreaming approach," to make sure that refugees' rights are respected, so that they can continue their lives.

A refugee station is temporary. In this country we expect that the condition that made them run away from their countries in the first place will eventually stabilize, like in South Sudan or Somalia, so that they can return. We're looking for durable solutions and they exist. For instance, when the cause of the refugee situation is resolved and things are secure in their country, we discuss with them about returning to their countries of origin. We sign what we call a "repatriation document," and then we speak with the refugees and support them to return and reintegrate peacefully in their country. When that's not possible, we negotiate and explore where opportunities may exist in the asylum country. Looking for durable solutions isn't easy because of the country's existing problems with its own citizens, but at this point, we're looking for resettlement possibilities. We ask other countries how they can assist with burden-sharing, for example, if they would consider taking in some people who can't live in Kenya, so that they can settle there for a new life.

AW Many refugees have been staying here for more than twenty-six years, and some are even third generation. You see kids growing up in the camps. How are they educated and integrated into society? They can't find a job or something to work on or to make some money. Since there has been no future for them for a very long time, how do you think about the situation?

WK As I said at the beginning, the refugees' situation was supposed to be temporary, and a camp was supposed to last for maybe five years. Now it's become very difficult. But we have the view that the humanitarian approach and the development approach start from the beginning of the emergency. The station that you've seen in the camps should not be there. We're looking for what we call an "out of camp policy." It means that we're asking countries to help refugees in some capacity. Refugees are like you and me: they didn't come empty-handed; they have knowledge and skills. They can learn, easily integrate into the local community, and start doing good things.

I'll mention a good example: Five refugees from South Sudan are going to Rio to compete [in the 2016 Olympics]. We're now discussing these types of capacities with development agencies. If they find refugees in the camp that have particular inborn talents, they should settle them in rural areas, where they'll have the

possibility of pursuing opportunities, as these athletes did. We're even looking forward to seeing how the international community and donors can help us in terms of livelihood activities and business opportunities. Somalis, for example, are very good in business. Sudanese are good in pasturing and raising cattle and cultivating crops. Keeping the people in a camp where they just wait for WFP or UNHCR to bring them food isn't the best way to make the most of their talents. We have another program called Kalobeyei in Kakuma, where we integrate new arrivals from South Sudan. Refugees at urban stations are integrating, teaching, running shops, and doing other crafts. Refugees are capable of changing their lives. But, as I said before, refugee life is supposed to be temporary. Having a camp for refugees isn't the best solution.

Because the majority of the refugees are youths, sometimes up to 60 percent, we always ask donors to help us build schools. One of the goals of the UN's Millennium Development Goals is that everyone is entitled to a primary education. We also encourage children to go to secondary school, and we ask for scholarships for tertiary education.

When a refugee has water, food, health care, and building materials for a shelter in the camp, our expenditure on him is about $200 a year in normal situations. We do everything possible, although resources are never enough. We do make sure that refugee children aren't left behind, because they're already disadvantaged by not being in their home country. The best thing we can offer them is education, training, and skills, so that when they return, they can help rebuild their communities and their countries.

AW Is the refugee situation getting worse in the past few years or is it stabilizing? And how would you evaluate international awareness of the situation in Kenya?

WK The numbers of refugees are increasing but resources are decreasing. As you've seen, the European community is much more focused on Syria. We continue receiving donations from countries like the US, Japan, Germany, and so on. We repatriated refugees from South Sudan some years back, but now with the new conflict, they'll come again. Ugandan refugees are still coming to Kenya. We saw more than 1,000 in the last month. This year more than 15,000 Somalis have returned, and we expect more. We asked donors to increase the repatriation funds for those returning to Somalia, because they're returning to a place that they left more than twenty-five years ago. They want to settle and start their lives, so we'd like to give them more grants so that their integration is more sustainable. They can't come back to Kenya because they have no schools, no livelihood, no health care, and no water. We're also checking on security in Somalia and Dadaab.

AW After working in this field for many years, what's the most difficult task in dealing with the situation?

WK Asylum fatigue, which you can start seeing in the countries that are hosting asylum seekers, and also donor fatigue. People can't go back to their countries for security reasons, but there are insufficient resources to care for them. The countries that have received them are also tired because their resources are

depleted. So we're kind of beat down and hopeless when we look at the refugees who are still there. They still have needs. The children need to go to primary and secondary school, and they need scholarships for tertiary education.

Another thing is the suffering that refugees experience during their flight. Women facing violence, children and youth being conscripted for armed forces—this hurts, because a generation is being wasted. Life needs to be rebuilt. UNHCR is trying to call on countries, donors, and other parties involved in the conflict to address what's going on. This is very challenging. It's very disturbing to see people suffering when you lack resources to support them.

AW Do you think the situation will improve?

WK We hope we have the possibility of changing the world into one where there's no violence. But even if there's no violence, we also have climate change. That's making people flee in search of greener pastures. In the future, they'll depend on how world leaders are dealing with their populations.

We have to build humanitarian and development activities together; they shouldn't be separate. From the beginning of the conflict or crisis, both humanitarian and development actors should come together and start thinking, "How can we work together, not only to save lives but also to help them rebuild?" We're still looking after their immediate future, but they shouldn't have to become dependent on donations. Humans are capable of adapting quickly if the potential is there. We're working with UNICEF, the Food and Agricultural Organization, and the Kenya Comprehensive Refugee Program to discuss such issues. We need to explore how we can complement each other, so we don't waste the minimal resources that we're receiving from donors.

AW How do you think this humanitarian concept has been served by politicians?

WK The situation is very difficult, but it's improving, and we have hope for a solution. For example, you've seen so many people visiting Somalia. The US secretary of state will soon be coming back. Our high commissioner, secretary general, and the leaders of other countries are talking to leaders in Kenya. They're waiting to discuss South Sudan and Somalia, seeking a regional solution to the regional problem. There's a political will, sometimes at the regional level, to examine the problems and call upon the leaders to tackle the problems at the national level.

For example, there are so many Somalis in other countries apart from Kenya: in Sudan, Uganda, Eritrea, and Ethiopia. So now African leaders and the EU are looking at problems at a regional level to tackle the Somali situation. They're discussing not only Somalia but also South Sudan, Burundi, and so on. The problem is very difficult, but they're not giving up.

AW The Kenyan government talks about cleaning out the camps. Do you think that's possible?

WK First of all, the responsibility of refugee management and protection lies with the government. Maybe you've noticed in Dadaab that many people are moving in

armed vehicles. This is the truth. Dadaab isn't far from the Kenya-Somali border. It's true that there might be some people crossing in and out. We can't deny that there are security concerns. The Kenyan government confirmed that they're mindful of Somali refugees in Kenya being treated in a humane and dignified way. The discussion is still ongoing. This isn't to say that they're going to close the Dadaab camp harshly. But they've formed a ministerial commission that's currently in discussions with us about Dadaab. We appreciate that they didn't close the door entirely, but we're still in discussions. They're asking our advice to see how they can best close the camp, but they're also looking into practical solutions for both Somalis and non-Somali refugees there.

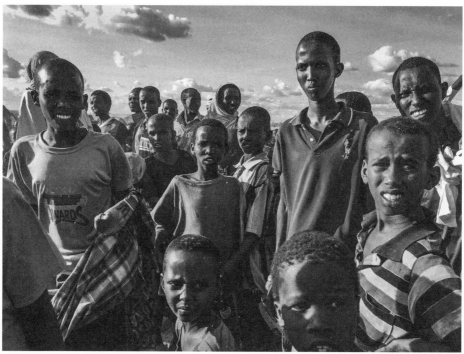

Dadaab Camp, Garissa County, Kenya, 2016

080

Filippo Grandi, UN High Commissioner for Refugees
Geneva, Switzerland, 2016-08-11

FG UNHCR is the UN organization tasked by states to ensure that people who are identified as refugees receive the protection that they've lost in their own countries. This is the essential function of the organization. Of course, it comes with many additional tasks, the most important of which is to ensure that refugees are assisted by receiving food, water, medical care, education, and so forth. But UNHCR also has another very important function that's less known: to help states find solutions for refugees. Traditionally, we say that there are three solutions for the refugees: they can go back to their country voluntarily when the situation allows; they can be resettled in third countries that accept them; or they can stay where they first arrived and be locally integrated into the population at large. These days there are many variations to those solutions, but helping states, promoting solutions, and ensuring protection are really our main activities and tasks.

AW What is the definition of a refugee?

FG A refugee is essentially a person who has lost her or his national protection for a variety of reasons. Usually it's because of persecution or the violation of human rights or conflicts that directly affect this particular person. Increasingly, in reality, these traditional reasons for defining a refugee are mixed with other factors—poverty, drought, climate factors, and so forth. So the definition is quite precise and is contained in the 1951 Refugee Convention. It's a very old document, although still very valid. Over the years, the complexities have multiplied, and, of course, we've had to adapt our work to this evolving situation.

AW When we talk about refugees, they're not necessarily asylum seekers.

FG An asylum seeker is a person who requests asylum in a particular country. He or she will go through a process to determine their status. If the determination is positive, the person will be recognized as a refugee. If it's not positive, the person will not be recognized as a refugee. So, not all asylum seekers are refugees, but refugees usually have been asylum seekers, because they sought sanctuary.

AW Has UNHCR existed since 1951?

FG Yes, since that time, because the 1951 Refugee Convention, or the 1951 Convention, as we call it, is the founding document of the whole, big, conceptual, and practical construction of refugee protection.

This was one of the many essential, crucial initiatives that came out of the Second World War and of the horrors of the war, like the 1948 Declaration of Human Rights, for example, and other documents, treaties, and legal foundations of the modern human rights system. It's part of that. When that Convention was issued, a number of states signed it immediately. Over the years this increased, and more and more states became part of this Convention.

Initially, the focus was very much on Europe. It's interesting that we've gone full circle and now the focus is again on Europe. But in 1951, of course, one of our main refugee problems, or perhaps "The Refugee Problem," was refugees coming across the Iron Curtain. There was a strong focus on individual cases fleeing the lack of freedom, violation of human rights, and persecution in countries in the Soviet bloc. That was the focus, although it wasn't explicitly said. Of course, over the years, as the situation became much more complicated, the Convention was enriched by many other documents—some of them global protocols, some of them specific to regions. There's a Convention related to African states called the AU Convention, one in Latin America, and then even more specific initiatives and documents that have amplified the notion and have, over the years, provided my organization and office with additional tools to intervene and help the people in need, because of these reasons.

AW How are you dealing with the European policies of basically shutting the doors and refusing many refugees seeking asylum?

FG If you take the possible journey of one refugee, it often starts in his or her own country. UNHCR estimates that today there are sixty-five million people in the world that we should be dealing with one way or the other. Of these sixty-five million, two-thirds are actually refugees in their own country. We call them "internally displaced people." The journey starts there many times. For example, look at Syria. Syria has six or seven million people who are displaced in their own country. We think that first and foremost there has to be much more effort to help people who are displaced in their own country. Many times refugees don't want to go far away; they want to stay near.

I recently met many people in Syria who told me, "We live five blocks from our house, but we can't go back because we'll be killed if we go back. But we don't want to go farther away, because as soon as the situation improves, we want to go back and ensure that nobody is occupying our house, that we can fix it," and so forth. There's merit in helping internally displaced people, but sometimes it's not possible for people to stay in their own countries, so they cross borders. Most of the more than twenty-one million refugees are in countries that are near conflicts—that is, near Syria, or South Sudan, or Colombia—countries that have been in conflict and thus produce refugees. But they stop very near for the same reasons. Much more help has to be given to those countries, in order to support the refugees that come to them.

We talk a lot about Syrians coming to Europe, but the vast majority of refugees are in Lebanon, Jordan, and Turkey. We should help them there much more than we have, not just with food and medicine but with job opportunities, education, and so forth. It's been very inadequate, and this is why they don't receive enough attention and support and move on. Now, in these cases, we believe it's important that countries that receive these people make a fair assessment and not push them back. I've come to Europe because in the last two years, more than a million refugees have come to Europe.

Europe is an interesting case, because Europe, of course, is the continent where the Refugee Convention was born. The European Union and European member

states have traditionally had very good asylum mechanisms, legislative systems, and practices to screen people to determine who's a refugee and host them. This was happening in a smooth way when numbers were small. When people started coming in large numbers, then the system collapsed. In 2015 we told Europe, and Europe itself said, "Well, the only way for us to deal with a larger number of people is to have good systems, but we have to distribute people in an equitable way throughout the Continent. Each country needs to take a share of this responsibility. There has to be screening at the beginning and then people get distributed." They called this the "relocation process." We supported that and thought it was a good, fair way to share this responsibility, but it failed. It failed because some states refused to take people, and there was no agreement on how to jointly handle this flow of refugees.

The result was actually an uncontrolled flow. A big mass of people went to two or three countries, essentially, Austria, Sweden, and, especially, Germany. Public opinion became very worried about this disorder. Politicians began exploiting this apprehension to stoke fears, just to gain votes for purely electoral purposes, and then every state fell back into its own borders, shut down, and pushed back. The worst scenario that we had envisaged one or two years ago happened, and, unfortunately, it was in the place where the modern concept of asylum, of protection, was born.

What about the future? We're a very pragmatic organization. We're the custodian of principles, but we also know that we have to work in realities that have political dimensions and that are very dynamic. I think that we're now going back to the European institutions and to the European states and telling them, "Look, the crisis now seems to be receding, there seems to be less pressure, we have a window of time now to look back at your collective systems. So let's try to establish systems that are equitable and that allow for shared responsibility, and let's respect the principles and orderly movements." We have time to do it now, but I'm very worried that the political context doesn't yet offer that space, and I'm also worried that new flows may come and Europe will still not be ready.

AW What's happened with war today and why has the situation become so complex?

FG The world is complex in so many ways, but from where I sit, here in my office in Geneva, I see two especially worrying phenomena. One, I see that we live in a world where making peace has become very difficult. The international systems for peacemaking were designed more or less at around the time of the Refugee Convention, after the Second World War, when the world was very different. That was the Cold War era. It was a world in which the victors of the Second World War sat in the Security Council with absolute power to make decisions on behalf of the international community. That wasn't perfect, but it served a purpose for a number of decades. I think in this multipluralistic world, in this globalized world, where communication is so fast and encompassing, we need to change that approach to making peace. We need to make it much more comprehensive and much more robust, because without that effective system, wars will multiply.

The sixty-five million displaced people and refugees that we deal with today are mostly the result of a dozen conflicts that have been ongoing for many years. I've

worked for refugees for thirty-two years, and of the seven or eight crises in which I've been involved, only one has been resolved: the Indo-Chinese refugee crisis. This dates back to the 1980s. All the other crises in which I have been involved—from Afghanistan, to Iraq, to situations in Africa—are still ongoing after thirty-two years. We have difficulties making peace and this produces refugees.

The other thing that's important to remember is that the refugee instruments were designed at a time when movements of populations were much more limited, difficult, and slow. Today, anybody with some money in his or her pocket and a mobile phone can move very quickly from any situation into the heart of the industrialized world. There are criminal networks ready to support this journey. We're facing a very difficult and different world, and we need to develop instruments to address this in the appropriate manner, respecting the rights of people but in a different context.

AW Do you think that one day we'll really cope with the situation or will the situation be out of control?

FG I think we can. Europe received one million people last year. This was manageable, but the way it dealt with it made it unmanageable. We always say that although sometimes states and even citizens are worried about the obligations that are enshrined in refugee legal instruments, one must not forget that those obligations are designed not only to protect the rights of the refugees but also to make it easier for states to deal with those flows.

Next month, in New York, there will be a global summit in the UN General Assembly on September 19. The whole idea behind that meeting sounds a bit abstract, but if you think about it, it's very important: How can we recast, reshape this notion of rights, which is written in the Refugee Convention?

In the preamble of the Convention, there's a beautiful paragraph that says, "Refugees are the responsibility of the international community." It uses less modern terms, but that's what it says. They're an international responsibility. But the way that the issue has evolved, because of the shortsightedness and selfishness of states, means that the refugees end up being the responsibility of the countries receiving them first. Turkey has three million, Ethiopia has 750,000, and Pakistan has more than two million. These aren't countries with many resources, and yet they have the biggest share of that responsibility, or the responsibility is shared by a few donors. The US gives us 20 to 30 percent of our funding. We also need to expand the base of those providing resources for refugees. We really need to make it global. If the phenomenon is global in size, speed, and methods, the responses have to be global. All countries have to participate in this effort, because all countries may one day face the consequences of these flows.

AW How can this be addressed with a more global understanding of human rights?

FG I think it can only be addressed politically. I'm the head of an organization but I'm not a political actor. My voice is moral, technical, not political. We need to convince political leaders not to demonize refugees. We need to go against this

rhetoric that has been promoted by so many politicians, especially in the industrialized world, that refugees and migrants are all dangerous enemies who are here to steal our jobs, occupy our places, and bring terrorism. We need to counter that rhetoric with a more positive one.

First of all, we shouldn't be afraid of refugees. They're the ones who escaped from fear. It's actually proven that both refugees and migrants make very good contributions to the societies that receive them, so we need to change that rhetoric. And then we have to convince all countries to share that responsibility financially or otherwise. These are the points that we want to discuss in New York and will be tasked with in the following two years, to design new systems for responding to the refugee crises. We're very excited about that, because we think there's now sufficient interest, after the European crisis, to try and convince political leaders to back these more collective responses.

AW You're quite positive and optimistic.

FG I always say I wouldn't do this job if I didn't have some drive and conviction that this is the right thing to do. I'm very realistic about the environment. It's very bad at the moment. It's very negative, very inward-looking. It's so extraordinary in a world in which any kid in Syria, even in Afghanistan, can press a button and be connected to America, or to Australia, or to Europe. It's very interesting that reactions to these flows are so inward-looking: "Let's close the borders; let's push them away." It's a contradiction. I think those are very real political dynamics, and we need to take them into account and oppose them. I'm hopeful—optimistic is perhaps too strong a word—but I also believe that there's no other way forward. Humanity often reacts negatively, in the wrong way for a while, until it realizes there's no other way, and then it gets back on the right track. We need to try to encourage it in the right direction.

AW Humanity will win at last. We have to have that behavior.

FG I hope so, but very big tests are ahead of us. We only spoke about mobility and conflict, but there are many other factors that are very important. Terrorism and climate change, for example, play a role in human mobility today and they complicate the picture. I grew up professionally in the 1980s and 1990s, in a world in which it was very clear that refugee movements needed to be addressed with humanitarian resources. You bring some health care and food and shelter. That's still very important, but it has become such a global phenomenon, interlinked with other global phenomena, that we as humanitarian organizations need to forge alliances with much bigger and more powerful players, financially and politically. This is where I see a window, the direction in which we need to go. Many leaders in the world see that now, and we need to make sure that they stay on course.

081

Amir Khalil, Four Paws International
Khan Younis, Gaza, Palestine, 2016-08-23

AW Dr. Amir, can you please tell us about the physical condition of Laziz the tiger?

AK Laziz has been evaluated by my team, which includes Dr. Frank Göritz from the Leibnitz Institute in Germany, my Romanian colleague, and me. We agree that the tiger is in good condition. During my last visit, the tiger wasn't in the best condition after a hard winter and after the war. So Laziz's condition improved in the last period with food and medicine, and in my opinion, he's now in good condition.

AW Good. How old is Laziz?

AK Nine years old, according to the owner. To be honest, plus or minus one year might be reasonable.

AW Do we know his species or country of origin?

AK All I can confirm, which the owner has also confirmed, is that he came through the tunnels from Egypt. I heard from the son one time that Laziz originally came from Australia to Africa. We checked in Australia, but no tiger his age was exported from there. So he might not be from Australia; we don't have any proof one way or the other. He could've been smuggled from Africa, especially from Egypt. Originally there was a couple, male and female.

AW Has the political situation in the area had an impact on Laziz and other animals in the zoo?

AK Animals have feelings, just like humans. They can sense disaster and feel earthquakes and floods well before we do. I personally believe that animals have their own internal tsunami alarm systems. I believe it's horrible for a tiger, which can hear and see much better than we can, to experience the bombing. They don't understand. To keep animals during any war or conflict, when nobody is able to care for them for a few weeks, is harmful for the animal. To keep an animal in a place like this, where he never sees or walks on grass, is inhumane. A wonderful creature like this deserves to be released from this situation. In my opinion, this is a jail. There's no quality of life for the tiger, which can grow up to 2.4 meters and isn't even able to turn around in his cage. This is a wonderful, beautiful animal. He should be in an outdoor place where he can walk through the grass and safely eat and drink.

AW Which parties did you have to contact to get permits to remove the animals? How did they react?

AK For the logistics of this operation, we have to work with four countries—Jordan, South Africa, Israel, and the Palestinian Authority—and the authorities in Gaza. The tiger needs import-export permits, certificates from the agriculture ministry,

and customs advisories. We need to have military approval and we need help with the massive logistics in transporting a large animal. I wasn't surprised about all this, but luckily we have a very good team. We were positively surprised to see that all these people agreed to help the animal to travel for a better life. Animals can connect people. Kindness can never be divided. If you're a kind man, you'll be kind to both animals and humans.

AW How will Laziz be prepared for the transport?

AK We started yesterday with a huge challenge. We tried not to tranquilize Laziz, because he shouldn't be tranquilized twice in one day. Doing so would be very dangerous for him. So with the help of the zoo owner and his son, we succeeded in getting Laziz into a large crate. He'll stay a day in Gaza, and then tomorrow morning, we'll go to Erez, and in Israel we'll have to tranquilize him, so we can take blood samples, complete the necessary examinations, and change the crate. We have to transport him to Johannesburg with El Al Airlines. Doing so needs special security approval, and the cage has to be safe. There's another cage waiting in Israel that is approved by the International Air Transport Authority, and it will be allowed on the plane. So tomorrow, Laziz will be tranquilized, transported to the airport in Israel, and at nine o'clock in the evening, he'll be flown to Johannesburg. After tomorrow morning, he'll be in South Africa in a sanctuary. He has a long journey ahead, but it's a trip for freedom.

AW Are there any practical risks you're afraid of, either during this trip or maybe after Laziz arrives?

AK Sure, risk exists. But we have a very competent team of experts, and we're well prepared for any emergency. There's no guarantee that everything will go well, but we have experience with such matters and have never had a bad result. With Laziz's current physical condition, we believe he'll succeed and enjoy the rest of his life in a species-appropriate environment.

AW Do you have any other plans for animals inside Gaza and other zoos?

AK Four Paws is an animal welfare organization. We're looking for long-term solutions. We previously came to Gaza and planned to cooperate with the people here. We can share our knowledge with them, but they also have to provide ideas from their side. We believe that the people in Gaza should have species-appropriate places for wild animals, but like any country, they need special regulations. They can't go on the street and buy a lion or a tiger. Our organization is willing to assist them in building a species-appropriate place for their wild animals. There are still four zoos here and many wild animals, so much effort will be required.

082

Antonio Luna, Refugee
Tijuana, Mexico, 2016-09-26

My name is Antonio Luna and I'm from Nayarit. Tonight, I'm going to try to cross the border, although I've already crossed it seventeen times by the sea over there through Tijuana. Of these seventeen times, they caught me four times. They didn't see what I did as a felony, because I'm not a coyote [one who smuggles immigrants into the US]; I'm just crossing to work to try to feed my family and buy property for my children. I have three children, and I'm crossing over now because my son had a car accident and we need to get some money for an operation on his hand. He cut open his hand and I told him it was very difficult right now in Nayarit because it was raining a lot, so I told him to wait for about fifteen days. It's my third day here. I'm waiting for God, and then I'll manage to cross tonight to be in San Diego.

Look, from here I'm crossing over, I'm entering; I'm waiting for the mist to arrive from midnight to 1:00 a.m. I'm waiting for the nightfall up there, and if I see that there's some mist, I'll start crossing. In about an hour I'll reach Tijuana, and I'll swim from 1:00 a.m. until 6.30 a.m. I'll be swimming all night long until Imperial Beach. When I get to Imperial Beach, I'll get out at the bridge, and at 6.30 a.m., I'll take the bus that goes to downtown San Diego. I'll catch the trolley-bus, and from the trolleybus I'll either get the Amtrak that goes to Oceanside or I'll get the Coaster, because there's a train called the Coaster. Therefore, I'll take one or the other to get to Oceanside. If I have the opportunity, if I'm lucky tonight, the Department of Immigration will enter the train and I'll be in the middle. If they catch me, they'll kick me out, and the next day I'll be back in Tijuana. And I'll try again. Like that, I entered sixteen times. The other times I entered, I did it to get property for my children, for my daughter mainly. And this time I'm very determined to get in because of my son's accident.

When I get to the US, if I manage to cross, I'll get to San Jose, California. In San Jose there's a big community of Mexicans and Latinos who'll get me a job. There are all sorts of jobs available on a daily basis, like construction, gardening, painting, landscaping, and so on. Last time I was there for approximately seven or eight months because my children are in Nayarit. I can't leave them for too long. My children told me to come back after seven to eight months. So I had to get back. It was the only way.

I can't pay someone to help me cross because they're asking $6,000 to $7,000. So for me it's easier to come from Nayarit with 1,700 pesos. I spend 1,300 pesos for the bus, and I change the extra into dollars. I'll spend $3 until downtown San Diego and from downtown San Diego, I'll catch the train that costs $13 to Oceanside, and there, if I get lucky, I'll start working in whatever it might be.

Right now, the surgeon who'll operate on my son told me that the operation costs 16,000 pesos. He has a contusion. Unfortunately, my son was working in a pizzeria but he fell under a car and his boss didn't want to be responsible for it. I told my son to let me deal with it. It's the only way for me to get money like that.

So I came, and for that reason I'm here, and let's hope I can cross and get that money. Last year in San Jose I was earning like ten to twelve dollars an hour. This year, I don't know how much they're paying. In fact, the dollars went up, so I don't know how much they're paying the Latin people and those without papers.

I'm going to show you the equipment I use to cross over. People bring other things, but I bring three little things that are very important. This lap belt is for the lungs, since when you swim for three to four hours in the freezing water, you need this belt to fit that part behind to help you. This is one part. These are my flippers, small flippers that help me in the upslope; it's very important to wear them. If I don't bring flippers, I can't fight against the whirlpool. When you get through that side, there are whirlpools that get in the way of your feet, so you need the flippers to get out of the whirlpools and not get submerged underwater. The third part I bring is this swimming vest. I first put on the belt underneath to help my lungs, and then this vest keeps me warm when I'm swimming. These are the three things I use. I don't wear pants because when swimming, if you have to get out and run, the pants rub too much against your legs, and it's too big of a problem. So just the lap belt for the lungs, the small flippers, and the swimming vest. That's all you need to enter. That's all my equipment.

Some people are afraid of water. When you get into the water at 1:00 a.m., it burns your face and body. When you put your foot in the sea, it starts burning, but you really need to make a decision that you're going to do what's required and not be afraid of the water, not be afraid of the sea. I came across dolphins once, four or five dolphins around me, at like 3:00 or 4:00 a.m. People say they're sharks, but I don't think they're sharks. They jump over the water and into the water, up and down, and keep looking at you, and they also swim in circles around you.

That's what I can tell you—to not be afraid of the dark, considering you're cross- ing from 1:00 a.m. until 6:00 a.m. to get to Imperial Beach. Yeah, it's like that. To cross through the sea, people shouldn't be afraid of the dark. They should be sure of their decision, of the purpose that they're going for. The dark and the sea get really rough, but you can't be afraid of that. If you get in and become afraid of the dark and the sea, you're not capable of crossing. So many people who crossed without knowing how to swim lost their lives. It's a reality. They fight, thinking that they can, that crossing through the sea is nothing. But they get into the water, and if they can't swim, well, the next day they're found drowned. In my case, I crossed sixteen times, so for me it's not an issue. I'm more afraid of going uphill because there are many people who kidnap other people. In the sea, the only things touching me are dolphins and fish.

083

Ingrid Hernández, Sociologist
Tijuana, Mexico, 2016-09-26

My name is Ingrid Hernández. I'm a sociologist, although I never say I'm a sociologist, because since I finished my degree, I've dedicated myself to art. I started to work in that direction in 2004 because I became interested in why people built their homes in different ways in Nueva Esperanza, because one house is very different from another.

The settlement is called Nueva Esperanza [New Hope], and it was formed approximately thirty years ago. It's mainly made for people from the south of Mexico, and there are inhabitants from Villahermosa, Coahuila, Guerrero, and Veracruz—especially from Veracruz and Guerrero. I was very interested in the relationship between their way of building their homes and their place of origin. So I started an investigation that was a sort of photographic register in the way that people built their homes. But I also did interviews to get to know some aspects precisely—not only their place of origin, for example, but what they were doing over there, if they had any background in home-building, how the house they were living in there was, and why they migrated.

I also wanted to know what was happening with this particular population and how they were integrated in the city, a sort of sociodemographic profile. I found that the population of that settlement mainly comes from Guerrero and Veracruz, but there are also people from Coahuila, Villahermosa, and Tabasco. Many of them came to Tijuana because they knew someone here, such as a relative. Some want to cross to the US. Most people stay here in Tijuana, and they're the ones we see here, who start living here and building the settlement. Because it's not their land, the people who live here think that at some point the government is going to kick them out of that place, so on one hand they don't see the point in investing a lot in their temporary home. On the other hand, the economic conditions aren't providing a long-term solution, so they combine these two things and are making a settlement. It's apparently provisional but it stays like that, as you see it now.

In the settlement, I noticed that people are building houses using residues from waste, not only waste from the area but also waste from factories. For example, a factory got rid of all of its waste to build TVs, so the people in the settlement use this waste to build houses, which gives each house a particular look, an aesthetical singularity. They also build houses with waste from the US that is resold here in Tijuana, such as garage doors that are sold here in hardware stores and are used as walls. A wall or a door like that currently costs 700 pesos. You need four to build a room, plus another for the roof. So we're talking about 3,000 pesos, which can seem quite cheap, but given their conditions, people here sometimes can't afford it, nor even have access to a home with these characteristics—a house made with garage doors. For that reason, we see more houses made with bits of junk.

I found out that most people here didn't have the opportunity to seek an education, so job opportunities are quite limited. Women, for example, mostly work in

textile factories around this area. In the 1970s, Tijuana expanded a lot, thanks to a program that allowed those factories of multinationals to settle here at the border. This also attracted many migrants, because the job opportunities were here. Those who don't work in the factories work as housecleaners one or two days a week, or there's also another type of work: scavenging cables and heavy metals that are then exchanged for money in places that are similar to recycling firms. Currently, in a factory you earn around 700 pesos a month [$35].

The families here have a minimum of three children, so it's a bit complicated to provide for a family of five with that amount of money. I met a family that had five children and they were working here because there are laborers' quarters. They were working the harvest, and I asked the woman if her children were going to school. She told me they weren't, because at school they'd ask for a birth certificate, and they don't have birth certificates; to get one would cost the price of their food for a week. So we can see how they're being stopped, and how the things that are very simple for us are quite complicated for families in these conditions.

I also forgot to comment on the reasons why people migrate from their place of origin. It's basically because there wasn't work for men or women, which left them in very precarious situations because of the violation of human rights and war. Many people are fleeing their villages because they're at war with drug trafficking.

The border with the US is precisely right next to this community. You can see the end of the border; the fence stops there. We can see the US and farther up is Tecatilla, and there's the fence that continues to the east of the country. All of this area is a path for migrants. In fact, the neighbors are always reporting people who are carrying backpacks and are waiting for specific times to cross. They cross in order to reach the community of Las Islas, and then cross through the part where there isn't any border. It's still a very difficult place to cross because there are canyons with many rocks, and there isn't any water. And on top of that, there's a lot of surveillance.

084

Ramon Sanchez, *Refugee*
Tijuana, Mexico, 2016-09-26

RS My name is Ramon Sanchez, from DF Mexico City [Distrito Federal; now Ciudad de México or CDMX]. I came here because our mother abandoned us when I was twelve. I started to sing on the bus, sell chewing gum and popsicles, and clean buses and cars. My oldest brother came illegally to the US, and he started to bring us here one by one. I was the second one to come from DF Mexico City to Tijuana.

The trucks entered in Tijuana on one side of the city gates, and that's where we got in, along with 498 others. We broke the chains and went through the gate, all 500 of us. The immigration authorities chased us, but I managed to get through. I got to Canton, California. I started to work collecting bottles and cans. It was my first job. I started at 8:00 p.m. and worked until 4:00 a.m., collecting soda and beer cans. After that, I started my second job, which was to polish the rims of shopping carts from different supermarkets.

I met a wonderful woman there who changed my life. Her name is Marisol Zúñiga.

She married me and gave me four children that I keep in my heart. Thanks to Marisol, my life and my way of thinking changed. She gave me the desire for self-improvement, since I hadn't studied beyond elementary school. Then I was an employee for Target, unloading containers. I'd then stay for thirty minutes working with flooring and fencing materials.

Then they promoted me to florist. At that time I was earning $7.50 an hour. They made me manager of thirty women. I stayed for three years at Target. Sixty-seven percent of the workers were Afro-American and 20 percent were Hispanic.

One day in 2002, I sat down at my desk at Target and decided I wanted to start a project. The Hispanic community needed to help its youth get out of drug addiction and vandalism, and help them focus on their studies. So I quit my job and started helping the Hispanic community, and my life expanded from there. My first daughter is named Marisol, like her mom. Then we had Vanessa, Ramon (named after me), and Eric.

We created a Hispanic soccer league in Canton. It grew day after day. We started to open our doors to some schools and municipalities. Then we created an organization called the Southern California Youth Soccer Organization (you can see it on Facebook under the name Southern California Youth Soccer Organization Mexico) and on the website.

Now, we're starting the program here in Tijuana. I'm going to be realistic. I want to go back to my family.

AW When and how were you deported?

RS They deported me on February 25, 2010, because my visa expired. I appeared in court in Los Angeles and the judge said that either my wife or I had to leave. He gave us five minutes to decide who would leave. We spoke with our lawyer. I left because I'm a man, and a mother should stay with her children. At that moment, I told the lawyer that I would leave if they gave us one month so I could show my wife how to manage the organization, and the judge agreed.

The month felt like an hour. When I went back to court, my entire family started to cry. Marisol was fourteen, Vanessa was twelve, Ramon was eight, and Eric was six. It was so painful from there on. We all hugged one another and the immigration officer put the handcuffs on me.

On that same day, tears were falling from my eyes with each step I took. When I arrived and saw the Mexican flag, the truth is that I had a really bad feeling. When they threw me out, no one helped me. I sat down at a McDonald's that no longer exists, at the exit where everyone was coming from, and I started to cry. I was thinking, *What am I doing in this place, in my country?* I felt like I didn't have a family. I spent hours there crying, and no one approached me to say anything or to give me a hug. For everyone who's thrown out and has children over there, we just want to find someone to give us a hug, to help us. There was no one like that.

I waited in a hotel in a nearby village. At that time it cost $110 a night. I spent three nights there. During those three days, I met a taxi driver who told me that his aunt was renting a flat in Sánchez Taboada. They pay $250 a month for a flat there. I started to observe the culture in Tijuana so I could keep working on my projects. I know how Tijuana was created and why, where the tunnels are, where the university is located, who created Tijuana, why they called it Tijuana, and why they call each area by a name, "The Five and Ten."

I had to learn everything about Tijuana to start my project. From there, I started the project to help young people get out of antisocial lives, out of drug trafficking. I helped the single moms who were being beaten up or forced into prostitution and children who didn't have shoes, or anything. I started to put the organization in place, and from there it started to grow. Right now, I'm creating the program in El Florido, in El Soler, and there in the "five and ten." From there, I'm going to expand that program. But I want to go back to California. It's been six years since I last saw my wife. I hope to God to see her. Six years without seeing her hurts. I have a picture of her and nothing more. It hurts so much to be apart.

AW Do you carry a picture of your family?

RS No, I've got a big one. My daughter Marisol is entering the army next year. She's going to the army because she wants to be licensed in federal law but also to help me, to help many people. My younger daughter Vanessa wants to be in the FBI so she can help people who need it, who've been deported without having any problems.

I love the US. It opened its doors to me and showed me what it is to always say the truth, to be honest, to help other people, to love your own family and be with

them, to fight for what you want, and to build a future for our children, who are American citizens.

I'd give my life for the US flag. Many people say that the US is very problematic but it's not. On the contrary, the US is a country where they show us what personal growth is, to have dignity, to love your homeland and your national anthem. I always look at our country's flag and stop to give a salute. I learned to listen to and respect our national anthem. For that reason, I love that country, and it'll always have a place in my heart. I hope this year I'll be back with my family and leave everything I'm doing with this organization here to humble people who are really needed here.

You can check our Facebook page and website. You can go to Canton, California, and go to one of the mayors named Reed. He lasted twelve years as a mayor overseeing the sheriffs whom we helped. We brought many young people to the sheriffs, to show them what the law is, and to teach them that they had to respect the law. Now we're going to do it here in Mexico. Today I asked the policemen to allow me to bring the youngsters to them, so they can explain to them that they have to respect the laws, so that they don't go in the wrong direction. To God and my Virgin of Guadalupe, I pray for me to come here, and that what I'm saying brings something good.

To help people is to do something nice. People need to know how many people are suffering and not to stop fighting. Those of us who came here after being deported, whether it's sweeping floors or washing cars to survive, have to stand up in our country [Mexico]. If we can stand up in the neighboring country, we can also do it in our own country. We need to show respect to our flag and our national anthem. I'm telling you one thing: Wherever my children are, I love that flag. My children are my life. I'd give my life for them, and I'm going over.

José Carlos Yee Quintero, Casa Del Migrante
Tijuana, Mexico, 2016-09-27

CY My name is Carlos Yee. I work here in the House of Migrants, coordinating the different care programs for migrants in Tijuana. I also work as a supervisor at the College of the Northern Border for a postgraduate program about international migration.

You told me that you wanted to know something about the flows of migrants in Mexico and especially in Tijuana, about people who hide. Mexico is very big, so we have different migration routes. The majority enter from the south, from Chiapas, and from there they take different routes. They can enter the train, "the Beast" route. They can get to Coahuila, to Tamaulipas; they can change trains, reach Jalisco, and go farther north. Ultimately, they can reach Mexicali and Tijuana.

The different ethnic groups all mark their routes. We have, for example, the Hondurans and the Guatemalans. The Central Americans usually take the Beast. They take the route around the Gulf, pass Chiapas, Veracruz, and reach Tamaulipas or Coahuila. There they try to get into the US undocumented. These ethnic groups are very large. They've been around for many decades.

We don't see them here in Tijuana. The main group that we take care of consists of deportees. We talk about people who lived in the US for only one day and up to thirty years. During that time some totally adopted the culture. They speak perfect English; some came at a very young age. Basically, from a cultural viewpoint, they're American.

They were deported for various reasons. They get caught driving under the influence, go to prison, and get deported to Mexico. They get here but have never been to Tijuana. They hardly speak Spanish. What we do is give them a base so that they can reorganize their lives and turn themselves into productive members of society. This phrase sounds a bit stiff, but that's what they're searching for. Although they don't have family or friends, and they don't know the city, we encourage them to establish ties with the House of Migrants so that they can work, feel comfortable and safe, and develop personally.

This flow is the strongest it's been in history. We noticed a new flow of Haitians that started around the end of May. This flow is directed toward the US to seek political asylum. This stream of Haitians doesn't go directly from Haiti to Tijuana. They migrated to Brazil between 2012 and 2013. They worked there and got work permits from Brazil. But after the economic and political crisis of 2016, a lot of them got laid off because the investment in infrastructure was cut. So they tried plan B. The number of these new people increased between June and August. They overtook the deportees in terms of numbers and became the biggest group. They come here with the intention of seeking asylum in the US, without really understanding the concept of asylum. We don't yet have data to know the different reasons for migration. It's clear that most of them simply need work. You ask

them what they'll tell the US in order to get asylum, and they respond that they need to work and that there's no work in Haiti.

The concept of asylum emerged to protect human lives. It emerged to protect someone in credible, fundamental fear of losing his or her life in the country of origin. It's a person who cuts ties with his or her country of origin, who escapes from there. Not having work isn't a valid reason for asylum. That's why a lot of them can be deported. It's not the first time that we've registered such a big stream of deportees.

In 2010 and 2011, after the earthquake, a big stream of Haitian migrants headed toward the US. They entered in Florida and elsewhere, but not through Tijuana. Tijuana is the costliest and farthest way. They enter and the US activates a concept that's called TPS (temporary protection status). It's for migrants who escaped because of the earthquake and entered during a specific period in 2011. Nevertheless, this is just a temporary permit. It's activated in case of a natural disaster, a war, or an event that is temporary. Basically, the US says, "You're in temporary danger in your country, so we'll give you a permit till a specific date. Afterward you have to go back to your country." This isn't what exists today. The ones who arrive now either have to seek asylum or have to apply for some kind of visa, like anyone else. That's basically the big stream of migrants we're seeing today.

AW Mexicans and Central Americans flee not only because of poverty but also because of violence. Can you explain this? Is it more difficult for them to get an interview to request asylum to the US when they enter the country illegally?

CY When we talk about the Central Americans, we're talking about people who are coming from countries with the highest murder rates worldwide. Honduras had the highest murder rate for more than four years. We're talking around 150 murders per 100,000 inhabitants, compared to the worldwide average of 6. We're talking about people who are in constant risk. In the most dangerous cities, for example, in San Pedro Sula, this rate reaches 187. There's a big chance that they could die if they stayed there: killed by gangs, by the Mara Salvatrucha, by all those criminal structures. They just flee without any knowledge about asylum or permits: if they don't escape, they'll be killed. They get to Mexico and a lot of them ask for refuge here, just like the Haitians, but Mexico accepts only a few. The others stay undocumented.

AW It's much more difficult for their applications to be accepted in the consulate, for them to be granted asylum.

CY Well, these are very different things. You think about migration and see all these people, but they're very different from one another. A lot of them feel unsafe because some of the same gangs are here. Gangs like the Mara Salvatrucha can enter Mexico and kill them for escaping. We're talking about people who own a small shop, maybe they sell cakes. The gangs charge fees that they can't pay. At one point the owners close the shop because they can't pay the fees. The gang says, "If you close, we'll kill you." So they close and escape to Mexico but fear that the gang will send someone to kill them. There's no real border control at the south of Mexico. You can cross wherever you want. We're talking about a river;

you take a boat for ten pesos and cross. Everybody crosses there. So they escape, and if they don't feel safe, they try to get to the US. A lot of them end up in Saltillo. There's a house there that helps them with asylum or permits. Some want refuge in Mexico and a humanitarian visa.

Some will stay and work in Monterrey and areas close by. Many don't and try to cross illegally through the desert near Coahuila. They walk for four days. They take water, food, and everybody knows where and how to cross. They take maps and explain it to each other.

They risk being killed by coyotes [smugglers], by the American ranchers, by the heat, or by something else. If they stay here, they face all kinds of risks from our culture. For example, investigations in Chiapas have shown that Honduran women are considered promiscuous, that they take away husbands. All those prejudices prevent these women from being able to freely work there, so they have to leave that area or adapt to this negative cultural concept.

You asked me about the other group, about the Mexicans who seek asylum. The US does receive applications from Mexicans. It's obliged to accept asylum applications from all around the world. They accept around 1.7 percent of Mexican applications, which is practically nothing. The ones they accept are mostly from Michoacán, from areas with many conflicts and much danger. Someone from the LGBT community who comes from an area with recorded incidents against this group is more likely to get accepted. Asylum isn't a dysfunctional concept, it's just wrongly understood. That's why Haitians and others fail. It's a communication problem; the wrong information gets amplified and turns into a problem.

AW How do the people without asylum cross?

CY It's almost impossible to estimate how many people cross. The best estimates are compiled using deportee numbers. For example, Mexico repatriated 60,000 Hondurans in 2013, but we don't know how many came and were not caught. That's why the estimates aren't very credible. The same happens in the US. We know how many people got deported and repatriated, but we don't know how many entered without being caught. We don't know how many people died in the desert, how many got kidnapped and left in another place. There are many aspects that are impossible to know. The general problem with the numbers from any survey based on official numbers is this: they're influenced by the funding, which DHS [Department for Homeland Security] or ICE [US Immigration and Customs Enforcement] received. If these agencies got a hundred million more one year and they employed 1,000 more migration officials, they'd catch more people. That doesn't mean that these people didn't exist the year before. That's why it's nearly impossible to know the numbers.

An important aspect about the US strategy to confine migrants is their use of images. One example: The fence that they constructed at the beaches that extends into the sea is very impressive for people who've never seen it in reality. It's a border that stretches from land into the sea. It seems a bit exaggerated and impossible to cross. It's full of cameras and surveillance. But just an hour from

here are parts without fences, and you just start walking. Or maybe the fence is just one and a half meters high and rusty. You kick against it and it collapses. These images of the fence and the borders are used to control possible migrants in their country of origin. Imagine there's a migrant somewhere in Veracruz planning his route for more than a year. He sees these images on TV and thinks that he'll never be able to cross—"Better I don't go, or go somewhere else." Different strategies of control exist that are connected to each other, creating a complete national strategy used by the US.

AW Can you tell us something about the house, its origins, and how it has evolved? How many people are here?

CY I forgot to talk about an aspect of the Beast. Something that's important to consider is that the Beast is very dangerous. The speed of the train increased several times over the last years, I think four times. They repaired the tracks and put up fences on the sides of the tracks so that the migrants can't get on the train. The consequences of these prevention methods are migrants falling down and dying. They fall down, hit the fence, and get mutilated. There's a shelter just for mutilated people in Tapachula. You see them in parks and on the streets. We're talking about measures of control coming from US foreign policy or somewhere else. They're implemented here in Mexico in a specific way, and they lead to human deaths. When you start to track why these things are happening, you discover those big strategies. They sound good on paper, but in reality, they violate different human rights.

Coming back to the House of Migrants. Tijuana has always been one of the calmer borders, except for the beginning of the twentieth century, when Chinese people and cotton plantation camps caused big problems for several decades. The migrant flow in Tijuana is rather calm. Not many have experienced violence, rape, and kidnapping. That's contrary to Tamaulipas, where many suffered from kidnapping.

In Tijuana we received three different kinds of migrants. We begin in the 1980s with a flow from south to north. Mexicans came to work in American agriculture and elsewhere. Central Americans also came to work and to get papers. In the 1990s we saw a big number of deportations. The deportees arrived and started to integrate into Tijuana's social systems. Tijuana is a rather young city, about 120 years old, so you can track nearly the whole population for some generations. Most people are migrants. I'm third-generation Chinese. Then the big repatriation programs started, following the Bracero Program. That resulted in this new generation, and, finally, it transformed into this flow of asylum seekers. There are different programs, like the Lateral Repatriation Program. This US program works like this: Someone is caught near the border of Chihuahua and is then deported to Tijuana. They do this in order to discourage migration. You're deported to Tijuana, but you've never been here. This causes bigger complications. This has been implemented because the coyotes [smugglers] offered a three-for-one price. They gave the migrants three attempts for the price of one, just like a package or a special. To avoid this, they started to repatriate the migrants laterally. Those are the three flows this house receives. This house also adapted to the necessities of migrants, treating them as a group of vulnerable people.

AW Can you tell us more about the house and its capacity and functions?

CY We have specific functions. We give legal advice, psychological help, and we help people with their paperwork. We also help them find jobs. Depending on their necessities, this could be a short-, medium-, or long-term job. We offer this to all the people who come here, deportees and people traveling from south to north.

We have a capacity of around 160 people. That's how many beds we have. But that's flexible. When there are more people and all the shelters are full, like in the last months, we let another 30 to 50 people sleep here at night. We register about 160 people every night. This doesn't mean that these are the same migrants. Theoretically, all 160 could leave one day and another 160 come the next day. We have to explain everything and give advice to each newcomer. This cycle of flows increases the workload.

AW And how does the house work? Where do you get your funds?

CY This house operates on donations and volunteers. We have volunteers that have been around longer than the house. They started giving food to the needy when this was still wasteland. The majority of contributions come from deportees who were here fifteen years ago, got help, and stayed in Tijuana. Now they come and help, bring rice, clothes, and other things. The basic costs are covered by different projects and international organizations that pay the employees. We receive help from the Scalabrinians [a Catholic congregation], because in the end this is a religious house owned by the Order of the Scalabrinians. They help a lot through their patronage and keep this house afloat.

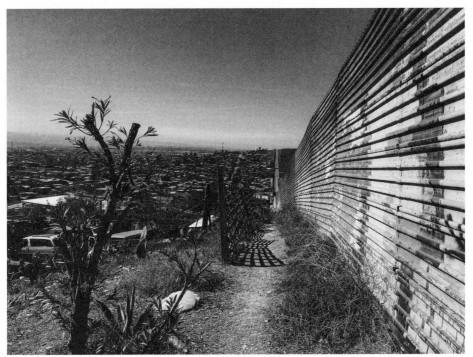

Mexico-United States Border, 2016

086

Maya Ameratunga, UNHCR Afghanistan
Kabul, Afghanistan, 2016-09-27

My name is Maya Ameratunga. I'm the head of UNHCR Afghanistan.

Nearly four decades ago the Soviets invaded Afghanistan, and following that there have been waves of displacement as the country went into civil war at different stages. For almost four decades, there have been internally displaced Afghans, and then also people who sought safety in Pakistan and in Iran. Some people are still fleeing for their lives, but many others are returning in difficult circumstances.

There are now about a million people who've been displaced in what we call a protracted situation. This means they've been displaced for many years, but there are also people being displaced in new emergencies. This year we had about 250,000 newly displaced people; last year it was about 400,000. Of course, the returnee situation is adding to the overall challenges of people trying to find safety, trying to find dignified lives where they can have shelter, jobs, land, and so on. So it's a very complex situation.

In 2016 we estimated that 30,000 people would come back from Pakistan and Iran. Now we've reached about 150,000 returnees from Pakistan, and we're planning for maybe more than 220,000 people for the year. It may be much higher than that. People are coming back due to the political situation between Pakistan and Afghanistan. These people have been living side by side in Pakistani communities for more than three decades, and, unfortunately, a difficult political relationship is now affecting the ability of Pakistani communities to continue hosting them.

UNHCR has been in Afghanistan for many decades, helping the repatriation operation and also internally displaced people. We have offices in all parts of the country, although they are becoming smaller as our resources are diminishing. We have about 250 staff throughout the country, and in addition we work with partners, especially local NGOs, who can implement programs for us.

We help the internally displaced who need protection and emergency shelter, and we help returnees with cash grants and supplementary assistance for more vulnerable people. Additionally, we're helping the Afghan government to be a refugee-hosting country for the first time. Afghanistan is actually hosting people who've fled here for their safety, so it's an interesting situation of all kinds of displacements.

Starting in 2002, we assisted right after the intervention of the international forces in Afghanistan. Since 2002 we've helped almost six million people return to their country. The main challenge is security, because the ongoing conflict affects everything. It affects displacements and people's ability to come back and restart their lives. Another challenge is that there are now so many global refugee crises in Syria, Iraq, South Sudan, and so on, so everyone's attention is stretched,

including that of donors and my own organization. These protracted crises like the Afghan situation need much more attention.

We're facing a possible humanitarian crisis at the moment. We have huge numbers of internal displacement. Now we have around 150,000 people who've returned as refugees from Pakistan just this year, most of them in the last couple of months. And in addition, there's the prospect of Afghans coming back from European countries. We'd like to urge European countries to take into account that returns need to be humane, orderly, safe, and dignified, so that they don't add to the existing displacement situation. Clearly, the existing resources are already inadequate to help even the IDPs and the returnees from Pakistan and Iran.

Sadly, people are sometimes unable to return to their place of origin because it might be in a war zone. These people are what we call "secondarily displaced." This means they have been displaced across the border and now they're coming back and becoming internally displaced. They're in a very difficult situation and are probably going to have a very difficult time restarting their lives. If they're unable to go back to their places of origin, they'll end up in places like Kabul, in squatter settlements, in very difficult conditions. But at least they're now citizens in their own country and have the opportunity to make a future for themselves, although it'll be a huge challenge.

The encashment center that you see here is one of four run by UNHCR. It's a one-stop shop for people returning to their own country after thirty years in exile. Here they'll collect a cash grant of $400 per person. They can also use services, such as medical clinics, if they aren't feeling well. They'll go through a mine awareness education program, because Afghanistan is the most mined country in the world. And then there are other services, such as vaccinations for measles and polio. Afghanistan is one of the few countries where polio is still endemic. So it's the best occasion to see the newly arriving returnees who will then make their way to their destinations.

I think it's very important to advocate that return to Afghanistan should be voluntary, safe, and dignified. This means that people should have choices. They should be given time to make up their minds, based on good information, on what they want to do with their lives. Without these elements, people will not be able to restart their lives in Afghanistan, and maybe they'll try to find hope beyond Afghanistan. So this is our collective responsibility to help Afghanistan, to help these people to restart their lives, but also to help hosting countries, Pakistan, Iran, and so on, to give shelter to refugees for a longer time, until Afghanistan's conditions are conducive for return. I think it's very important that we think of this as the international community's responsibility. Of course, security comes with peace, and this is where UNHCR relies on governments to create the peaceful conditions for people to come back.

087

Ahmad Shuja, *Human Rights Watch*
Kabul, Afghanistan, 2016-09-27

I'm a research associate at Human Rights Watch based in Kabul.

The historical roots of both the IDP and refugee situations go back more than a hundred years. But the most relevant parts happened thirty to thirty-five years ago, when the Soviet occupation of Afghanistan started and with it the Afghan jihad and the whole war against the occupation. Massive numbers of people were displaced from their villages and from rural areas from insecurity and violence. Many of them found life in Afghanistan untenable, so they went across the borders into Pakistan, Iran, and, in some rare cases, they ended up on the shores of Europe, Australia, the US, and Canada. Typically, the upper-middle-class or middle-class people with education and world savvy would actually end up in places like these, using organizations like UNHCR and IOM [International Organization for Migration].

There have been successive waves of internal displacements since then. In the 1990s, when the civil war in Kabul was raging, tens of thousands of people were again displaced in the same fashion. Most recently, as the conflict escalated in the mid- to the late 2000s, more than a million people have been displaced in the country. But hundreds of thousands of people are also going back to places where they'd already come back from, like Iran and Pakistan, and many are now going to Europe as refugees seeking protection and a better future.

An important point is that the security situation in Afghanistan has been going downhill for the past four or five years. We've seen record numbers of civilian casualties in six of the last seven years that the UN kept records. This downward spiral is, unfortunately, worsening.

Hence, economic prospects are also decreasing. This is why many people who are being branded as economic refugees aren't just this but also conflict-displaced refugees looking for a better life. A young man in Kabul in his twenties or thirties, looking to settle down and have a family, would think: *It's safe for now to live in Kabul, but will it be safe in two years when I have a wife? Will it be safe in five years when I'm raising kids? Will I be able to offer my kids the necessary education?* People not only live in the present but also plan for their future, to give their families and children a better future. So there are going to be more IDPs and more desperate refugees ending up on European shores seeking protection.

The better educated, who typically have better information and resources, are usually able to go farther away. Those who are less educated with less information and money typically end up across the border in Iran or Pakistan. Or they smuggle themselves to Europe through a very long, convoluted, and dangerous process, where they then get detained in multiple places, then work for six months just to stitch together their pennies to go to the next destination.

There are 1.2 million IDPs in Afghanistan and that number is growing by the hundreds of thousands every quarter. The Afghan government, even with assistance from UNHCR and other humanitarian agencies, is unable to provide even the barest necessities for the existing IDP population, let alone returnees from Iran, Pakistan, or Europe. It's trying its best despite strained resources, but it's unable to go to many of the places that are just too insecure. It also lacks the expertise to offer the protection that these IDPs need.

The tens of thousands returning from Pakistan, often involuntarily, are likely returning to situations of destitution and poverty. A lot of these people can't get back to their villages, particularly the people coming from Pakistan, because they've been displaced for thirty years, in some cases forty. They no longer have connections in their villages; they can't go back and claim their land that their grandfathers tilled. In some cases, their villages are too insecure for them to go back. They end up in urban areas, displaced, disconnected, and landless.

People coming back or being returned from Europe, particularly Germany, face a similar situation. They've been to Europe, are typically better educated, and have worked with international NGOs. For them to go out into their villages and join their families is very difficult. They also face security problems, and in many places, they actually become homeless.

IDPs face a million problems. They have basic needs such as drinking water, jobs to put food on the table, and a place to sleep at night that is warm enough in the winter and cool enough in the summer. As you know, many places in Afghanistan can have extreme temperatures of cold and heat, and we've had reports of tens of IDP children actually dying in Kabul because of the severe winter cold.

In addition, people who've been uprooted from their communities lose their social support structures—the cousin that could've lent them money if the crop went bad, the friend who could've taken them in if their home was destroyed. These social support structures have completely evaporated. The people are scarred, traumatized; they've actually fled for their lives with only the clothes in their bags. A lot of them are trying to maintain connections with their families, with their hometowns, and with their villages, so they can go back and harvest their crops or maybe take that crop out of that region so they can have some form of livelihood. But people are desperate, and the Afghan government doesn't have the barest infrastructure or resources as a government to actually offer meaningful support. The resources of international NGOs, UNHCR, and other humanitarian organizations are also stretched very thin. UNHCR just announced a one-hundred-million-dollar plan of emergency relief for Afghan IDPs.

Local and international human rights organizations and humanitarian NGOs increasingly experience problems with their work. There have been increases in kidnappings, attacks on health facilities, and looting of supplies. The space for humanitarian organizations to operate in Afghanistan with a reasonable degree of safety is shrinking.

When we tell the story of Afghanistan in the last fifteen years after the Taliban, it's not a story of predominantly good outcomes or a story of predominantly bad

outcomes. There have been massive strides forward in many cases, but there are many problems that still need to be addressed. I grew up as a refugee in Pakistan. The international community's intervention created the space for me to return to my home country. I was able to gain full employment in Afghanistan, so I think I'm much better off as a human being as an Afghan citizen. Millions of Afghans are better off, but at the same time, we've had war and conflicts, and countless Afghan civilians, women, children, and old people have been caught in the cross fire, not just because of the Taliban, or because they were caught by improvised explosive devices, but also because of night raids and aerial bombardments by the US or other international agencies and militaries that were active in this area. You remember the very painful incident in Kunduz, where an oil tanker that had been hit by the Taliban was being emptied by tens of local residents, but a German airstrike decimated tens of people. In the south and east, there've been many more counterterrorism and counterinsurgency operations that have had a devastating toll on local civilians. So the picture is mixed.

On top of the conflicts that have caused internal displacement and civilian casualties, there's a lot more work to be done in literacy and education. In the last ten years, education was about establishing more schools and getting more teachers trained, but now we have to work on increasing its quality. Also, the scars of a nation that has been through multiple generations of conflict are going to take generations to heal. In some cases it won't be solved at all, and Afghans will just have to live with it.

We've seen this with the peace deal that the government struck with Gulbuddin Hekmatyar, one of the most notorious Kabul warlords of the 1990s, who's been brought in from the cold. But he's not the only one. There are other people occupying positions of power and strength in the government whose militias looted, conducted extrajudicial killings, raped and extorted people, and ran private prisons with impunity. There's a lot of work to be done in the area of human rights. A lot of improvement is needed in general social welfare to uplift increasingly poor and desperate people, particularly in rural areas. So the overarching story isn't predominantly positive or negative, but a lot more good work needs to happen.

088

Haji Khista Khan, Refugee
Kabul, Afghanistan, 2016-09-28

HK I'm Haji Khista Khan and I'm sixty-five years old.

AW What are your problems?

HK The problem is that most Afghans came here from Pakistan because of Pakistan's hot weather. Sometimes they're spending the month of Ramadan here in Afghanistan, and then they return to Pakistan. Half of the families were there, and half of them are here, after we came for the month of Ramadan. Now they're blocking the border and not letting anyone without a passport through. We tried many times with our women and children, but there was no chance. We're stuck here.

This is a big problem for us. We want to go back to Pakistan, to take our families with us, but we can't because they closed the border. We have our refugee cards with us. We're up to thirty family members there, including my nephew's family and my family. A lot of Afghans have the same problem. Their families are stuck on that side.

AW Where were you living in Pakistan?

HK I was living in the Etihad colony in the city of Peshawar.

AW What do you want from the government?

HK The Pakistani government isn't helping us; they deported everybody and asked us to leave. We had our business there. When we went to our shops, the police would arrest us, take our money, and then free us. We left all we had there: our homes, everything. We don't have anything here. We want our government to help us. We're renting a home here. The government should give us a piece of land to build our home on.

Still, we're happy in our country, even if it's insecure. But what can we do? There's fighting in all the provinces. There's war in Kunduz, Kandahar, Helmand, and Baghlan. Kabul is a little more secure, and that's why we live here. We live here in rental houses. Now we're stuck in the middle; some of our families are stuck in Pakistan and we're here. We can't go there and they can't come here. So we have these types of problems.

AW What do you want from the United Nations?

HK The world and the United Nations can see what's going on in Afghanistan. We ask the international community to help us. They should help the poor people, the ones who don't have homes. They should give them a piece of land. These are the main problems, and we need security to be united. We wish for peace in our country, and we want God to help us achieve this. We have a good country and land, and we need security here. Wherever you go, you'll need to come back to your own country.

Abdul Ghafoor, *Afghanistan Migrants Advice and Support Organization*
Kabul, Afghanistan, 2016-09-28

AW About one million people have been internally displaced in Afghanistan since 2015. What are the reasons for this massive displacement both internally and externally?

AG The most important reason is the deteriorating security situation in Afghanistan. In 2001 or 2002 the Taliban controlled much less of Afghanistan than it does today. It didn't have any presence in the north. These people don't have security, jobs, and a means of survival, so they have to move somewhere else to find security, something for their future, and for the sake of their children.

After the fall of the Taliban regime, a large number of people came back to Afghanistan from the neighboring countries, even from Europe. At that time they were hopeful about the future of Afghanistan. But after they stayed here for a few years, they lost hope. There was a lot of corruption and no clear policy that encouraged people to return to Afghanistan. So, based on my experience, those who had once returned to Afghanistan chose to leave again. They remigrated, because they just couldn't find what they expected in Afghanistan.

People were very hopeful when the current national unity government came into power. They thought, *Okay, maybe they can do something together.* But, again, nothing changed. Our research last year showed that more than 100,000 Afghans left Afghanistan because they felt hopeless about the government, about the future of Afghanistan, and about their own future. The Taliban kept capturing more provinces. They attacked the city of Kunduz and captured it in the blink of an eye.

AW How many Afghan refugees are now in Pakistan, and how many will return in the near future?

AG There are at least 1.8 million registered Afghans in Pakistan, and also a large number of unregistered people. How many of them will return will mostly depend on the policies adopted by the Afghan and Pakistani governments. It looks like it's very tough for Afghan refugees to stay there, because they're being restricted. They're not being allowed to go to school as they could in the early years. If it gets more restrictive, I expect another million will return to Afghanistan because they just can't deal with this pressure from the Pakistani government.

Pakistan has given an ultimatum to Afghans to leave Pakistan by the end of March 2017. I don't think that's fair, looking at the Afghan situation and the two countries' relationship over the last decades. They share the same cultural and religious values. The Afghan government here is responsible for convincing the Pakistani government not to force the Afghans to leave Pakistan, and, of course, UNHCR plays a role. If they're sent back to Afghanistan, there's only disaster awaiting them. Afghanistan isn't ready to absorb this number of people. They can't survive here. They'll have to remigrate, either going back to Pakistan, Iran, or a European country.

AW Why are many Afghans being forcibly repatriated?

AG Unfortunately, a large number of them were expelled from neighboring countries. Iran has had a policy of expelling Afghans for a long time. Pakistan used to be a little better, but recently it's been forcing Afghans to leave. That's also the case with the Western countries. A large number of them have been deported from Western countries, Scandinavia, and the UK, and Germany is talking about a bilateral memorandum of understanding to send at least 80,000 Afghans back to Afghanistan. These deals are very worrisome. These refugees were hoping for a safer future. They went to those countries for protection. It wasn't that they didn't like Afghanistan, or the lifestyle, or that they were into luxury. If they're returned, there's going to be chaos in Afghanistan.

Refugees don't have any kind of protection upon returning, because the Afghan government as a whole, and the Ministry of Refugees and Repatriation, have no reparations for them. They can't provide them with anything, from shelter to security. As a result of that, based on my own experience, large numbers of those who were returned from Western European countries have already remigrated because they couldn't survive. They couldn't go back to their provinces because of the security issues, so they were forced to stay in Kabul. They were stuck in Kabul for a long time, and in cities like Kabul, you can't survive if you don't have a good network of people, a good source of income. And the security in Kabul has also not been very convincing. It wasn't good enough to encourage people to say, "Okay, if we're not safe in our own provinces, we can stay in Kabul." Most of those who returned in 2013 and 2014 have remigrated and are already back in Europe. In that sense, deportation doesn't make any sense right now because it doesn't work. It'll only create more headaches for the Western countries and for Afghanistan.

AW Tens of thousands of Afghans entered Europe last year, which is a new phenomenon. Among them are many unaccompanied minors. If you could give them a message, what would you tell them?

AG One of my messages for unaccompanied Afghan minors who have ended up in Europe, mostly in Sweden and places like Germany, is to integrate and understand the politics of those countries, the immigration regime of those countries, and to acclimatize. Otherwise, there will be a clash of cultures. That can create problems for the Afghan minors and the people living in those countries. The easiest way to get into those societies is to be cool enough to integrate, and that'll make things easier for them. Otherwise there will be many problems for both sides.

Of course, it's not easy for the minors to do this alone, unless there's a little support from the host countries. I don't see many integration initiatives. It would be easier if there were some projects that help the minors and the refugees as a whole to understand their host countries' culture and context. It can make the life of refugees, and of the host nation's people, much easier. If they keep on blaming each other for problems, that's not going to be a solution. They need to come together and work together.

AW Is there a role for the politicians in this, in terms of talking to their own population?

AG Of course, the politicians can play a vital role. They could relax their immigration policies a little, not be so hard on refugees, and stop treating them as dangers to their integrity, cultural values, and the like. It's going to be okay, you know. And of course the people of those countries are going to follow their leaders. If the leader says refugees are a danger to the integrity of the citizen population and we shouldn't let them in, of course the people will follow them. But if they take it a little easier on the refugees, I think it's going to be okay.

AW We saw really contradictory outcomes with the regional elections in Germany. Merkel, who stood up for refugees, has now been punished by the electorate.

AG Well, there are different views of that, you know. When Merkel said, "We welcome this number of refugees into Germany," she wasn't ready for this large number of people. She only said, "Okay, for example 80,000 or 100,000." And when the number kept on increasing, neither the German politicians nor the German government nor the people were ready for that. If they'd prepared for that, I don't think they would've had problems. But they were only expecting a limited number of people, and when the numbers kept growing, that's when the clash started.

AW Let's go back to the Afghan authorities: Who's signing the readmission agreements?

AG Unfortunately, the Afghan government didn't have a very clear policy about this. At the beginning of 2015, the Afghan leader of the Ministry for Refugees and Repatriation pleaded with the Western governments and told them that Afghanistan wasn't safe enough for refugees to return yet. He understood that we couldn't give them anything if they returned. But there was a lot of pressure on him at the time from the embassies, from the Ministry of Foreign Affairs, even from president Ashraf Ghani himself, to accept returns from European countries. This led to the current bilateral agreements that they're planning to sign.

Last year, for example, we didn't have deportations from Norway, but this year the number is very high. Even their families are being deported in high numbers, and are stuck here now. Some of them don't even have male guardians. In a country like Afghanistan, especially in Kabul, if they don't have male guardians, it's really hard for women to survive. So this kept happening because there was a lot of pressure put on the minister concerning refugees and repatriation, and he just couldn't stand up under it.

The deal with Germany is another worrying point. There was a big demonstration in Hamburg a few days ago. Thousands of Afghans came onto the streets saying, "What are you doing?" This is the kind of stuff that shows the Afghan government's lack of a clear policy. There's also a lot of pressure within the parliament. Some are encouraging the bilateral agreement and some aren't encouraging it; time will tell what will happen. In my opinion, it's a total failure to encourage Germany or other European countries to send all those people back.

AW If I hear you correctly, there's a dirty deal going on. You're blaming the ministry, saying that it received a lot of pressure from within.

AG Yes, exactly. This pressure has been on the minister for a long time. On February 28, 2015, I met with him and a member of the European Parliament and another activist. The minister clearly stated that Afghanistan wasn't ready to take this many people because of security issues. He stated, among other things, that the Taliban has more control than they had in 2002. There's also been a lot of pressure from the UK and from Norway. They put a lot of pressure on the minister of Foreign Affairs, saying, "If you don't take this number of refugees, we're not going to give you donations or fund your development," and stuff like that.

So there's a game, and what's happening in between this game and politics is that those vulnerable refugees are being used as a tool. That's what makes me angry about the whole thing. They're using these refugees as bargaining chips: "If you don't do this, if you don't take this many back, I won't give you this money." And the Afghan government has to understand that it's not a matter of ten or a hundred people, it's a matter of thousands of people who have used a lot of money and who have nothing left in this country. If they're returned, what are they going to do? What does the government have for them? Nothing, I'm sure.

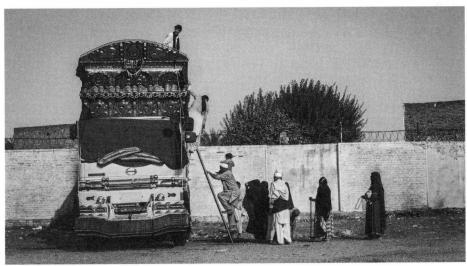

Peshawar, Pakistan, 2016

090

Farida Begum, *Refugee*
Nayapara Camp, Bangladesh, 2016-10-02

FB My name is Farida Begum. I'm Rohingya, from Myanmar.

I came here almost twenty-four years ago. Bangladesh is a small country that has helped us as much as it could. As it's a small country, we're thinking about how we can go back to our homeland, or once our own country is independent. We want to settle somewhere. We want safety and dignity. Now our children are receiving primary education. I regret that they won't get higher education. If our people live in this situation, their lives will be in darkness.

I'm teaching my children to tailor, and they're going to school. Now I'm a deputy camp leader, but it has no incentives. It's very difficult to make money, even for a cup of tea. I'm struggling for the welfare of my community as best as I can.

AW What are your duties as a camp leader?

FB As a deputy camp leader my duty is to try to solve conflicts, to mediate among the quarrelsome, to oversee education and medical affairs, to attend social and camp meetings, and to receive training.

AW How many female leaders are there in the camp?

FB There are two women leaders in each block and fourteen women leaders of seven blocks. We work together with the male leaders.

AW How are you elected? How do people choose you?

FB At first, I was elected by the community, and then the forty-nine leaders elected me as a deputy camp leader.

AW How long will you serve as the camp leader?

FB Our term is for two years, but I'll serve as a deputy camp leader for one year; then I'll be in a member position.

AW Are you the first woman deputy camp leader?

FB No, there was a woman camp leader like me before.

AW What's the difference between Nayapara and Kutupalong? It seems that in Kutupalong, women cover their faces, but here they don't.

FB Wearing the hijab is a religious matter. Some religious leaders say women can show their faces and some say they can't, but nobody disturbs the women who don't wear hijabs.

AW What's the difference between the hijab and the niqab?

FB Some younger women wear the niqab, which covers the entire face, because the face is the main attractive physical feature. I wear a hijab because I'm older, and I have to do a lot of work for the community and my family. I'm head of the family.

AW What's your hope for the future of the camp, your community, your family, and yourself?

FB We don't see any hope in our future in the camp, but we're thankful to have this place to live. We've been here for almost twenty-four years, thanks to the Bangladeshi government that provides us with shelter, and we're grateful to the Bangladeshi people and police for protecting us. But we don't want to stay here anymore. We want a lasting solution. We want to go back to our homeland with full citizenship, or to a place where we can live peacefully and get the same rights as other people in the world. As it's not our country, we're always afraid here. It's not our country, and we're not getting full rights. We came here many years ago and still our children aren't getting higher education. We want our children to be well educated, to be professionals. We have no jobs, no accredited certificates. We don't want to spoil our children's lives.

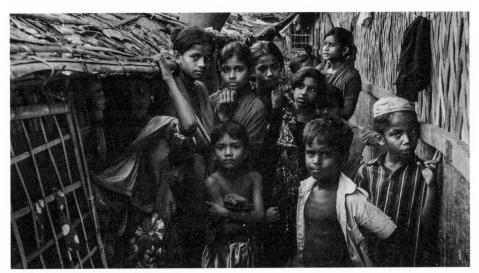

Nayapara Camp, Cox's Bazar, Bangladesh, 2016

091

John McKissick, *UNHCR*
Nayapara Camp, Bangladesh, 2016-10-02

JM We're in the Nayapara camp. It's been here since 1992. At that time there were twenty other camps, and there were 250,000 refugees here who came in several waves between 1991 and 1992 as a result of the ethnic violence in Rakhine State in Myanmar. From 1992 to 2005, 230,000 of these 250,000 refugees went back to Myanmar. At the end of the repatriation, there were 20,000 left and they were able to close all the camps except Nayapara and Kutupalong. In those two registered refugee camps, we have a total of 33,000 registered refugees. That means they're recognized by the government as refugees.

However, starting in 1992, some refugees returned. They went back home to Myanmar, the conditions continued to be bad, persecution existed, and they had no rights as citizens. So they came back to Bangladesh, and this time they didn't have any legal status. So while we only have 33,000 registered refugees, there are between 200,000 and 300,000 undocumented Myanmar nationals. They're in a refugee-like situation and therefore of concern to UNHCR. Now the government has recently done the census, and by the end of that year, we'll know exactly how many Rohingya are living here, and hopefully they'll be given certain rights. Chief among them is the right to stay until the conditions improve in Myanmar so they can go home.

AW Thank you. Can you tell us something about the current situation of the refugees in these camps?

JM Well, the living conditions aren't that good because this is a protracted refugee situation. They've been here for almost twenty years. The government provides land and security for the refugees, and it administers the refugee camps. But because this land is under the Ministry of Forestry, we're unable to actually expand the camp to accommodate them in more comfortable conditions. There are 33,000 living here and the population is constantly increasing. Sixty-five percent of all the refugees living in these two camps were actually born inside the camps, and the conditions are bad; they don't even meet our emergency standards.

However, the international community also has so many refugee crises all over the world, and there's some donor fatigue; that's why you see these sheds that are in such miserable condition. Every year we give the refugees new plastic sheets, which they use as a roof, but it's hardly what you'd call a livable situation, which leads many refugees to actually look for other ways of having a better future. Unfortunately, one of these ways was to get on these very dangerous boats run by smugglers and going to Thailand and Indonesia. Of course, many of those refugees didn't achieve their goal of a better future, and many died on the way. Some have come back and told us about the terrible ordeal that they went through. But what can they do? Terrible conditions in the camp, no durable solutions in terms of voluntary repatriation. Conditions aren't right in Myanmar, local integration isn't a possibility in Bangladesh, and resettlement is likewise not a possibility.

AW Could you tell us something about the history of UNHCR's operations in the camps?

JM UNHCR has been here as long as the refugees. We and our partners provide assistance and protection, shelter, water, sanitation, hygiene, essential non-food items such as cooking fuel, and many other nonfood items, such as plastic sheets. We also provide nonprofit education to the children in the camps.

Importantly, UNHCR is globally known as the protection agency. We provide protection for the refugees. So we have a permanent presence in the camp Sunday to Thursday, and we're there to address all the needs of the refugees and help them with things like dealing with violence. They're living in such congested conditions with no meaningful livelihoods; the husbands are frustrated and the wives are also miserable, so sometimes violence occurs in the camps. This often leads to domestic violence and sexual and gender-based violence, and we're here to deal with that, because the UNHCR policy is zero tolerance for sexual and gender-based violence.

Child protection is another issue. We want the kids to go to school, but there's no formal education here, and there's no certificate to show after they've finished grade eight. So sometimes the parents just pull their kids out of school. Unfortunately, we sometimes see child labor in the camps. It's difficult to keep the kids in school, unless at some point the government agrees to a formal education. We're working closely with the government on these issues. I'd like to point out that Bangladesh is one of the leaders in the Sustainable Development Goals [UNHCR's "leave no one behind," which includes refugees and stateless people in development strategies], and we want the refugees to be included in this fantastic performance. We want the refugees to be part of that thorough formal education and be able to obtain certificates so when they do go home or to another country, they have a future. They can show that they've been educated and they can find jobs, or they can go on to higher education.

AW How could the international community do more about the situation in Bangladesh?

JM The international community is doing a lot in terms of community-based projects. We have regular donor visits from Dhaka, from all of the embassies, and the ambassadors always tell us that the Rohingya situation is one of their priorities; they also want to find solutions. So we're working very closely with these communities, not only for these 33,000 in the registered refugee camps but also for the 60,000 to 70,000 living in the makeshift camps. But there's only so much they can do with so many competing needs. The Syria situation, South Sudan, Yemen, Mali—there are so many critical hot spots for refugees all over the world. This is just one of many that they have to try to cope with.

AW Can you please tell us about the difference between the official camps and the makeshift camps?

JM The two official camps are Nayapara and Kutupalong. The UNHCR has the mandate for protection and assistance, works closely with the government on the administration of these camps, and provides limited livelihood opportunities.

Then there are two makeshift camps. One is also in Kutupalong, because they're all together in one vast camp. Half is the registered camp, the other half is the makeshift camp. Then there's the other camp, not too far from here, near Nayapara, and there's Shamlapur.

The difference between the registered camps and the makeshift camps is that there's much more assistance provided in the registered camps. We don't see organized livelihood opportunities in the makeshift camps, for example. We don't see refugees' self-management with democratically elected refugee leaders the way we do in the two registered camps. We work very closely with the camp community and with the government, and the refugees are really able to manage their own affairs to a large extent. But in the makeshift camp, it's a little bit different; they're on their own, they don't have organized activities, and they don't receive food from WFP [World Food Programme].

AW Are the undocumented refugees not going to register?

JM They've now participated in the census, and when the results of the census are announced at the end of the year, they'll receive an information card. With the information card, we'll be able to balance out a bit of the disparity between the registered and unregistered refugees. They'll have more access to health services like the registered refugees, and hopefully there'll be more education opportunities as well. So we're hopeful that there won't be such a large disparity in the treatment of the documented and the undocumented refugees soon.

It's the first time in their lives that these Myanmar nationals will actually have an identity document, because in Myanmar they had no document and in Bangladesh until now they had no legal status. Just a simple identity card means a lot to a Rohingya. We may take this for granted in the West, but for a Rohingya, it's like gold to have an identity card. So we look forward to the governments' announcement that the Rohingya and all of these undocumented refugees will soon receive identity documents.

AW The media has reported that the camps might possibly be moved to Hatiya Island. Do you have more information about this?

JM This is one of the government's goals, because, unfortunately and paradoxically, Cox's Bazar is a major tourist destination. You see so many tourists and middle-class Bangladeshis coming to Cox's Bazar all the time. Tourism and refugees don't necessarily mix very well, so the government thought it would be best to move them to a place where they wouldn't interfere with the tourism industry. However, it's not possible if the international community is struggling so much just to get basic assistance in the two registered camps and even less in the makeshift camps. It has even fewer resources to actually move them to an isolated location like Hatiya Island. Furthermore, UNHCR would only be involved in such a decision if the refugees would also agree and want to move voluntarily. But if you talk to the refugees themselves, I think you'll have a hard time finding very many who'll be willing to move. They've made their life here and eventually, when the conditions are right, they'd like to go home. It's just on the other side of the Naf River; they're very close to home now.

AW What's your best-case outlook for the future of the Rohingya?

JM The best scenario is to find durable solutions for these refugees, because their protracted situation, which has now lasted more than twenty years, isn't sustainable. Voluntary repatriation is the preferred solution, if the conditions are in place, so that the repatriation can take place in safety and dignity. Right now these conditions aren't there. Although the new commission that was set up in Myanmar to look at the situation in Rakhine is a very good first step, we're still very far from achieving the conditions and the citizenship rights that the Rohingya deserve in Rakhine State.

So right now voluntary repatriation isn't on the table. Unfortunately, resettlement isn't on the table either. Between 2006 and 2010 we were able to resettle about 900, but that came to an end in 2010. The third solution is local integration. However, Bangladesh is a small country in terms of geography but a huge country in population. A million additional foreigners seeking protection as refugees is a huge problem for the government of Bangladesh, and that's why local integration isn't a possibility.

I think the best solution is a combination of all three options: resettlement, repatriation, and local integration. We have to improve the conditions in Myanmar for voluntary repatriation. The international community has to reopen the resettlement of some Rohingya, and the Bangladeshi government has to work on local integration for some Rohingya who have historical ties, who have had families living in Bangladesh for generations.

AW Could you tell us about Rohingya culture and the possible challenges that refugees might face living in camps?

JM There are similarities between Rakhine State, Bangladesh, and the Rohingya, because they share the same culture and religion. They're very devoted Muslims, the women wear burqas, and they share the same language. So this is one of the historical reasons why the military government of Myanmar didn't accept Rohingya as nationals of Myanmar, because culturally they're closely related to the Bangladeshi population.

But they've been living in Rakhine State for hundreds of years, and that's why they're called the Rohingya and not Bengali. They enjoy many cultural ties with the Bangladeshis, so here they thrive because they can communicate and pray together. There's peaceful coexistence between the host communities and the refugees in the refugee camp. This isn't a closed camp. There's no wall around the camp, and the refugees come and go. They don't have permission to seek employment in the formal work sector, but they find opportunities outside the camp in fishing, construction, farming, and making salt. This brings them very close to their Bangladeshi brothers and sisters, so they live really quite well together in Bangladesh, unlike the problems that you see in Myanmar, where there are such ethnic clashes between the Buddhist majority and the Muslim minority.

AW Where does the term Rohingya come from?

JM My understanding is that Arakan used to be called Rohang. So in ancient history the place where the Rohingya came from was called Rohang, therefore the people were called Rohingya. Over the centuries the other Myanmar people renamed Rohang as Rakhine. However, the Rohingya are very proud of their historical roots. You know they arrived in Arakan shortly after Muhammad, the great prophet of the Muslim religion, and they've been there ever since.

AW Do you think Kofi Annan's appointment to the Rakhine State commission could help the situation?

JM UNHCR welcomes the appointment of the former secretary general of the United Nations to the Rakhine commission. We're very hopeful that it's going to lead to greater peace, stability, and security for the Rohingya, and eventually also to citizenship rights and reconciliation with the other ethnic groups in Myanmar, so they can all live together.

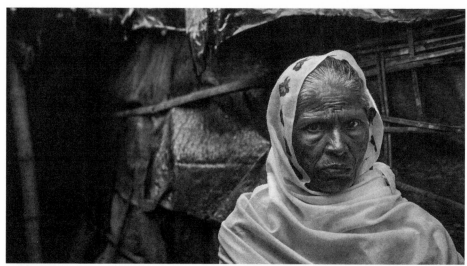

Kutupalong Camp, Cox's Bazar, Bangladesh, 2016

092

Peppi Siddiq, International Organization for Migration
Kutupalong Camp, Bangladesh, 2016-10-03

PS My name is Peppi Siddiq and I've been working here with IOM for the past four years. We have a large program in Cox's Bazar, in the southern part of Bangladesh, where we provide humanitarian assistance to undocumented Myanmar nationals, basically, the undocumented Rohingya population who live in and around Cox's Bazar. Specifically, we have programs in three makeshift settlements. One of them is Kutupalong where we are today. We mainly give access to health care and primary and secondary education and provide clean water and sanitation, promote hygiene in the community, and other basic humanitarian needs. We have a joint program with the World Food Programme that offers a nutrition service for pregnant and lactating mothers and for young children under five. We're just about to start an education program with UNICEF that provides primary education for children between the ages of four and fourteen. The literacy and numeracy around here can be improved, because currently there's no access to education for this large population. The literacy rate is around 26 percent. In total there are around 60,000 undocumented Myanmar nationals in the camps, and on top of that there are smaller settlements in and around Cox's Bazar. So we're dealing with a community of around 250,000.

AW Could you give us some basic information on the demographics of the refugee population in Cox's Bazar?

PS There's just been a government census, which should give us a lot more detailed information. Right now, we have mostly information about the demographics in camps. It's a very young population; the great majority is under the age of thirty-five. There are 6,000 children between the ages of four to fourteen in Kutupalong, which is a very high percentage. A lot of the livelihood here comes from day labor. People go out to crop the fields, work as fishermen, or work as construction workers in Cox's Bazar or around the larger towns. But it's a very vulnerable community with not a lot of access to livelihoods.

AW What sort of rights do the registered refugees have here?

PS Currently the registered refugees aren't really recognized, so they don't have formal rights. The community by and large has been quite accepting and welcoming, and the government has also been fairly permissive in the sense that it allows people to settle here, but they don't really have rights.

AW What are the main challenges that IOM faces in their work in the makeshift camps?

PS We're dealing with an undocumented population, so it requires a lot of goodwill and coordination with the government, the local administration, and other NGOs who work here. It's been quite challenging to ensure that we're all working together and that we all understand what's happening here. We've been here now for three years, and it's gotten a lot better. We also see a remarkable change in the

government's attitude, in terms of the services that can be provided and the kind of work that can happen. Over the past three years health care, water, sanitation, and nutrition have improved quite a bit. There are still areas that we struggle with, particularly when it comes to protection, gender-based violence, access to justice, and receiving police protection. These are areas that we're working to improve, and we hope to see some change in the future.

AW What other issues do the Rohingya refugees who live in the makeshift camps face?

PS When we talk to the Rohingya in the makeshift camps, they're fairly content with the provision of basic services. But the real problems are about the right for the children to go to school and to really get an education. That has been one of the most pressing issues. Thankfully, we can address that very soon, as we're just about to start the education program. Beyond that, it's the overall sense of insecurity. It's the feeling of not really belonging here but not being able to go back home and having been here for twenty years in some cases. But living without papers and living without a future is really challenging to deal with.

AW What do you think is a reasonable and long-term solution to these problems?

PS The long-term solution has to be a political one, negotiated between Bangladesh and Myanmar, the two countries that are currently hosting the population. We're hopeful that there are signs of dialogue with the Kofi Annan commission now in place.

Kutupalong Camp, Cox's Bazar, Bangladesh, 2016

093

Mary Finn, SOS Méditerranée Search and Rescue Team
Sicily, Italy, 2016-10-06

AW Please introduce yourself and tell us something about your experience in Lesvos.

MF I work here as part of the rescue team as a crew member on the RIB-two. Our job is to approach the refugee boats. The culture mediator on the RIB gives a message to the refugees about who we are, that we're a humanitarian organization, and that we're there to rescue the people and try to keep them calm. Our next job is to distribute the life jackets to the refugees. We do this because even when they're calm, things can change very quickly. If the boat capsizes or people start jumping into the water, at least they stay afloat if they have life jackets on, and then we can pick them up more easily. It takes quite a long time to distribute the life jackets to the migrants, so we have to constantly keep them calm and tell them that they're going to be okay. On the last rescue, the boat had more than 700 migrants on board. It's a big challenge for our team to distribute life jackets to everyone and keep the people calm, and then we have to load the people on our RIBs slowly and bring them back to the *Aquarius*.

The Mediterranean is a very different type of rescue from the rescues I experienced in Lesvos. It's way more intense. The rescue took almost seven hours. And it's very easy for things to go wrong quickly. In Lesvos, it was a lot more controlled and calmer. The boats were much smaller and had less people on them. And there were a lot of official rescue boats around, so it was easy to control the situation. We were just taking the people off the rubber boats and putting them onto the authority boats. There was less possibility for things to go wrong.

The skills we learned in the rescue teams in Lesvos are very transferable. I've used those skills here, and it has really helped to improve my work. We do lots of training as a team. It's important that we can work together as a team, trying to do these rescues as quickly and efficiently as possible, to ensure that everybody is safe as quickly as possible. The team has to work fast, and we have to trust one another's skills. We train for mass casualties and how to react if there are many people in the water. We train on how to drive the RIBs in bad weather. We train for many different things, and ultimately, it always improves our rescue skills. I've learned many skills here that I'll continue to use in the future.

AW What about your personal experience? What are your wishes for those people?

MF Our experience on the *Aquarius* is quite different from Lesvos. In Lesvos, after we rescued the people, we'd hand them over to the land teams, and then they'd get processed and sent to the camps. Here we have two or three days sailing with them on the ship to take them to Italy. So you have that real personal contact with the refugees. We get to speak to them and spend time with them. I find this very interesting, because I really have learned a lot about where they're coming from, why they're fleeing, and their stories. It's difficult because they're so happy to be here, to be rescued, and to be on their way to Italy. You really see the joy in their faces; there's so much happiness, especially when Italy comes into sight.

But for me it's difficult to see, because you know that from there on, their lives don't get much easier. The reality of this bad situation in Europe isn't good. The prospects for them aren't good, and it's going to be very hard for them to build a new life in Europe. I like to give them hope and tell them that their life will improve and will be better, but at the same time, it's important that we tell them the reality, that things are going to be slow. They have to spend a lot of time in Italy to be processed and registered. And their hopes of getting to the UK, which a lot of them want to go to, are very slim.

It's important that we give them this information and try to inform them of what their situation is going to be like once they're in Europe. It's always a little bit sad. We spend three days with these people, and you start to get to know them. It's tough to see them go and to say goodbye, knowing that their lives aren't going to be easy from there onward. It's nice to keep in contact with some of them and see how their journey is progressing. Often there are some happy endings, and it's always a pleasure to know that without us, they wouldn't have made it to Europe. It's a really good feeling when they come to us and say, "Thank God, you saved our lives. God bless you," and tell us that we're doing an amazing job. This makes me feel very proud of my work here.

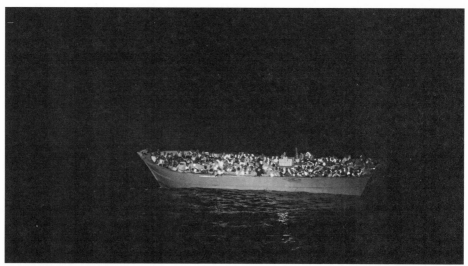

Mediterranean Sea, 2016

094

Alameen Hamdan, *Refugee*
Calais, France, 2016-10-20

AH I'm Alameen Hamdan from Sudan, and I'm seventeen years old.

AW What's the situation right now in Sudan?

AH The situation right now is that I have to stay here and not describe my situation. But this is everyone's circumstance in Darfur and Kurdufān [Kordofan]. This is the effect of war. And then there are problems in my country that are too big.

AW Can you please explain to us why you came?

AH This question is too difficult. I came here from my country, where daily security wasn't good. I regularly saw people die. And the government doesn't respect other people in my country.

AW Please tell us about your trip to France from Darfur.

AH The journey took me around three months. First, I headed to Libya, and then I crossed the sea to Italy to get here. I arrived here four weeks ago. It was the most difficult thing in my life. I nearly died. But on the other hand, I want to change my life, and money is important to bring to my country in the future.

AW Where do you want to go and what's your plan?

AH I want to go to the United Kingdom. My plan is to seek help, first with the language, and then I want to help the UK understand the Sudanese people. The UK government should understand the problem in Sudan.

AW Are you alone or with your family?

AH My family is in Sudan. After I get asylum, I'd like to bring my family to Europe and improve their lives. My family stays in Sudan in centers, like here in the Jungle. Some of my family work as farmers, but there are groups of people who kill and do bad things, not only to my family but to everyone in that area. Night isn't a good time. Security isn't good in my country.

AW How long have you stayed here in France already?

AH I've stayed here for three months. I'll try to go to the UK, God willing. After I arrive, I think the most important thing is to study, then to work, and then to help my family. I need to help with anything my family needs.

AW Can you please tell us about the living conditions here?

AH Anyone can see that the conditions here are bad. It rains daily and we must sleep on the ground. We're like animals here in the Jungle! What is this? I cross borders

to come to Europe to see if anything is available, and then I end up in this Jungle. This isn't good. This is inhuman. They should show consideration for humanitarian issues, because this isn't a healthy environment. The weather is so cold, the food is bad, and the toilets are so bad.

If Europe cares about humanity, as long as there's a camp here, they should respect us and consider us as humans, not keep us among forests like animals. Some say refugees don't understand, but refugees understand everything. People here are sleeping on the ground with a high degree of humidity. We need a solution. As you see, whenever we complain, there are no solutions. It's a big problem, coming to Europe and living in this situation.

AW What do you do every day here?

AH Every day I keep thinking that I've been here for three months, just sitting, not doing anything. I want something new. I've tried several times to go to Britain, but it's not working. The police accuse me of bad behavior and put me in jail without charging me. All refugees suffer from this; they want to reach Britain using cars or trains, but once the French police catch them, they treat them badly. The police hit you, especially in isolated areas. This is inhumane and uncivilized. As for prison, I can't understand why they put us in prison. We don't steal or commit any crimes to deserve to be in prison. Generally, this is how it has been in the last three months. After that, we started to ask for help from the related organizations, to help us to reach Britain, and to help the people who want to stay in France. Unfortunately, so far, there's no solution for both cases.

AW What did you do before in Sudan?

AH I was a student, and I was looking for a respectful life, which isn't available in Sudan. There's no respect for humans. I'm talking about Darfur. There's no problem in the other parts of Sudan. However, the ruling regime applied certain methods to displace citizens of Darfur. They're scattered in camps throughout Sudan and across neighboring countries. We're dispersed with an unstructured social system. It was structured, but the regime destroyed it.

Life in Sudan is unforgettable. Objectively, in my opinion, it was very hard, especially the lack of social life, political life, and economic life. They destroyed the social structure within the Sudanese state. Also, the regime is still ruling the country despite its war crimes. The International Court of Justice wants the president himself because he committed a series of crimes. But until now the court didn't issue any reliable decision to catch this culprit. The president isn't the only one responsible for committing those crimes. There's a group of people around him who shared those crimes in Sudan.

AW Would you like to stay in France?

AH Yes. I'm in the European Union. From a legal aspect, I'd apply for asylum in any country. But as a refugee, I prefer certain countries, like Britain, because they're easier than other countries. In France, there's an important factor, which is the language, and also the French culture. It requires time to learn.

095

Abbas Ali Sabhan, *Refugee*
Mosul, Iraq, 2016-10-27

AS My name is Abbas Ali Sabhan. I was born in 1995, and I live in Qayyarah.

AW What do you do?

AS I'm a student in the sixth grade, in preparatory school. We study construction.

AW About Daesh, what did they do? How did they treat people? What kind of things did they forbid and allow? Give us an idea about your life before Daesh. How did you live, before, during, and after Daesh?

AS Before Daesh, we used to live well. We used to go to school. I was in the sixth grade, in Qayyarah secondary school. On June 10, 2014, Daesh came. They closed the schools and opened their own schools, where they taught fighting and religion, mainly about extremist ideas. When Daesh came, they started controlling how we dressed. They'd say, "This is too tight; this doesn't fit with Islamic law." And they'd take you, punish you, and put you in jail. We used to go out before Daesh came, especially for celebrations, and no one asked where we were going. We used to go to Mosul, but when Daesh came, we couldn't go to Mosul or Kirkuk or anywhere else. You had to stay in your district.

If you tried to go to Mosul, for example, they'd immediately catch you and put you in jail. The punishment could be the death penalty. If you went out, you'd be caught and jailed or maybe killed. We were starving. They'd beat you and insult you, take a fine from you and punish you. You can't even smoke cigarettes. They don't let women dress as they wish. A woman needs to wear a hijab; if not, they'd take her and her husband, and beat him and put him in jail.

In 2015 I started working against them. I entered their places at night. I took their weapons, and if they had cars outside, I took the petrol or their batteries. They caught me in 2016 and took me to the Islamic police, as they called it, for investigation. They tortured and beat me, and then they sent me to court. I was jailed for one month. You don't see the light or sun, only torture, whipping, and so on. They told me, "Join us and you can be free." After one month, they brought me to the Qayyarah marketplace. They invited a lot of people and cut off my hand in the marketplace.

But now we're free. We're finally rid of Daesh. Now life is like it used to be. We go out freely and you can wear your beard and hair as you wish. No one asks you where you're going or where you're coming from. The schools are opening again.

AW Abbas, what came to your mind when Daesh brought you to the marketplace and cut off your hand?

AS I was depressed and psychologically broken. I lost a part of my body that I'll never get back. It's irreplaceable. Now, I don't want to go back to that marketplace; I don't want to see it.

During the war, Daesh was always attacking, bombarding us with shells fired from a mortar, randomly shooting civilians and pretending that the military was shooting! There were many mortars that wounded civilians. It's impossible to find a house in Qayyarah that didn't get shelled. Before they withdrew, they found an oil well and used it to harm civilians. They ruined it and bombarded it.

AW You're a student and you can't go to your school. As you see the view behind you, all this smoke and devastation, do you still have hope?

AS I'm a student, but they cut off my hand and I can't write with my left hand. So now when I see students going to school, I feel broken inside because they ruined my future. I'm depressed because I can't finish my studies and go to university. I can't work either. I can only stay at home.

AW How do you see the future? How do you feel after you lost these two years in this war?

AS During the Daesh occupation, we lost hope that we'd get back our freedom. They made us believe there wouldn't be a school or government anymore. They made us think only about destruction, bombardments, and killing. We weren't able to think about the future, only about how to survive. They were killing, devastating people, and educating kids about fighting, teaching a whole generation about murder. They taught them that the military and the police officers are faithless and that they must kill them. They didn't do anything to serve people.

AW What's your message to the world?

AS Don't be with Daesh. Daesh has extremist thinking. They kill and slaughter. They don't represent Islam; they just use Islam to kill. They're godless.

096

Gérard Dué, *Croisilles Mayor*
Croisilles, France, 2016-10-31

GD My name is Gérard Dué. I've been mayor since 1995 in the municipality of Crois-
illes, an urban area in the community of Arras. Our 1,900 inhabitants have access
to everything you can find in a town, with many organizations and a young
population. It's quite a dynamic place.

I'm sixty-five years old. As mayor, I'm also vice president at the Community of
Municipalities and hold positions at the Federal Department of Energy. I devote a
lot of time to moving town projects ahead. We built a new police station, a
retirement home, and we're about to build a center for waste recycling and a
health center. You can see that Croisilles is a town with a lot happening and it's
central compared to neighboring municipalities.

AW Did you grow up in this municipality?

GD I was born here in 1951. I think I'm the last mayor to be born in this munici-
pality.

AW From a personal point of view, as a French citizen, what do you think of the
migrant crisis, and especially the migrants who are coming to France?

GD I prefer to talk about refugees, because the people who come here now are human
beings fleeing war, religious conflicts, and dictatorships. We need to refocus on
this when we consider refugees' issues, such as the problems at the Calais
Jungle. We might be paying for years of mistakes in countries where our prede-
cessors sought resources such as ore and oil. I think we're experiencing a
boomerang effect of colonization.

These people didn't come here for pleasure. They fled their countries and went to
sea on old rafts. So what do the Italians do? Either they let them sink or they cut
open the barbed wire fences at the border and welcome them. Today we're
welcoming them, but we need to put them somewhere. It's a humanitarian
disaster.

AW We heard many things regarding the CAO [Centres d'accueil et d'orientation], the
reception and orientation center in your municipality. Can you please explain the
history of the CAO?

GD The CAO wasn't planned for the region of Pas-de-Calais. The prefect wanted it. The
Jungle was supposed to shut down on October 17. She wanted to create a CAO, so
she asked the deputy prefect of Arras to find a location for one. On Sunday
morning we met with the deputy prefect, the director of the association La Vie
Active, and other staff. My assistant visited the location to see if it was suitable.
On Monday, La Vie Active, the operator that manages that building, checked the
premises for functionality and assessed the budget. On Tuesday, the firemen
checked security. Everyone agreed to receive the refugees. When we held a

meeting Thursday evening, I was stunned to see more than 200 people chanting "No to the migrants" in front of the town hall.

I explained that there are 164 CAOs in France, but the crowd apparently was led by people with personal agendas, perhaps negative views of me or the town council. We invited a number of protesters in to address their questions, many of which we'd already asked ourselves concerning the deputy prefect and the director of La Vie Active. We answered questions for an hour and a half, and protesters left the room more or less relieved, saying, "We'll see."

After the vote, with nine in favor of receiving the refugees, four against, and two abstentions, the town council ruled in favor. Unfortunately, we had to be escorted to our cars by the police.

On Thursday, Friday, and Saturday evenings, about 150 people, led by Aurélien Vérasseine from Génération Identitaire [a French nationalist political movement], who opened a coffee shop that serves as a private club for members of the Front National [right-wing political party], visited the councillors who had voted in favor. They also visited me and bombed my house with eggs. Some associations asked to delay the closing of the Jungle, so it was postponed until the 24th. There were minor demonstrations all week, and on Thursday we held a public meeting for registered residents of Croisilles.

More than 200 people attended, including the deputy prefect, director, myself, regional counselor, deputies, and even the priest. The authorities who tried to answer questions were interrupted by individuals who sought to disrupt the meeting rather than understand the situation. After a while, things settled down and answers could be heard. Little by little people left and encountered members of Génération Identitaire and the Front National outside, who were shouting "Death to the migrants." Under warning of possible arrest by the deputy prefect, protests continued over the following days but with less intensity and fewer participants; perhaps fifty or so remained. On Monday afternoon we welcomed about thirty refugees who arrived from Sudan to the applause of around forty people from Croisilles who were ready to help them.

Today there are more than a hundred people ready to help refugees. We have to manage the volunteers, because everyone wants to do everything, but that's not possible. We must determine what these refugees need. The first thing they want to do is to learn French, so we have a few teachers and they've already started teaching with games. We also have doctors, pharmacists, and nurses, so we'll open a hospital soon. We're having a meeting this Wednesday to focus on that goodwill and to assess what they can contribute to help the refugees integrate as soon as possible.

AW What's the most radical change in your daily life as a mayor now that things are set up?

GD The most radical change was seeing, in these demonstrations, hatred in the eyes of people with whom I had interacted every day. It's complicated to determine how to coexist with people who so easily turned to hate. That, I think, will be a

difficult challenge. Their behavior worries me because if they are selfish people who think they're superior to those who are trying to understand, we'll have a great divide. For example, there are people at the bike club who are wondering if they're still going to associate with the same people.

Today, when people who earlier demonstrated against migrants come here, we take them to the CAO to show them that refugees are human beings. They have a head, two hands, and two arms. One man, who at first was a bit annoyed that his son had made a drawing for the refugees, changed his view after his son spent an afternoon playing table tennis with the refugees. The next day, the man returned to drive some of the refugees to football. I'd say more than three-quarters of demonstrators will open their minds based on their experience at the CAO. But others could remain full of hatred.

AW Are you worried for France?

GD Yes, I'm worried. We blame the current president [François Hollande] for everything, but people don't know why they blame him. Today, people want everything. As soon as there's unemployment, it's someone else's fault. In 1940 it was the others' fault, it was the Jews, and so on. We saw where this led. It's the fear of others. We as individuals need to get involved in associations, in political movements. We shouldn't expect everything from others either.

AW Do you think these refugees can integrate in France?

GD Yes. They're not idiots. They had to plan for their departure and their arrival in Calais. Some had financial help from their families to escape wars, religious issues, and so on. These people will study, learn to speak French quickly, and try to find a job, any job. They will work to succeed and return the favor to those who helped them. Here in the Nord-Pas-de-Calais, we have Italians, Poles, Portuguese, and Spaniards, and today all these people now have the upper hand. Similarly, the refugees who never stop striving will integrate very quickly.

097

Anonymous, *Refugee*
Paris, France, 2016-11-01

Water for free,
as well as electricity,
everything is available
and affordable.
Thank God we have something to eat
and something to drink,
and we're not looking for hotels.
It's enough for us to stay here.
It's comfortable,
and we don't want anything more
from them.
I'm thanking God
they brought me here,
to Paris. We could only see Paris
through the television.
And we could only see the Eiffel Tower
on perfume bottles.
Now we saw it with our eyes.
We are staying here in the streets
and we were offered
some help by French people.
They offered us free beer,
the bars are open,
and there's freedom everywhere.

098

Nezir Abdullah Ali, *Refugee*
Mosul, Iraq, 2016-11-02

NA My name is Nazir Abdullah Ali and I'm thirty-six years old. I've been working in thermal power, in electricity production, since 2006. I have two brothers, three sisters, and my mother. My father died in 1988.

Qayyarah is a popular area, and we were always known to cooperate with each other before the Americans entered. After the Americans, we suffered from the siege. ISIS began to appear at the end of 2003 or at the beginning of 2004 after the army and the police formed. They began to kill soldiers and policemen and accuse them of working with the Americans. Since 2004, ISIS was setting off explosions and car bombs in crowded markets. They were blowing up police and army houses and murdering people in the market.

We were suffering from these problems until 2014, when ISIS entered Mosul and the security forces suddenly withdrew. Until now we don't know what happened. As we slept, the security forces, the police and army, were in Mosul and Qayyarah. When the morning came, the security forces were withdrawn from Mosul, Qayyarah, and everywhere. After that, ISIS appeared. We didn't know the people who said they were from ISIS. They were ordinary people working with ISIS. We suffered killings and harassment. Many people left their shops and employment. There were no longer any salaries because of ISIS.

They made people follow rules, such as wearing a beard and long clothes, and those who didn't follow were punished with flogging, murder, and insults. Those who owned mobile phones, such as our neighbors, were accused of communicating with security and executed. ISIS took children from their houses and accused them of being smuggled into the land of the infidels. They call these lands outside their mandate "infidel lands," but the lands within their mandate are called the "land of the caliphate."

Since June 10, 2014, we suffered greatly from these problems until security forces started liberating provinces. For two years, two months, and fifteen days, Qayyarah was occupied by ISIS. The operations began and families were hopeful during the battle. Everyone knew that the citizens of Qayyarah helped the security forces, and the security forces were cooperating with the local people.

On August 25, 2016, Qayyarah was liberated. We thank God that we got rid of ISIS's ideology and injustice. We as citizens felt safe, and we still feel like that, praise and thanks to God and to the Iraq security forces, which freed the citizens from the injustice of ISIS. The markets were opened. But ISIS began burning oil wells, and we've suffered from this problem for more than five months. During the battle they burned oil wells in the middle of the city near the Qayyarah hospital. My house is close to that hospital, and I had to leave it for more than two months. I came back today to my house and I'm cleaning it now. As you can see, I'm wearing cleaning clothes. The well hasn't been treated or extinguished so far, but the company promised us that in two or three days they'll extinguish the fire.

If anyone from the state or international organizations can help us to extinguish these fires, we'll be thankful, because they've harmed us and all of our children, our homes, and the whole region. We hope that anyone who cares about us can cooperate with us to turn off these wells. As citizens we can bear anything and everything; we can carry on without electricity and without water. Despite all this, we thank God, and we can now bear everything except ISIS. We returned to our normal life and the markets opened. I came back to my job and thank God, today I received my first salary since ISIS left. So, thank God, the next days will be better than what passed before.

AW What about war and peace?

NA War is destruction for countries, infrastructure, and all people. We love peace.

Islam is a religion of peace, forgiveness, and cooperation. I wish that ISIS hadn't destroyed the appearance of Islam in front of other religions and all other people. ISIS doesn't represent Muslim people. Here we're all Muslims, and we know the truth of Islam. Islam is peace. ISIS is the opposite of Islam. Islam prohibits killing oneself without reason and prohibits stealing, so Islam is a religion of peace. I hope that peace spreads to all the world.

Thank God that the security forces helped citizens with bombs and mines. They were telling the citizens that the houses were full of bombs and explosives. My cousin found a bomb and took a picture of it by phone, then went to the police and told them about it, so they dismantled the explosives. Anybody who finds a bomb can tell the security forces, because they're professionals and will do their job. But thank God we only found one bomb in Qayyarah at the beginning of the liberation. It exploded on someone and he died. That was the only one in Qayyarah; it happened when the security forces were busy. After this there was cooperation between the security forces and the citizens in all ways, like with electricity and water. I don't want to praise myself, but I work with electricity, so I helped them if they needed anything, and all the citizens did the same.

AW What's your message to the world, the Security Council, or the United Nations?

NA We want to send a message to the world that we in Iraq are tired. I'm thirty-six years old. In my first year, the Iran-Iraq War went on for eight years. After that Iraq invaded Kuwait and the siege happened for thirteen years. Then came the ISIS occupation. I've lived just one year of my life without war. So I wish for the world to hear this message: We say *enough* of wars and destruction. All people were hurt from this war. Everybody should live in peace and all countries should have freedom.

AW What do you expect for the future?

NA We're optimistic for the future because this war with ISIS united the Iraqi people. There are no longer differences between us. They were thinking about dividing us, but on the contrary, we're now united. Now the people from the south— Baghdad, Al Anbar, Salah, Aldeen—are all united from fighting against ISIS.

We hope that all of Iraq will be free like Mosul, as well as other areas still controlled by ISIS, because they're killing a lot of people. God willing, it'll be finished forever and peace will be everywhere in the world.

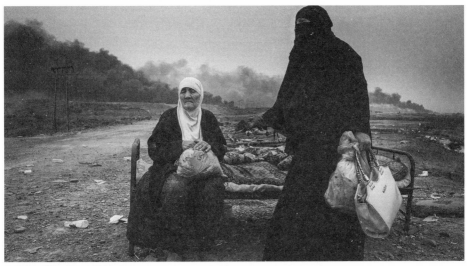

Outskirts of Mosul, Iraq, 2016

099

Bruno Geddo, UNHCR
Erbil, Iraq, 2016-11-16

AW What is the general situation of the IDPs in Iraq? How many are there and where are they from?

BG The situation is dramatic. We have 3.4 million IDPs in Iraq since January 2014, and we still have the old group of IDPs of around one million from the late 2000s when there was another war going on. We're expecting as many as another million from the Mosul offensive. If we put all this large-scale displacement together, this requires an enormous amount of resources to respond to. These displaced Iraqis will have been victimized twice: first from the war and then when they don't receive adequate humanitarian assistance here.

AW Do you think that the humanitarian organizations are ready for the upcoming crisis in Mosul? What are the expected numbers?

BG It's going to be a massive challenge. We're building camps at a frantic pace. There will have to be a mix of options. If you count 700,000 IDPs in need of shelter, not all of them will be able to find shelter in UN camps. There will be a need for emergency sites and for sponsorship. Sponsorship will enable a substantial number of displaced Iraqis to find a temporary place to stay. Important sources for sponsorship include tribes, family and friends, the West Asian Football Federation, mosques and religious institutions. Our policy is a roof over every head within twenty-four hours of arrival. So far, we've completed five camps and we can accommodate 45,000 people.

AW How does the UN carry out humanitarian efforts in Iraq, and what are the main challenges in your work?

BG First of all, we don't carry out humanitarian efforts alone. We operate in a system where each agency specializes in certain sectors of activity in the humanitarian sphere. UNHCR takes care of shelters that are given to families when they've lost everything. When they escape and reach our camps, which are under our management, we set up a new zone under a tent. We take care of the protection side of things and help people who've been deeply traumatized find a new balance and begin a new life.

Having to respond to displaced Iraqis who've left everything behind—very often in a state of panic, as they've had to run for their lives—is a major challenge. They need to restart a new life in a camp under a tent with very basic facilities, and this is all they have. We need to provide food, water, hygiene, and shelter. We need to manage that aspect of these camps, but we also need to provide protection. Protection has many dimensions, but one of the most important ones is that because they had to flee for their lives and are deeply traumatized when they arrive, they need deep psychosocial counseling so the will to begin a new life is restored. We help them look for jobs so they can provide for their families, and we help them register for identification documents, so they have access to services

like education and health care. Helping them heal from the trauma of being displaced is equally as important as providing material assistance, as it helps empower them to start a new life.

But the mandate of UNHCR also has another side, which is providing solutions. UNHCR is active in terms of facilitating peaceful coexistence and social cohesion between communities who have returned. On the one hand, we have 3.4 million displaced Iraqis, but we also have 800,000 who have already returned, and these 800,000 also need some assistance to rebuild their property, acquire basic services, and reintegrate into their communities.

AW How do you see the future of Iraq in the next years?

BG I think we're at a turning point. If the Mosul operation is successful, Iraq may be able to finally turn the page after forty years of intermittent wars. Iraqis may be able to find the will to live together, reconcile, and go beyond the sectarian, religious, political, and tribal differences that have divided this country for so long. We help those who return to rebuild their houses and basic infrastructures, so that they can reintegrate in their communities and resume normal lives.

Two of our major objectives are peaceful coexistence between communities and social cohesion between those who left and have returned and those who've never left but equally suffered by staying behind. We don't want anyone to be left behind. It's key that people start talking again. So we do activities that bring people together. We repair marketplaces, do garbage collection, plan agricultural projects, and bring people together, encouraging conversation between them. When you talk to each other and trade with each other, you're better able to understand each other and to live together peacefully.

AW Do you expect many Iraqis currently seeking asylum overseas to return to Iraq in the near future? What are the economic, social, or security obstacles facing the returnees?

BG This is a difficult question. Iraq has suffered through forty years of wars since 1975, 1980, 1991, 1993, 1996, and 2014. The people have never had time to get relief or catch their breath. It's a deeply traumatized country. I believe passionately that the international community has a role to play in helping Iraqis turn this page, to reconcile among themselves. This may be the turning point. If ISIS is removed from Iraq, a new page could be turned. Iraq needs all the support it can get from the international community in terms of political, financial, and, of course, humanitarian support and development assistance. The international community shouldn't succumb to fatigue because of forty years of intermittent wars.

I'm aware that there've been many thousands of Iraqis seeking asylum in Europe and elsewhere over the last two years. This is a painful story. And I'm aware that there are some minorities who have concluded that their only possibility for physical survival and to maintain their identity is to move to another country. But we shouldn't give up. Let those who have legitimate asylum claims, who are fleeing persecution or war, be recognized as refugees. Our hope is that, eventually,

Iraqis will be willing to return home. They long for belonging and they miss their home. It's just a matter of making them feel secure enough in a future Iraq, particularly for members of minorities. Exile and asylum is needed when you're fleeing for your life; if you need protection, it should be provided in Europe. But the eventual answer for many of these Iraqis now abroad would be to return home. As UNHCR, we'd love to be part of the solution in helping them return home when they feel they can safely do so.

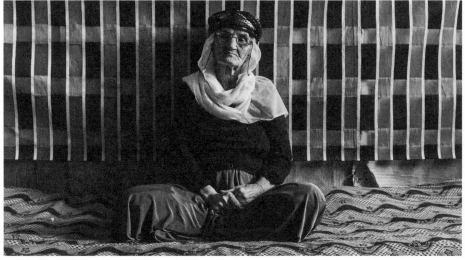

Erbil, Iraq, 2016

100

Namshah Sallow, Refugee
Erbil, Iraq, 2016-11-16

AW Grandmother, what's your name and where are you from?

NS I'm Namshah Sallow from Bahzani village in Bashiqa province.

AW Tell us the story of how you left Bahzani and came here.

NS Oh, the situation was bad. We just escaped without any plan. I said, "I swear I won't leave; what would ISIS do to me?" They replied, "What are you saying, dear? They're looking for beautiful women to have sex with, they take drugs, disrespect everyone, and cut off heads." So I left everything I own—my head coverings, my accessories, everything. Now they've burned it down. Allah knows. In the entire village, they only burned down my house. It was a small house; it wasn't a big castle, and it was old. My children are all married and built their own houses. I was the only one left there. I stayed in my old house with a married girl, and I was alone. Well, they came and said, "Let's go." I said, "What does Daesh have to do with me? I'm an old woman." They said, "Don't believe that. They're heretics. If they come here, they'll immediately start beheading people." So I agreed, "Hurry, let's go, we're escaping."

We were going to stay for one night in Shekhan, but they said that Daesh had arrived there, so we came here. We sat on the street until the afternoon. We don't have anyone to help us or any money for rent. My child came and said, "Mom, my friend works in this building, a liquor store." We went there and he invited us in.

There were five families there. The floor was very dirty, with gravel and stones everywhere. There were cement cinder blocks and no running water and electricity, but it's better than sitting on the road. Our neighbor brought us food, and the liquor store owner gave us a blanket to sit on. What could we do? We were shivering from the cold. There were twenty people staying in a room like this one, and all there was were four walls. Really, we've been living in fear for one month. When our elders came, I told them that we're living here in fear. What if a drunk man came and killed us? So they got us doors, curtains, and something like a carpet that we can sleep on.

AW Grandmother, when you left Bahzani, did you see Daesh?

NS No, we didn't. They just told us to leave, but one person came to our coffee shop that had been burned down. My child came and said, "You must leave immediately." They said, "Only the Yazidi devils are left." In Bashiqa and Bahzani we are Yazidis. We're afraid of the Christians. They haven't taken control of Qaraqosh yet. Really, everyone is on top of one another. From 4:00 a.m. until 8:00 a.m., we entered Mahatiya. They told us that four cars had entered Bashiqa. We were the last people to leave.

ISIS said, "We're going to Bashiqa and Bahzani to oppose the Yazidis." They've taken all Yazidis from Sinjar. There are only Yazidis in our village, no Muslims or Christians. For 300 years our ancestors have been Yazidis. We continue their traditions. My own grandmother was a hundred years old. I remember her from when I was little. She spoke about a time when Muslims came to our village and told us we must convert or they would kill all of us. We said we didn't want to become Muslim, and they should kill us immediately. We were praying in our own way, "Saka, saka, saka." We have seventy elder sheikhs, and we were praying to them and God to save us. In Iraq, there aren't even one million Yazidis because of beheadings and killings. They don't let us increase our population. They keep killing us. When I look at other religions, they all have large populations, like the Christians and the Muslims. But the Yazidis' population is low. They give the orders from one side and they kill us.

AW What difficulties did you face on the way to the camp?

NS They were raping the women, and they kept trying to kill us. We didn't have any way to fight back. We only had one Kalashnikov and there were only fifty bullets in the cartridge. That's only three shots—pow, pow, pow. Our possessions, our stuff, and our blankets could be lost, but what's important is to keep our honor.

AW Did you all escape?

NS Well, no. One person died from thirst and hunger. His name was Abdal Karat. He died on the mountain road and fell there on the ground. Only two people stayed behind, an elderly husband and wife. ISIS came to the door and asked why they didn't leave, and they said, "We're old; we don't have the strength to escape." ISIS said, "Will you become Muslim, or should we kill you?" Out of fear, they said, "Yes." When ISIS was searching the other houses, the couple escaped through a mountain road. They reached the mountains, and when a man from there asked them where they'd come from, they said, "We came from the village." After the woman begged, the man agreed to let them stay, and he took them to Shekhan. Those two were the only ones left.

AW Is there news from Bahzani about your home?

NS They've destroyed 150 homes. One hundred houses have been burned. The first house was mine and my coffee shop. The refrigerator, the gas tank, the stove—it's all gone. It has been three years that they've left the house empty. Daesh wasn't stealing; it was the Shebek people, or the Fadhliya people, or the other nearby villages were stealing stuff. Among the thieves, there are Shias. The Shias didn't escape, only the Sunnis. The Shias stole. ISIS didn't steal.

AW What would they do with it?

NS Daesh is looking for money and women to deflower, and they're looking for gold. Otherwise, they're looking for someone to behead. Daesh doesn't steal household items. The neighboring villages come and steal stuff. Now Bahzani and Bashiqa have been saved, and ISIS has been defeated there.

AW Are you thinking of going back if it's safe?

NS No, we won't go back, because there isn't water or electricity. Everything has been trashed and burned already. Should we just sit outside? There are no stores or markets, no butcher. What will I do?

AW Do you prefer to stay here?

NS Not forever, no. There isn't any room here. I'll go to Shekhan. The rent is 150,000 dinars. I'll go with my daughter. What can I do in Bashiqa when it's in such a bad state?

AW How do you get money to buy food?

NS Allah sends it to us.

AW What do you mean? Do you have a son?

NS He was executed. We get his pension.

AW How did they execute him?

NS Saddam executed him. Saddam Hussein and his party executed him.

AW Tell me his story.

NS He was eighteen years old. At seventeen, he missed his army service. In 1982, they played music and danced, and on his way from Bahzani to Bashiqa, they asked for his ID. He said, "I don't have one." Then they threw him in prison for fifteen days. In 1982, Saddam decided that the people in prison should be executed. We thought it was a joke. But it wasn't. Fifteen days later, they took him home. People came from Bashiqa so they could see him. His father was handicapped. They wanted to execute him on an electric pole. Other people said, "They're old; don't do it here in front of their house." So they took him to the other side and executed him there and then brought him to us.

He didn't do anything. He only missed forty days of military service. He was in Halabja. His commander told him to use chemical weapons like a pesticide, and he did it. They really hit Halabja with chemical weapons. People fell to the ground like dead bugs. Someone snitched on him, and they executed him. Saddam, you're the president. Issue a general pardon for all the people. He'd become crazy. In that village, a man lost two children. He said, "Please spare me my third child." They executed him too. Let's pardon all the people. The people will love you and applaud you. If someone is a tyrant, they'll be repaid with tyranny.

AW If your family wants to take you out of Iraq, would you go?

NS No, really, no. My child has been out of Iraq for ten years and he invited me, but I didn't go. He asked me three times before I became a refugee. I don't like it abroad. I think that Iraq is better for me personally. Some people like it; some

don't. If I'd have liked it abroad, I would've gone six years ago. My child was asking me to go before Daesh came.

AW Where is your child?

NS He's in Germany.

AW In which city?

NS I really don't know. I spoke with him yesterday.

AW When your area is saved from ISIS, will you all live together? I mean the Yazidis, the Muslims, and the Christians? Would you have a problem with that?

NS No, no, we used to have a Muslim house in our neighborhood, they lived just like the Yazidis. They'd come visit us. When a sheikh comes to us, we pray for them for 5,000 dinars. We had two neighbors, Hassan Rahu and Khakil Davud, really good people. They like our religion. They made a gravestone next to our graves. They said, "We don't want to bury our dead people in the mosque." When two of their people died, they buried them in our graveyard. Muslims and Yazidis are equal, but the Yazidis are oppressed. There are no Yazidi representatives in the government.

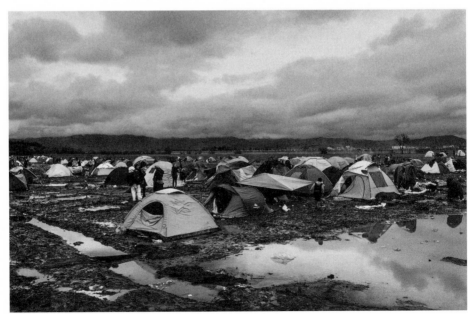

Makeshift Camp, Idomeni, Greece, 2016

Timeline

1916 The United Kingdom and France sign the Sykes-Picot Agreement partitioning the Ottoman Empire. This agreement gives Britain control over Palestine, Jordan, and southern Iraq; France gains control over Lebanon, northern Iraq, Syria, and southeastern Turkey. The Agreement also determines the modern borders of the Middle East according to the colonial powers' interests, ignoring ethnic and religious groupings.

1917 The UK promulgates the Balfour Declaration supporting a "national home for the Jewish people" in Palestine. This is followed by the League of Nations' mandate for the British administration of Palestine, which lasts from 1920 to 1948.

1945 The Second World War ends, leaving 40 to 60 million persons displaced around the world.

1947 The United Nations recommends the partition of Palestine into Jewish and Arab states, which the Arab leadership in Palestine rejects. This triggers the first stage of the Arab-Israeli war, also known in Arabic as *al-Nakba* ("the catastrophe") and in Israel as the War of Independence.

1948 Israel declares independence on May 14. On May 15, Egypt, Iraq, Jordan and Syria invade Israel and Palestine, starting the second stage of the Arab-Israeli War. 750,000 Palestinian Arabs flee their homes and seek refuge in Jordan, Lebanon, Syria, and other neighboring countries. The United Nations Relief and Works Agency for Palestine Refugees in the Near East (UNRWA) is established to provide medical aid and education for these refugees.

The Ain al-Hilweh refugee camp is established in southern Lebanon by the Red Cross to accommodate Palestinian refugees. Today, it is Lebanon's longest-lasting refugee camp and houses 120,000 refugees, including those fleeing the Syrian civil war.

From 1948 to 1951, around 700,000 Jews, including many displaced from the Second World War, immigrate to Israel from European and Arab countries.

1950 The Office of the United Nations High Commissioner for Refugees (UNHCR) is created in the aftermath of the Second World War to help the millions of refugees in Europe.

1951 The UN adopts the 1951 Refugee Convention, which states that persons with "a well-rounded fear of being persecuted because of his or her race, religion, nationality, membership of a particular social group or political opinion" qualify as refugees. The 1967 Protocol would later broaden the Convention's scope to reflect the global dimensions of displacement.

The Provisional Intergovernmental Committee for the Movements of Migrants from Europe (PICMME) is created in Brussels as an operational and logistics organization facilitating the movement of refugees, economic migrants, and internally displaced persons. The PICMME would eventually become the International Organization for Migration (IOM) in 1989.

1964 The Palestine Liberation Organization (PLO) is established by the Arab League.

1967 During the Six-Day War, Israel takes control of the Gaza Strip and Sinai Peninsula from Egypt, East Jerusalem and the West Bank from Jordan, and the Golan Heights from Syria. Around 200,000 Palestinians are displaced, many for the second time after 1948.

1973 In the 1973 Arab-Israeli War (also known as the Ramadan War or Yom Kippur War), a coalition of Arab states led by Egypt and Syria launch a surprise attack on Israel.

1975 The Lebanese Civil War begins and lasts until 1990. 120,000 people are killed, over one million displaced outside Lebanon and 75,000 internally displaced.

1977 Burma launches Operation Dragon King in Rakhine State, stripping the Rohingya ethnic minority of Burmese citizenship. 200,000 Rohingya flee across the border to Bangladesh; however, most are repatriated to Burma.

1978 Israel, Egypt, and the U.S. sign the Camp David accords in which Israel establishes diplomatic relations with Egypt and agrees to Palestinian autonomy for Palestinian inhabitants of Gaza and the West Bank.

1979 The USSR invades Afghanistan and supports its communist government in its war against the opposition groups, known as the mujahideen, backed by the U.S., Pakistan, and other countries. By the year's end there are 400,000 Afghan refugees in Pakistan and 200,000 in Iran.

1982 As the Lebanese Civil War rages on, Palestinians are massacred in Beirut's Sabra and Shatila camps by the Israeli-backed Lebanese Christian Phalangists.

1985 Under the reformist Mikhail Gorbachev, the USSR prepares to withdraw from Afghanistan by training and equipping the Afghan army against the mujahideen.

1987 The first Palestinian intifada begins in Gaza and the West Bank. Gaza's Muslim Brotherhood forms Hamas, the political and military organization.

1988 The US, USSR, Afghanistan, and Pakistan sign the Geneva Accords, formalizing the Soviet Union's withdrawal from Afghanistan and setting a timetable for Soviet troop withdrawal.

1989 The last Soviet troops leave Afghanistan as the country disintegrates into civil war. Over six million Afghans are refugees, mostly in Pakistan and Iran.

Burma is renamed Myanmar in the wake of a military crackdown. The Burmese military increases its presence in Rakhine State, leading to reports of human rights violations against the Rohingya. 250,000 Rohingya flee to Bangladesh.

1990 The Dublin Protocol, which assigns responsibility for processing an asylum application to a single EU Member State, is established by the Dublin Convention and open to accession by the countries of the European Community, Norway, and Iceland.

1991 The Kutupalong and Nayapara refugee camps are established in Cox's Bazar in Bangladesh. These would eventually become part of the world's largest refugee camp in 2018 with over 550,000 Rohingya refugees.

1992 Kenya establishes the Dagahaley, Hagadera, and Ifo camps in the town of Dadaab to house refugees fleeing the Somali civil war. In 2011 a new wave of refugees from severe drought in East Africa arrives, making Dadaab the then-largest refugee complex in the world with over 439,000 refugees. The new camps of Ifo II and Kambioss are added to accommodate the influx, and later closed in 2017 and 2018 as Dadaab's population declines.

1993 Israel and the PLO sign the Oslo Accords marking the end of the first intifada and the start of the Oslo peace process. Oslo I is signed in Washington, DC, in 1993 and Oslo II in Taba, Egypt, in 1995. The Accords include provisions aimed at establishing Palestinian autonomy, inter alia, by creating the Palestinian Authority responsible for limited self-governance in the Gaza Strip and West Bank and acknowledging the PLO as the legitimate representative of the Palestinian people.

1996 The Taliban, a Sunni Islamic fundamentalist political movement and military organization, comes to power in Afghanistan. Under their rule, between 500,000 and one million civilians are internally displaced.

2000 The second Palestinian intifada begins in which 1,000 Israelis and 3,200 Palestinians are killed.

2001 The US invades Afghanistan following the September 11 attacks, purportedly to overthrow the Taliban and stop the country from being used as a base for terrorist operations. Hamid Karzai is sworn in as the head of an interim Afghan government. Five million Afghan refugees are repatriated from Pakistan, Iran, and other countries in the following years.

2003 The Dublin Convention is replaced by the Dublin II Regulation, which aims to prevent asylum seekers from submitting applications in multiple Member States.

A US-led coalition invades Iraq, overthrowing Saddam Hussein's government and starting the Iraq War, which would last for the next decade. The Bush administration justifies the war by asserting that Iraq possesses weapons of mass destruction.

2005 Iraq holds multi-party elections in which Nouri al-Maliki is elected prime minister. Under his reign, sectarian tensions worsen and the country is wracked by civil war leading to an estimated 2.3 million refugees leaving the country by 2008; 1.7 million are internally displaced.

2007 Hamas asserts control over the Gaza Strip after Israel's unilateral retreat in 2005. In response, Israel and Egypt impose an ongoing land, air, and sea blockade on the Gaza Strip and its two million residents.

2011 The Arab Spring, a series of popular uprisings against economic decline, corruption, and government oppression, spreads across the Middle East and North Africa. It begins in Tunisia in December 2010 and spreads to Egypt, Syria, Yemen, Bahrain, and Libya, among other countries. Authoritarian crackdowns result in the majority of revolutions dying out by mid-2012.

In Syria, however, the rebel Free Syrian Army is formed and mobilizes against Bashir al-Assad's authoritarian rule. Two peace initiatives by the Arab League are unsuccessful.

President Obama's withdrawal of US troops from Iraq is followed by two years of Iraqi insurgency and violent sectarian conflict.

2012 The Syrian civil war escalates after a failed UN-mediated ceasefire into a proxy war, with the rebels backed by Qatar, Saudi Arabia, Turkey, and the US on the one hand, and the Syrian government by Iran on the other. Various peace initiatives by Kofi Annan and Lakhdar Brahmi as Joint Special Envoys for the United Nations and the Arab League, the Geneva I Conference, and the 16th Summit of the Non-Aligned Movement in Iran are all unsuccessful.

750,000 Syrian refugees flee to Egypt, Iraq, Jordan, Turkey, and other countries. Jordan opens the Zaatari Camp in July 2012 to host Syrian refugees. By 2013, more than 156,000 refugees live in Zaatari.

2013 The Dublin III Regulation replaces Dublin II and applies to all European Commission states except Denmark. A responsibility-sharing mechanism is introduced in the recast Regulation to relocate asylum seekers from frontline Member States like Italy and Greece which receive disproportionate numbers of arrivals.

2014 The Islamic State of Iraq and Syria (ISIS), a Salafi jihadist militant group, launches broad military offensives in northern Iraq and declares a worldwide Islamic caliphate. ISIS takes control of Fallujah, Mosul, and Ramadi; 500,000 civilians flee from Mosul alone. From 2014 to 2017, almost six million Iraqis are displaced during the war against ISIS in Iraq. ISIS also persecutes the Yazidis living in the Sinjar mountains, massacring five thousand Yazidis and displacing 500,000.

Syrian opposition rebels expel ISIS from their stronghold in Raqqa. From September to October, ISIS captures 350 Kurdish towns and villages around Kobane, displacing 400,000 Kurds who flee to Turkey. As the Geneva II Conference on Syria ends without success, 76,000 are killed in the Syrian civil war. Three million Syrians seek refuge in Jordan, Lebanon, Turkey, and other Middle Eastern countries, and 100,000 flee to Europe.

NATO officially ends its combat mission in Afghanistan but its personnel remain to provide training and support to Afghan security forces.

2015 Russia enters the Syrian war in support of government forces and is pivotal in several victories including the government's recapture of Palmyra, Aleppo, and Deir ez-Zor from rebel forces.

The UN Security Council passes Resolution 2254 setting out a timetable for negotiations and a unity government in Syria. However, the international community cannot agree on a representative of the Syrian opposition, and the future of Bashar al-Assad remains unresolved.

In Syria, the Kurdish People's Protection Units (YPG) and their allies retake the city of Kobane in the autonomous region of Rojava from ISIS. During the year-long siege, 400,000 civilians fled Kobane, mostly for Turkey.

Hungary erects a razor-wire fence at its border with Serbia after thousands of refugees transit through its territory towards Austria.

Germany suspends the Dublin Protocol and offers all Syrian asylum seekers the right to remain in Germany regardless of their first state of entry into the EU. 1.1 million refugees arrive in Germany in 2015.

The EU Justice and Home Affairs Council on migration adopts an emergency relocation mechanism from Italy and Greece to other member states. The relocation target is set at 120,000 people in clear need of international protection. Only a fraction of that number are relocated by the mechanism's end in September 2017.

Over 500,000 refugees and migrants arrive on the island of Lesvos. Most are from Syria, Iraq, and Afghanistan.

2016 The Battle of Aleppo, one of the longest sieges in modern history, finally ends as government forces retake the city. By the end of 2016 there are 5.5 million Syrian refugees abroad and 6.6 million internally displaced.

The Republic of Macedonia seals its border with Greece, effectively closing the Balkan Route. Tens of thousands of refugees are stranded in Greece. 14,000 amass at the Idomeni makeshift camp near the Greek-Macedonian border waiting for the border to reopen so they can continue their journeys to Germany, Sweden, and other European countries.

The EU-Turkey Statement is announced on March 18 after two summits in Brussels between EU leaders and the Turkish government. The so-called EU-Turkey deal aims to limit the influx of refugees and migrants reaching Greek shores from Turkey. Turkey agrees to take back irregular migrants and in return Syrian refugees in Turkey would be resettled to the EU. The EU also agrees to give Turkey three billion euros in aid for refugees and to restart talks on visa-free travel for Turkish citizens and Turkey's accession to the EU.

The United Kingdom and Gibraltar vote to leave the European Union during the Brexit referendum on June 23. In March of the following year, Prime Minister Theresa May triggers Article 50 and formally begins the process of withdrawing the UK from the EU.

After terrorist attacks on the Jordanian-Syrian border, Jordan closes its border with Syria for most of the year, trapping 40,000 refugees on the Syrian side.

Kenya threatens to close the Dadaab camp complex on the grounds that the al-Shabaab terrorist group is using it as a base from which to plan attacks in Kenya.

French police dismantle the Calais makeshift camp known as "The Jungle" which houses over 3,000 refugees.

Donald Trump is elected as the President of the United States. He promises to build a wall on the Mexican-American border to stop Latin Americans escaping poverty and violence from entering the US.

As Afghan-Pakistani tensions increase, Pakistan repatriates 381,000 Afghan refugees to Afghanistan.

2017 The Battle of Mosul ends as the Iraqi army, together with Kurdish and foreign forces, retakes Mosul from ISIS. 10,000 were killed and almost one million displaced.

In response to an attack by the Arakan Rohingya Salvation Army on Burmese police and army posts, the Burmese military launches a systematic campaign of extrajudicial killings, rapes, and arson against the Rohingya. 530,000 Rohingya flee across the border to Bangladesh.

Angela Merkel is elected to a fourth term as German Chancellor, while Germany's right-wing, anti-immigrant Alternative für Deutschland (AfD) party surges to become the third largest party in the German Parliament.

Populist politicians and parties make notable gains in Europe, including Austria, the Czech Republic, France, Hungary, Italy, Poland, and the UK.

Glossary

1951 Refugee Convention The Convention Relating to the Status of Refugees was signed in Geneva in 1951 and amended by the 1967 Protocol. In the aftermath of the Second World War, these were the main agreements created by the international community to define refugee rights and legal protections.

Balkan Route The route taken by over one million refugees, since 2015, who entered Europe mainly via the Greek islands or Bulgaria and traveled through Macedonia, Serbia, Croatia, Slovenia, and Austria with the aim of arriving in Germany or Sweden.

CAO The Reception and Orientation Centers *(Centres d'accueil et d'orientation)* were established by the French government in 2015 to provide migrants from the Calais refugee camp with temporary accommodation, administrative support with asylum applications, and health-care.

Druze The Druze are a monotheistic community of around one million living mainly in Israel, Jordan, Lebanon, and Syria.

Eid al-Adha and Eid al-Fitr The two most important Islamic festivals are Eid al-Adha, the Festival of the Sacrifice commemorating the Prophet Ibrahim, and Eid al-Fitr, which marks the end of Ramadan.

EU The European Union is an economic and political union of 28 countries created in the aftermath of the Second World War. Today it includes Austria, Belgium, Bulgaria, Croatia, Cyprus, Czechoslovakia, Denmark, Estonia, Finland, France, Germany, Greece, Hungary, Ireland, Italy, Latvia, Lithuania, Luxembourg, Malta, the Netherlands, Poland, Portugal, Romania, Slovakia, Slovenia, Spain, Sweden, and the United Kingdom.

EU-Turkey Deal In the EU-Turkey Statement of March 18, 2016, the EU and Turkey sought to reduce irregular migration from Turkey to Europe by agreement that: 1) All new irregular migrants crossing from Turkey to the Greek islands as of March 20, 2016 would be returned to Turkey; 2) For every Syrian returned to Turkey from the Greek islands, another Syrian would be resettled to the EU; and 3) the EU pledged an additional 3 billion euros for a total of 6 billion euros to improve the living conditions of Syrian refugees in Turkey.

Fatah Fatah (in Arabic, *Harakat al-Tahrir al-Watani al-Filastini*) is the ruling party of the Palestinian National Authority and the largest faction in the Palestine Liberation Organization. Fatah has de facto governed the West Bank since the 2007 conflict between Fatah and Hamas that split the Palestinian Authority.

Frontex Frontex is the European Border and Coast Guard Agency which supports EU Member States to manage the bloc's external borders. It was actively involved in the EU response to refugees arriving to the Greek islands from Turkey in 2016 and 2017.

Hamas The Islamic Resistance Movement (in Arabic, *Harakat al-Muqawamah al-Islammiyah*) is a Palestinian fundamentalist organization founded in 1988 that has governed the Gaza Strip since it was elected in 2007. Some countries including Israel and the United States regard Hamas as a terrorist organization.

HRW Human Rights Watch is a non-governmental organization which originated as Helsinki Watch in 1978 to highlight human rights violations in the Soviet Union and Eastern Europe. Today, HRW promotes human rights worldwide through investigative research and advocacy.

IDP Internally displaced person(s) are displaced within their own country by armed conflict, violence, and other human rights violations.

Intifada The intifadas are the Palestinian uprisings against Israeli occupation of the West Bank and Gaza Strip. The First Intifada lasted from 1987 to 1993 and the Second Intifada from 2000 to 2005.

ISIS The Islamic State of Iraq and Syria, also known as ISIL (Islamic State of Iraq and the Levant) and Daesh, is a Sunni extremist jihadist group that emerged from the al-Qaeda organization in Iraq around 2011. Its aim is to establish a worldwide caliphate based on fundamentalist Islamic principles. It is designated as a terrorist organization by the UN and many countries.

IOM The International Organization for Migration was established in 1951 as an operational logistics agency to facilitate orderly migration. It currently has 173 Member States. IOM became a Related Organization of the UN in September 2016.

Kurdistan / Kurds The Kurds are an ethnic group of around 40 million primarily located in Kurdistan, an area including parts of Iran, Iraq, Syria, and Turkey. Although Kurdistan was never a state, there are strong Kurdish nationalist movements for Kurdish autonomy and self-determination. The Gulf War, Syrian civil war, and the Kurds' ongoing conflict with Turkey are among the main causes of Kurdish displacement.

MSF Médecins Sans Frontières is a non-governmental organization founded in Paris in 1971 which provides medical assistance to people affected by armed conflict, epidemics, and other disasters.

NATO The North Atlantic Treaty Organization is a political and military alliance created in 1949 by nine European nations, Canada, and the United States to counter Soviet expansionism after the Second World War. Today, NATO has 29 member countries including Turkey and former Soviet bloc states.

NGO Non-governmental organizations are usually non-profit organizations that operate independently of governments and pursue humanitarian and other charitable causes.

Oslo Accords The Oslo I Accord (1993) and Oslo II Accord (1995) are the first agreements in which Israel and the PLO recognized each other. The Accords marked the start of the Oslo peace process by giving the Palestinian Authority limited autonomy over the Gaza Strip and West Bank.

PLO The Palestine Liberation Organization (in Arabic, *Munazzamat al-Tahrir al-Filastiniyyah*) is a political organization founded in 1964 with the aim of Palestinian liberation. It is recognized by many countries as the sole legitimate representative of the Palestinian people.

PKK The Kurdistan Workers Party (in Kurdish, *Partiya Karkerên Kurdistanê*) is a Kurdish left-wing political and military organization founded in 1987 that advocates for Kurdish autonomy. It is based in Iraq and Turkey and has been sporadically involved in armed conflict with Turkey since 1984. The PKK is regarded as a terrorist organization by the European Union, NATO, the US, and the UK.

Refugee A person who has been forced to leave his or her country to escape war, violence, or fear of persecution due to race, religion, nationality, political opinion, or membership in a particular social group.

Rohingya The Rohingyas are a stateless ethnic group numbering about two million worldwide, of which about one million lived in Myanmar's Rakhine State. They are not recognized as citizens by the Burmese government. As a result of repeated Burmese military crackdowns and ethnic cleansing, many Rohingyas fled to Bangladesh or are displaced within Myanmar. Approximately one million Rohingya refugees live in refugee camps in Bangladesh's Cox's Bazar district, and many others are refugees in India, Thailand, Malaysia, and other countries.

Taliban The Taliban is an Islamic fundamentalist political and military organization that de facto ruled Afghanistan from 1996 to 2001. Despite not being officially recognized by most countries, it has been involved in ongoing peace talks with the US and the Afghan government since 2010.

UN After the Second World War, the United Nations was founded in 1945 by 51 countries to maintain international peace and security and promote international relations, social progress, and human rights. Today, it has 193 Member States that act through the General Assembly, the Security Council, and other bodies and committees.

UNHCR The United Nations High Commissioner for Refugees, also known as the UN Refugee Agency, was created in 1950 with a mandate to help the millions of Europeans who had fled their homes during the Second World War. UNHCR supports Member States, which bear the primary responsibility to protect refugees, to conform to their obligations under international refugee law.

UNRWA The United Nations Relief and Works Assistance for Palestine Refugees in the Near East was created in 1949 to provide education, health care, and social services to Palestinian refugees from the 1948 Arab-Israeli War. Today, it also provides aid to Palestinian refugees in Jordan, Lebanon, and Syria in addition to those in the Gaza Strip and West Bank.

WFP The World Food Program was created by the United Nations in 1961 to provide emergency food aid to people affected by war and natural disasters.

Yazidi The Yazidis are an ethnic and religious Kurdish-speaking group of around 500,000 to 600,000 people indigenous to Iraq, Syria, and Turkey. In August 2014 ISIS killed thousands of Yazidis and displaced tens of thousands at Mount Sinjar in northern Iraq.

YPG The People's Protection Units (in Kurdish, *Yekîneyên Parastina Gel*) is a primarily Kurdish militia formed in 2004 and the main faction of the Syrian Democratic Forces. Its sister militia is the all-female Women's Protection Units (in Kurdish, *Yekîneyên Parastina Jin*).

Index

Note: Page numbers in italic type indicate photographs.

England. *See* United Kingdom

Enver, Mustafa, 189

Ercoban, Piril, 119–23

Eritrean refugees, 78

Ethiopia, 304

Ethiopian refugees, 78, 297

European Union (EU): border management for, 49–50; Justice and Home Affairs Council, 363; participation of, in foreign wars, 111; response of, to refugee crisis, 16–20, 27–28, 33–37, 59, 72, 100, 108–10, 112, 121–22, 131, 140, 155, 158, 169–70, 178–81, 302–3; Turkey's agreement with, 108, 112, 119–20, 122, 131, 140, 150, 178, 181, 364; United Kingdom's vote to exit, 364; and United Nations, 267; values of, 19, 27, 155–58, 170

Eurotunnel, 77

Facebook, 4, 46, 277, 281

family reunification, 16, 17, 79, 95, 101

Faris, Muhammad, 104–7

Fatah (Palestinian National Liberation Movement), 162, 163, 212

Finn, Mary, 339–40

Firas, Dana, Princess of Jordan, 184–86

Food and Agricultural Organization, 299

fortress mentality, 155, 181, 216–18

Four Paws International, 307

France: attitudes toward refugees in, 78, 346–47; numbers of refugees in, 78; partition of Ottoman Empire by, 360; politics in, 78; refugees in, 73–84, 341–42, 347; UK relations with, 82

freedom, 31, 91, 105–6, 120, 124, 139, 168–69, 171, 194, 219–20, 231, 235, 241, 292–93, 302, 343–44, 348, 350–51

Free Syrian Army, 91, 362

Frontex, 17, 21, 49–51, 59

Front National, 346

Gaddafi, Muammar, 292

Galinos, Spyros, 17, 33–37, 59

Gaza, 62–63, 193, 197, 200–202, 205, 209–15, *215*, 222, 230–35, *242*, 306–7, 360–62; education in, 62–63, 214, 230–35; Hamas, 212–13, 215, 239, 240–41; refugees in, 201, 211–12; tunnels in, 193, 229, 306; zoo, 165, 228–29, 306–7

Geddo, Bruno, 352–54

Génération Identitaire, 346

Geneva Convention, 27

Geneva peace accords (1988), 361

genocide, 268, 281

Germany: desirability of, for refugees, 5–6, 8, 13, 52, 87, 144–45; expulsion of Afghans from, 327; numbers of refugees in, 16, 19, 140, 328; refugees in, 2–6, 140, 146–47, 254–57, 263–64, 290, 328, 363; support for Iraq from, 295

Ghafoor, Abdul, 326–29

Ghani, Ashraf, 328

Gibraltar, 364

Giles, Sarah, 252–53

globalization, 155

God, 31, 32, 68–69, 90, 95–97, 99, 189, 194. *See also* Allah

Goldstein, Baruch, 246

Goldstein Massacre, 246

Golias, Nikos, 58–61

Gorbachev, Mikhail, 361

Göritz, Frank, 306

Grandi, Filippo, 301–5

Greece: as entry point, 7–8, 14–21, 26–27, 33–42, 170; refugees in, 10–13, *13*, 364; return of refugees by, 112, 117, 150

Guatemalans, 315

The Gun Admirer (film), 236

Gush Shalom, 169

Habib, Emil, 206

Hadalat camp, Syrian-Jordanian border, *107*, *135*

life under, 11, 134–35, 158, 223–24, 291, 341, 343–44, 349–50; and oil, 349; violence of, 128–29, 134–35, 223–24, 343–44, 349–51, 355–56

Islam. *See* Muslims/Islam

Islamic Jihad, 239

Islamic State. *See* ISIS

Islamic University, 236

Israel: creation of, 159, 219, 241, 243, 360; Egypt's treaty with, 245; establishment of, 211; exceptionalism of, 216, 218–19; gay rights in, 200, 203; and human rights, 197–99; Lebanon and, 167; occupation by, 195, 197–210, 212–13, 216, 219–20, 231, 238–42, 250; Palestinians and, 159, 162–66, 185, 190–96, 197–221, 230–51, 360–62; politics in, 197, 206–10, 216; settler movement in, 245–46, 249, 251; sterile buffer zones created by, in Hebron, 247; US relations with, 171, 219, 241. *See also* one-state solution; two-state solution

Israel Defense Forces (IDF), 196, 248; mock arrests, 250–51

İzmir, Turkey, 108, 111–12, 119

Jabhat al-Nusra, 178

Jarrah, Rami, 124–25

Jerusalem Open House, 203

Jews, 164, 189, 192, 196, 200–201, 204, 206, 208–10, 213, 240–41, 243–44, 347; Ashkenazi Jews, 243; Sephardic Jews, 243

jobs. *See* work

Joint List (Israel), 208

Jordan: closing of border by, 364; numbers of refugees in, 122, 302; Palestinians in, 162, 186, 211; pressures on resources of, 181–82; refugee camp conditions in, 175; refugees in, 14, 110, 154, 169–70, 181–86, 363; West Bank occupied by, 244

Joumblatt, Kamal, 167, 171, 172

Joumblatt, Walid, 167–72

Jungle camp, Calais, France, 73–84, 341–42, 345, 364

Justice and Development Party (AKP; Turkey), 258, 260

Karen refugees, 271, 273

Karzai, Hamid, 362

Kato Tritos Cemetery, Lesvos, Greece, *57*

Katzanos, George, 29

Kenya, 296–300, 361, 364

Kenya Comprehensive Refugee Program, 299

Kerry, John, 246, 270

Khalil, Amina, 85

Khalil, Amir, 306–7

Khan, Haji Khista, 325

Khdeir, Mohammed Abu, 163

Kim, Yanghee, 280

King, Martin Luther, Jr., 208

Kiryat Arba, West Bank, 244, 245

Kobane, Syria, 128–29, 223–27, 363

Kohesta, Emran, 86–88

Kouyou, Wella, 296–300

Kreisky, Bruno, 207

Kuala Lumpur, Malaysia, *282*

Kurdi, Aylan, 20, 38, 75, 241

Kurdish refugees, 65–71, 128–31, 256–57, 363

Kurdistan Workers' Party (PKK), 114, 130, 135

Kurds, 128–31, 258–61

Kutupalong camp, Bangladesh, *336*, *338*, 361

Kuwait, 170

labor. *See* work

Labor Party (Israel), 245

language: as barrier, 116, 225; English as international, 79; in refugee camps, 4; spoken by rescue personnel, 252

Lateral Repatriation Program, 318

Law of the Sea, 27

Muhammad (prophet), 96, 336

Museum of Memories, Beirut, Lebanon, 165

Muslim Brotherhood, 361

Muslims/Islam: burial practices among, 29–32; disputes between, 171; in Lebanese politics, 158; obligations of, to other Muslims, 10, 110, 261; Palestinian, 193; Rohingyan, 268–70, 279, 284, 335–36; values of, 99, 166, 264, 284, 294, 344, 350; Western hostility to, 166, 170, 276

Myanmar, 265–88, 332–38, 361

Mytilene, Lesvos, Greece, 38

Nakba (Palestinian exodus), 204, 206, 209, 211, 214, 219, 243, 360

Nasser, Gamel Abdul, 206

nationalisms, 111, 156, 198, 243, 346, 366. *See also* populisms

National League for Democracy, 273, 286

Nation of Islam, 208

NATO. *See* North Atlantic Treaty Organization

Nayapara camp, Bangladesh, *289*, 330–32, *331*, 361

Netanyahu, Benjamin, 169, 198, 213, 240, 241

niqabs, 331

Nizip camp, Gaziantep, Turkey, *179*, *183*

Noor, 288–89

Noor, Muhammad, 276–82

North Atlantic Treaty Organization (NATO), 34, 36, 112, 134, 149, 363

Norway, 328, 329

Nueva Esperanza, Mexico, 310–11

Obama, Barack, 111, 241, 362

Odeh, Ayman, 206–10

one-state solution, 199–200, 220

optimism, 84, 106, 207, 305, 350. *See also* hope; humanity: faith in

Orbán, Viktor, 170

Orthodox Christianity, 27

Oslo Agreement (1993), 62, 207, 213, 239, 246, 362

Osman, Ahmad Muhammad, 223–27

Osman, Ahmet, 134–35

Ottoman Empire, 360

Oweida, Mohammed, 228–29

Pakistan, 121, 262–63, 277, 304, 320, 322–23, 325–27, *329*, 364

Pakistani refugees, 3, 12, 65, 78, 141–42, 145

Palestine Liberation Organization (PLO), 160, 162, 212, 239, 241, 360, 362

Palestinian Artists Association, 236

Palestinian Authority, 212, 246, 362

Palestinians: armed resistance of, 238–42; attitudes toward, 206, 280; distorted narratives promulgated about, 217–21; human rights of, 198–99; identity of, 204; intifadas of, 190, 212, 246–48, 250, 361, 362; Israel and, 159, 162–66, 185, 190–94, 197–221, 230–51, 360–62; in Jordan, 162, 186, 211; in Lebanon, 151–53, 159, 162–66, 169–72, 173, 211, 360; living conditions of, 153, 201, 211, 214–15; and Nakba, 204, 206, 209, 211, 214, 219, 243; political power of, 206–7; refugee accounts, 62–64, 162–64; rights of, 217–18, 249; right-to-return of, 209, 218, 239, 241; special circumstances of, 238–39, 241; United Kingdom and, 360. *See also* one-state solution; two-state solution

Pappe, Ilan, 218

Petra National Trust, 185

photography, 55–56

PKK. *See* Kurdistan Workers' Party

PLO. *See* Palestine Liberation Organization

police: in Afghanistan, 12; in Bangladesh, 330, 338; in France, 81–84, 342, 346; in Greece, 10, 46, 51, 69, 71, 102, 112, 141–46, 150; Hungarian Armed Forces, 132–33, 137, 145–46; in Iran, 65, 89, 115, 145; in Iraq, 343, 349–50; Israeli civilian police, 249; in Malaysia, 280, 288; in Mexico, 314; in Pakistan, 325; in Serbia, 137; in Syria, 105; in Thailand, 266; in Turkey, 11, 65–68, 114, 116, 117, 118, 126, 145, 258, 260

politics: anti-refugee sentiment in, 27, 155–56, 159, 303, 304–5, 328; and exploitation of migrants, 137; fear of science in, 105; refugee crisis blamed on, 17, 25, 31–33, 56, 59, 104, 110, 122, 131, 329

populisms, 155, 216, 218, 364. *See also* nationalisms

Protocol of the Refugee Convention (1967). *See* 1967 Protocol of the Refugee Convention

Provisional Intergovernmental Committee for the Movements of Migrants from Europe (PICMME), 360

pushback, 27, 102, 115–16, 118, 141–44

Qatar, 110, 280

Qayyarah, Iraq, 349–50

Quintana, Tomas, 280

Qur'an, 238, 240

Rabin, Yitzhak, 199, 201, 207, 209

racism: anti-Arab, 206–8, 216; in United States, 218

Rakhine Buddhists, 265, 269, 279

Red Cross, 39, 163, 224, 360

refugee camps, *9, 13, 28, 50, 80, 88, 92, 138, 157, 179, 183, 255, 358*; as artificial worlds, 274; conditions in, 22, 23, 176, 271–72, 332, 341–42; education in, 93, 333; lack of electricity in, 108; living arrangements in, 22, 108, 271, 332; medical care in, 22, 23–24, 112–13, 175–76, 334; official campus vs. makeshift camps, 333–34; rain/snow, 15, 65–66, 70–72, 84, 89, 116, 141–43, 225, 254, 341; tents in, 23, 76, 84, 93, 101, 103, 113, 352

Refugee Convention (1951). *See* 1951 Refugee Convention

refugee crisis: descriptions/explanations of, 14, 26, 31–32, 33, 72, 110, 149, 217; EU response to, 16–20, 27–28, 33–37, 59, 72, 100, 109, 121–22, 131, 140, 155, 158, 169–70, 178–81, 302–3; US response to, 109–10, 218, 304

refugees: beatings of, 8, 10, 71, 142, 288, 342; defined, 14, 301, 360; desire to return home, 18, 22, 87, 91, 102, 106, 123, 156, 189, 263–64, 274, 290–91, 330, 331, 353–54; EU rules on, 15–16; evaluation of, 19; global extent of, 14; harassment of, 8, 10, 66, 70, 256–57; hardships experienced by/reasons for leaving home, 14, 17, 19, 22, 23, 31, 33, 39, 45, 48, 55–56, 63, 86, 89, 91, 109–10, 115, 145, 160–61, 180, 262, 265, 341–42; health problems of, 22, 69, 71, 87, 112, 176, 224–27, 287, 288; human capital represented by, 161, 236, 297–98; mental health of, 23, 43–45, 71, 112, 187, 254, 257, 352–53; migrants compared to, 19, 272–73; obligation to aid, 11–12, 16–20, 25, 27–28, 33, 35, 72, 108, 121–23, 155–56, 159, 185, 304–5, 342; papers of, 22, 66, 69, 70, 71, 92, 146, 175, 187–88, 290–91, 334; personal narratives of, 7–12, 22, 62–71, 85–107, 115–18, 126–27, 141–47, 187–88, 222–27, 254–61, 265–66, 288–89, 308–9, 312–14, 330–31, 341–44, 348–51, 355–58; refusal of, 27, 35; registration of, 49, 150, 334; secondarily displaced persons, 321; sex work and, 14. *See also* 1951 Refugee Convention; education; work

religion, 90, 99, 110, 145, 158–59, 166, 199, 204, 218, 238, 264

relocation process, 20, 303, 363

rescue operations and shoreline reception, 15, 19, 20–21, 27, 38–42, *42*, 46–48, 51–54, 58–61, 69, 339–40, *340*; medical care for refugees, 252–53; rescuers' accounts, 38–42, 60–61, 252–53

revolution in Syria, 91, 105, 125, 134, 139

rights. *See* human rights; legal rights

right-wing politics: in Europe, 110, 156, 216; in France, 346; in Germany, 364; in Israel, 169, 198, 213; in Lebanon, 169, 171; in United States, 216

Rohingya, 265–70, 273, 275–87, 330–31, 332–38, 361, 364

Rohingya Vision, 276, 281

Russia: and Afghanistan, 178; response of, to refugee crisis, 122; and Syria, 91, 111, 134, 139–40, 363. *See also* Soviet Union

Rwandan refugees, 296

Saada, Hanna Abu, 190–94

About the Author

Ai Weiwei

Ai Weiwei uses a wide range of mediums, from architecture and art installations to social media and documentaries, to examine society and its values. His recent exhibitions include *Ai Weiwei: Bare Life* at the Mildred Lane Kemper Museum in St. Louis, *Ai Weiwei* at the K20/K21 in Dusseldorf, *Ai Weiwei: Resetting Memories* at MUAC in Mexico City, *Ai Weiwei: Unbroken* at the Gardiner Museum in Toronto, *Ai Weiwei: RAIZ* at Oca in São Paulo, *Ai Weiwei: Life Cycle* at the Marciano Art Foundation in Los Angeles, *Fan-Tan* at Mucem in Marseille, and *Good Fences Make Good Neighbors* with the Public Art Fund in New York City.

Ai was born in Beijing in 1957 and currently works in Berlin. He is the recipient of the 2015 Ambassador of Conscience Award from Amnesty International and the 2012 Václav Havel Prize for Creative Dissent from the Human Rights Foundation. Ai's first feature-length documentary, *Human Flow* (2017), premiered at the 74th Venice Film Festival. His other films include *The Rest* (2019) and *Vivos* (2019).

Editors

Boris Cheshirkov
Boris Cheshirkov is a spokesperson for UNHCR based in Athens, Greece, and served as a writer on Ai Weiwei's documentary *Human Flow*.

Ryan Heath
Ryan Heath is the senior editor at POLITICO and a regular policy commentator on CNN, MSNBC, and BBC. His books include *Please Just F*ck Off*, *It's Our Turn Now: Holding Baby Boomers to Account*, and *Steelie Neelie: In Her Own Words*.

Chin-chin Yap
Chin-chin Yap is the producer and writer for the documentary *Human Flow* (2017). She also produced the films *The Rest* (2019) and *Ximei* (2019).

Acknowledgments

The author and editors would like to thank the interviewees:

The Abboud Family, Ibrahim Abujanad, Abou Ahmad, Fareshta Ahmadi, Fadi Abu Akleh,Peter Albers, Salam Aldeen, Nezir Abdullah Ali, Huda Alkahlot, Hussain M. F. Alkhateeb, Mariam Alshekh Aly, Amama, Maya Ameratunga, Munther Amira, Hanan Ashrawi, Sanaa Ahmad Ataullah, Atiq Atiqullah, Bahareh, Abu Bakr Bashir, Murat Bay, Farida Begum, Tibor Benkő, Peter Bouckaert, Gilles de Boves, Asmaa Al-Buhaisy, Krzysztot Burowski, Sukriye Cetin, Chaled, Tanya Chapuisat, Boris Cheshirkov, Thomas Conin, Mohammed Daoud, Mustafa Dawa, Gérard Dué, Hagai El-Ad, Mustafa Enver, Piril Ercoban, Muhammad Faris, Mary Finn, Princess Dana Firas, Spyros Galinos, Bruno Geddo, Abdul Ghafoor, Sarah Giles, Nikos Golias, Filippo Grandi, Alameen Hamdan, Andrew Harper, Ingrid Hernandez, Rozhan Hossin, Nadim Houry, Rami Jarrah, Walid Joumblatt, Abeer Khalid, Haneen Khalid, Amina Khalil, Amir Khalil, Haji Khista Khan, Mohammed al-Khatib, Emran Kohesta, Wella Kouyou, Mona Khalid Kurraz, Giorgia Linardi, Andreas Lindner, Antonio Luna, Majuna and Noor, Manan and Zaki, Maung Kyaw Nu, John McKissick, Melinda McRostie, Aris Messinis, Amjad Moghary, Mohammed, Mohammed and Hasmira, Sadia Moshid, Ioannis Mouzalas, Nidaa Muhammed, Samah Nabil, Hind Nahed, Mohammed Noor, Ayman Odeh, Ahmad Muhammad Osman, Ahmet Osman, Mohammed Oweida, Hanna Abu Saada, Mukhaimar Abu Saada, Abbas Ali Sabhan, Namshah Sallow, Christian Salomé, Mohammed al-Samaraei, Ramon Sanchez, Ismetollah Sediqi, Yehuda Shaul, Ahmad Shuja, Peppi Siddiq, Hamid Sidiq, Cem Terzi, Pascal Thirion, Sally Thompson, Mustafa Toprak, László Toroczkai, Ahmad Touma, Zaharoula Tsirigoti, Rafik Ustaz, Vaise, Maha Yahya, Jose Carlos Yi, Paul Yon, and Mahmoud al-Zahar.

and:

Ai Weiwei Studio, B'Tselem, Breaking the Silence, Andy Cohen, Heino Deckert, Melissa Fleming, Michael and Nicolai Frahm, Cheryl Haines, Nora Joumblatt, Miki Kratsman, Lisson Gallery, neugerriemschneider, Participant Media, Paul Moawad, Anne Richard, Samia Saouma, Cem Terzi, UNHCR, Larry Warsh, and everyone who contributed to the film *Human Flow* (2017).